Sir Edwin Landseer

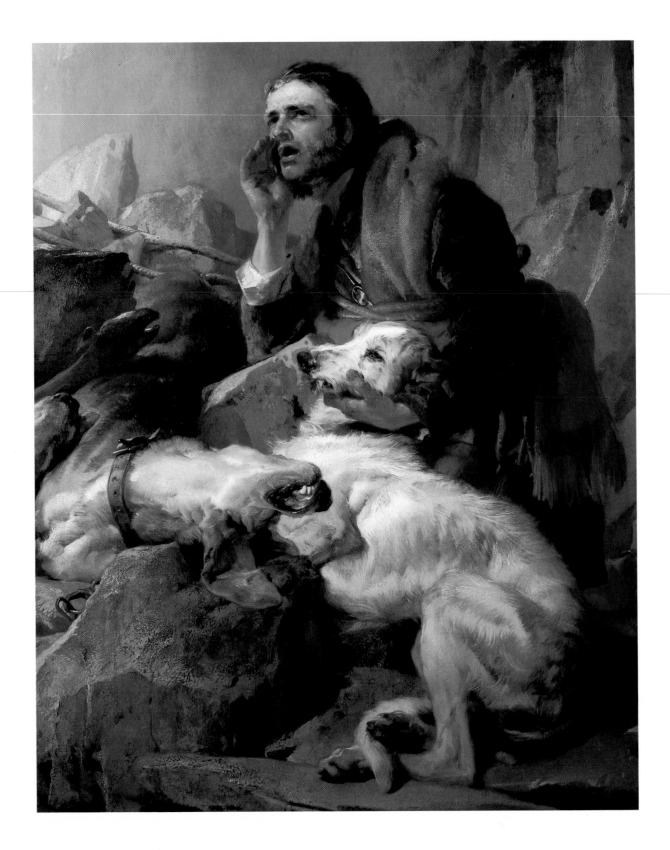

Sir Edwin Landseer

Richard Ormond

With contributions by

Joseph Rishel and Robin Hamlyn

PHILADELPHIA MUSEUM OF ART

THE TATE GALLERY, LONDON

COVER: Detail of *Man Proposes, God Disposes* (no. 151)
FRONTISPIECE: Detail of *The Life's in the Old Dog Yet* (no. 119)

Published in conjunction with an exhibition of the art of
Sir Edwin Landseer

Philadelphia Museum of Art
October 25, 1981, to January 3, 1982

The Tate Gallery, London
February 10 to April 12, 1982

In Philadelphia, this exhibition was supported by a grant
from the National Endowment for the Arts, a Federal agency,
and by a Federal indemnity from the Federal Council on the
Arts and the Humanities

In London, this exhibition was presented with support from
S. Pearson & Son

Library of Congress catalog card number: 81-81916
See last page for Library of Congress Cataloging in
Publication Data

Edited by Jane Iandola Watkins

Designed by John Anderson

Composition by Pan Graphics,
Berlin, New Jersey

Printed in Great Britain by
Balding + Mansell, Wisbech, Cambs.

Paper
ISBN 0-87633-044-8 Philadelphia Museum of Art
ISBN 0-905005-97-X The Tate Gallery, London

Cloth
ISBN 0-8478-0390-2 Rizzoli, New York
ISBN 0-500-09152-8 Thames & Hudson, London

Contents

Lenders to the Exhibition

Her Majesty Queen Elizabeth II

The Duke of Abercorn

Aberdeen Art Gallery and Museums

Dr. Roger L. Anderson

The Duke of Atholl

The Duke of Beaufort

Mark Birley, Esq.

City Museums and Art Gallery, Birmingham

The Trustees of the British Museum, London

Bury Art Gallery and Museum

Viscount Camrose

The Trustees of the Chatsworth Settlement

John Dewar & Sons Limited

Lord Dulverton

Lord Fairhaven

Fitzwilliam Museum, Cambridge

Guildhall Art Gallery, London

Hamburger Kunsthalle

The Iveagh Bequest, London

Pierre Jeannerat

Henry P. McIlhenny

Ian D. Malcolmson

The Earl of Malmesbury

City of Manchester Art Galleries

Milwaukee Art Museum

National Galleries of Scotland, Edinburgh

National Gallery of Ireland, Dublin

National Gallery of Victoria, Melbourne

National Loan Collection Trust

National Portrait Gallery, London

The Duke of Northumberland

Perth and Kinross District Council
 Museum and Art Gallery, Perth

C. H. Pittaway

Ian Posgate, Esq.

Private collections (19)

Royal Academy of Arts, London

Royal Holloway College (University of London),
 Egham

Sheffield City Art Galleries

The Duke of Sutherland

The Trustees of the Tate Gallery, London

The Marquess of Tavistock

Tennant Holdings Limited

Tyne and Wear County Museums Service
 (Laing Art Gallery, Newcastle upon Tyne)

Victoria and Albert Museum, London

Walker Art Gallery, Liverpool

The Warner Collection of Gulf States
 Paper Corporation, Tuscaloosa

Mrs. John Wintersteen

Yale Center for British Art, New Haven

Preface

LANDSEER'S name was a household word in Victorian England: few artists rivaled his success and popularity. Landseer kept that broad public following to a large extent, even through a long period of critical neglect. His greatest animal images—*The Monarch of the Glen* or the lions of Trafalgar Square, for example—have always been remembered with a durable affection. Even during the artist's lifetime Philadelphia would have been aware of Sir Edwin Landseer, as engravings of his works spread his fame throughout the world. Originals of his works, however, seldom crossed the Atlantic to North America until after World War II. An exception was the five paintings that were sent three years after his death to the 1876 Centennial Exhibition in Philadelphia, of which two are included here: *Study of a Lion* and *The Traveled Monkey*. They were exhibited in the British contribution to the Fine Arts section, shown in the newly constructed Memorial Hall, which the next year would be the first home of the Philadelphia Museum of Art. But, on the whole, Americans have known Landseer's images only in black and white and have had little opportunity to observe his splendor as a painter.

Therefore one purpose of this exhibition is to show Sir Edwin Landseer to Americans as a painter who gave his memorable compositions, otherwise known through engravings and photographs, considerable brio. It will also show the range of his work, in subject matter, conception, and scale. For Americans it is thus an exploration of only dimly familiar territory and an opportunity to know the work of an artist as renowned in his day as was his contemporary in France, Gustave Courbet. It is Joseph Rishel, Curator of European Painting before 1900 at the Philadelphia Museum of Art, who encouraged his museum to enter upon this rewarding voyage; he was stimulated to do so by his knowledge of Landseer's works in the original, not least of them in the collections of Henry P. McIlhenny, the chairman of the Philadelphia Museum's board of trustees, and of Mrs. John Wintersteen, Mr. McIlhenny's sister.

The Tate Gallery agreed to collaborate with the Philadelphia Museum of Art on the project—but hardly as an exploration, since its walls contain so many of Landseer's canvases. As the national museum of British art, it is interested in a serious reassessment of this major British artist's work. Robin Hamlyn, of the British Collection, was assigned the task of working on the exhibition.

Particularly attractive to the Tate Gallery was the fact that Richard Ormond of the National Portrait Gallery, London, had already been asked by the Philadelphia Museum if he would collaborate with Mr. Rishel on the selection of the works and write the bulk of the catalogue. Mr. Ormond, who has written definitive works on Sargent and (with his wife Leonée) on Lord Leighton, had already found extensive archival material to add to what has been published on Landseer. Although there had been exhibitions of Land-

seer's work at the Royal Academy in 1961 and at the Mappin Art Gallery, Sheffield, in 1972, these had not been accompanied by substantial catalogues. Campbell Lennie had written a generous biography of the painter, published in 1976, but there has been nothing for over a hundred years that has attempted a thorough documentation of the relationship of his life and work. Since the exhibition contains his major masterpieces, this publication plays an important role in reevaluating Landseer as both a man and a painter.

As with all exhibitions the ambitions for this undertaking could never have been realized without the great generosity of the lenders, especially the gracious support of Her Majesty Queen Elizabeth II. With the Tate Gallery's own substantial holdings, the lenders have made it possible to show all facets of Landseer's work—with the exception of the sculptured lions in Trafalgar Square. They have also been extraordinarily cooperative about having their works cleaned for the exhibition; as a result most of them will be seen in their original radiance. We must thank them here for their generosity.

Many have worked with Mr. Ormond, Mr. Rishel, and Mr. Hamlyn to make the exhibition a reality, both in Philadelphia and in London. It seems particularly appropriate to thank George Marcus and Jane Iandola Watkins of the Philadelphia Museum of Art who have worked on the catalogue.

We hope that both the discovery of Landseer for Americans and the rediscovery for the British will be as much enjoyed as has been this collaboration between the Philadelphia Museum of Art and the Tate Gallery.

Jean Sutherland Boggs
Director, Philadelphia Museum of Art

Alan Bowness
Director, The Tate Gallery

Acknowledgments

THERE ARE NUMEROUS professional and private individuals who have helped with advice and information at every turn. First and foremost my debt is to the owners who have allowed me to see their pictures and patiently answered many questions. Without the generosity of Her Majesty Queen Elizabeth II, this exhibition would have been immeasurably impoverished, and I have been fortunate from the beginning in the wholehearted support and encouragement of Sir Oliver Millar, Surveyor of the Queen's Pictures. B.D.M. Booth of the Moorland Gallery, London, provided much-needed guidance on breeds of deer and birds represented in Landseer's pictures, and a similar service for dogs was provided by Harry Glover of the Kennel Club, London. To the editorial and publishing skills of George Marcus and Jane Iandola Watkins of the Philadelphia Museum of Art I owe the elegant and professional appearance of the catalogue. The burden of typing has been bravely borne by Winifred Underwood, Margaret Money, and Sue White, working with great accuracy under considerable pressure of time. Documents in the Royal Collection are quoted by gracious permission of Her Majesty Queen Elizabeth II. I am grateful to other repositories and the Mackenzie family for permission to quote from manuscript material. Finally a special word of thanks to Leonée Ormond for support at home, for patient listening, and for answers to interminable questions.

R.O.

THE AUTHORS and the institutions would like to acknowledge the help and services of the following: Charles Alabaster, Hazlitt, Gooden & Fox, London; Alphabet House, Lumberton; Juliette Avis, National Portrait Gallery, London; Sherry Babbitt, Philadelphia Museum of Art; Major J. C. Balfour; Barnes & Bradforth, Fine Art Photographers; Alan Bell, Assistant Keeper, National Library of Scotland, Edinburgh; Mary Bennet, Keeper of British Art, Walker Art Gallery, Liverpool; Dr. B.C.R. Bertram, Curator of Mammals, Zoological Society of London; Georgiana Blakiston; Anne F. Bowman, Philadelphia Museum of Art; Patrick Boylan; Rory Cameron; Raymond Catton, Librarian, Royal Veterinary College, London; G.A.D. Chalmer, Loch Laggan Estates Limited; Jeannie Chapel; Mark Chatfield; George Cheston, Philadelphia; Margie Christian, Christie's, London; Bernice Connolly, Philadelphia Museum of Art; A. C. Cooper Limited, Fine Art Photographers; James C. Corson, Honorary Librarian, Abbotsford, Scotland; Peter Day, Curator, Chatsworth House; Geoffrey de Bellaigue, Surveyor of the Queen's Works of Art; Frances Dimond, Curator, Photograph Collection, Windsor Castle; Mrs. M. Draper, Archivist to the Bedford Estates, London; William Drummond, Covent Garden Gallery, London; Viscount Dunluce, Department of Conservation, Tate Gallery; Owen Edgar, Owen Edgar Gallery, London; Jacques Foucard, Louvre; Sarah Fox-Pitt, Senior Research Assistant, Archives and Library, Tate Gallery; Eleanor Garrey, Houghton Library, Harvard University; Sarah Graham, Chairman, National Loan Collection Trust; Andrew Greg, Laing Art Gallery, Newcastle upon Tyne; Hilary Gresty, Tate Gallery Library; Stephen Hackney, Department of Conservation, Tate Gallery; John Harper, Department of Conservation, Tate Gallery; Gregory Hedberg, Minneapolis Institute of Arts; Gill Hedley, Assistant Keeper of Fine Art, Laing Art Gallery, Newcastle upon Tyne; Charles Hilburn, Tuscaloosa; Derek Hill; F. W. Hills, Hazlitt, Gooden & Fox, London; Carol Homan, Philadelphia Museum of Art Library; Holly Hotcher, Department of Conservation, Tate Gallery; Beth Houghton, Tate Gallery Library; J. W. Howes, Borough Librarian and Arts Officer, London Borough of Waltham Forest; Jane Hume, Secretary, British Collection, Tate Gallery; Malcolm Innes, Malcolm Innes and Partners, London; Dr. David Iredale, Archivist, Record Office, Forres; Francina Irwin, Keeper of Fine Art, Aberdeen Art Gallery; Peter Johnson, Oscar and Peter Johnson Limited, London; Evelyn Joll, Thomas Agnew & Sons, London; L. T. Joyce, Department of Architecture and Sculpture, Victoria and Albert Museum; Dwight de Keyser, Philadelphia Museum of Art; Molly Klobe, formerly of Columbia University; Dr. R.J.B. Knight, Custodian of Manuscripts, National Maritime Museum, London; David Lambert, Photographic Department, Tate Gallery; Lionel Lambourne, Assistant Keeper, Department of Paintings, Vic-

toria and Albert Museum; Judith Landrigan, Sotheby Parke-Bernet, New York; G. Langley, County Reference Librarian, Central Library, Bristol; Jane Langton, Registrar, Royal Archives, Windsor Castle; the late Seymour Leslie; Suzanne Lindsay, Philadelphia; Richard Lockett, Keeper of Fine Art, City Museums and Art Gallery, Birmingham; James Lomax, Assistant Keeper, City of Manchester Art Galleries; Professor John MacQueen, School of Scottish Studies, Edinburgh; Miss I. M. McCabe, Librarian, Royal Institution of Great Britain; Henry P. McIlhenny, Philadelphia; Jeremy Maas, J. S. Maas & Company, London; Judith Marle, Landseer Productions, London; Peter Marlow, National Trust, Ballynahinch; Colin Mathew, Christ Church, Oxford; John Millard, Acting Curator, Laing Art Gallery, Newcastle upon Tyne; Angelina Morhange, Research Assistant, National Gallery, London; Edward Morris, Keeper of Foreign Art, Walker Art Gallery, Liverpool; Guy Morrison, Spink & Son, London; Beatrice Morton; Joanna Mundy, Keeper of Art, Perth and Kinross District Council Museum and Art Gallery; A.V.B. Norman, Master of the Armouries, Tower of London; Charles Pettit, Assistant Reference Librarian, County Library, Dorchester; Barbara Phillips, Philadelphia Museum of Art; Homan Potterton, National Gallery of Ireland, Dublin; Dr. A. D. Potts, School of Fine Arts and Music, University of East Anglia, Norwich; Brigadier Geoffrey Proudman, CBE, British Deer Society; Staff of the Public Record Office, Kew, London; Anthony Radcliffe, Keeper of Sculpture, Victoria and Albert Museum; Ruth Rattenbury, Deputy Keeper, Tate Gallery; Hon. Mrs. Roberts, Curator of the Print Room, Windsor Castle; K. Roberts, Barclay's Bank, Fleet Street Branch, London; Hinda Rose, Maggs Brothers, London; Beryl Rosenstock, Philadelphia Museum of Art; Fernande Ross, Registrar, Philadelphia Museum of Art; Francis Russell, Christie's, London; Sidney Sabin, Sabin Galleries Limited, London; M. R. Schweitzer, Sotheby Parke-Bernet, New York; Dr. Lorenz Seelig, Bayerische Verwaltung der Staatlichen Schlösser, Gärten und Seen; Barbara Sevy, Librarian, Philadelphia Museum of Art; J. M. Sheard, Estate Office, Bolton Abbey, Yorkshire; John Shepley, New York; Peyton Skipwith, Fine Art Society, London; Martha Small, Philadelphia Museum of Art; Mark Southgate, House of Commons Library; Ira Spanierman, Sotheby Parke-Bernet, New York; Anthony Spink, Spink & Son, London; Timothy Stevens, Director, Walker Art Gallery, Liverpool; Tim Sturgis; Dr. Georg Syamken, Hamburger Kunsthalle; John Tancock, Sotheby Parke-Bernet, New York; Julian Treuherz, Keeper of Fine Art, City of Manchester Art Galleries; Peter Van der Merwe, Curator, National Maritime Museum, London; B.D.J. Walsh, London; Susan Weinstein, Philadelphia; Lavinia Wellicome, Curator, Woburn Abbey, Bedfordshire; C. Wilkins-Jones, County Local Studies Librarian, Central Library, Norwich; Reginald Williams, Department of Prints and Drawings, British Museum; Catherine Wills; Mrs. John Wintersteen, Philadelphia; Christopher Wood, Christopher Wood Gallery, London; Harry Woolford; Michael Wynne, Assistant Director, National Gallery of Ireland, Dublin.

Dramatis Personae

ABERCORN, Lord James Hamilton, 2nd Marquess, later 1st Duke of (1811–1885). Succeeded his grandfather as 2nd Marquess in 1818 and created duke in 1868. Lord lieutenant of Ireland, 1866–68 and 1874–76. He and his wife were devoted friends and patrons of Landseer for over 40 years.

ABERCORN, Lady Louisa Hamilton (née Russell), Marchioness, later Duchess of (died 1905). Eldest daughter of the 6th Duke of Bedford (q.v.) by his second wife. Married Lord James Hamilton, later 1st Duke of Abercorn, in 1832. One of Landseer's closest friends. He often visited her and her family at the Priory in Surrey and at their lodge, Ardvereike, on Loch Laggan, Scotland.

ABERDEEN, George Hamilton Gordon, 4th Earl of (1784–1860). Prime minister (1852–55), leader of the Whig party, noted scholar, and antiquarian. Landseer stayed several times at his Scottish home, Haddo House, and painted *The Otter Hunt* (no. 135) for him.

ALBERT of Saxe-Coburg-Gotha, Prince (1819–1861). Prince Consort of Queen Victoria. Played a leading role in public affairs and was passionately interested in the arts. Sponsored the Great Exhibition of 1851, and was one of Landseer's keenest admirers.

ASHBURTON, Hon. Louisa Caroline (née Stewart Mackenzie), Lady (died 1903). Second wife of the 2nd Baron Ashburton. She was a noted beauty and personality with whom Landseer fell passionately in love.

ATHOLL, John Murray, 4th Duke of (1755–1830). Highland landowner and chieftain, and famous sportsman. As a young man Landseer was a frequent guest at his castle at Blair Atholl.

BEAUFORT, Henry Somerset, 7th Duke of (1792–1853). Aide-de-camp to the Duke of Wellington (q.v.), Tory member of Parliament, and an avid sportsman. Landseer stayed several times at his seat, Badminton, Gloucestershire, and painted a number of pictures for him.

BEDFORD, Georgiana, Duchess of (1781–1853). Daughter of the 4th Duke of Gordon (q.v.), she married the 6th Duke of Bedford as his second wife and had 10 children. One of Landseer's most intimate friends and very probably his mistress.

BEDFORD, John Russell, 6th Duke of (1766–1839). A rich and powerful landowner, and a supporter of the Whig party. Passionately interested in art, horticulture, and natural history. Landseer's most important early patron.

BELL, Jacob (1810–1859). Owner of a pharmaceutical company and distinguished research chemist. Devoted himself to Landseer's interests.

BIDDULPH, Sir Thomas Myddleton (1809–1878). General. Appointed Master of Queen Victoria's household in 1851, and Keeper of the Queen's Privy Purse, after Phipps (q.v.), in 1867. Involved in tangled negotiations regarding Landseer's late royal commissions.

BLESSINGTON, Marguerite (née Power), Countess of (1789–1849). An Irish woman of great beauty, she married the 1st Earl of Blessington in 1818. Lived with her stepson-in-law, Count d'Orsay (q.v.), and they attracted to her Gore House salon the fashionable and artistic leaders of London, including Landseer. Also a prolific poetess and writer.

BOXALL, Sir William (1800–1879). Painter and director of the National Gallery. One of Landseer's closest artist friends.

BREADALBANE, John Campbell, 2nd Marquess of (1796–1862). Scottish landowner and Lord Chamberlain of the Queen's household. Friend and patron of Landseer, who frequently stayed and hunted at his home in the Mar forests.

BROOKS, Charles William Shirley (1816–1874). Humorous writer and *Punch* editor. His diaries are a fruitful source of information on Landseer's later years.

BUTLER, William. Landseer's manservant for over 30 years.

CALLCOTT, Sir Augustus Wall (1779–1844). Landscape painter. One of Landseer's closest friends, with whom he collaborated on a number of pictures.

CHANTREY, Sir Francis (1781–1841). Leading portrait sculptor of the age, with wide range of interests and friends. A friend and patron of Landseer. The Chantrey Bequest, which he established at the Royal Academy for the purchase of works by contemporary British artists, continues today.

CHRISTMAS, Thomas (born 1797). Fellow student, artist, and close friend of Landseer. Married the artist's sister Jane (q.v.).

COLEMAN, Edward J. (died 1885). Wealthy stockbroker. Lived stylishly at Stoke Park, where Landseer often stayed in the 1860s. A close friend of Landseer, Coleman owned several of his most important late works.

CONSTABLE, John (1776–1837). The famous landscape painter became friendly with Landseer through Charles Robert Leslie (q.v.).

DEVONSHIRE, William George Spencer Cavendish, 6th Duke of (1790–1858). The "bachelor duke," wealthy landowner, bibliophile, and art connoisseur. One of Landseer's most important patrons.

DICKENS, Charles John Huffam (1812–1870). Landseer was one of the novelist's circle of friends in the 1840s.

D'ORSAY, Alfred Guillaume Gabriel, Count (1801–1852). French-born dandy, socialite, and amateur artist. Lived with Lady Blessington (q.v.) and established a fashionable London salon. One of Landseer's most intimate friends.

EASTLAKE, Sir Charles Lock (1793–1864). Painter, art historian, president of the Royal Academy, and director of the National Gallery. Landseer was a friend of Eastlake and his wife, Elizabeth (née Rigby) (1809–1893).

EDWARD, Prince of Wales, later Edward VII (1841–1910). A friend and patron of Landseer, with whom he shared a liking for fast living.

ELCHO, Francis Richard Charteris, Lord, later 10th Earl of Wemyss (1818–1914). Landowner, politician, and sportsman. Close friend of Landseer in his later years.

ELLESMERE, Lord Francis Egerton, 1st Earl of (1800–1857). Second son of the 1st Duke of Sutherland. Heir to the vast Bridgewater estates and a famous collection of old master paintings. Active in Parliament, president of various learned societies, writer, translator, and poet. A friend, fellow sportsman, and patron of the artist.

ELLICE, Edward (1781–1863). Secretary of war, 1833–34, and a deputy governor of Hudson's Bay Company. Entertained frequently at the lodge he took at Glen Quoich at Inverness. He and his family formed part of Landseer's intimate Highland circle.

ELLIOT, Jane (née Perry). Daughter of James Perry, editor of the *Morning Chronicle,* sister of Kate Perry (q.v.), and wife of Sir Thomas Frederick Elliot, a nephew of the 1st Earl of Minto. A bluestocking like her sister.

FITZHARRIS, Lady Corisande Emma (née Bennet), Viscountess (1807–1876). Daughter of the 5th Earl of Tankerville, and sister of the 6th (q.v.), she married Viscount FitzHarris, later 3rd Earl of Malmesbury, in 1830. Beautiful and intelligent, but sadly childless, she was one of Landseer's circle of aristocratic friends in the 1830s. He drew and painted her on several occasions.

FRITH, William Powell (1819–1909). Painter of *Derby Day* and other topical subjects. Wrote at length about his friend Landseer in his *Autobiography and Reminiscences* (London, 1887–88).

GAMBART, Ernest (1814–1902). Belgian-born publisher and printseller, whose marketing techniques, although highly successful, upset many people, including Landseer. Published many prints after Landseer's works.

GILBERT, Annie. A horsewoman and leader of the London demimonde. Posed for *Taming the Shrew* (no. 149).

GORDON, Alexander Gordon, 4th Duke of (1743–1827). Lord Keeper of Scotland. Father of Georgiana, Duchess of Bedford (q.v.), and a friend and patron of Landseer.

GRANT, Sir Francis (1803–1878). Portrait painter, president of the Royal Academy after Eastlake (q.v.) (elected 1866), and a very close friend of Landseer.

GRAVES, Henry (1806–1892). Printseller and publisher. Published many Landseer prints. His son Algernon compiled the first catalogue of Landseer's work.

HARDINGE, Charles Stewart Hardinge, 2nd Viscount (1822–1894). Son of a famous field marshal, the 1st Viscount, who like his son was a friend and patron of Landseer. The artist spent more time at their house, South Park, than anywhere else in his last years.

HAYDON, Benjamin Robert (1786–1846). History painter, author of a famous diary, and teacher of three Landseer brothers.

HAYTER, Sir George (1792–1871). Portrait and history painter. Son of the miniature painter Charles Hayter, his family fraternized with the Landseers.

HAYTER, John (1800–1895). Portrait painter. Brother of Sir George Hayter. Fellow pupil of Landseer, whom he drew and painted, at the Royal Academy schools.

HILLS, Thomas Hyde (1815–1891). Partner in Jacob Bell's (q.v.) pharmaceutical company, he inherited from Bell the task of looking after Landseer, which he did devotedly.

HOLLAND, Henry Richard Vassall Fox, 3rd Baron (1773–1840). Whig party leader. He and his witty and formidable wife, Elizabeth (1770–1845), made Holland House in London a brilliant social and political center. Landseer was their friend and frequent guest.

HORSLEY, John Callcott (1817–1903). Painter. Often a guest with Landseer at Redleaf, the home of William Wells (q.v.). Wrote his reminiscences of Landseer.

HOUGHTON, Richard Monckton Milnes, 1st Baron (1809–1885). Politician, poet, and rake. He and his wife were friends and admirers of Landseer.

KEYL, Frederick William (1823–1871). German-born animal painter and Landseer's only recorded pupil. Wrote verbatim accounts of his conversations with Landseer in the 1860s.

LANDSEER, Anna Maria (1805–1871). The artist's second-eldest sister.

LANDSEER, Charles (1800–1879). The artist's second-eldest brother, a history painter, and fellow Academician.

LANDSEER, Emma, later Mrs. Mackenzie (1809–1895). The artist's youngest sister and a miniature painter.

LANDSEER, Jane (née Potts) (died 1840). Mother of the artist.

LANDSEER, Jane, later Mrs. Thomas Christmas (q.v.) (born 1795). The artist's eldest sister.

LANDSEER, Jessica (born 1807). The artist's second-youngest sister, his devoted companion and housekeeper, together with Barbara Potts (q.v.), and a miniature painter.

LANDSEER, John (1769–1852). Father of the artist, engraver, and author.

LANDSEER, Thomas (1798–1880). The artist's eldest brother and the engraver of many of his works.

LEHMANN, Rudolf (1819–1905). German-born portrait painter and friend of Landseer.

LESLIE, Charles Robert (1794–1859). The painter, born of American parents, was a lifelong friend of Landseer.

LESLIE, Lady, Constance Wilhelmina Frances (née Dawson Damer) (died 1925). Wife of the amateur artist Sir John Leslie, 1st Bart., of Castle Leslie, Glaslough, County Monaghan. Wrote her reminiscences of Landseer.

LESLIE, George Dunlop (1835–1911). Son of Charles Leslie. Assisted Landseer with some of his late pictures, and wrote revealing reminiscences of Landseer's last years.

LEWIS, Charles George (1808–1880). Son of Frederick Christian Lewis. Landseer's friend from childhood, and the engraver of many of his works.

LEWIS, Frederick Christian (1779–1856). Engraver and painter. His family and the Landseers were neighbors and close friends. Engraved a number of the artist's early works.

LEWIS, John Frederick (1805–1876). Son of Frederick Christian Lewis and childhood companion of Landseer. Painter famous for his brilliant oriental scenes, whose early work is very similar in subject and style to Landseer's.

MAROCHETTI, Baron Carlo (1805–1867). Italian-born sculptor patronized by Queen Victoria and other notables. A close friend of Landseer, who modeled his Trafalgar Square lions with his help and in his studio.

MATHEWS, Charles James (1803–1878). Actor and dramatist. Accompanied Landseer to Glenfeshie in 1833, and wrote humorous accounts of their trip.

NORTHUMBERLAND, Algernon Percy, 4th Duke of (1792–1865). Naval officer and supporter of various scientific, literary, and artistic undertakings. Important early patron of Landseer.

NORTON, Hon. Caroline Elizabeth (née Sheridan), later Lady Stirling-Maxwell (1808–1887). Granddaughter of the famous playwright Richard Brinsley Sheridan, daughter of Thomas Sheridan, and sister of Richard Brinsley Sheridan (q.v.). Distinguished for her beauty and wit, she was a popular and prolific poetess and writer. Unhappily married to her first husband, Hon. George Chapple Norton, from whom she was separated. Campaigned for protection of married women's rights. Married Sir William Stirling-Maxwell in 1877. Intimate friend of Landseer.

OSSULSTON, Lord. See Tankerville, 6th Earl of.

PEEL, Sir Robert, 2nd Bart. (1788–1850). Prime minister (1834–35, 1841–46) and Tory party leader. Commissioned several important works from Landseer and corresponded with him extensively.

PERRY, Kate. Daughter of James Perry, editor of the Morning Chronicle, and sister of Jane Elliot (q.v.). A figure in the London literary scene, she was a close friend of Thackeray (q.v.). Landseer was devoted to her, and is said to have proposed to her in the 1830s.

PHIPPS, Sir Charles Beaumont (1801–1866). Son of 1st Earl of Mulgrave. An army colonel and Keeper of the Queen's Privy Purse. Much involved with Landseer over royal commissions and one of his allies at court.

POTTS, Barbara (1777–1861). Landseer's aunt and housekeeper.

PRICKETT, Elizabeth. An elderly widow who was Landseer's next-door neighbor. He nicknamed her his "pocket Venus." One of the few people who could cope with him in his last years, and toward whom he displayed enormous gallantry.

QUAIN, Sir Richard, 1st Bart. (1816–1898). Distinguished physician. Friend and medical adviser of the artist.

REDGRAVE, Richard (1804–1888). Genre and landscape painter and art historian. Left valuable records of his association with Landseer.

ROGERS, Samuel (1763–1855). Popular poet, art collector, and friend of the famous. His breakfasts were part of the London season. Landseer met him through the Hollands (q.v.). Landseer's sharp caricatures of the poet show that their friendship had an edge.

RUSSELL, Lord Cosmo George (1817–1875). Son of the 6th Duke of Bedford (q.v.) by his second wife. An army major and, like many of his brothers and sisters, a friend and patron of Landseer.

RUSSELL, William (1800–1884). Son of Lord William Russell (who was murdered by his valet), and great-grandson of the 4th Duke of Bedford. Accountant-general of the Court of Chancery. Perhaps the closest and most loyal of Landseer's friends. Landseer was also close to his wife, Emma.

SCOTT, Sir Walter (1771–1832). The celebrated Scottish novelist had an immeasurable influence on Landseer's work.

SHEEPSHANKS, John (1787–1863). Wealthy cloth manufacturer. Amassed a distinguished collection of modern British works, including 16 Landseers, which he gave to the British government.

SHERIDAN, Richard Brinsley (died 1888). Grandson of the famous playwright, son of Thomas Sheridan, and brother of Caroline Norton (q.v.). Landowner and member of Parliament. Married Marcia Maria, daughter of Sir Colquhoun Grant. Landseer stayed often at Frampton Court, their house in Dorset.

SIMPSON, W. W. The artist's first patron. He and his wife figure frequently in Landseer's correspondence.

SKERRETT, Marianne (1793–1887). Queen Victoria's dresser, confidante, and private secretary, 1837–62. Much used by Queen Victoria in her dealings with artists, and a friend and ally of Landseer.

SMITH, Sydney (1771–1845). A worldly and pleasure-loving canon of Saint Paul's, author of sermons and other works, and perhaps the most celebrated wit of his age. He is credited with a famous remark at the expense of Landseer. When asked to sit, Smith is said to have replied: "Is thy servant a dog, that he should do this thing?"

SUTHERLAND, George Granville Leveson-Gower, 2nd Duke of (1786–1861). Immensely wealthy landowner, who earned a reputation for ruthlessness in the Highland clearances. His wife, Harriet (1806–1868), was Mistress of the Robes to Queen Victoria and an influential figure at court. Landseer was a frequent guest at their Scottish house, Dunrobin Castle, and painted their children.

TANKERVILLE, Charles Augustus Bennet, Viscount Ossulston, later 6th Earl of (1810–1899). Eldest son of the 5th Earl. One of the largest landowners of the border region, with an ancestral castle at Chillingham. He met Landseer in the early 1830s, and they became lifelong friends and sporting companions.

THACKERAY, Anne Isabella, later Lady Ritchie (1837–1919). Daughter of the novelist and an author and a novelist in her own right. Published her reminiscences of Landseer in *Cornhill Magazine* (April 1874).

THACKERAY, William Makepeace (1811–1863). The prolific journalist and novelist, whose name was established by *Vanity Fair* (1847–48), became friendly with Landseer in his later years. In 1860 Landseer contributed a drawing of a black sheep to illustrate the novelist's story *Lovel the Widower,* published in the *Cornhill Magazine.*

TUKE, Dr. Thomas Harrington. A specialist in mental illness, he took charge of Landseer during his last years.

TWEEDIE, Dr. Alexander (1794–1884). One of Landseer's medical advisers, with whom he corresponded at length.

VERNON, Robert (1774–1849). Art patron who amassed a fortune as a contractor for army horses. Gave most of his large collection of contemporary pictures, including a very distinguished group of Landseers, to the British government.

VICTORIA, Queen (1819–1901). Landseer's friend and single greatest patron.

WELLINGTON, Arthur Wellesley, 1st Duke of (1769–1852). Field marshal and prime minister (1828–30). Introduced to Landseer in 1824, he commissioned two important works.

WELLS, William (1768–1847). Shipbuilder and art collector. His house at Redleaf in Kent, a meeting place for artists, was Landseer's second home.

WELLS, William or Billy (1818–1889). Nephew of the older Wells (q.v.), with whom he is often confused. Agricultural innovator and member of Parliament. Inherited his uncle's house and art collection but lived chiefly at Holme Wood in Huntingdonshire. One of Landseer's fellow sportsmen in Scotland.

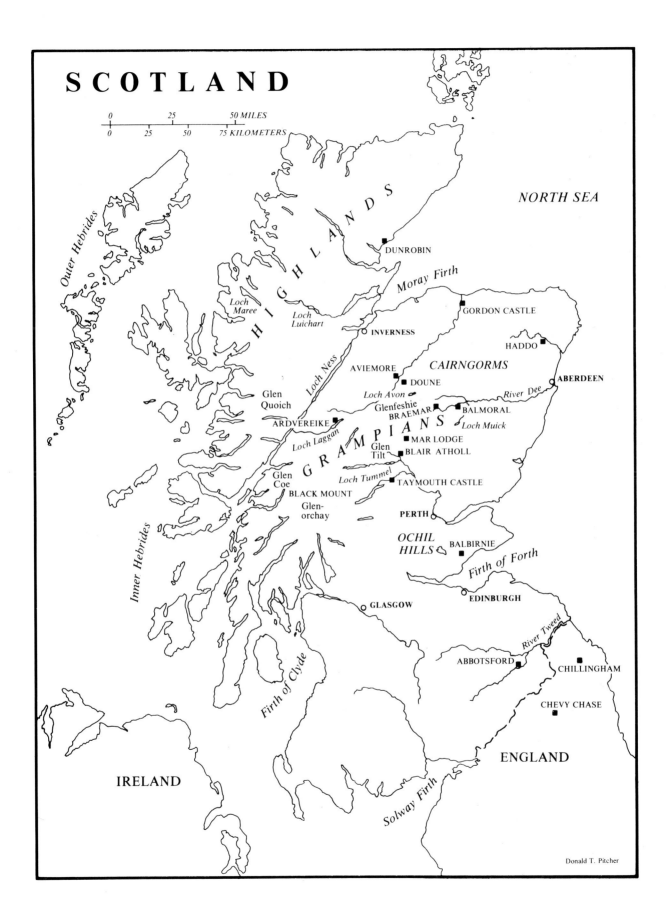

SCOTLAND

0 25 50 MILES
0 25 50 75 KILOMETERS

NORTH SEA

Outer Hebrides

HIGHLANDS

Loch Maree

Loch Luichart

Moray Firth

■ DUNROBIN

■ GORDON CASTLE

○ INVERNESS

HADDO ■

Loch Ness

AVIEMORE *CAIRNGORMS*

■ ● DOUNE

ABERDEEN

Glen Quoich

Loch Avon

Glenfeshie

River Dee

BRAEMAR ■ ■ BALMORAL

ARDVEREIKE ■

Loch Muick

Loch Laggan

GRAMPIANS

■ MAR LODGE

Glen Tilt ■ BLAIR ATHOLL

Glen Coe

Loch Tummel

BLACK MOUNT

■ TAYMOUTH CASTLE

Glen-orchay

PERTH ○

Inner Hebrides

OCHIL HILLS

BALBIRNIE ■

Firth of Forth

○ GLASGOW

EDINBURGH ○

Firth of Clyde

River Tweed

ABBOTSFORD ■

CHILLINGHAM ■

CHEVY CHASE ■

ENGLAND

IRELAND

Solway Firth

Donald T. Pitcher

xv

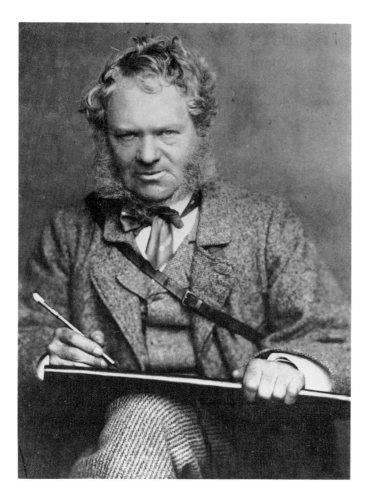

1. Sir Edwin Landseer, c.1860. The artist was furious when the photographers, John and Charles Watkins, sold prints to the public, and he tried to suppress them. This and other photographs in the Royal Collection reproduced by gracious permission of Her Majesty Queen Elizabeth II

Sir Edwin Landseer: A Biography

SUCCESS CAME EASILY and early to Edwin Landseer. By the age of sixteen he was an active exhibitor at the Royal Academy, already patronized by leading collectors and talked about as a rising star. With his professional success came social success; from a fairly sheltered background he blossomed into a dandy and man of the world. His charm quickly won him an entree into the drawing rooms of the great, and throughout his life he was able to move in the highest aristocratic circles.

Landseer was the son of an engraver, John Landseer (fig. 2), an idiosyncratic character who was also a writer, antiquarian, theorist, and champion of his profession. Said to have been the son of a jeweler from Lincoln who later moved to London, John Landseer had been apprenticed to the landscape engraver William Byrne. Many of John Landseer's early plates were landscape and topographical views, but he also contributed to Thomas Macklin's Bible. It was through the publisher that he met the woman he would marry in 1794, Jane Potts, who had posed with the Macklin family for the picture *The Gleaners* by Sir Joshua Reynolds. They settled in Marylebone at 71 Queen Anne Street (later to become 33 Foley Street), and brought up a large family.

Increasingly concerned with the rights of engravers, John Landseer led the battle to win them recognition within the art establishment. But, despite this, according to the painter and diarist Joseph Farington, he was "warm in His temper" and "not liked by those of His Profession."[1] After his own election to the Royal Academy as an Associate Engraver in 1806, John Landseer continued to fight for full membership to be extended to engravers. In 1807 he gave an important series of lectures on the history and the practice of engraving in which he aired his grievances. Discouraged, it is said, by his failure to make any progress with his campaign, John Landseer buried himself in research on Babylonian antiquities, on which he wrote two books; he also promoted two short-lived polemical magazines and published a description of fifty pictures in the National Gallery. He remained in demand as an engraver of landscapes, and during the last five years of his life contributed a series of drawings of archaeological sites to the Royal Academy. John Landseer would engrave only one important picture by his youngest son, *Alpine Mastiffs Reanimating a Distressed Traveler* (no. 13), a somewhat stilted plate in comparison with the work of younger engravers; he also wrote a pamphlet about it.

Opinionated, intellectual, voluble, domineering, and embittered, John Landseer must often have been a trial to his family. He was deaf and carried a large ear trum-

1

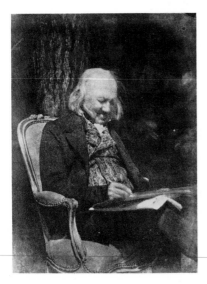

2. John Landseer,
the artist's father.
Royal Collection

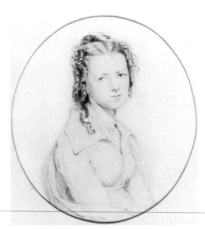

3. Jane Landseer,
drawn by her son Edwin.
National Loan Collection
Trust

pet, which he waved at people, and he also had a habit of talking to himself. His appearance and behavior became more eccentric with age, his opinions more blunt and outspoken.

Although he cannot have been an easy person to live with, John Landseer appears at his best in the family circle and his seven children were devoted to him. He took great pride in his offspring, trained them rigorously as artists, and promoted their careers. The success of Edwin must have been a source of particular pleasure, and a consolation for his own sense of failure. His wife remains a shadowy figure, perhaps because of the almost total absence of family reminiscence. Edwin Landseer's early drawing of her (fig. 3) shows her to have been attractive and one suspects that it was she who adored and spoiled her youngest son. There is at least one extant letter from Landseer to her, but none of his biographers give details of her life or even the date of her death, which occurred on January 19, 1840.[2] It is possible that there was some scandal, but the record is almost equally silent about John Landseer's brother Henry, also an artist, who lived with the family for a time in the early 1820s; on the other hand, Mrs. Landseer's sister Barbara Potts (fig. 4) figures prominently in Edwin Landseer's life and correspondence. She, with his sister Jessy, helped to keep house for him until her death at the age of eighty-four on September 26, 1861.[3]

There were seven surviving Landseer children: Jane (born 1795); Thomas, an engraver (1798–1880); Charles, a painter (1800–1879); Edwin (born March 7, 1803); Anna Maria (1805–1871); Jessica, or Jessy (born 1807), a miniature painter and later Edwin's housekeeper; and Emma (1809–1895), also a painter of miniatures.[4] The family was very united, perhaps too much so, for all the unmarried members continued to live together in the parental home in Upper Conway Street

(later renamed Southampton Street). Of the sons, only Thomas married, moving close to Edwin at 11 Cunningham Place, St. John's Wood, but his wife was clearly an embarrassment;[5] at the end of his life Thomas was living at 11 Grove End, St. John's Wood, with Charles and Jessy.

Neither of Landseer's brothers was quite a gentleman (John Constable called Charles a "common man"), and both owed much of their success to Edwin's influence on their behalf. Charles's election as an Academician (1845) and as Keeper of the Royal Academy schools (1851) is said to have been done to please Landseer, and Tom depended on him to a very large extent as a source of engraved work. Tom (fig. 5), like his father, was deaf; he was not very practical, and in Landseer's correspondence with Jacob Bell there were patronizing comments about his improvidence, his living from hand to mouth, and his inability to organize his personal or professional life. Charles, too, was slightly deaf, also good-natured and a noted wit and punster. He was less of a problem than Tom, but Landseer's efforts to find him patrons and to introduce him to society were of limited success. In 1844 he would write revealingly to Bell from Taymouth Castle: "Charles . . . is not quite *used* to the class of Society he finds here. I am so sure that it is a very bad thing for anyone to confine themselves to *one* Set—or for young men to be constantly living together—they become creatures of habit and unfit for the World."[6]

As the youngest boy in the family of seven, attractive, full of spirit, and precociously talented, Edwin was pampered and adored by his brothers and sisters. He remained strongly attached to all the members of his family. He saw them frequently when he was in London, corresponded when he was away, and was always eager to hear family news and gossip. In 1832 Constable told his fellow-artist C. R. Leslie that it was "delightful to see

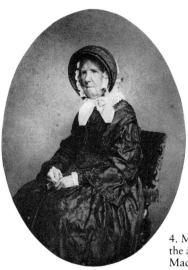

4. Miss Barbara Potts, the artist's aunt. Mackenzie collection

5. Tom Landseer, the artist's brother, photographed by John and Charles Watkins. National Portrait Gallery, London

Landseer's kindness to his sisters,"[7] and many years later Leslie's son, G. D. Leslie, would recall his impressions of Jessy (fig. 6), to whom Landseer had been closest: "Her unselfishness and large-heartedness struck me at times as something quite heroic; she was shrewd and clever, had a strong sense of humour, was an excellent judge of people's character, and above all deeply religious. The skill and tact with which she managed her brother's house never failed."[8]

Details of Landseer's early life are very fragmentary. It is not known what schools, if any, he attended; one later source says that he was educated at home, which, given his father's cranky views, is not at all unlikely. One can imagine that he was wild and naughty, and used to having his own way. He is said to have first drawn models set by his mother at the age of four, but his father soon took his artistic education in hand, insisting that he should always finish any drawing that he had begun. Walking one evening along the Finchley Road with a friend, John Landseer remarked:

These two fields were Edwin's first studio. Many a time have I lifted him over this very stile. I then lived in Foley Street, and nearly all the way between Marylebone and Hampstead was open fields. It was a favourite walk with my boys; and one day when I had accompanied them, Edwin stopped by this stile to admire some sheep and cows which were quietly grazing. At his request I lifted him over, and finding a scrap of paper and a pencil in my pocket, I made him sketch a cow. He was very young indeed then— not more than six or seven years old. After this we came on several occasions, and as he grew older this was one of his favourite spots for sketching.[9]

Landseer's juvenile drawings (*see* nos. 1–3), mostly of animals, and lovingly preserved and annotated by his father, date back to the age of four or five. From the

beginning he seems to have had an instinct for the most characterful aspects of animal life—woolly sheep and huge hogs, mastiffs and mongrels, depressed cab horses and rugged bulls, lions and tigers that he sketched at the Exeter 'Change or the Tower menagerie. Although often crude, Landseer's early drawings are striking for the knowledge of animal forms that they reveal and for his strong emotional response to the animals. In 1815 his youthful precocity as a draftsman was recognized by the award of a silver medal from the Society of Arts for his drawing of a hunter. His first contributions to the Royal Academy also belong to this year: drawings of a mule and heads of dogs belonging to his early patron W. W. Simpson, a landowner and evidently a family friend. Landseer often went to stay with him and his wife at Beleigh Grange, Maldon, in Essex, and his first recorded letter, of 1818, was addressed to Simpson: "I must apologize for detaining the pictures so long, but hope you will now receive them safe & that you will like 'the Brutus' as it has generally been admired & thought the best thing I have done on so small a scale."[10] Apart from the picture of his mastiff Brutus, Simpson commissioned other sketches of his animals and clearly encouraged the artist to exploit his talent for farmyard scenes. Although Landseer soon outgrew Simpson's patronage, he remained a loyal friend, and in the 1840s exerted himself to try to help Simpson out of financial difficulties.

In 1815 Landseer and his brothers first began studying under B. R. Haydon, the prophet of "high art" and the author of a diary that is one of the most remarkable documents of the Romantic period. According to Haydon, John Landseer "brought his boys to me and said: 'When do you let your beard grow and take pupils?' "[11] This was the beginning of the school that Haydon ran, which came to number more than a dozen pupils. Haydon claimed credit for having trained the youngest

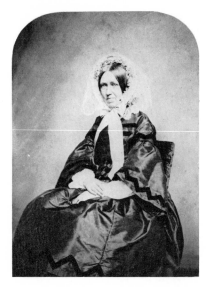

6. Jessica Landseer,
the artist's sister.
Mackenzie collection

given by William Hazlitt in 1818, and Landseer himself wrote in old age about "Leigh Hunt, J. Hunt etc., my father's friends, who used often to drop in on Sundays to dine. They all talked pearls and diamonds, and astonished us boys."[14] William Bewick recalled a visit he made to the picture gallery of Sir John Leicester, in company with Haydon, Leigh Hunt, Keats, and the Landseers: "He [Sir John] and Lady Leicester and their friends came in to see those remarkable men, and we were all introduced (a very unusual thing on such occasions)."[15]

Landseer's studies were not restricted to Bell's school or Haydon's studio. His close friend Thomas Christmas recorded that he and Landseer used to sketch monkeys and lions at Mr. Cross's menagerie at Exeter 'Change. One lion in particular attracted their attention: "On its death Mr Cross presented them with the carcass, which they removed to their studio, and again studied as long as possible. The skin was afterwards preserved and stuffed. They then dissected the body. The skeleton was articulated, and set up, and formed the object of future drawing and study."[16] Landseer later owned the famous series of anatomical drawings of the horse by George Stubbs, and he emulated his great predecessor in his painstaking study of animal form. No one could accuse him of anatomical ignorance when it came to drawing or painting animals.

In 1816 Landseer was formally admitted to the Royal Academy schools. His fellow students included Christmas, the miniaturist William Ross, Joseph Severn, and John Hayter, a member of a large artist clan, who exhibited a picture of Landseer as *The Cricketer* in 1815.[17] Another painter who portrayed Landseer at this early period was his friend Charles Leslie, who included him in his history picture *The Murder of Rutland* (fig. 9). More than forty years later, Landseer himself vividly recalled sitting to Leslie for the figure of the young Rutland with ropes around his wrists. It was Leslie who called Landseer "a pretty, little curly-headed boy," and remembered the Keeper of the Royal Academy schools

Landseer and for having brought him so early to public notice. Haydon's attitude towards his former student later was soured by jealousy. In 1824 he wrote of Landseer "strutting about and denying his obligations to me,"[12] and he attacked Landseer for not visiting him in prison or helping him financially.

It was Haydon who first encouraged Landseer to study anatomy, lending him sketches of lions to copy in April 1815. He later claimed that Landseer had "dissected animals under my eye, copied my anatomical drawings, and carried my principles of study into animal painting. His genius, thus tutored, has produced solid & satisfactory results."[13] We know from his fellow-student William Bewick that for three sessions he and the Landseer brothers attended classes in anatomy at the school run by Sir Charles Bell, one of the greatest anatomists and surgeons of the age. Landseer's surviving anatomical studies in red and black chalk (*see* nos. 4–6), spanning a period from 1817 to 1822, are close in style to Bell's and reveal how much he was influenced by the spirit and practice of scientific illustration.

Haydon's influence extended beyond anatomy. Although they were attending the Royal Academy schools, the Landseer brothers were still working in his studio on a series of immense cartoons in 1818, when a humorous drawing of them and Bewick at work (fig. 8) was published in the *Annals of the Fine Arts*, a magazine edited by James Elmes, but largely a mouthpiece for Haydon. Landseer is said to have painted the ass in Haydon's *Christ's Entry into Jerusalem*, and he later purchased his master's immense picture *The Judgment of Solomon*. There is no doubt that contact with an artist of such grandiose ambition as Haydon must have enlarged Landseer's imagination and turned him away from all thought of becoming simply an animal painter.

Through Haydon, Landseer also came to know a number of the great literary figures of the period. John Keats recorded meeting the Landseers after a lecture

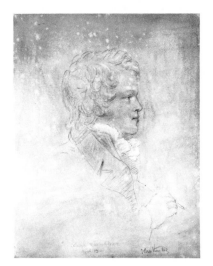

7. Edwin Landseer, drawn
by John Hayter, 1815.
Mackenzie collection

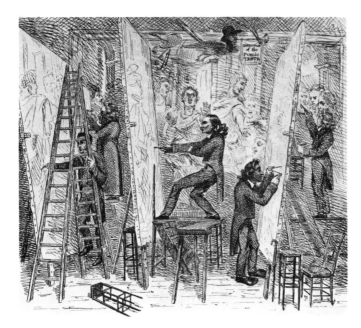

8. Caricature of B. R. Haydon's pupils, including the Landseers and William Bewick, copying cartoons. From *Annals of the Fine Arts*, London, 1818

Johann Fuseli asking, "Where is my little *dog boy?*"[18] It was Leslie again who noted perceptively that Landseer, like other students, benefited from Fuseli's "wise neglect." Many years later Landseer would describe Fuseli's picture of Hamlet rushing to follow the ghost as "one of the best things in Art," and he thought William Blake "mad but often fine."[19] Although much younger than most of the students, and only five feet three inches in height, Landseer was well able to take care of himself. Nor was he always a model of good behavior. In December 1817 John Constable and Joseph Farington were discussing the "misbehaviour of the young Landseers when copying Raphael's Ananias cartoon,"[20] and Richard Redgrave is the source of another story of Charles and Edwin Landseer teaching a fellow student to mimic Haydon.

Landseer remained in the Academy schools for approximately three years. He was still not a member of the life school in November 1817,[21] perhaps because of his age, but such an embargo cannot have mattered very much. He was by then a regular contributor to the annual exhibitions of the Royal Academy and the Society of Painters in Oil and Watercolours, and he was soon to be taken up by the leading collectors of the day. His *Fighting Dogs Getting Wind* of 1818 (no. 12) went to Sir George Beaumont; *The Cat Disturbed* of 1819, to Sir John Grey Egerton; *The Seizure of a Boar* of 1821 (location unknown), to the 3rd Marquess of Lansdowne; *Impertinent Puppies Dismissed by a Monkey* of the same year (Christie's, February 13, 1976, lot 102), to Sir John Leicester, later Lord de Tabley; and *The Larder Invaded* of 1822 (location unknown), to Sir Charles Coote. In a list of pictures he had sold by 1821, Landseer could point proudly to the fact that he had already earned more than a thousand pounds,[22] and his election as an Associate of the Royal Academy in 1826, at the astonishingly early age of twenty-four, surprised no one but himself.

A year before, Landseer had moved out of the parental house to 1 (later 18) St. John's Wood Road, a small house on land formerly belonging to the Red Hand Farm, on the west side of Regent's Park. It was to remain his home until his death in 1873, although for many years he owned only the leasehold, until the 1840s paying eighty pounds a year to the landlord William Atkinson. It is said to have been a dealer, William Mayor, who suggested to Landseer that he find a place of his own "where you can keep a dog or two, and have a garden, and so on,"[23] and lent him money to pay the premium for the lease. Haydon, as usual by then, made a bitter gibe about the young Landseer keeping "a gig, though he has not paid for his room, yet nobody finds fault."[24] Landseer's house was to undergo a series of reconstructions, in 1830, 1840, 1844, and 1850–51, gradually developing into a substantial villa. His house was kept for him by his aunt Barbara Potts. Landseer's Bank Accounts record regular payments to her of between one and two hundred pounds a year from the first extant ledgers of 1832. He also kept a manservant, William de Boo, followed in 1842 by William Butler, who remained for the next thirty years. His sister Jessy seems to have come at about the same date and gradually assumed more of the burden of the housekeeping as time passed. By the 1850s Landseer was paying her more than two hundred pounds a year, and there were regular payments to other members of his family.

In 1824 Landseer went to Scotland for the first time, visited Sir Walter Scott, and fell in love with the Highlands. He traveled by boat as far as Scarborough with C. R. Leslie, but became so seasick that he disembarked there and made his way to Scotland by land.[25] A misreading of Leslie's memoirs has led to the assumption that Landseer also accompanied Leslie and another artist G. S. Newton, on a trip to Loch Lomond, Loch Katrine,

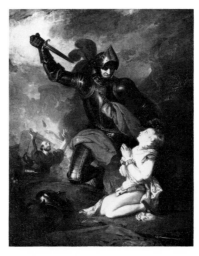

9. *The Murder of Rutland by Lord Clifford.* Oil on canvas, by C. R. Leslie, 1815. Pennsylvania Academy of the Fine Arts, Philadelphia. Landseer sat for the figure of Rutland.

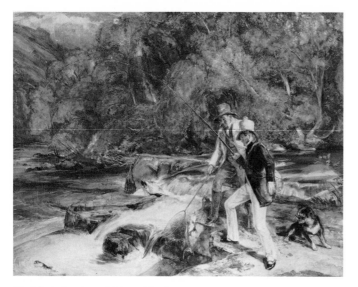

10. Edwin Landseer fishing with a keeper.
Watercolor by J. F. Lewis, by 1830. Private collection

the Trossachs, and Saint Fillans. In fact, he went off on his own to stay with the Duke of Atholl at Blair Atholl, making studies of the duke's keepers and of red deer in preparation for his picture *Death of the Stag in Glen Tilt* (no. 30). The complement to this modern sporting scene was Landseer's romantic vision of border history, *The Hunting of Chevy Chase* (no. 23) of 1825–26, a work inspired by Scott, painted in emulation of the Flemish masters, and commissioned by the Duke of Bedford. That Landseer's Scottish subjects appealed especially to ducal taste can be demonstrated by subsequent commissions in the late 1820s: *Highlanders Returning from Deerstalking* (no. 29) went to the Duke of Northumberland; *Sport in the Highlands* (private collection, Scotland), to the Duke of Gordon; and the *Highland Whisky Still* (no. 28), to the Duke of Wellington.

Landseer's visit to Scott in 1824 was a momentous one, for the influence of the novelist was to prove profound and long lasting. C. R. Leslie recorded spending a week in Edinburgh with Landseer, before Scott came up for the day to take the painter back with him to Abbotsford.[26] Landseer stayed there for ten days in early October, Scott writing at the time to a friend: "While I am writing to you Mr Landseer who has drawn every dog in the House but myself is at work upon me under all the disadvantages which my employment puts him to. He has drawn old Maida [who features in several Abbotsford pictures; *see* no. 55] in particular with much spirit indeed and it is odd enough that though I sincerely wish old Mai had been younger I never thought of wishing the same advantage for myself" (*see* no. 21).[27] Scott enjoyed Landseer's company and admired his art. In 1826 he would describe Landseer's painted dogs as "the most magnificent things I ever saw—leaping, and bounding, and grinning on the canvas,"[28] and he chose the painter as one of the illustrators of the Waverley edition of his novels (*see* no. 69).

Once discovered, Scotland was to become Landseer's favorite hunting ground. He went there every year during the autumn months to shoot, hunt, and sketch. In September 1825 he wrote a letter to William Ross from Blair Atholl: "I have not time at present to give you my adventures, only that I have been further north this season and am a little crazy with the beauties of the Highlands—and have been working very hard at painting, Deer and Grouse shootings &c &c have been my amusements. My career is now nearly over . . . after the Marquess of Huntly where I am going to revisit my movements will be south."[29] Landseer was at Blair Atholl again the following autumn, and in November 1827 Scott noted in his Journal that he had seen Landseer in the Duchess of Bedford's train, when she was on her way back from her shooting place in the Highlands. This was the Doune, a hunting lodge close to Aviemore in the Cairngorms, which the Bedfords took every year. Further south was the remote valley of Glenfeshie, where the duchess constructed a series of rough huts, and it is this retreat which she loved so much and which is associated so closely with her and with Landseer. The painter had his own hut a short distance away on the other side of the Feshie, close to that of another great sportsman and friend Horatio Ross.

Two visitors to Glenfeshie have left vivid accounts of their experiences. Lord Ossulston, later the 6th Earl of Tankerville, amusingly described how, coming over the mountains, he mistook Landseer for a poacher:

> He was a little, strongly built man, very like a pocket Hercules or Puck in the "Midsummer Night's Dream." He was busily employed in gralloching his deer. This he did with great quickness, and dexterity. . . . He next let the head hang over, so as to display the horns, and then, squatting down on a stone opposite, took out of his pocket what I thought would be his pipe or whisky flask; but it was a sketch book! Seeing that we had mistaken our man, I came out into the open, and then found myself face to face with my friend of many years to come—Landseer. He was staying with the Duke and Duchess of Bedford in their little settlement of wooden houses on the other side of the Fishie.[30]

Ossulston gave a witty picture of his fellow guests, including the actor Charles Mathews, whose letters to his family of 1833 provide a fascinating commentary on life in the huts, which he compared to an Indian settlement:

> The buildings themselves looked like the poorest peasants' cottages. The walls made of turf and overgrown with foxglove, and the roof of untrimmed spars of birch. . . . The beds of the ladies resembled small presses or chests of drawers, with mattresses stuffed with heather and pillows of the same let into them like the hammocks on a vessel. The gentlemen's apartments were in tents, each containing

two small heather couches, side by side on tressels, one small table and a wash-hand-stand and foot-bath, but no chairs, curtains, nor looking-glass. . . . Here we have been now above a week, living on venison, grouse, hares, partridges, blackcock, ptarmigan, plovers, salmon, char, pike, trout, beef, mutton, pork, &c, &c, all killed by ourselves and nearly on the spot; at any rate all (even red deer and ptarmigan) within a mile of the house. The ladies have only the dress of the country shape and material. Bedgown of some light material, generally striped; a blue cloth or grey stuff petticoat, very short; scarlet, grey, and blue stockings, aprons, and mittens. . . . The gentlemen wear the kilts, and, in short, everything is picturesque in the extreme. It is without exception the most delightful sort of life I have ever seen or experienced. Amusements of every kind are constantly going on. The guitar is in great request, and a small piano of two octaves, made on purpose for travelling, is constantly going. Lord Ossulston and Miss Balfour both sing beautifully, and we get up songs, duets, and trios without end. . . . The party is much too full of fun to allow anything like study to go on, and even were that not the case, painting were impossible in our present dwelling.[31]

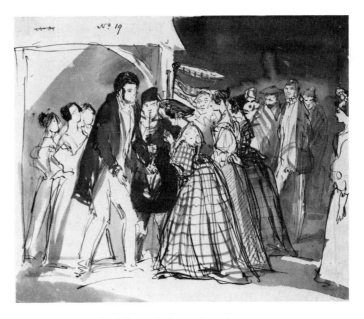

11. Reception at Glenfeshie, with the Duchess of Bedford, Edward Ellice, and others, sketched by Edwin Landseer. Private collection

The 6th Duke of Bedford (fig. 12) was Landseer's single most important early patron, a warm admirer of his art, and a great personal friend. His much younger second wife, Georgiana, a daughter of the Duke of Gordon, was a large and exuberant character, doted on by her husband, but deeply resented by the children of his first marriage. Landseer's earliest recorded visit to the duke's home at Woburn Abbey took place in February 1823, and he was soon a frequent guest both there and at the duke's other properties, including his London house on Campden Hill and Endsleigh in Devonshire. The duke's letters to Landseer, the only side of the correspondence to survive, are full of good-natured advice and encouragement. He took great interest in the pictures that he commissioned himself, advising Landseer, for example, on the type of deer to be included in *Chevy Chase* (no. 23), or giving his views on designs for a silver-gilt salver (no. 96). He was especially concerned that Landseer should finish his paintings properly. Discussing the *Highland Whisky Still* (no. 28) in 1827 he wrote: "I feel confident that you will bring forth a work on which will rest your future Fame . . . with due attention to all the *accessories*, and minor details—I trust you will not be satisfied without you make it a highly finished picture."[32] The duke's letters include invitations to shooting parties ("rely on seeing you with your gun for the last ten days of shooting"), to dinner parties, and to exhibitions (perhaps he "could point out some of the best things" at the British Gallery). There are comments about other artists, especially the improvident Haydon, about the Academy, politics, sport, and travel. He asks Landseer to recommend a bird stuffer, praises a miniature painted for him by Landseer's sister Jessy, and insists on paying more for a portrait of the duchess painted by Landseer.

The exact nature of Landseer's relationship with the duchess remains uncertain. They were certainly intimate friends and warmly attached to one another. According to contemporary gossip, Landseer was the duchess's lover and the father of at least one of her children, Lady Rachel Russell. The duke could scarcely have been ignorant of the rumors of their liaison, but he seems to have been a tolerant husband, prepared to overlook his wife's lapses because she brought him such happiness. Haydon, as usual, is a good source of gossip. In 1829 the sight of Landseer "on a blood horse with a white hat, & all the airs of a Man of Fashion" roused his fury: "but I never gave in to the vices of Fashion, or degraded myself or disgraced my Patrons by becoming the pander to the appetites of their wives."[33] And in a similar vein he wrote later: "I never seduced the Wife of my Patron and accepted Money from the Husband while I was corrupting his Wife & disgracing his family."[34] It can be argued that there is never smoke without fire, and that, if knowledge of the affair was so widespread as to reach Haydon's ears, it must have had some foundation in truth. His diary is by no means the only source of information. In 1833 a scandal magazine called *The Satirist* carried a short piece about the duchess's illness in Ireland: "Strong draughts were resorted to which relieved the patient, Edwin Landseer is Her Grace's draughtsman."[35] In 1836 Lady William Russell, who hated the duke's second wife, would write wickedly: "Son amant actuel n'est pas plus le peintre mais dit-on son valet de chambre Suisse."[36]

Landseer was elected a full Academician in February 1831, before he was thirty. The decade that followed was the most successful and the most creative of his entire career. His industry and fertility of imagination

were matched to a fluent technique that showed no signs of flagging. Major works, such as *Hawking* (no. 72), *Bolton Abbey in the Olden Time* (no. 73), *Highland Drovers' Departure* (no. 41), and *Van Amburgh and His Animals* (Royal Collection) won him critical acclaim, but it was often his smaller pictures of dogs such as *Suspense* (no. 63), *The Old Shepherd's Chief Mourner* (no. 66), and *Dignity and Impudence* (no. 68) that captured the popular imagination. The publication of numerous prints (Landseer became the most published artist in Britain) won him a vast and devoted popular audience.

Some of his best works of the 1830s were bought by Robert Vernon and John Sheepshanks, representatives of a new breed of capitalist, and the collections they gave to the nation are a tribute to their discriminating taste. By and large, however, his patronage was markedly aristocratic. The Duke of Bedford gave him further commissions for deer pictures (*see* no. 118), and he painted the Russell children over and over again. The Duke of Devonshire commissioned *Bolton Abbey,* and the Earl of Ellesmere, *Return from Hawking* (collection of the Duke of Sutherland). Landseer became famous for his sometimes ingratiating portraits of children with their pets, painting examples of this genre for such notables as the Duke of Abercorn, the Duke of Sutherland (no. 79), Earl Bathurst, the Duke of Cambridge, and Sir Robert Peel. And, of course, he was in constant demand as a painter of their favorite dogs and horses. It was in this guise that he first came into royal favor. The Duchess of Kent had chosen him in 1836 to paint her daughter Princess Victoria's spaniel *Dash* (no. 99) as a birthday present. It was not until the following year that Victoria herself met the painter, "who brought a beautiful little sketch which he has done this morning, of a picture he is to paint for me of Hector and Dash [no. 100]. He is an unassuming, pleasing and very young looking man, with fair hair."[37]

Professional success was matched by social success.

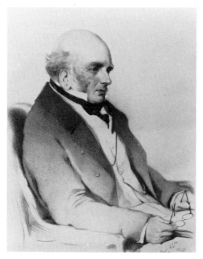

12. The 6th Duke of Bedford. Lithograph by R. J. Lane, after Edwin Landseer. British Museum, London

Landseer became a habitué of Woburn Abbey and Chatsworth, Goodwood and Badminton, Holland House and Lansdowne House. He was good-looking, witty, and a noted raconteur. His tastes and attitudes corresponded to those of the great Whig magnates with whom he was especially intimate. Neither politics nor conventional religion meant very much to him. He loved the outdoor pursuits of the upper classes, he could hunt, shoot, and fish, and he was equally accomplished at indoor games. He enjoyed dancing, possessed a good singing voice, played chess, and often helped to produce amateur theatricals. There is a bill for costumes supplied to him for a play at Woburn in 1830, as well as stories of how he designed sets, rouged the ladies' cheeks, and generally stage-managed. Many of his paintings and drawings of the Russell family show them in masquerade and fancy dress. There is no doubt that Landseer was attractive to women and adept at flattering them and flirting with them. Among his close friends were the beauty and poetess Caroline Norton and the bluestocking Kate Perry, to whom he is said to have proposed in the early 1830s. Constable described a visit that Landseer made to his house in 1831, when "he fell in love with my eldest daughter—and I could not say nay. It was to paint her—& what may such a magic pencil as his *lead to.*"[38]

Landseer's social contacts were very wide. He was just as much at home in the raffish atmosphere of Lady Blessington's salon at Gore House as he was in more polite drawing rooms. One of Landseer's closest friends was Lady Blessington's intimate, the dandy and amateur artist Count d'Orsay, and their correspondence reveals the bohemian and unconventional side of his character. About 1838, in a letter offering to paint a pretty girl whom d'Orsay had discovered, he asked: "But who is she?! I am naturally anxious to know, black or white? tall or short, sweet expression of Face or handsome? Let me know all as much depends on it, in point of fact they are my terms—a very pretty person—I would pay for sitting—so if your beauty is a regular love—I will take less than your splendid 1000!!!"[39]

Landseer was more cultivated and widely read than one might imagine from most descriptions of him, and he moved in several literary circles, including those of Dickens, Thackeray, and Ainsworth. He was a devotee of the theater, and a close friend of Charles Mathews, with whom he went to Glenfeshie; Charles Young, whom he painted as King John (Garrick Club, London); Charles Kean, for whom he helped to design sets; and W. C. Macready, in whose diary he features regularly. He had many artist friends and was often to be found dining out with Academicians like Sir Francis Chantrey, Sir Charles Eastlake, and Sir Francis Grant. His knowledge of art was considerable for someone who had traveled so little, and he was often consulted about old master paintings and issues affecting the arts in general. He gave evidence to the 1837 commission of inquiry

13. Jacob Bell. Daguerreotype. Pharmaceutical Society, London

into the affairs of the Royal Academy, and to later commissions relating to the National Gallery and the Academy in 1857 and 1863; when his friend Sir William Boxall became director of the National Gallery, he frequently gave him advice on acquisitions.

One of Landseer's favorite haunts from the early 1830s was Redleaf, the home of William Wells, a remarkable sportsman and collector. Landseer painted many animal studies for Wells, and he came to regard the bachelor establishment of his friend as a second home. He sometimes spent months at Redleaf, as in 1844 when his house was being rebuilt, and at least a quarter of his early surviving correspondence was written from there. His letters to Wells are missing, but the handful remaining from Wells to Landseer are written in an informal and affectionate tone. Wells had been a captain in the East India Company's service and later a highly successful shipbuilder, and he retained some of the habits and idiosyncrasies of an old sea dog. He was humorous, genial, and eccentric, and he loved entertaining artists and sportsmen at his table. His collection of old master and contemporary paintings and his gardens were equally famous. From the accounts of many artists who stayed at Redleaf it is clear that Landseer, who was represented in the collection by more than twenty works, was its presiding genius. There are many Redleaf anecdotes about Landseer, the most often repeated concerning a spaniel that the artist had promised to paint. He kept postponing the work until finally, nailed down by Wells, he waited for everyone to go to church, quickly had the dog brought up to him, and finished the picture in two and a half hours to the astonishment of his host and guests; thereafter it always hung on Wells's bedroom door. Landseer was equally intimate with Wells's nephew and heir, another William (or Billy) Wells, with whom he hunted in Scotland and with whom he stayed at Holme Wood.

The impression that Landseer made was one of bril-

liant success and good fortune, but he was not a simple or straightforward personality and underneath this facade there were clear signs of stress. He was unreliable about finishing pictures, he broke engagements on the flimsiest of pretexts, he took offense easily. His vanity and sense of insecurity are captured in a telling description by the writer Harriet Martineau, who met him in 1834: "There was Landseer, a friendly and agreeable companion, but holding his cheerfulness at the mercy of great folks' graciousness to him. To see him enter a room, curled and cravatted, and glancing round in anxiety about his reception, could not but make a woman wonder where among her own sex she could find a more palpable vanity."[40] Another pen portrait comes in Frances Trollope's novel *The Blue Belles of England*, published in 1842. Landseer is thinly disguised as the diminutive portrait painter Bradley, who has "a marvellously sweet harmony in his features, the charm of which only wore off when the look of unrest, that sundry stormy feelings had left upon them, became perceptible," and an "extraordinary familiarity of address."[41]

Landseer disliked being watched as he painted, and was acutely nervous of showing his work until finished, invariably covering his pictures with Holland cloths or turning them to face the wall. G. D. Leslie recalled Landseer "in an old home-spun shooting jacket; calico sleeves were tied on his arms like those that butchers wear. He wore generally an old straw hat, the brim of which was lined with green, had his palette and brushes in his hand and looked extremely picturesque, reminding me strongly of some of the figures in Rembrandt's etchings."[42]

Landseer was hypersensitive to criticism and quick to detect slights. His lack of balance and judgment is shown in the needless quarrels he provoked with old friends. His slowness in producing some designs for gunlocks for William Russell led to some jocular remarks by Russell, which Landseer misinterpreted. Russell wrote to him in 1838: "I have just received with some Surprise a note from you asking me *'why I always endeavour to convince people disposed to treat you kindly that you are not to be trusted and never make good your promises, that you have not notion of punctuality, &c &c.'*"[43] In the same spirit, the painter chose to misconstrue the motives of Caroline Norton, who had innocently asked for the portrait of herself. "It would take more to offend me than a huffy note, from you," she wrote about 1838, "as I have seen too much gentlemanlike and generous feeling in you, not to forgive you for being touchy, even when I think it unjust. I *did* wish to have the picture you did of me . . . *to give away*: you may not think that a compliment."[44]

The strain of keeping up his career, of satisfying his patrons, and of maintaining his social position, cost Landseer more effort than he cared to admit. In May

1840, at the height of his powers and reputation, he suffered a severe nervous breakdown. The immediate causes of the breakdown remain obscure. His mother's death only a few months before in January 1840 may not be entirely unconnected. Lady Holland laid the blame on the fatigue and the mental anxiety of his being on the hanging committee of the Royal Academy, "where there are so many jealousies & bickerings, & then the shock of the murder of poor Ld William [Russell], with whom he was very intimate. . . . He is full of terror & horror, expecting an assassin to destroy him. It is really very shocking."[45]

Other people attributed Landseer's collapse to the widowed Duchess of Bedford's refusal to marry him, but it is by no means certain that he proposed. If he had, such a refusal would have touched him in the sorest of places, emphasizing the social barrier that separated him from the upper classes, for all his talent and success. Shortly before he left for the Continent to recuperate, the duchess wrote through her agent to express her sympathy and anxiety: "The Duchess is so very unhappy and anxious about you that she cannot be reconciled to your intended trip till I have seen you and has directed me to visit you at Dover."[46] Whether marriage was ever in the air or not, their relationship remained close until the duchess's death in 1853.

To the dismay of his friends, Landseer's breakdown proved not to be a temporary crisis. In July 1840 he wrote to Count d'Orsay from the seclusion of Redleaf:

You may be quite sure I should not have left London without seeing you had I not been in great haste, by the advice of my physician who *ordered me* off *immediately* Since I have received fishing, *Farming* and regular *Pilling*, my nervous system has in part regained its strength. The only thing against me is *self-torture*. My unfinished works haunt me—visions of noble Dukes in *armour* give me nightly scowls and pokings. . . . my imagination is full of children in the shape of good pictorial subjects. Until I am safely *delivered*, fits of agitation will continue their attacks.[47]

In August Landseer was ordered abroad, traveling by way of Belgium to the Rhine and Cologne, from there by easy stages to Geneva, and home by way of Paris, under the watchful eye of his longtime friend Jacob Bell.[48]

The drawings he made on his trip, chiefly of peasants and animals, are full of verve and character, and point to the revival of his spirits. Nevertheless, it was some months after his return to London before he took up the reins of active life once more. Henceforth, he was to be plagued by attacks of nervous depression and all kinds of phobias and complexes. The state of his health became an obsession with him, and his friends were subjected to detailed accounts of his ailments and symptoms. His letters monotonously chart the ups and downs of his mental state, his bouts of nervous prostration, his physical lassitude, and his struggle for health and equilibrium.

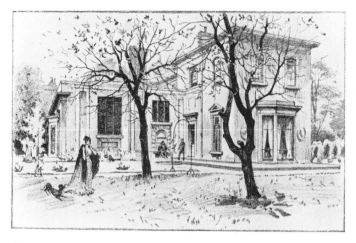

14. Sir Edwin Landseer's house, No. 1 St. John's Wood Road, London, drawn by H. E. Tidmarsh. From *Magazine of Art*, London, 1895

It is difficult sometimes to judge how serious and disabling his mental illness was, for Landseer was a hypochondriac, and he often used ill health as an excuse for broken promises and engagements. He also managed to continue painting through all but the worst crises, finding in work a balm for his personal problems.

Some of the most detailed letters he ever wrote about the state of his health were addressed to Dr. Alexander Tweedie during a particularly bad period in 1857. "Every day finds me weaker," he wrote in July, "lately for the nights I have endeavoured to do without morphia —only find little difference in my sensations. My appetite is *vanishing*—I am always suffering from the pain, cramp in my left side—and am irritible beyond measure, I cannot occupy myself in any way whatever—my inside retains its small contents but a short time the least thing makes it necessary to indulge the W. C. feeling—I have given up the tonics—as they make no kind of difference in my feelings."[49]

Landseer had drugs and pills to help overcome his depression. He also drank. When and how much are unclear, for references to the subject are scarce, but wine rather than spirits seems to have been his vice. Occasionally Landseer himself mentioned the subject, as when he said he was giving up wine, or again, as in a letter of October 1857, that he intended to "plunge madly into drink."[50] Describing his alcoholism in later life, his fellow-artist T. S. Cooper found it surprising because "he had formerly been a man of abstemious habits, or at any rate, temperate habits."[51] Another friend, however, who met him at Lord Aberdeen's home, Haddo House, in the early 1840s, still remembered twenty years later that Landseer had drunk too much.[52]

A large share of the credit for keeping Landseer on the rails for so long must go to Jacob Bell (fig. 13), who became an essential prop in Landseer's life, as friend, confidant, business manager, and general factotum. As a young man, Bell had studied drawing at Sass's Academy, where he is said to have met Landseer. He contin-

ued to sketch all his life, and he commissioned a number of notable works of art, including eight or nine major Landseers, a version of Rosa Bonheur's *Horse Fair,* and W. P. Frith's *Derby Day,* all of which he bequeathed to the National Gallery.

It was Bell who picked up the pieces after Landseer's initial breakdown, shepherded him abroad, and continued to look after him thereafter. Landseer's capacity for dealing with the problems of everyday life was very limited, and any difficulty or obstacle was at once referred to the long-suffering Bell. He put Landseer's financial affairs in order, advised him on investments, and negotiated with patrons, publishers, and engravers—a ticklish and time-consuming business. He supervised the rebuilding of Landseer's house and helped to enlarge the estate by the purchase of more land. He lent Landseer his carriage, stabled his horses, and looked after his servants and animals when he was away. Both men had keys to one another's houses and were constantly in and out, Landseer always leaving one of Bell's pictures turned to the wall as a sign that he had called. Landseer's demands were incessant. Could Bell answer the enclosed as he thinks fit? Could he send some colors and an easel? a waistcoat that Landseer had left behind, a sporting rifle? Could he provide a pair of sheep's heads for Landseer to paint from? a drawing of a poor man's coffin? a model of the Savior on the Cross? Is Nell in pup? Where is the pony? Will he buy Hafed in at Tattersall's? Would he superintend the packing of the pictures? and so on.

Without Bell, and his partner and successor Thomas Hyde Hills, to whom as one friend observed Landseer clung as to a nursemaid, it is difficult to see how he could have pursued his professional career. There must have been times when Bell's patience was tested to its limit, but he rarely complained, even in letters to his brother

15. Sir Edwin Landseer's studio. Photograph. Among the pictures are an early lion study, *Digging Out the Otter, Highland Mother,* the sketch for *Chevy Chase* (no. 25), *Queen Victoria and the Duke of Wellington Reviewing the Life Guard,* and *Lady Godiva.* Mackenzie collection

James, who also played a part in supporting the artist. And occasionally Bell was rewarded by rare moments of genuine gratitude, as in a letter of 1844: "I am afraid you as well as he [James] thought me a moody ungrateful beast I said so little in praise of your *wonderful* kindness and gt devotion to my interest. I am free to acknowledge to the whole world the endless obligations I am under. Perhaps some day I may be able to give you a leg up."[53] And again in a letter of 1845: "Perhaps it may X your mind that I *inflict* you with a 1000 matters on my behalf of which you have no business with—and that I am unmindful of the *all* you have done and the all you still continue to consider about and execute with *angelic* patience (for I have become irritable and disagreeable). Then another cause for regret on my part is, my unpaid for obligations to Brother James—I can only say I live in hopes of making all *faces* look content and of feeling something approaching *self-gratification if I ever arrive at 'riper years.'* "[54]

Landseer's house (fig. 14) was gradually transformed from a simple cottage into a substantial villa, reflecting its piecemeal method of construction in a rather conservative style and the profession of its owner. A major scheme of remodeling took place in 1844 under Bell's supervision. Landseer retreated to Scotland, but bombarded his friend with correspondence, asking endless questions and giving instructions. He was rude about the builder Thomas Cubitt, suspicious of the workmen ("Is it usual for workmen to leave off at 5.30? in other places I find men working much longer"), and paranoiac about the cost: "The weather makes me nervous about the Building—and the constant expenditure here in *nothing* makes me think seriously of becoming a pauper not knowing if I have any Cash at Gosling [his banker]." Advised by the Duchess of Bedford, he questioned the means of lighting the dining room, which had no windows, and gave instructions for canvas panels to be inserted in the walls where he later drew Scottish scenes in charcoal in what he called his "new style." He told Bell that "my first object in a Bedroom is freedom of air and a comfortable lookout—more healthful than the beauties of elevation." He wanted gas lighting fitted, "for industry for long winter evenings," preferred white to dark marble as safer and more "gentlemanlike," complained of symptoms of dampness, and was furious about needless damage to the new drains.[55] There were further bouts of rebuilding, the most considerable in 1850–51, with Henry Ashton as architect, Cubitt as builder, and Bell once again as overseer.

The house was fairly compact. There were two studios and a small sketch room on the ground floor, the smaller usually filled with lumber and unused, the larger running along the side of the main block and opening into the garden so that animals could be brought in (fig. 15). G. D. Leslie recalled it as a "gloomy looking place, the light just focused on the easel at which he worked,

whilst darkness brooded over the rest of the room, in which were other easels with canvases on them that were abandoned for the time. There was not the slightest attempt at decoration or adornment anywhere about the place."[56]

Other rooms in the house included a drawing room, a second reception room called the middle room, a small dining room lit by skylights, a billiard room, an armor room, and eight principal bedrooms. The catalogue of the sale of contents[57] gives a clue to the style in which the house was furnished. There were over thirty pairs of stags' heads and antlers dispersed throughout the house, bulls' horns, rams' heads, a wild boar's head; a human skeleton and that of Hafed, Landseer's favorite deerhound; bison and tiger skins, a stuffed swan; helmets, shields, and swords; innumerable framed prints, copies of the Elgin marbles, a reclining Venus, a piano, a full-size billiard table, a Spanish mahogany dining table, chests and sideboards, japanned French bedsteads, a carved oak writing table and settee, an invalid's couch, a Louis XIV chair covered in crimson Utrecht velvet, various "indulgent" chairs, sofas, and ottomans, birchwood chairs and Pembroke tables, Axminster and Brussels carpets, blue-figured merino curtains, chintz and crimson damask curtains, an elephant inkstand, ormolu candlesticks, Peruvian vases under glass covers.

The outstanding feature of the property was the garden, extending around the house on three sides and reaching down to the Regent's Canal. Landseer was obsessed by the need for privacy; he bought up strips of land to prevent building, erected walls and planted trees to shut out his neighbors. The garden housed constantly changing menageries, including horses, dogs, deer, sheep, foxes, a chained eagle, and a raven left behind by Charles Dickens when he went to Italy.

The effect of Bell's businesslike methods can be seen most clearly in the improvement of Landseer's finances. On the evidence of Landseer's accounts at Gosling's Bank, which may not represent all the sources of his income, his earnings in the 1830s were relatively modest: £1017 in 1832, £2275 in 1836, £3298 in 1839. By 1847, however, Landseer's income had risen to £6432, and it fluctuated a little below that figure for the next decade or more, rising to one dramatic peak of £17,352 in 1865. In comparison with the earnings of high Victorian painters such as Lord Leighton and Sir J. E. Millais, Landseer's income for most of his life was no more than that of a successful man in other professions. Throughout his career his output was erratic, and many commissions remained incomplete or unfulfilled. Judging from figures in the 1840s, when the account books are more explicit about the individuals on whom checks and drafts were drawn, more than half Landseer's income came from copyright fees on engravings: £2028 from an income of £3968 in 1845, £2500 from an income of £4394 in 1846, and £3162 from an income of £6432 in 1847.

A letter from Jacob Bell to Landseer of September 1842 gives some insight into the role he played as Landseer's business manager and the tough bargaining that was necessary to protect the artist's interests:

> Boys has just been here and consented to give our price for the copyright of the Royal Mother & Brats. . . . Moon has called on me to pay 200 gs for Breeze. . . . I shall also call on McLean for his 230 gs. Boys has given up the Princess: I shall therefore draw up an agreement with Graves for 500 gs the two pictures. . . . I have not been able to settle the Candy dog & monkey. Graves paused & wished to look at it again. I sounded Boys but finding that he did not admire the dog, I said nothing about the Copyright. There appears to be a little prejudice against the dog's legs. If Graves consents to what he originally seemed anxious to give, 100 gs, I shall close: it is my policy to be quite independent and not to appear at all anxious to dispose of the copyrights.[58]

Although he recognized the immense value of engraving in the popularization and exploitation of his work, Landseer disliked its commercial aspects. Publishers, in his view, were cynical and mercenary businessmen or worse. His comments on the Belgian-born dealer and publisher Ernest Gambart are in character. "We have no experience in Gambart," he wrote to Bell in 1848, "except his presuming upon one transaction as being the key to all I am ever to do or ever have done—it is by me he gets his bills taken which he gives freely enough. . . . has anyone any knowledge of his *real means*. . . . he does not give me the idea of a Gentleman . . . and remember he does not care one D— for art."[59]

In 1849 there was a row about Tom Landseer's engraving of *The Drive* (no. 126). Gambart wanted to exhibit a proof of the unfinished state, explaining to Bell that it would be shown only "to the trade . . . & people get booked on the strength of it." Landseer maintained that people would take the present state of the plate for finished, and instructed Tom, who had already plagued Bell for an advance on the plate, not to furnish Gambart with a proof. Gambart was furious, writing to Tom that

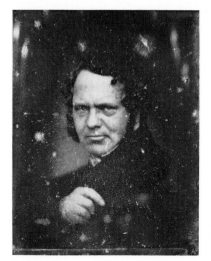

16. Sir Edwin Landseer. Daguerreotype, c. 1850. Mackenzie collection

17. The Duke of Devonshire with Lady Constance Grosvenor. Oil sketch by Sir Edwin Landseer. Private collection

the publisher "must be the best judge of what proofs may be shown," and protesting to Bell about the artist's interference. Landseer was unmoved. "It is quite time to give that Frenchman up," he told Bell, "he only thinks of himself not the least feeling for Art or the reputation of the Author or Authors—a Heartless flattering humbug. If possible I should like to take other things in progress out of his hands."[60]

Landseer was rightly concerned that engravings should be as faithful to his paintings as possible, and he took immense pains in touching and retouching proofs to insure the highest quality of reproduction. On the other hand, his arrogant and often peremptory behavior toward engravers reveals an unlikable side of his character. Even his brother Tom came in for disparaging and patronizing remarks, and old family ties did not prevent him from quarreling bitterly with Charles Lewis, whom he had known since childhood. The lively and intimate tone of his early letters to "Dear Charles" gradually chills into the formality of "Dear Charles Lewis" and finally "Dear Sir." Lewis was a prickly and quick-tempered individual, as Bell had discovered when he had to mediate between the engraver and Gambart in 1848. Relations with Landseer plummeted when Lewis accepted a private commission from the Duchess of Bedford for plates of Lord Cosmo and Lord Alexander Russell on horseback (see no. 22). In May 1850 Landseer berated Lewis for breaking his engagement by keeping the pictures for so long, and a year later wrote fiercely: "The Duchess of Bedford is impatient to have the Pictures of her Equestrian sons home immediately."[61] More bullying letters followed on this subject and on the series of plates Lewis had undertaken for Landseer's *Forest* series. "What are you about C. L.?" he wrote in 1852, "Have you begun the second large plate? When is my former note to receive your attention and I the reply?"[62] Scrawled by Lewis on one of these letters is the

word "Lies," and on another, offering Lewis some drawings, is a note in his hand saying the evidence of this letter had saved him from a lawsuit which Landseer intended to bring against him on the grounds that the drawings were not his.

Lewis was sued over another Landseer engraving, that of *Collie Dogs*. The owner, tired of waiting for his picture, removed it from the engraver's studio before the plate was finished. Lewis wrote plaintive letters to Bell asking him to intercede with Landseer, arguing that if the picture was not returned he would be forced to break his contract with the publisher, Henry Graves, and accusing the artist of procrastination in touching the proof. Landseer was unrelenting, telling Lewis in 1855:

It is impossible for an engraver to copy exactly *chalk touching*—unless he feels and understands the *spirit* of the touches—and is quite *sure* of his method in the translation. No power should induce an Engraver to say he can make a beautiful thing of a Work when his only object is a mercenary motive—In all the plates you have done from my works I have touched most sincerely. Yesterday you *insinuated* the contrary—in future I shall avoid giving you an opportunity for the repetition of such remarks.[63]

At a subsequent interview between the interested parties, Lewis lost control of himself when Landseer sided with Graves, and declared emotionally that "he would hand down to posterity the infamy of Edwin Landseer." Lewis was dramatizing his grievances, but it is clear that the matter would not have come to law without the artist's intransigent attitude. Once before the courts a compromise was quickly reached, Lewis agreeing to bring the plate to an acceptable standard within a stipulated time.

Where Landseer's own work was concerned, the boot was on the other foot. Patrons struggled in vain to persuade him to finish pictures, and major commissions invariably led to letters of entreaty and recrimination. When these were unanswered people turned to Jacob Bell, who had the unpleasant task of trying to sort matters out. Long-suffering as many of Landseer's patrons were, and inured to the vagaries of the artistic temperament, there were times when their patience became exhausted. Robert Vernon, who had put together one of the very best collections of Landseer's work, was not a little put out when in 1842 he discovered in a print shop an engraving of a picture of his dogs which he had commissioned four years earlier but had never seen, *Lady and Spaniels* (see no. 143).

A more distressing episode arose from a commission given in 1853 by a group of Derbyshire gentlemen for a portrait of Landseer's old friend and patron, the 6th Duke of Devonshire. It aroused misgivings in the artist from the start, who wrote to the duke that he could undertake portraits only "when combined with the picturesque or sort of story."[64] In March 1853, Landseer was complaining of a "nervous addled head," and the

duke sent him to recuperate for a month at his house in Brighton. From Chatsworth, where he went in June to make studies and where he was overwhelmed by the great works of art, Landseer wrote that he felt like "a horrid imposter." He had decided to portray the duke out of doors, with his heir Lord Cavendish and a third, female figure; one early oil study showed just the duke and Lady Grosvenor (fig. 17), another was described as the duke with Lord and Lady Cavendish. Landseer submitted a sketch of his proposed composition in July 1854, but he was off to the Highlands in August complaining of being "seriously unwell." In poor health himself, the duke finally tackled Landseer in June 1855, writing his own memorandum of their interview. He pointed out the embarrassment caused to himself and his friends by the long delay, and the fact that no actual work on the picture had yet commenced: "Sir Edwin again inquiring, D.D. replied thus all I can say is that I urge you to begin in earnest and to conduct yourself like a man of honour and honesty. Soon after this, Sir Edwin rose to withdraw saying that he thought the best thing he could do was to go home and work, to which D.D. expressed assent by the word 'Certainly.' " Landseer was still promising rapid completion of the work a year later, but with the duke's death in 1858 the project was quietly shelved, although not without remonstrance from the duke's executors.

In the face of all his personal and professional problems, Landseer continued to paint pictures of high quality which enhanced his popularity. He was a favorite with the aristocracy, but it was his position at court which gave him an unrivaled prestige in the eyes of the public and which today is the aspect of his career most often stressed. As well as painting a succession of royal pets, Landseer undertook major portrait commissions, including the great unfinished equestrian picture of Queen Victoria (no. 101), the conversation piece *Windsor Castle in Modern Times* (no. 105), and the portrait of Victoria and Albert in fancy dress (no. 109). He taught the Queen how to etch (many of her early plates were from drawings by him), corrected her sketches, and brought his own to show her. He became a friend, and Victoria and Albert would sometimes drop in at his studio when riding in the park. He was one of the artists they asked to execute frescoes in the pavilion at Buckingham Palace, and Prince Albert would consult him on art questions, such as the proposed museums at South Kensington.

One might imagine from what has been written about Landseer and Queen Victoria that he was obsequious and ingratiating. This was not so. The Queen found Landseer no easier to deal with than did his other patrons. As early as 1839 she was discussing his faults with Lord Melbourne, his "idleness and laziness," his "not coming to Windsor when I said he might paint me," his "never sending in his bills."[65] The problem of getting

18. Miss Marianne Skerrett. Royal Collection

him to finish pictures, especially those "surprise" ones intended for birthday and Christmas presents, was a perennial one. In 1844 she was putting pressure on Landseer to begin a picture intended as a present for her beloved uncle Leopold, King of the Belgians, through her dresser and confidential go-between, Miss Marianne Skerrett: "The Queen of the Belgians has written to H.M. again & though reluctantly gives up the hope of the picture this year but trusts that you will fulfill your promise early next year. H.M. hopes also (I mean the Queen of England) that you will on your return set to work at the Fresco as both H.M. & H.R.H. are most anxious to have it finished."[66] On December 20, 1847, Miss Skerrett would write to him ingenuously about another surprise Christmas present: "HM has not the least *doubt* of the picture coming."[67]

Landseer for his part often felt harassed by the peremptory commands issued at short notice from Windsor Castle or Buckingham Palace. He told Count d'Orsay in 1840 that he had gotten into a "scrape" for staying away from the palace to draw Miss Power, and enclosed a letter from Baroness Lehzen to prove it: "Her Majesty wishes Mr Landseer to come, as soon as possible, to the Palace, to paint one of the Prince Consort's favourite dogs."[68] In 1841 he confided to Edward Ellice that he was at Windsor Castle, "working perhaps a little too much,"[69] and excusing himself to Lady Abercorn a year later he wrote: "I am still occupied at the Palace. Her Majesty is all whim and fancy . . . but then I am rewarded by romping with the Princess Royal."[70] On another occasion he complained to d'Orsay that he had to go to the palace on *Monday* at 12, *Tuesday* and *Wednesday ditto*. . . . I hoped to have *told* you all this tonight at the Opera, but am quite knocked up with my *all* day at the Palace."[71] Apologizing to his close friends Mrs. Elliot and Miss Kate Perry for his seeming want of attention, he blamed it on "the good little Q." who "is a very *inconvenient* little treasure."[72]

Relations between the artist and his royal patron would no doubt have been much less harmonious had it not been for Miss Skerrett (fig. 18). J. C. Horsley described her well: "To begin with, there was less of her than I ever saw in any woman; under five feet in height, and as thin as a shred of paper, she had a face of the brightest intelligence, but of almost comical plainness of feature. Her mind was of the purest and strongest, sustained by devout Christian faith, and illumined by brightest intelligence. She was a remarkable linguist and a widely read and cultivated woman."[73]

Miss Skerrett's almost illegible letters to Landseer, conveying the commands of her royal mistress, are models of diplomatic tact, and they are spiced with gossip about books, mutual friends, and the world at large. She reminds him that a painter at court is not as free as one at home, and advises him to carry out the recommended alterations. She commiserates with him over his state of health, and tries to cheer him: "You ought to have a good time before you, but *when* will you ever think you have?" He has not been very talkative on paper, why hasn't he replied to her last letter? She is asked to remind him about some etchings: "The Queen thanks you a thousand times for the list and the idea of the thing." She praises Millais's *Huguenot* at the Royal Academy of 1851 and later his *Ophelia*. She describes Charles Kean's Macbeth, and is delighted that the artist is to meet him and his wife, "who have the highest opinion of you." How is he getting on with the Balmoral picture? The sketch will be sent to him, but "the Queen hopes you will not do anything to it—she is always afraid to let your things go for fear of anything happening to them." He must not allow himself to get downcast and discouraged. She urges him to get away: "It is no good shutting yourself away and painting at this time of year. Everyone requires some change." She thanks him for being "infinitely a better correspondent than I have known you sometimes," and inquires how he can take "pleasure in painting from poor wounded animals who have a better right to the hills than you." She is "grieved beyond measure" by the news of the Duchess of Bedford's death "because I know your friendship." She offers the consolations of religion.[74]

Miss Skerrett was undoubtedly a little in love with Landseer. The tone of her letters is flirtatious, motherly, protective. The artist, for his part, was amused by this spritely and quizzical character. He called her "the dearest and most wonderful little woman I ever knew. If anything goes wrong in Buckingham Palace, Balmoral, or Windsor, whether a crowned head or a scullery maid is concerned, Miss Skerrett is always sent for to put it right."[75] It is only fair to add that Landseer amused dinner parties with humorous stories about Miss Skerrett and the Queen, and he once referred to her casually in a letter to Bell, another of her correspondents, as "old Skerrett."

Landseer's role as court painter took on a new significance as a result of the royal family's infatuation with Scotland. They paid their first visit there in 1842, and six years later they leased Balmoral, which they later owned and remodeled. While they were by no means the first to discover the attractions of the country, their residence did help to foster the popular and romantic vogue for the Highlands. In Landseer's Scottish subjects they found the mirror of their own feelings and ideals about Highland scenery and character. Describing a small book of "exquisite" Highland sketches by Landseer, the Queen wrote: "Now that we have been in Scotland & in the Highlands, we can judge how true are the representations of the scenes & scenery there."[76] When Landseer was drawing John Macdonald (no. 114), one of the royal ghillies, in the presence of the Queen he had compared the head to Giorgione: "Landseer was also much pleased with the simplicity & goodness of the man, who is particularly gentle, kind & well meaning. It is a pleasure to watch Landseer draw in chalks, & it is wonderful the effect he produces."[77]

Even before her first visit to Scotland, Queen Victoria had secured Landseer's picture of *The Sanctuary* (no. 121) as a birthday present for Albert, and it was she who recommended him as a painter of Scottish scenes to Leopold and Louise of the Belgians. In 1847 Prince Albert persuaded the Marquess of Breadalbane to give up to him the colossal picture of *The Drive* (see no. 126), a scene painted at Glenorchay. That same year the royal couple met Landseer by appointment at Loch Laggan, and he was soon requisitioned to paint a charming conversation piece of Queen Victoria sketching with her two eldest children (no. 111), as another surprise Christmas present for Albert. The Queen herself made pencil copies of Landseer's rough charcoal murals on the walls of the lodge at Ardvereike, belonging to the Marquess of Abercorn, and in *Her Leaves from a Highland Journal*, she wrote on more than one occasion of her regret that Landseer was not present to record a particular scene or effect. At the end of the decade, Queen Victoria commissioned three Highland subjects from Landseer as presents for Albert: *The Free Kirk* and the pendants, *Highland Lassie Crossing a Stream* and *Highlander with Eagle*, the former symbolic of peace, the second of the natural spirit of the country. "Do me the kindness to say to Her M. that I delight in the commission," Landseer told Miss Skerrett, "(I wish the pictures might be larger) and am equally eager either for storm or sunshine."[78]

Landseer paid his first visit to Balmoral in 1850, the year in which he was knighted. He had come to paint a large group portrait of the royal family in the Highlands. He arrived at Loch Muick, as the Queen noted in her Journal, on a flawless September day: "The lake was like a mirror, & the extreme calmness, with the bright sunshine, hazy blue tints on the fine bold outline of hills coming down in to our sweet loch quite enchanted

Landseer. We landed at the usual landing place, where there was a haul of fish. . . . Albert walked round & we got into the boat & picked up Landseer, who was sketching a little further up."[79] This was to be the setting for Landseer's picture (*see* no. 112), a symbolic meeting between Albert, who has been out stalking, and Victoria, who has been fishing, surrounded by attendants with the Prince of Wales and the trophies of their sport. Writing to Landseer after his four or five days at Balmoral, Sir Charles Phipps, the Keeper of the Queen's Privy Purse, assured him that his visit, in the drawings he had made and the "*Impressions* you left behind," was a very successful one.[80]

Landseer paid brief visits to Balmoral during the three succeeding autumns, but try as he would he could not bring the "boat picture" (as it came to be known) to a successful conclusion. As sitting succeeded sitting, his patrons, too, became discouraged, and the evident failure of the picture may have contributed to Landseer's waning patronage at court. The international court painter F. X. Winterhalter was called on one occasion to advise on the likenesses, the root of the problem. In April 1854, Queen Victoria recorded that she had sat to him "for the last time,"[81] and she was not to see him again for ten years. Miss Skerrett remained in touch, and various royal officials struggled to sort out exactly what sums were owed for which pictures—a tricky problem as Landseer never sent in proper accounts. In her widowhood, Queen Victoria turned to Landseer once more, but this is not surprising for he had been intimately concerned with the scenes and events of her married life, and she looked back to these with overpowering nostalgia. Characteristically, his last important royal commission was for another pair of contrasts, a recollection of Prince Albert in the Highlands (*Sunshine*), and Queen Victoria as a widow at Osborne (*Sorrow*) (nos. 116, 117).

The pattern of Landseer's Highland holidays had been established long before he visited Balmoral, and his connection with the royal family in Scotland should not be overstressed. Every autumn he went north to enjoy the pleasures of Highland landscape and sport, hoping to restore his shattered nerves and instilling his mind with fresh images for the great sequence of deer pictures on which his fame chiefly rests. The people with whom he stayed were, by and large, the familiar companions of his youth: Lord Ossulston at Chillingham Castle, the Marquess of Breadalbane at Black Mount and Mar Lodge, the Ellice family at Glen Quoich, the Balfours at Balbirnie, the Marquess of Abercorn at Ardvereike, the Duke of Sutherland at Dunrobin, and the Duke of Gordon at Gordon Castle.

His trip to the Highlands in the autumn of 1844, which is well documented, chiefly in letters to Bell,[82] serves as an example of how he passed his time. He arrived in Edinburgh on September 12, in company of

his brother Charles, and set off in fine weather to Taymouth Castle to stay with the Breadalbanes. In a letter written at this time, Landseer described the marquess as "kind in the extreme and has indulged me more in the Highlands than any friend I ever had, in the meantime—I eat his mutton drink his wine get his money rob him of his Picture and laugh at him, all to please my own selfish ends—my nights are bad." From Taymouth he went to the Forest House at Black Mount on September 16, while his host went off to Blair Atholl to wait on Queen Victoria who was visiting Scotland for the second time. "My health goes on *bravely*," he wrote to Bell on September 19, "I have been out two Days Deerstalking. Nothing can be more beautiful or so healthy as this place my comfort and happiness would have been rendered complete had you accepted my proposals [i.e., to accompany him]." On September 25, Landseer set off across country to the Doune, while Charles traveled to Blair Castle to make some sketches for Queen Victoria, a commission arranged by the Marquess of Breadalbane. He told Bell that "yesterday I was motionless for an hour and a half in *deep snow* watching a herd of Deer in hopes of a Shot which did not come off—I saw them through my Glass going ahead in their various flirtations —Stags Fighting &c." He was by now in his beloved Glenfeshie, where the weather continued "all against sketching and sport," but he did manage to pursue work on his *Forest* series of drawings. On October 20 he was describing floods in the neighborhood, "danger to the Houses—and great alarm to our breed of Ladykind— who were sadly put to their shifts as the *necessary* was washed away! . . . one Bridge was also sent down the stream as a warning to other Bridges to be stronger. . . . I wounded a stag yesterday—and knocked myself up following him." He returned to Taymouth Castle on November 3, where he was soon out on "the snow clad mountains killed 7 hares—14 brace of Grouse and Black Cock did not begin shooting till past 1.oc." He spent a week with the Balfours at Balbirnie, declined an invitation from the Duke of Argyll, and returned to London via Edinburgh on the weekend of November 16–17, having been away for two months.

Landseer's identification with the spirit of the Highlands became more pronounced as he grew older. His was not the idealized romanticism of the outsider, but one founded on knowledge and close association. "There is a stern *sincerity* about Highland rocks," he wrote to an old friend in 1859, "a sort of unadorned truth that you don't find in the *rich* combinations of the Banks of Conan—where everything is suggestive of comfort and tenderness."[83] He might have said the same of the strong and stubborn character of the Highlanders, and he is still remembered with respect in the glens. Landseer was an erratic shot, though very defensive on the subject, and he spent as much time sketching deer as shooting them. It is significant that many of his later deer pictures

19. Louisa, Lady Ashburton, and her daughter Mary. Oil on canvas, by Sir Edwin Landseer, c.1863. The Marquess of Northampton

are less sporting scenes than evocations of the animal in its natural surroundings, symbols of the elemental forces of nature itself. Landseer hated cruelty to animals. He once drew a presentation portrait of Richard Martin, the founder of the R.S.P.C.A. (Ashmolean Museum, Oxford), and he supported the campaign to stop the practice of clipping dogs' ears. Both as a sportsman and an artist he was deeply divided in his attitudes to the noble beast he hunted and celebrated. In a revealing letter to Lord Ellesmere of 1837 he tried to analyze his feelings:

> There is something in the toil and trouble, the wild weather and savage scenery that makes butchers of us all. Who does not glory in the death of a fine stag? on the spot—when in truth he ought to be ashamed of the assassination. . . . Still, with all my respect for the animal's inoffensive character— my love of him *as a subject for the pencil* gets the better of such tenderness—a creature always picturesque and *never* ungraceful is too great a property to sacrifice to common feelings of humanity.[84]

"He was acknowledged to be the best company of his day," wrote his friend Lord Ossulston. "His powers of description, whether of people or of scenery, were most graphic and amusing, and though simple in words, had very much of natural poetry in them. And in his anecdotes, which were full of humour, the marvellous changes of voices, and expression of countenance he could assume as a perfect actor, brought the persons themselves whom he was speaking of in reality before you."[85] Another impression of him was recorded by Lady Leslie, wife of the amateur artist Sir John Leslie: "His eyes sparkled when he told a good story and as easily welled out tears by the narration of anything sad for he was a man of intense impressionability. He was witty and brought forth wit in others and the very Prince of storytellers, with a dramatic power of narration and an incomparable mimic both of human beings and of animals. He would take one on imaginary walks in the

Zoological Gardens imitating the birds and beasts wonderfully well."[86]

There are many accounts of Landseer's prowess as a storyteller, although few stories are as funny when printed as when told. On a visit to the South Kensington Museum he was cautioned by a policeman for going too close to his own picture *The Old Shepherd's Chief Mourner* (no. 66): " 'I am afraid I have touched it before.' 'More shame to you!' was his angry retort. 'You might know better at your age!' "[87] There were stories about royalty. "Oh, Mr. Landseer, I am delighted to make your acquaintance, I am so fond of *beasts!*" remarked the King of Portugal when introduced to him.[88] There were ghost stories, for Landseer was keenly interested in spiritualism and the occult, stories about animals and about low-life characters. Some of the best stories concerned Landseer's servant William Butler, who could be maddening, but who had his comic side. He amused the artist one day by announcing, "Did you order a lion Sir Hedwin?," when the zoo sent around the carcass of a dead lion. William was very protective of his master. Even the most distinguished visitors were turned away from the door. After being assured that Landseer had gone to a wedding, the Prince Consort was surprised to see him gazing out of his studio window. When showing some visitors around the studio, William was asked if he helped his master: "Yes," he said, "I arrange canvas, put out the brushes and the paints, and he has only, after all, to lay them on."[89]

Not everyone was charmed and amused by Landseer. Caroline Fox, who met him in 1846, thought him arrogant, with "a love of contradiction, and a despotic manner."[90] J. C. Horsley underlined his propensity for name-dropping in a description of a dinner at which Landseer monopolized his hostess with talk of "dooks and doochesses."[91] Another jaundiced observer was Scott's son-in-law J. G. Lockhart, who recalled a dinner given by Landseer for his cronies in January 1851:

> The dinner was good, but very queer and conceited, a mixture of finery and *the fast* school. . . . We had Lords Abercorn, Ossulstone, Mandeville and Ed. Russell, and they all called the knight "Lanny," and he called them "Ossy," "Many," "Ned," Abercorn only "Marquis"—I suppose he being the only one that pays. All dog, and horse, stag, and Queen for talk; utter boobies; awful eaters and drinkers; and when I left them at half-past ten, they were all starting for some place where a new American game of rackets is played by gaslight, Lanny and all.[92]

Descriptions of Landseer in society tend to conform to a stereotype, but what was he really like behind his social mask? There are hints in his correspondence with d'Orsay and Bell of forays into the demimonde, and it would not be in the least surprising to discover that he had a succession of mistresses. Certainly, he was very attracted to women, and his gallantry toward

them was noticed at the time. His description of a model, written to his fellow-artist William Mulready, is frankly admiring: "There's much good about her Shapes and *Color.... such* flesh is *nice* too."[93] He wrote to an unidentified correspondent, apparently with reference to a shared model:

I fully intended calling to thank you personally for your highly finished picture of the Brompton Blue Belle, your details amount to an essay on character, so minute and nice is your observation—I must call or give her an invitation to come here, not that your article on her has increased my eagerness to open a new book with her nevertheless I am greatly obliged by the time you have given me in showing her up.... does your wife want a girl model? I have lots of addresses so you may take your choice.[94]

Better documented is Annie Gilbert, the model for Landseer's well-known picture *Taming the Shrew* (*see* no. 149). According to contemporary sources she was a purer version of "Skittles," with whom she has been wrongly identified, and she died young. In December 1858, Landseer wrote to Jacob Bell:

Do tell me talking of neighbours—if you will let me have your carriage one night to take Annie G. to the play (with her sister) and will you give Hills leave to receive them at 15 L. P. afterwards? for a glass of soda water?—A. G. has no end of *lovers*, but seems to patronize me! I suppose she thinks my Picture will be a *trump* card for her. She has got a little too *fat* in some places—she says if I finish the Picture and people rave about it she will richly reward me! I am trying to do things *soberly*.[95]

Landseer mentions her again in another letter to Bell of the same period: "Annie Gilbert has had a fall Hunting—but is not much the worse—I hope soon to finish the group in which she is no. 1 copper bottomed. She had a party the other Eve her Birthday & asked me—the lot were rather too fast for me sober as I have become & I did not go."[96]

Landseer enjoyed the racy company of women like Annie Gilbert, but when he fell in love, it was with a girl of quality. It is refreshing to discover that in spite of all his nervous troubles, he was capable of losing his head to a pretty girl twenty-five years his junior. Louisa Stewart Mackenzie, or Loo as she was known to her intimates, was the third daughter of James Stewart Mackenzie, from whom she inherited an estate in Ross of over thirty thousand acres. She was beautiful, captivating, willful, and ambitious, and people fell in love with her easily, especially women; Florence Nightingale, Lady Trevelyan, and Mrs. Carlyle were among her warmest admirers, the last two fierce rivals for her affections. She was a close friend of Ruskin, and later of Browning, who proposed to her. Carlyle called her a "bright vivacious damsel.... they say she is much of a coquette, and fond of doing a stroke of artful dodging!"[97] A more flattering description comes from another close

20. Bronze lions in Trafalgar Square designed by Sir Edwin Landseer

friend, the American sculptress Harriet Hosmer: "Born of a great race, she looked her greatness, but her chief charm lay neither in her nobility of presence nor in her classic outline of feature, but in the ever varying radiance of expression.... And to these rare gifts was added the perhaps still rarer one of an exquisitely modulated voice, rich and musical."[98] Henry James would call her "this so striking and interesting personage, a rich, generous presence that, wherever encountered, seemed always to fill the foreground with colour, with picture, with fine mellow sound.... this brilliant and fitful apparition was a familiar *figure* for our friends, as throughout, for the society of her time, and I come in my blurred record, frequently upon her name."[99]

It is not known when or where she and Landseer fell in love, but perhaps it was at her Scottish home at Loch Luichart. Landseer was one of a house party there in September 1858, the month in which she announced her engagement to the retiring but immensely wealthy Lord Ashburton, a man even older than Landseer. They were married in November, to the surprise and resentment of many of his family and friends. Writing a year after the event, Lord Stanley was shocked to hear that Lady Ashburton was pressing Landseer to visit her, "considering that she threw him over to marry Ashburton, being all but engaged to him."[100] Landseer's feelings about Louisa are vividly conveyed in a series of letters he wrote after the breach: "All you said last Eve was so *true*," he told Jane Elliot in December 1858,

so friendly and gentle—when in real truth my folly deserved a sharper treatment—you did not say I ought to be ashamed of myself! so I tell you frankly I am—in spite of this acknowledgement I *must* write a *common sensible* page to poor dear Loo—so send me her direction (address) and put your foot on me!—Am I guilty of folly and weakness?—it is against all *sincerity* to act the *dissembler* with so dear a *friend as you*—yours is my only *sympathy do not* withdraw your friendly advice—my head tells my heart I am a horrid old fool—repent and amend! let us have no more of it!—I

21. *Sir Edwin Landseer Sculpting His Lions*. Oil on canvas, by John Ballantyne, c. 1865. National Portrait Gallery, London

really do try to forget and forgive—they say a certain *dreadful* place is paved with good *intentions* so am I! the Book I promised to close—is not locked! hope plays the D—l with me. . . . did you read her last letter?—it came open? I am afraid you think there is a dangerous flame [?] in her mind—? *she* is only rash not bold *in* error—true [?] *good* I could make her—It is a misfortune for EL as he requires all his energy just now having lots of irons in the Fire—and wild ambition to achieve something *at last*.[101]

In January 1859 Landseer invited Mrs. Elliot to come to see his picture *Flood in the Highlands* (no. 147): "I wish you could have seen poor Loo—(or heard her sobs) when she saw it,"[102] and a month later he reported to Mrs. Elliot's sister Kate Perry that he had not heard from Loo for weeks, "which you will think a good symptom of her returning reason and common sense!—I construe it in another form—we shall see!"[103] In August he was writing more philosophically: "Thank Lady A for allowing me perusal of the enclosed—say I still fancy my appreciation and knowledge of her character and nature —arms me against small minds and false *gossip*—L. has everything in life at her feet—once when I was talking *grave* nonsense to her she said remember you are God's child—and so good came out of a Humbug."[104] In 1863 Landseer finished a charming portrait of Loo with her daughter Mary (fig. 19), and continued to see and correspond with her.

Meeting Landseer in April 1864, after a lapse of some years, Queen Victoria noted that he "was terribly affected when he saw me, & is grown very old."[105] "I wish I had time now to write my thoughts and intuitions—as to what my downhill old life is to be," he told Sir Charles Phipps in 1866.[106] His nervous ailments grew worse rather than better with age, and his later correspondence is peppered with comments about his health. He was, as always, in the hands of doctors, latterly those of Sir Richard Quain, who treated so many eminent Victorians, but drugs and rest cures produced only temporary alleviation. "Flogging would be mild compared to my

sufferings," he wrote to his sister Jessy from Balmoral in June 1867, "no sleep, fearful cramp at night, accompanied by a feeling of faintness and distressing feebleness."[107] To his unfailing friend and guardian Thomas Hyde Hills, he confided at the same period: "My health (or rather condition) is a mystery quite beyond human intelligence. I sleep well seven hours, and awake tired and jaded, and do not rally till after luncheon."[108]

Some of Landseer's acquaintances were unaware of his distressing mental state. The artist Rudolf Lehmann noticed his failing eyesight—"I saw him try four pairs of spectacles previously to examining a picture on the wall"—but felt that "he did not otherwise show any failing of his powers, and was very communicative, even garrulous."[109] Other observers noted, however, the symptoms of underlying stress. Shirley Brooks described an incident after a dinner party in February 1867, when Landseer had tried to knock the cabby's head off.[110] After another upset later the same year, at a dinner given by Sir William Boxall, Landseer wrote contritely to his host: "I beg you to pity my condition of *Health*. In real sober truth—I have become so irritable and *excitable* that I am dangerous to myself and a nuisance in society. I wish to Heaven you were obliged to be my keeper and to compel me to go to Foreign parts with you. If you have forgiven my outburst of last night—and like me to write to Peto [Sir Morton Peto?] (off my own bat)—I will do so—at all events before you go. . . . (I have a most wretched night)."[111]

At various times in the mid and later 1860s, Landseer's condition became so bad that he had to be confined, under the care of the neurologist Dr. Thomas Tuke. With some exaggeration, Lord Frederic Hamilton, a son of the Duke and Duchess of Abercorn, described him during his periods of violence as "a dangerous homicidal maniac. Such an affection, however, had my father and mother for the friend of their young days, that they still had him to stay with us in Kent for long periods."[112] Another witness of Landseer's illness was the animal painter T. S. Cooper, who (with Landseer's brother Charles) went to visit him in the country, during one of his attacks:

> I was indeed shocked when I saw him so changed. He was always crying out for more drink, and was to all appearance half out of his mind. He said to me: "Oh! Cooper, you do not know how ill I have been, and still am! And they don't care anything about me; they leave me alone and they do nothing to help me; they will not even give me anything to drink when I am dying of thirst." . . . He did not seem to understand what I said. There were other friends with him as well as his medical man, and they all said he was in no pain whatever; but it was a very sad case, and I felt greatly distressed.[113]

Hamilton and Cooper describe Landseer at his worst and imply that in his last years he was a hopeless alcoholic and mental wreck. If this were the case, it is incon-

ceivable that he could have created, as he did, some of his largest and grandest compositions. However awful his sufferings, Landseer remained true to his artistic vision, and he showed astonishing powers of recuperation so far as work went. His desire to return to "harness," to "meditation in the old studio," to the unfinished canvases that haunted his imagination, was so strong that it seems to have been the chief prop shoring him up from total collapse. Again and again he struggled back to his easel, his art seemingly deepened and enriched by the mental anguish he suffered.

He was a sick and lonely man, but he continued to inspire loyalty and affection among his friends, and not just for old times' sake. He could still be amusing company, and in his better moments he was sensitive to others, generous, and outgoing. The Abercorns, the William Russells, the Tankervilles, and others continued to invite him to stay with them just as they had previously done. The two houses where he went most regularly were South Park, near Penshurst in Kent, and Stoke Park near Slough. The first belonged to Lord Hardinge, a man of culture and intelligence, keenly interested in the arts. His house was a haven for the artist where no demands were made on him, and nothing expected of him. The second house belonged to the rich financier E. J. Coleman, who commissioned several major pictures including *Man Proposes, God Disposes* (no. 151). Landseer's extensive surviving correspondence with Coleman[114] reveals a close, reciprocal friendship. When things got too much for the artist in London, he instinctively turned to Stoke Park, often inviting himself for days at a time. Coleman had converted a building on his estate for the artist's use as a studio—a gesture that moved Landseer deeply. The favors were not all one way. Landseer brought his friends down to Stoke Park, where Coleman liked to entertain the famous and wealthy on a princely scale.

Some of the most touching friendships of Landseer's last years were with artists younger than himself. Both W. P. Frith and J. E. Millais, whom he had championed in their early days, remained devoted to him, Millais finishing off four canvases after his death. Landseer's protégé Frederick W. Keyl left detailed accounts of his evening conversations with the artist from 1866 to 1869.[115] One can almost hear the artist speaking, so full and graphic are Keyl's notes. The talk ranged over natural history, breeds and types of dog, sporting reminiscences, literature, politics, friendships, and scandal. Landseer was often wayward and deliberately provocative, the not uncritical Keyl noting on March 22, 1869: "Sir E's want of reading and education makes him constantly take up opposite sides in talk—as a certain smartness & repartee is soon obtained. He cannot argue properly nor follow argument."

Landseer prided himself on his practical knowledge of wild and domestic animals. He described to Keyl how the Chillingham wild cattle had roared when he touched a calf, "which gave a bark—he jumping behind a Tree, then rushing out upon them shouting when they ran away—but so will Bear, tiger, Lion. *Timidity* is not want of courage. A Deer will run away as long as he can so will the bull. But at bay fights with great skill & courage & dies without a sigh." Reminiscences of deerstalking feature largely in these conversations. Landseer once told Keyl of the prowess of a coilie, like his own Lassie, "only more Wolflike in the head & sharper in the nose still," who had tracked a wounded stag over difficult ground for several miles. Following the "yaf, yaf" of the dog, Landseer and the keepers came on the stag in the water, "the bitch before him. (But I cannot write the imitation of voice & gesture & expression of the very Animals—the Deer head & neck up—eye faintly rolling in corner—the very ears seemed to go back). He broke his neck by a bullet & so ended him." On another occasion Keyl would describe Landseer remarks, illustrated by his "small expressive and beautiful hands (yet they are manly)."

Landseer, a cynic and a man of the world, enjoyed shocking his companion. He loved society scandals and the sordid motives they revealed. The status attached to moneymaking disgusted him, and he spoke to Keyl scornfully of the dubious practices of successful financiers. He was himself haunted by the fear of "being done," discoursing volubly on the sins of cabbies, waiters, tailors, and art publishers. Even his friends were not immune from censure. He accused Baron Marochetti of borrowing other men's ideas and earning vast sums for works he never touched.

Much of the time Landseer talked with Keyl about himself, but he had trenchant things to say about the world around him. He proposed that France and Ireland be excised from the map of Europe: "There would not be Peace unless Ireland were dipped in the sea like a tea sieve." He discoursed on the nature of genius and the

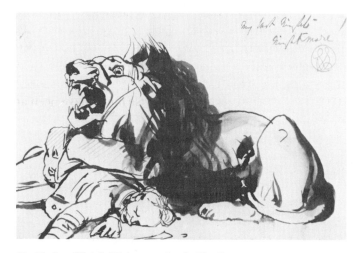

22. *My Last Night's Nightmare*, sketched by Sir Edwin Landseer. The Marquess of Salisbury

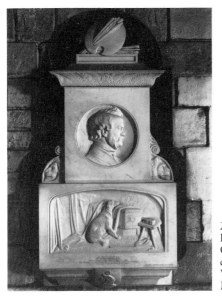

23. Memorial to Sir Edwin Landseer in Saint Paul's Cathedral, London, designed by Thomas Woolner. The National Monuments Record

origins of language, a subject of particular interest. He attributed alcoholism to people who used their brains too much. He preferred Goldsmith to Thackeray and accused Dickens of repetition, always going "with love back to Sir Walter Scott." He believed in willpower and the possibility of the individual controlling his own destiny.

Ill health did not inhibit Landseer's mobility either in London society or outside. Every autumn he went to the Highlands, and throughout the year he carried out a taxing round of country-house visits. He was with the Barings at Norman Court in December 1864, writing to a friend that four days of shooting had quite "renewed my boldness."[116] He stayed at Osborne in May 1865 to paint the Queen's Skye terrier Boz. In November he was injured in a railway accident on a journey to Lord Wharncliffe at Wortley Hall near Sheffield. "It might have been worse," he told Sir Charles Phipps, "when within a mile of Wortley last Eve at half past 5 our express train ran into a luggage lot of Carriages left without light or warning—Here I am in a dark room at Wortley Hall—a goodish doctor who plastered up my wounded Head all attention three or four times a day—I bled which was probably a good thing."[117] Three weeks later he wrote to his friend Lord Houghton: "They will not let me do much more than meditate in the old Studio. . . . today in spite of the wise men I have been at my Easel, & feel all the better for my little spell of work."[118] In August 1866 he spent a fortnight at Baron Marochetti's picturesque villa at Vaux on the Loire— one of his few trips abroad—but he returned, as he told the Prince of Wales, "rather less well than before I started."[119] He paid a visit to Sandringham later the next year, and he also stayed at Balmoral and at Loch Luichart with his old flame Lady Ashburton.

Landseer had declined the presidency of the Royal Academy in January 1866, following the death of Sir Charles Eastlake. Justifying his decision to his close friend Lord Hardinge, he wrote that "my common-sense tells me to be content and grateful in my old age—to the gt Father of mercy who enables me to love my art more than ever—at 60 I am a more ardent and I hope a better informed *student* than I was at 16."[120] Although Landseer's output shows a progressive decline during the last three decades of his life, he managed to exhibit no less than thirty-seven works at the Royal Academy between 1860 and 1873. There is a gap between 1861 and 1864, but otherwise he was represented every year, and by some of his largest and greatest works. A few pictures were old commissions, albatrosses like the Balmoral boat picture (*see* no. 112) and the equestrian portrait of the Queen that he had begun in 1838. The majority were painted at the time, however. *Man Proposes, God Disposes* (no. 151), for example, was painted within the space of two years, and the Chillingham wild cattle and deer (nos. 153, 154), within a similar time span. Old patrons such as Queen Victoria, the Prince of Wales, the Duke of Sutherland, and the Earl of Tankerville were joined by new admirers drawn chiefly from the world of high finance: E. J. Coleman, H. W. Eaton, Albert Grant, and Sir John Pender.

The largest and most taxing commission with which Landseer was involved was that for the four lions at the base of Nelson's Column in Trafalgar Square (fig. 20; *see* no. 150). This commission from the government dated back to 1857. During the 1860s Landseer's letters were full of references to "lionizing" and the "lion's den"—the Brompton Street studio of his friend and collaborator Baron Marochetti. At times elated by the challenge of a new medium (fig. 21), at times overborne by the size of the project (fig. 22), Landseer struggled on with the huge clay models. In 1859 he told Bell that the lions were pausing while certain complicated machinery was installed. In 1863 he was urging a busy Gladstone to come and see what progress he had made. To Lord Houghton he wrote in August 1864: "B. Marochetti is in the Highlands fishing & shooting—my colossal lionizing cannot go on with my being *constantly* present, the Baron's staff are not up to the novelty of the subject and put me back whenever they attempt to lend a hand."[121] By July 1866 Landseer had "two monsters in metal," and all four were installed and unveiled the following January. Landseer was genuinely touched by the warm praise he received from his friends, and suitably scornful of his critics.

Describing Landseer's improving condition in February 1871, Thomas Hills told Shirley Brooks, "He knows people."[122] Much of the time he clearly did not, and he was subject to fits of ungovernable fury and suspicion, what Brooks called "that provoking condition that makes him see enemies in friends."[123] "Landseer, who seems . . . to have been in a state almost bordering on insanity," wrote the artist Richard Redgrave in April

1871, was "one day well and the next day in a state of intense nervous irritation."[124] He still tottered into his studio, working on strange religious works, but he was not up to much exertion, and his handwriting had become very shaky. By 1872 his behavior was so erratic that Hills and his family had him certified, with the concurrence of Gladstone and other prominent men.[125] This made the handling of his affairs easier, but not of the artist himself. When Queen Victoria asked about the possibility of acquiring *The Baptismal Font* (no. 158), she was tactfully informed that an indirect approach might be counterproductive, while "he would feel honored & flattered by a direct communication."[126] A few months later he sold a picture promised to the Queen to somebody else. Sir Thomas Biddulph, who went to see him in August 1872, reported that "his mind wanders painfully. He at times would talk very reasonably, and then declare he was imprisoned, & that his doctor was killing him. . . . Mr Hills who was in the house told Sir Thomas that his power of painting was by no means altogether gone."[127]

The last year of Landseer's life was pathetic. "Beset by a vision of his own funeral," wrote one obituarist, "he lay silent, and tolerating no interruption, his vital forces sinking under his too easy and long indulgence in images of terror and mystery. His life was at times a burden of fear and gloom."[128] His death on October 1, 1873, was, in Queen Victoria's words, a merciful release, "as for the last 3 years he had been in a most distressing state, half out of his mind, yet not entirely so."[129] A touching account of his death was given by his sister Jessy to Lady Leslie:

He used often to look up with tears in his eyes & say he loved *Him* more than anybody else & did not require the Bible read to him. He certainly became more & more like a little child, and for the last six days & nights grew gradually weaker & did not crave at all for wine but only took the nourishment administered to him & not always that—the afternoon he took to his bed (which he scarcely left afterwards) was the first he had ever refused driving out with Dr Tuke. From that time he was closely watched & attended by Doctor, relations & friends, not forgetting poor devoted little Mrs Prickett, tho' I avoided calling his attention to anyone he was not accustomed to. I believe he was all unconscious of Mr William Russell's presence at this bedside the day before he died. On the Monday Evening when Dr Tuke was with him I was called into the room, when my poor dear Brother regularly took leave of me, repeating "God Bless you" twice & then asking me to go. I had the Revd Chas. Campe in his room 3 times to offer up short prayers in his behalf. He looked beautiful some hours & days after his death, there was a cast taken.[130]

Landseer was the most famous English artist of his generation, and he was mourned throughout the nation. Long obituaries paid tribute to the peculiar nature of his genius, although they did not gloss over his faults. The

Illustrated London News, for example, blamed courtly and fashionable influences for the "sleek, subdued self-consciousness" of his animals, and their exaggerated human qualities. But having said that, the obituarist came down heavily on his side: "On the other hand, no painter of animal life can for a moment be compared to him for intelligent invention, for humour and its congenial pathos, for breadth, variety, and subtlety of observation. No painter has ever so widened and deepened our sympathies with the dumb creatures that minister so largely to our pleasures and necessities."[131] Other obituaries drew attention to his love of the mysterious and the terrible, nature in its wild and sublime moments, his technical virtuosity, the exuberant quality of his imagination. Landseer's mental problems were treated with sympathy and discretion, but they may account for the relative absence of personal anecdote and reminiscence. Nevertheless, Landseer had been a much loved figure, he had possessed the common touch both personally and in his art, and he aroused warm feelings in the minds of his contemporaries. He was the author of some of the most popular pictures of the nineteenth century, images constantly reproduced and familiar everywhere:

Mourn, all dumb things, for whom his skill found voice,
 Knitting 'twixt them and us undreamt-of ties,
Till men could in their voiceless joy rejoice,
 And read the sorrow in their silent eyes.[132]

Landseer was accorded the honor of a public funeral, and he was buried in Saint Paul's Cathedral (fig. 23), alongside Sir Joshua Reynolds, Sir Thomas Lawrence, and J. M. W. Turner. On the day of his funeral, October 11, 1873, many shops had their blinds closed, flags flew at half-mast, his lions in Trafalgar Square had mourning wreaths in their jaws, and crowds lined the streets as the funeral cortege moved slowly toward Saint Paul's. The pall was carried into the cathedral by the five senior Royal Academicians present, led by their president and Landseer's intimate friend Sir Francis Grant. Among the many wreaths was one that would have touched Landseer especially—"A Tribute of Friendship and Admiration for Great Talents. From Queen Victoria." The service, with splendid music and anthems, was conducted by the bishop of London, and the address was given by the Reverend J. A. Hessey. Early the following year, the Royal Academy paid the painter its own tribute, with a retrospective exhibition of more than five hundred of his works, the occasion for fresh assessments of his achievement. In May 1874, his executors held a five-day sale of his paintings, drawings, and prints, fourteen hundred lots in all, which raised almost seventy thousand pounds. Landseer's will had already been proved at one hundred and sixty thousand pounds, the residue of his property being divided among his brother Tom and his three sisters.

Richard Ormond

Notes

1. Joseph Farington, *The Farington Diary,* ed. James Greig (London, 1922—28), vol. 8, p. 86.

2. *See Gentleman's Magazine,* n.s., vol. 13 (1840), p. 217.

3. *See Gentleman's Magazine,* n.s., vol. 11 (1861), p. 574.

4. *See* Saint Marylebone Parish, County of Middlesex, Parish Registers, Baptisms 1821, Greater London Council Record Office, vol. no. P. 89 MRY1 22, pp. 144—45. Dates of birth in the parish records are preferred to those in published sources. Landseer's birth is usually given as March 7, 1802, but seems more likely to be 1803, the year of his birth recorded in the Saint Marylebone Parish Register for May 23, 1821, the date of the baptism of all of the Landseer children.

5. The painter B. R. Haydon records that Thomas took her back after she had a child by another man, and later stories suggest that she was both vulgar and avaricious. This child, George, also became an artist and died at the age of forty-four in 1878.

6. Landseer to Bell, September 19, 1844, Royal Institution, London.

7. *Constable Correspondence,* 1965, vol. 3, p. 83.

8. George Dunlop Leslie, *Our River* (London, 1888), p. 17.

9. Stephens, 1874, pp. 21—22.

10. Landseer to W. W. Simpson, August 2, 1818 (copy), set of Grangerized Royal Academy catalogues belonging to J. A. Anderdon, Dept. of Prints and Drawings, British Museum, London, 1818 catalogue, facing p. 6.

11. *Autobiography and Memoirs of Benjamin Robert Haydon* (1786—1846), ed. Tom Taylor, new ed. (London, [1926]), vol. 1, p. 248.

12. *Haydon Diary,* 1960—63, vol. 2, p. 466.

13. *Ibid.,* pp. 357—58.

14. Landseer to William Powell Frith, V & A, Eng MS, 86 CC 33, no. 31, quoted in Frith, 1887—88, vol. 3, p. 243.

15. *Life and Letters of William Bewick,* ed. Thomas Landseer (London, 1871), p. 170.

16. *Notes and Queries* (London), vol. 12, November 15, 1879, p. 383.

17. A joint letter from George and John Hayter to Landseer of September 16, 1816, addressed "Dear Ned," reveals a cheerful intimacy. George was trying to solicit a commission from Princess Charlotte on Landseer's behalf. Mackenzie collection, no. 1084.

18. Charles Robert Leslie, *Autobiographical Recollections,* ed. Tom Taylor (London, 1860), vol. 1, p. 39.

19. Frederick W. Keyl's Papers, August 27, 1867, Royal Archives, London.

20. *John Constable: Further Documents and Correspondence* (London, 1975), p. 212.

21. Joseph Farington records that John Landseer had sought permission for his son to copy a lion by Rubens, then at the Royal Academy, but this was refused because Edwin was not yet a student of the life school. *See The Farington Diary,* vol. 8, p. 153.

22. Landseer's "MS list of pictures painted up to 1821," V & A, Eng MS, 86 RR, vol. 3, no. 194.

23. *The Portfolio* (London, 1885), p. 34.

24. *Haydon Diary,* 1960—63, vol. 3, p. 99.

25. C. R. Leslie to Ann Leslie, August 24, 1824, describing Landseer's seasickness, Castle Leslie Archives, Eire.

26. C. R. Leslie to Ann Leslie, October 3, 1824, describing his activities with Landseer in Edinburgh, Castle Leslie Archives, Eire.

27. *Scott Letters,* 1932—37, vol. 8, p. 392.

28. *Journal of Sir Walter Scott* (London, 1890), vol. 1, p. 119.

29. Landseer to Ross, September 24, 1825, Humanities Research Center, University of Texas at Austin.

30. The Earl of Tankerville, "The Chillingham Wild Cattle. Reminiscences of Life in the Highlands" (privately printed, 1891), p. 24.

31. C. Dickens, *Life of Charles J. Mathews* (London, 1879), vol. 2, pp. 49—51.

32. The Duke of Bedford to Landseer, May 31, 1827, one of twenty letters from the duke, V & A, Eng MS, 86 RR, vol. 1, no. 26,

33. *Haydon Diary,* 1960—63, vol. 3, p. 386.

34. *Ibid.,* p. 404.

35. *The Satirist* (London, 1833), quoted in G. Blakiston, *Lord William Russell and His Wife* 1815—1846 (London, 1972), p. 372.

36. *Ibid.*

37. Queen Victoria's Journal, November 24, 1837.

38. *Constable Correspondence,* 1965, p. 52.

39. Landseer to d'Orsay, undated, Houghton Library, Harvard University, MS Eng 1272, no. 1.

40. *Harriet Martineau's Autobiography,* ed. M. W. Chapman (London, 1877), vol. 1, p. 351.

41. Frances Trollope, *The Blue Belles of England* (London, 1842), vol. 2, pp. 43—46; *see also Letters of Charles Dickens,* ed. M. House and G. Storey (Oxford, 1974), vol. 3, p. 299n.

42. George Dunlop Leslie, *Riverside Letters* (London, 1896), p. 194.

43. Russell to Landseer, December 20, 1838, V & A, Eng MS, 86 RR, vol. 5, no. 281.

44. Norton to Landseer, undated, V & A, Eng MS, 86 RR, vol. 4, no. 240.

45. *Lady Holland to Her Son* 1821—1845, ed. Earl of Ilchester (London, 1946), pp. 184—85.

46. Stephen Hammick to Landseer, 1840, V & A, Eng MS, 86 RR, vol. 3, no. 166.

47. Landseer to d'Orsay, July 13, 1840, Houghton Library, Harvard University, MS Eng 1272, no. 4.

48. Landseer's travel diary is in the Mackenzie collection.

49. Landseer to Tweedie, July 31, 1857, Humanities Research Center, University of Texas at Austin; *see also* letters of September 8, 1857, and November 8, 1857, same collection.

50. Landseer to unidentified correspondent, October 20, 1857, Humanities Research Center, University of Texas at Austin.

51. Thomas Sidney Cooper, *My Life* (London, 1890), p. 23.

52. Keyl's Papers, March 1, 1867, Royal Archives, London.

53. Landseer to Bell, 1844, Royal Institution, London.

54. Landseer to Bell, August 31, 1845, Royal Institution, London.

55. Quotations from letters of Landseer to Bell, 1844—45, Royal Institution, London.

56. Leslie, *Riverside Letters,* p. 197.

57. Sale of contents of Landseer's house, Daniel Smith, Son & Oakley, London, July 28—31, 1874.

58. Bell to Landseer, September 1, 1842, V & A, Eng MS, 86 RR, vol. 1, no. 47.

59. Landseer to Bell, 1848, Royal Institution, London.

60. Correspondence between Landseer, Bell, Tom Landseer, and Gambart, November 1849, Royal Institution, London.

61. Landseer to Lewis, British Library, London, Add MS, 38608, f. 38.

62. *Ibid.,* f. 58.

63. *Ibid.,* f. 92.

64. Landseer's letters to the Duke of Devonshire and Joseph Paxton about the commission are in the archives at Chatsworth. Those from the duke and Paxton to Landseer are in the Mackenzie collection.

65. Queen Victoria's Journal, January 9, 1839.

66. Miss Skerrett to Landseer, October 25, 1844, Royal Archives, Add C/4/10.

67. Miss Skerrett to Landseer, December 20, 1847, Royal Archives, Add C/4/20.

68. Landseer to d'Orsay, March 13, 1840, enclosing Baroness Lehzen's letter of March 10 to himself, Houghton Library, Harvard University, MS Eng 1272, nos. 3, 3a.

69. Landseer to Ellice, August 2, 1841, National Library of Scotland, Edinburgh, MS 15033, f. 181—82.

70. Landseer to Lady Abercorn, V & A, Eng MS, 86 RR, vol. 3, no. 192.

71. Landseer to d'Orsay, undated, Houghton Library, Harvard University, MS Eng 1272, no. 40.

72. Landseer to Mrs. Elliot and Miss Perry, undated, Houghton Library, Harvard University, MS Eng 176, no. 55.

73. John Callcott Horsley, *Recollections of a Royal Academician,* ed. Mrs. Edmund Helps (London, 1903), pp. 126—27.

74. Miss Skerrett's letters to Landseer, Royal Archives, Add C/4/1—363.

75. Horsley, *Recollections,* p. 128.

76. Queen Victoria's Journal, January 13, 1843.

77. *Ibid.,* September 21, 1850.

78. Landseer to Miss Skerrett, November 20, 1849, Royal Archives, Add C/4/160.

79. Queen Victoria's Journal, September 17, 1850.

80. Phipps to Landseer, September 27, 1850, V & A, Eng MS, 86 RR, vol. 4, no. 259.

81. Queen Victoria's Journal, April 10, 1854.

82. Landseer's letters to Bell, Royal Institution, London.

83. Landseer to Miss Perry, August 24, 1859, Houghton Library, Harvard University, MS Eng 176, no. 30.

84. Landseer to Lord Ellesmere, September 9, 1837, quoted in London, 1961, no. 152.

85. The Earl of Tankerville, "The Chillingham Wild Cattle," pp. 30–31.

86. Lady Leslie, "Memories," Castle Leslie Archives, Eire.

87. Rudolf Lehmann, *An Artist's Reminiscences* (London, 1894), p. 252.

88. Frith, 1887–88, vol. 1, p. 326.

89. A. West, *Private Diaries* (London, 1922), p. 302.

90. Caroline Fox, *Memories of Old Friends* (London, 1882), vol. 2, p. 62.

91. Horsley, *Recollections*, p. 276.

92. A. Lang, *Life and Letters of John Gibson Lockhart* (London, 1897), vol. 2, p. 343.

93. Landseer to Mulready, undated, V & A, Eng MS, 86 NN1.

94. Landseer to unidentified correspondent, Humanities Research Center, University of Texas at Austin.

95. Landseer to Bell, December 12, 1858, National Maritime Museum, London, AGC/7/36.

96. Landseer to Bell, December 4, no year, Royal Institution, London.

97. R. Trevelyan, *A Pre-Raphaelite Circle* (London, 1978), pp. 138–39.

98. *Harriet Hosmer: Letters and Memories*, ed. C. Carr (London, 1913), p. 356.

99. Henry James, *William Wetmore Story and His Friends* (London, 1903), vol. 2, pp. 195–96.

100. *The Stanleys of Alderley*, ed. N. Mitford (London, 1939), p. 269.

101. Landseer to Mrs. Elliot, December 17, 1858, Houghton Library, Harvard University, MS Eng 176, no. 26.

102. Landseer to Mrs. Elliot, January 30, 1859, Houghton Library, Harvard University, MS Eng 176, no. 27.

103. Landseer to Miss Perry, February 23, 1859, Houghton Library, Harvard University, MS Eng 176, no. 28.

104. Landseer to Miss Perry, August 24, 1859, Houghton Library, Harvard University, MS Eng 176, no. 30.

105. Queen Victoria's Journal, April 13, 1864.

106. Landseer to Phipps, January 1, 1866, Royal Archives, PP Vic 7437 [1870].

107. *Cornhill Magazine*, vol. 29 (1874), p. 97.

108. *Ibid.*, p. 99.

109. Lehmann, *An Artist's Reminiscences*, p. 251.

110. Shirley Brooks, "MS Diary," February 3, 1867, *Punch* offices, London.

111. Landseer to Boxall, May 15, 1867, Boxall Papers, National Gallery, London.

112. Lord Frederic Hamilton, *The Days before Yesterday* (London, 1920), p. 22.

113. Cooper, *My Life*, p. 20.

114. Over sixty letters from Landseer to Coleman, collection of his grandnephew, B.D.J. Walsh, to whom I am indebted for the opportunity of consulting them.

115. Keyl's Papers, Royal Archives, London.

116. Landseer to Phipps, December 8, 1864, Royal Archives, PP Vic 17085 [1864].

117. Landseer to Phipps, November 7, 1865, Royal Archives, PP Vic 20861 [1866].

118. Landseer to Lord Houghton, November 24, 1865, Trinity College, Cambridge, Houghton Papers, 14/80.

119. Landseer to the Prince of Wales, September 11, 1866, Royal Archives, T.4/107.

120. Landseer to the 2nd Viscount Hardinge, January 27, 1866, National Portrait Gallery Archives, London.

121. Landseer to Lord Houghton, August 10, 1864, Trinity College, Cambridge, Houghton Papers, 14/79.

122. Shirley Brooks, "MS Diary," February 9, 1871, London Library.

123. G. S. Layard, *A Great "Punch" Editor, Being the Life, Letters, and Diaries of Shirley Brooks* (London, 1907), p. 470.

124. F. M. Redgrave, *Richard Redgrave, C.B., R.A., A Memoir Compiled from His Diary* (London, 1891), p. 316.

125. *See* correspondence in Gladstone Papers, British Library, London, Add MS, 44205, f. 247–51.

126. Arnold White to Sir Thomas Biddulph, July 18, 1872, Royal Archives, PP Vic 13635 [1872].

127. Memorandum from Biddulph, August 29, 1872, Royal Archives, Z.200/92.

128. *Daily News* (London), October 3, 1873, p. 5c.

129. Queen Victoria's Journal, October 1, 1873.

130. Jessy Landseer to Lady Leslie, in the latter's hand, October 13, 1873 (copy), collection of the author.

131. *Illustrated London News*, vol. 63, October 11, 1873, p. 350.

132. *Punch* (London), vol. 65, October 11, 1873, p. 143.

Landseer and the Continent:
The Artist in International Perspective

EDWIN LANDSEER was certainly one of the most English of English painters. He rarely traveled abroad and seems to have been little concerned with the exhibition of his paintings on the Continent or with the works of his contemporaries there. His earliest biographers present him on a nearly adoring level as a cherished national resource, and one to be heralded as such.

Two of his earliest prints—*A French Hog* and *A British Boar* (nos. 7,8), published in 1818—draw a comparison which, in their harsh satire of the state of affairs across the Channel, stand with Hogarth's *Calais Gate* as one of the more vivid examples of English jingoism. In his chauvinistic attitude, which would not again be revealed so blatantly in his work—but which he demonstrated later, for example, in his off-the-cuff remark that France and Ireland could sink into the sea with little loss[1]—he was probably not unlike many of his patrons and most of the English public who crowded to see his paintings and bought his prints. Despite the complex political and economic network that formed internationally between the victory at Waterloo and the Crimean War, insular contentment seems to have been the dominant tone in English artistic circles, most often taking the air of a benign but superior detachment from matters abroad.

There were, of course, major exceptions: many of those closest to Landseer traveled to the Continent, alert with curiosity about the landscape and the artistic ideas current there. Landseer's friend from childhood J. F. Lewis, after his first trip outside England, virtually abandoned his hunt subjects and his animal painting, similar to those of Landseer, for the picturesque genre scenes on which he made his reputation. Sir David Wilkie, whom Landseer deeply admired and who advised him in his youth,[2] radically altered his art after his own travels to France, Italy, and Spain in 1822, and Turner, of course, roamed throughout Europe in search of subjects.

A deep interest in broadening the foundations of English art—to fight provincialism in all its aspects—dates back to the lectures of Reynolds. It was continued, albeit in a very eccentric and completely English way, by Landseer's teacher B. R. Haydon in his defense of history painting in the grand manner. Landseer's close associates in his middle years Sir Charles Eastlake and his wife carried on the battle for a wider view, and found a firm ally in Prince Albert, at least as it concerned the pursuit of "higher" forms of subject matter, in his encouragement of the mural cycles for the Houses of Parliament. Yet, despite these tendencies toward a broadening sophistication among those so close to him, Landseer seems to have remained completely detached, content with his English subjects and his very English manner and style.

However, with the reopening of Europe at the end of the Napoleonic Wars an increasing fluency in trans-European artistic relationships emerged. This was no more dramatically illustrated than through the English participation in the vast Exposition Universelle in Paris in 1855. Some 375 works by 152 English painters and watercolorists were hung in the exhibition on the Avenue Montaigne, which was combined with the regularly scheduled Salon.[3] Only living artists were included, much to the dismay of several English critics who felt the need to support more fully the achievements of the English school, particularly through Wilkie and Turner. The English selection was closely appraised by the French press, with general agreement that the selection was by far the most comprehensive of the foreign contributions.

Landseer was represented by nine paintings and some twenty-nine prints after his work (by fourteen different engravers and lithographers).[4] At the close of the exhibition in October he was among the ten artists (and the only Englishman) to be granted the highest award: the Grande Médaille d'Honneur. Considering that the other painters awarded included Decamps, Delacroix, Ingres, Meissonier, and Horace Vernet[5]—and even knowing the political nuances of such international awards ceremonies—it is obvious that by mid-career Landseer had been placed within the highest international artistic circles (*see* fig. 24). Even Ruskin had to

24. Nicaise de Keyser (Flemish, 1813–1887)
The Great Artists: The Nineteenth-Century School, 1878
Oil on canvas, 114 x 162"
Musée des Beaux-Arts, Nice
Landseer is seated at the far left, next to Rosa Bonheur. Others portrayed include Turner, Meissonier, Ingres, Delacroix, and Horace Vernet.

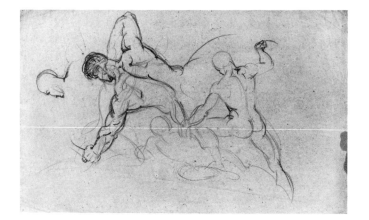

25. Edwin Landseer
Fighting Men (sketch on reverse of a sheet of anatomies), 1816
Pencil on paper
Sabin Galleries Ltd., London

26. Edwin Landseer
The Crucified Thief (after Rubens)
Chalk on paper, 17⅜ x 11⅝″
Her Majesty Queen Elizabeth II

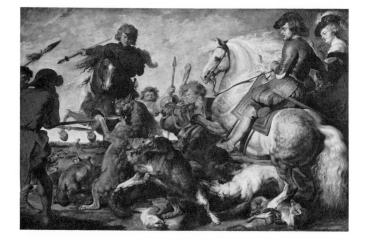

27. Peter-Paul Rubens (Flemish, 1577–1640)
Wolf and Fox Hunt
Oil on canvas, 96 x 148½″
The Metropolitan Museum of Art, New York, Kennedy Fund, 1910

admit that Landseer had become by far the best known English painter abroad, although he hastened to add in his peculiarly xenophobic way that Landseer's fame was probably directly dependent on his defects rather than his virtues.[6]

The evolution of Landseer's art is difficult to analyze, particularly because of the very early emergence of his formed style, a style that was so closely harbored within his own family. Certainly the most immediate influences on Landseer were English. George Stubbs (1724–1806), whose series of anatomical studies of the horse Landseer eventually owned, certainly had defined the genre within which Landseer would make his earliest pictures. This inclination was supported by James Ward (1769–1859)—particularly at his most dramatic—and Philip Reinagle (1749–1833), who contributed a more narrative quality to animal painting. On a more modest scale, Landseer had to have been aware of the engravings of Thomas Bewick (1753–1828) and, through him, perhaps had a knowledge of English animal subjects going straight back to Francis Barlow (1626–1702). An immediate precedent for the early interior scenes was the work of Sir David Wilkie (1785–1841), and before him that of George Morland (1763–1804) and Francis Wheatley (1747–1801). Yet, there is little in the work of these artists to explain the dramatic intensity and particularly the scale of even some of Landseer's earliest paintings. While Fuseli's benign neglect of his young students at the Royal Academy is often noted, there is occasionally a sense of the horrific in Landseer's work—most often shown in marginal drawings (fig. 25)—which almost certainly derives from his Swiss master.

Landseer's desire to carry his art beyond the traditional limits of English animal painting may, in turn, have derived from Haydon's emphasis on the importance of grand historical narrative and the antique.[7] It was Haydon who schooled his young pupil to be the "Snyders of England," and it is certain that the study of earlier European painting—particularly seventeenth-century Dutch and Flemish works—contributed as strongly to his formation as did English painting.[8] Even before his son began to study with Haydon and Fuseli, John Landseer surely had preached that there was much to be learned in looking at the old masters. He himself was later to publish a discussion of selected pictures from the National Gallery, and while warning firmly against giving false weight to the past, he considered the virtues to be learned from them immense.[9] It is not surprising, therefore, to find the young Landseer drawing after Rubens, for example, the wonderfully worked drawing at Windsor (fig. 26) of the unrepentant thief from the Flemish artist's *Crucifixion,* in Antwerp. Moreover, as has frequently been noted, Landseer's first major historical work—*The Hunting of Chevy Chase* (no. 23) of 1825–26—is clearly derived in composition

from Rubens's *Wolf and Fox Hunt* (fig. 27), now in New York, but then with Lord Ashburton.

That several of the hunting scenes that he painted well into his maturity were cast in the tradition of Frans Snyders (1579–1657) was frequently noted by his contemporaries, and many acclaimed that Landseer far surpassed this artist. Ormond has pointed out in comparing *Fighting Dogs Getting Wind* (no. 12) to the picture by Snyders of two dogs fighting (Hermitage, Leningrad) that this influence emerged very early. A general revival of interest in seventeenth-century Flemish painting was reflected in the early part of the nineteenth century both in contemporary criticism and in the art market. Just as the Dutch seventeenth-century "little masters" had served as a foundation for Wilkie and William Mulready (1786–1863), the Flemings, on a grander scale and with greater dramatic force, provided a general point of reference for Landseer.

Little note has been made, however, of the range of Landseer's borrowings or the subtlety with which they were turned to his own ends. With regard to *The Hunting of Chevy Chase,* not only did he borrow from Rubens the composition of the horses and huntsmen surrounding the struggling beasts, but he also quoted, in an adaptive manner, the rearing horse in profile and the horn blower. Still other sources are reflected in the painting. For example, the howling dog crushed by the stag's head relates closely to a figure in Snyders's *Staghunt,* now in Brussels (fig. 28), while the hound next to it, rolling on its back, grasping at the antlers, is strikingly close to the figure of a similar dog in a picture by Paul de Vos (c. 1596–1678), now also in Brussels (fig. 29). That these adaptations from earlier Flemish pictures were a sophisticated procedure is further revealed by a Landseer sketch of a bull attacked by dogs (fig. 30). This work of 1821 clearly anticipates *Chevy Chase:* the crushed hound after Snyders survives almost intact into the later work. However, here the inspiration, at least in part, is almost certainly drawn from de Vos's picture of the same subject painted for the Torre de la Parada, now in the Prado,[10] which introduces the dramatic image of the squirming dog that he used again so effectively four years later.

It is also instructive to compare *Bull Attacked by Dogs* with a painting by Abraham Hondius (1625/30– c. 1695)[11] of the same subject, now in Antwerp (fig. 31) but known to have been in London during the nineteenth century.[12] The expiring dog lying on its back, the one leaping at the bull's ear, and the third tossed in the air may well have gone into the making of this picture, combined with other elements from Snyders and de Vos. The possibility of Landseer's knowledge of this painter is particularly intriguing since Hondius spent the later part of his life—after 1666—in England and many of his pictures, particularly hunting scenes and game pieces, remained there.

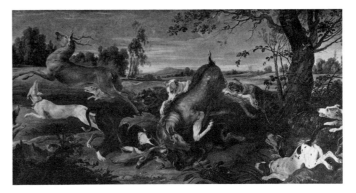

28. Frans Snyders (Flemish, 1579–1657)
Staghunt
Oil on canvas, 86⅝ x 165⅜"
Musées Royaux des Beaux-Arts, Brussels

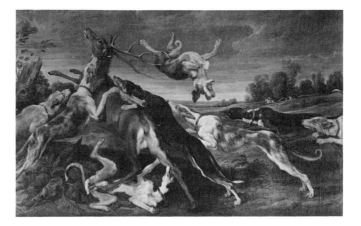

29. Paul de Vos (Flemish, c.1596–1678)
Staghunt
Oil on canvas, 85⅜ x 137"
Musées Royaux des Beaux-Arts, Brussels

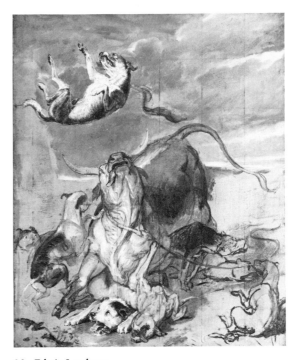

30. Edwin Landseer
Bull Attacked by Dogs, 1821
Oil on canvas, 23¾ x 19¾"
Private collection

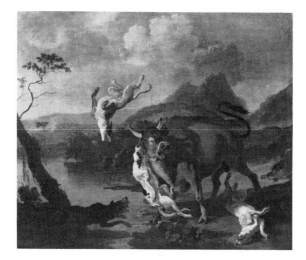

31. Abraham Hondius (Dutch, 1625/30–c.1695)
The Bull Hunt
Oil on canvas, 24⅝ x 29½"
Museum Mayer van den Bergh, Antwerp

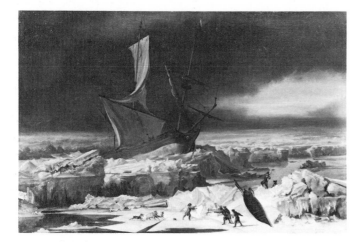

32. Abraham Hondius (Dutch, 1625/30–c.1695)
Arctic Adventure
Oil on canvas, 21⅞ x 33⅜"
Fitzwilliam Museum, Cambridge

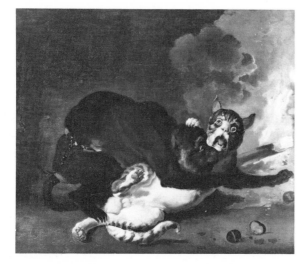

33. Abraham Hondius (Dutch, 1625/30–c.1695)
The Monkey and the Cat
Oil on canvas, 24½ x 29"
The Cleveland Museum of Art, Gift of The Butkin Foundation

Hondius was also well known for his views of frozen disasters, and it is possible that even as late as 1863–64 when painting *Man Proposes, God Disposes* (no. 151), Landseer was recalling a work such as Hondius's *Arctic Adventure* (fig. 32), then, as now, at the Fitzwilliam Museum in Cambridge. The wooden forms, broken and thrust up in the slabs of ice, offer a more telling, and accessible, comparison than Caspar David Friedrich's *Frozen Shipwreck* (Kunsthalle, Hamburg), which has often been mentioned in connection with this picture.

The taking up of other traditional subjects through Landseer's versions of tales from Aesop offers other areas of comparison. In *The Cat's Paw* (no. 19), for example, the complete departure from the traditional eighteenth-century rendering of the subject that continued in numerous illustrations to La Fontaine well into the nineteenth century[13] has often been noted. The elements of violence and cruelty are completely at odds with that tradition; however, possible sources emerge in seventeenth-century treatments of the subject. An illustration to the tale of "The Monkey and the Cat" by Marcus Gerards introduces the same degree of satanic wickedness,[14] far beyond the playful banter of eighteenth-century illustrations, while another painting by Hondius (fig. 33) handles the narrative with a markedly similar degree of violence—sexually suggestive in its cruelty—that appears in Landseer's picture.

David Teniers, the Younger (1610–1690)—not the Flemish artist's interiors, but certain other subjects—is another possible source for Landseer's art. The Louvre's *Archduke Leopold Hunting* (fig. 34), adapted in a popular French engraving, may well stand behind Landseer's treatment of hawking (no. 72), albeit very freely interpreted, while Teniers's comic pictures—particularly those involving "monkeyana"—obviously suggest influences. The German critic Gustav Waagen mentioned the Teniers painting *Monkeys Shaving Two Cats* in the London collection of Thomas Baring,[15] the patron who owned Landseer's *Monkey Who Had Seen the World* (no. 20).

That images and notions from seventeenth-century pictures would have been adapted, particularly in the earlier pictures, is not surprising. Through his father and his older brother Thomas, Landseer would have seen engravings after numerous old masters, and at a relatively early point in his career he had access to most of the important collections of earlier pictures then in England.[16] However, the nimbleness and range of his visual interest are impressive and suggest a mind of considerably greater sophistication and knowledge than has often been suggested of him, or, one suspects, than he himself in his charming but somewhat squirish public personality would have cared to have probed. Visual images from the past—particularly from Northern seventeenth-century pictures—continued to guide him throughout his life, although less as a source of specific

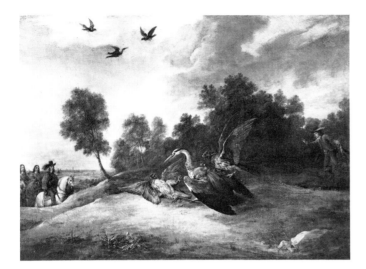

34. David Teniers, the Younger (Flemish, 1610–1690)
The Archduke Leopold Hunting
Oil on canvas, 31⅞ x 46½"
Louvre, Paris

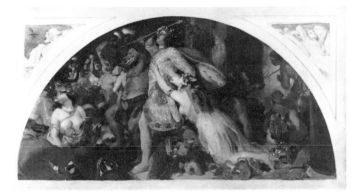

35. Edwin Landseer
The Defeat of Comus, 1843
Oil on canvas, 34 x 66"
The Tate Gallery, London

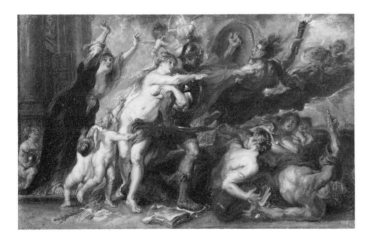

36. Circle of Peter-Paul Rubens
Outbreak of War—The Horrors of War
Oil on canvas, 19½ x 30¼"
The National Gallery, London

motifs than as a means for investigating new compositions of greater expressive force. For example, *The Defeat of Comus* (fig. 35), commissioned by the Prince Consort in 1843 for the Garden Pavilion of Buckingham Palace—the hero striding into the monster-ridden darkness—echoes Rubens's *Outbreak of War* (Pitti Palace, Florence), a version of which then was owned by Landseer's friend Samuel Rogers (fig. 36).[17] Even in the late and enigmatic *Swannery Invaded by Eagles* (no. 156) there are reminiscences of Snyders, whose works are often populated with horrific, marauding eagles (*see* fig. 37).

If, however, one turns to contemporary artists abroad for their influences on Landseer, little can be readily identified. Certainly, through Fuseli, he would have had some knowledge of activities in Paris and Rome, but there is no visual evidence that this affected his art in any direct way. Géricault's abundant praise of the young painter's achievements in 1821 has been frequently noted, yet it is not until much later, with *Flood in the Highlands* (no. 147), that one is tempted to draw some comparison. In his review of the picture in 1860, the French critic Thoré-Bürger saw certain reflections of the *Raft of the Medusa*, which the young Landseer may have seen when it was shown with great success in London the year of Géricault's visit. However, that comparison is at best tenuous: "This very dramatic and very picturesque subject, taken in a broad context, is interpreted in an odd way. The British artist has had almost the same idea as Géricault in the composition of his *Raft of the Medusa*. . . . Like Géricault, M. Landseer has done away with the cause, and has shown only an episode of the flood." After testing the comparison further, Thoré-Bürger saw its limitations, much to the detriment of the English work, which he said finally had "no effect, either real or fantastic."[18]

If this response to a major Continental contemporary falls short, one may query what knowledge Landseer would have gained of contemporary French activity through his connection with the Gore House set of Lady Blessington and Count d'Orsay in the early 1830s. Whereas it is unlikely that Landseer would have learned much through his friendship with the fashionable Count d'Orsay, the house was frequented by a lively international lot. It would have been particularly through the frequent presence of the young Marquess of Hertford—just then assembling one of the most important collections of French art of his day (to which three Landseers would eventually be added)—that some curiosity, if not knowledge, might have materialized. Horace Vernet (1789–1863), whom Landseer is quoted as admiring beyond all other French painters,[19] was certainly a favorite of Hertford by 1855. Vernet's *Mazeppa and the Wolves* of 1826 (fig. 38), one of the most praised and reproduced French works of its time, could have played some role in the conception of *The Hunted Stag* (no.

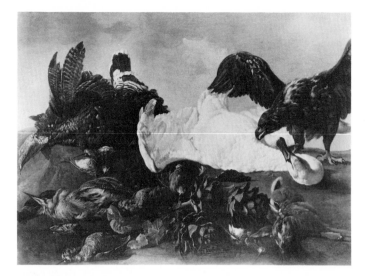

37. Frans Snyders (Flemish, 1579–1657)
Dead Game
Oil on canvas, 48½ x 65¼"
Philadelphia Museum of Art, W. P. Wilstach Collection

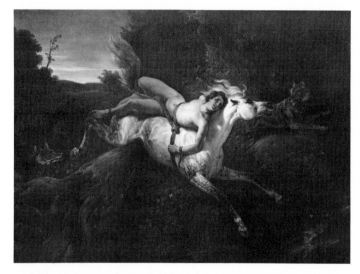

38. Horace Vernet (French, 1789–1863)
Mazeppa and the Wolves, 1826
Oil on canvas, 39⅜ x 54⅜"
Musée Municipal, Rouen

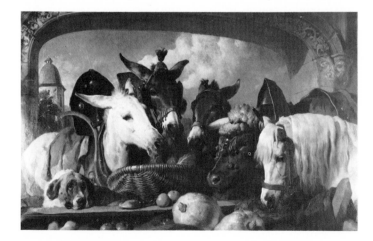

39. Sir Edwin Landseer
The Tank: Geneva, 1851
Oil on canvas, 57 x 103"
Los Angeles County Museum of Art, William Randolph Hearst Collection

38). The wild leap of the horse pursued by wolves may, in its romantic intensity, have served as a spiritual if not literal precedent.

Landseer's own infrequent travels abroad are no more revealing of any interest in contemporary artistic activity across the Channel. Whereas the recuperative nature of his only well documented tour, that of 1840, through Belgium and up the Rhine to Switzerland, and his hasty return through France, may serve as a partial explanation for the absence of his examination of contemporary work, it must stand as typical. Landseer produced a number of drawings suggesting enthusiasm for the landscape and simple market life, with an occasional note of a picturesque element, such as a Gothic fountain in Frankfurt.[20] However, the results are in no way striking, nor do they suggest any new direction of his style under the influence of his firsthand Continental experience. The major work that he later based on his travel drawings, *The Tank: Geneva* (fig. 39), suggests that beyond certain intriguing aspects of picturesque local color he felt there was little to be gained through direct contact abroad. His later, scantily documented visits to the Baron Marochetti's villa on the Loire seem to have been essentially holidays.

As early as the 1830s, prints after Landseer's works were circulated abroad with some regularity. When French critics finally had the opportunity of seeing his paintings at the Salon of 1855, they consistently referred to this artist whose work was already so familiar to them through engravings and other reproductive prints. In this Landseer was, on one level, simply profiting from the general *goût anglais* that had begun to flourish under Louis-Philippe; the French taste for English literature and decorative objects came into full vogue in the Second Empire, particularly encouraged by the close relationship between the two courts. The Goncourts could, with mingled familiarity and ennui, describe an overcrowded Parisian apartment they visited as having "walls covered with large English engravings, Landseers before his time."[21] Or more charmingly, they could assume such casual knowledge of specific works in describing a governess in the park leading "those little ratting terriers, whom Landseer shows teasing a parrot."[22] Things reached such a degree of familiarity, nearly saturation, that in 1875 the *Art Journal* reported with some irritation the overheard remarks of two visiting Frenchmen noting Landseer prints in the window of a shop in Pall Mall: "Mon Dieu, encore des chiens!"[23]

It was with the presentation of Landseer's paintings among the English selection at the Exposition Universelle of 1855 that full critical response was first given voice in France. It would be difficult to overemphasize the general impact of the English showing in Paris in 1855, the first opportunity that a French audience had to survey a broad selection of contemporary works from across the Channel. Even as late as 1878 the critic

Duranty vividly remembered the splash ("grand bruit") made by the English at the exposition: "In 1855, English art was a revelation to us. The intimate, witty, and semiphilosophical nature of its subjects, pointing to the derivation from Hogarth and Wilkie, the poetic oddity of certain compositions, the rigor of the history painters, the piquant singularity of the colors, the—to our eyes—unusual freshness of certain dissonant harmonies, the originality and importance of the watercolors, a genre that seemed to us quite new, and finally the Pre-Raphaelites with their affectations of naïve meticulousness or primitive simplicity—all this came as a surprise to us."[24]

Not surprisingly, given his fame at home and his success, evidenced by the judgment of the awards jury in the fall, Landseer was among the most discussed of the English painters. For Baudelaire, he was simply the painter of beasts "whose eyes are full of thought."[25] In this sentiment he reflects Théophile Gautier, who brought to his extensive survey of the English selection at the exposition not only the greatest previous knowledge of their work, but also the most catholic taste and broadest tolerance. Gautier opened his review in the *Moniteur* with a warning to his French audience that English art *is* a thing apart: "The distinctive characteristics of England are a genuine originality and a strong local flavor: it owes nothing to other schools, and the arm of the sea a few leagues long separating it from the Continent keeps it at such a distance that it would seem to be as wide as the Atlantic Ocean."

He then proceeded to analyze national character still further, noting the pervasive English taste which

explains the thoroughbred purity, perceived and admired by the most uneducated, of the dogs, horses, oxen, and sheep of that country, and the huge popularity there paid to such a painter as Sir Edwin Landseer, who certainly would not have obtained an equal success among us, since our admiration is reserved for large "machines," historical subjects, and classical scenes, in which only man is important.

But this is not to say that we do not have some very remarkable animal painters. Rosa Bonheur, Brascassat, Troyon, Jadin, Philippe Rousseau, and Decamps have treated this genre with unquestionable superiority, but in a wholly different and, so to speak, contrary spirit. The artists we have just mentioned have considered the animal from the purely picturesque point of view; they have striven to render its form, color, pose, the tufts of its fur, and the shimmer or stripes of its coat with the greatest possible truth; but not believing it to have a soul, they have not looked for it. When it comes to animals, the French school is materialist, and the English school spiritualist. . . .

Landseer gives his beloved animals soul, thought, poetry, and passion. He endows them with an intellectual life almost like our own; he would, if he dared, take away their instinct and accord them free will; what worries him is not anatomical exactitude, complicated joints, the thick-

ness of the paint, masterful brushwork: it is the very spirit of the beast, and in this respect there is no painter to match him; he penetrates the secret of these dark brains, he knows what makes these unconscious little hearts beat, and reads in these dreamy eyes the faint astonishment produced there by the spectacle of things. Of what does the hunting dog dream near the hearth, the sheep ruminating on its bent knees, the stag raising to the sky its black and glossy muzzle from which drip strands of saliva? Landseer will tell you in four strokes of his brush. He is on intimate terms with beasts: the dog, giving him a shake of the paw like a comrade, tells him the news of the kennel; the sheep, blinking its pale eyes, bleats out its innocent complaints to him; the stag, which like a woman has the gift of tears, comes to weep on his breast over the cruelty of man, and the artist consoles them as best he can, for he loves them with a deep tenderness and does not have a fool's disdainful scorn for their afflictions.[26]

Each picture deserved its own description. *Shoeing* (no. 134) in composition is "very simple"; *The Drovers' Departure* (no. 41), "a charming picture" with "countless details," establishes a sentiment that is particularly effective, "a slight sadness smiling through tears which already dispels the hope of return"; *A Jack in Office* (no. 62) is done with a "singular subtlety of expression." As for *Macaw, Love Birds, Terrier, and Spaniel Puppies* (no. 103), he thought it "impossible to show a better grasp of the attitudes and expressions of these different animals." In short, Gautier was altogether charmed and quite determined to introduce his audience gently into the poetry of these subjects. On the question of execution he was more critical, warning: "We French would desire a richer paint, a steadier brushstroke, more rigorous drawing; but what charm, what feeling!"

Georges Planche in the influential *Revue des Deux Mondes* made, perhaps, the single most praising observation of all French critics, in being reminded by *Shoeing* of Géricault's treatment (in lithography) of the same subject: "Since we have lost Gericault, no artist . . . has produced a work of its class to be compared with this of Landseer—at least, in painting, for, in statuary, Barye is equal to Gericault and, consequently, to Landseer."[27] Other Parisian critics were on the whole less positive than the powerful voices of the *Moniteur* and *Revue des Deux Mondes*. The often very negative but highly urbane Viel Castel turned the isolation of the English school to its own detriment and considered Landseer simply as "English—purely English."[28] Maxime du Camp reflected the opinion of others in finding Landseer disappointing in face of the anticipation fostered by his engravings, speaking of his "dry, hard, brittle palette."[29]

After 1855 Landseer was a known factor for French critics and one whose career they followed with some regularity. The London correspondent for the *Gazette des Beaux-Arts*, Rafaelle Monti, for example, com-

mented regularly on works shown at the Royal Academy with some alertness, although rarely with complete sympathy. It was, however, the vast exhibition held in Manchester in 1857, "The Art Treasures of Great Britain"—in which Landseer showed some twenty-four works—that allowed two major French critics to review their feelings about the artist.

Charles Blanc, who reveled in the gathering of old masters in unprecedented numbers, thought that their deliberate juxtaposition with contemporary works was audacious and intensely naïve; he was particularly offended by the comparison drawn between Landseer and Snyders, finding little to treasure in the former.[30] Thoré-Bürger was more tempered in his comments, pondering Landseer's works at some greater length, but drawing no less harsh a conclusion of the artist as a painter:

> Of all the present painters in England, Sir Edwin Landseer is far and away the most renowned. Engravings of his paintings are to be found everywhere among his compatriots; they are even quite widespread on the Continent. Some authoritative connoisseurs go so far as to place him at the level of the greatest animal painters of all past centuries. M. Landseer, however, is by no means a painter like Rubens or Snyders. He falls short in every respect. It is the painting aspect that is weak in his talent, or at least M. Landseer is not in control of its execution. He could not be more uneven in his pictures . . . in which breadth of drawing, color, perspective, and especially chiaroscuro are completely lacking. But since M. Landseer is marvelously in possession of his animals, since he has studied their habits, grasped their ways, and penetrated their instincts, his compositions always do well, once they are engraved. The imperfections of the painting are eliminated in a good print, and the intelligence of the artist remains.[31]

Three years later he qualified his opinions still further in reviewing the Exposition Générale in Brussels: "It is quite surprising to find a painter so absolutely worthless who has so much fame."[32]

After the initial rush of interest and enthusiasm in the 1850s, French critics found Landseer of less interest just at the point that his insular fame had reached its apogee. Paul Mantz, not surprisingly, was among the most negative, noting in 1860 that Landseer's art had declined after his early work and that Géricault would perhaps have modified his enthusiastic judgment of 1821 if he could have seen his paintings then.[33] In 1862 Mantz commented:

> Those who judge M. Landseer only by the engravings that have been made from his paintings run the risk of placing him a little too high in their esteem. The artist . . . is not a first-rate painter; . . . he often mixes his paints with a sort of powdery gray ["gris poudre"] that removes all accent and truth from the characteristic color. M. Landseer's coloring is thus rather arbitrary; the engravers who have been commissioned to reproduce his works have succeeded, by bringing out the contrast between the blacks and the whites, in giving him a variety and vigor that he completely lacks; but for the spirit, flavor, and sentimental character of his scenes of intimate life of dogs, stags, and monkeys, M. Landseer needs no help from anyone, and although the weakness of his brush makes it impossible to compare him to the real masters, it is certain that he has hit close to the animal comedy.[34]

Philippe Burty was kinder, although somewhat forced in his attempt at objectivity; as he noted, in crossing the Channel "our judgment is on its guard and becomes more impartial." He considered Lady Godiva's Prayer at the Royal Academy in 1866 less than mediocre, although he excused it because of the age and the ill health of the artist.[35] However, by 1869 Landseer had made a complete recovery for Burty:

> Sir Edwin Landseer, whose expeditious procedures and calumnies against the good sense of animals we scarcely prize, has been completely rehabilitated in our eyes this year. His two Studies of Lions [see no. 150] are truly remarkable. Certainly these lions do not have the harsh beauty of the ones that prowl, gape, or stretch themselves around an ecstatic Daniel in the Légende des siècles. These lions posed for Monsieur Landseer in some menagerie, and were perhaps whipped by Crockett to make them hold the pose. But if they do not have the souls of desert lions, they at least have their fur. It took Sir Edwin Landseer, who is the Horace Vernet of the other side of the Channel, less than a morning, we are assured, to brush them. His Swannery Invaded by Eagles [no. 156] is truly touching. One is moved—and not by mawkishness—at this peaceful, snow-white assembly which symbolizes the dying poet; one waxes indignant at this gang of birds of prey that pounces on it, strikes, assaults, and kills it. . . . The combat, however, is relentless, and blood flows equally in the camp of the winged bandits and on the side of the swans, which succumb while striking noble attitudes and calling the avenging gods to witness! Sir Edwin Landseer is now well along in years, but his hand has never seemed to me so steady.[36]

At the Exposition Universelle of 1867 in which the English showing was both badly handled and small, only one Landseer, The Taming of the Shrew (see no. 149), was shown,[37] and it seems to have gone little noticed, although at least one French critic, Monti, had praised it highly at its showing in London in 1861. Other pictures were noted by French critics as they appeared at the Academy during the last years of his life, only to be regretted, such as the unfinished Queen Victoria on Horseback (no. 101). Sympathetically, the London correspondent for the Gazette des Beaux-Arts noted that the memorial exhibition at the Royal Academy in 1874 was simply too large, and that few artists could withstand such complete exposure, but it was, nonetheless, an "eminently regrettable" event.[38] Indian Tent (Wallace Collection, London; then the Prince of Wales) and The Swannery Invaded by Eagles (no. 156) were shown in Paris at the Exposition Univer-

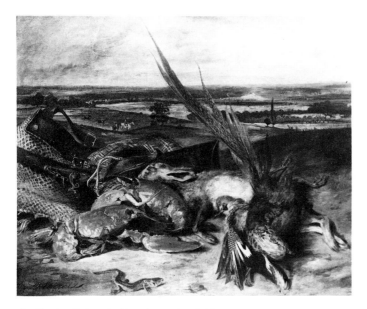

40. Eugène Delacroix (French, 1798–1863)
Game and Shellfish, 1826
Oil on canvas, 31½ x 39⅜"
Louvre, Paris

selle in 1878,[39] with perhaps the most revealing comments being those of Duranty. He sadly regretted the heroes of 1855, when English art was such a revelation to those on the other side of the Channel, and felt that it had declined to a bourgeois level clearly inferior to that of earlier English painting "dominated by the talent of the late Landseer."[40]

Landseer was given considerable thought by Hippolyte Taine in his notes on England, first published in 1871, but more as an example of certain English failures than as a specific criticism.[41] Ernest Chesneau devoted several pages to him in his uncritical and rambling *La Peinture anglaise* in 1882, but simply reviewed past opinion and, at one point, took it upon himself to apologize for the naïveté of French enthusiasms in 1855: "They found a completely new and unexpected style, and in their leniency rather resembled children, who like to munch away at sour and unripe fruit."[42] His pictures continued to be included in broad survey exhibitions abroad—Vienna in 1873, Brussels in 1878, Rome in 1902—but this was perhaps more a reflection of the conservative makeup of the English selection jury than of any real approval of Landseer.

However, his appeal on a popular level continued to hold sway in France nearly as long as it did in England, as is indicated by the inclusion of *The Hunted Stag* (no. 38) in the Hachette survey of great arts *Les Chefs-d'oeuvre des grands maîtres*, which was published shortly after the turn of the century. Charles Moreau-Vauthier (himself a writer of children's books), in this gathering of works, perplexing to modern sensibilities, ranging from Rubens to Guido and Degas to Alphonse de Neuville, made a charming plea for the virtues of Landseer. Warning his reader not to be embarrassed by the degree of sentiment in the picture, he suggested that, for him, it was like a reading from his childhood—all Scottish lakes and mists. In an almost Proustian evocation, he noted that the scene was of a primeval age older than Oudry, older even than the seventeenth century. It was from another place and time and he gently reminded his French readers that it was, after all, an English picture true to "that race who are more in love with nature than yourselves, more akin to its powers and sentiments."[43]

The enthusiastic, if short-lived, critical response that Landseer received in France in 1855 brings to question his impact on French art. Early in his career, Landseer was able to impress a major artist from across the Channel, evidenced by the often-quoted letter from Géricault to Horace Vernet, written from London on May 1, 1821, shortly after he had seen the exhibition at the Royal Academy:

> The exhibition that has just opened has only confirmed for me once again that only here do they know because they perceive color and effect. You have no idea of the fine portraits this year and the great number of landscapes and genre paintings; animals painted by Ward and by Landseer, who is eighteen years old; the masters have produced nothing better in this genre; one should not blush to return to school; there is no other way to arrive at the beautiful in the arts except by comparisons.[44]

The painting Géricault saw was *Fighting Dogs Getting Wind* (no. 12). While it would be futile to search for direct influences that this or other Landseers might have had on the formed and profoundly different artist during the few remaining years of his career, his response to the work of the young and immature painter is impressive. This is so even in light of the freshness the progressive French found in English art, which was then moving so steadily into Romanticism, unimpeded by the formal restraints of David and the École.

It is well documented that Delacroix shared many of Géricault's sympathies and enthusiasms for English painting, seen particularly in his correspondence from England during his long visit there in 1823 and his later recollection of that trip. There has been speculation that certain works, specifically his *Game and Shellfish* (fig. 40), a work perhaps begun in London, may reflect an awareness of Landseer. Certainly, the handling of the animals themselves—the rough, light-on-dark treatment of the hair of the rabbit and the plumage of the pheasant, as well as the general tonality with translucent browns and ambers fluidly worked into reds and greens—provides a general parallel to Landseer's style of the early 1820s, but there is little here that could not equally be explained through Delacroix's firmly documented interest in Lawrence, Wilkie, and Constable.[45] Speculation is further quelled by the fact that throughout his published writings, even during 1855 when he served on the awards jury of the Salon that so highly honored

Landseer, Delacroix never mentioned the English artist.

It was not until well into the 1840s, after the circulation of Landseer's prints on the Continent had begun to have its effect, that a direct impact on French artists appeared. Not surprisingly, it was among the painters of battles, hunts, and other animal subjects—a genre that underwent a revival of activity with Romanticism in France—that Landseer's strength was most strongly felt. It is with Alfred Dedreux (1810–1860),[46] a painter of hunts and equestrian portraits, who as Charles Blanc pointed out was almost half-English in any case, given his love of horses, the course, Scottish ponies, and greyhounds—"these magnificent long-haired greyhounds that leap, or dream like natural people, in Landseer's paintings"[47]—that a striking influence is to be found. Dedreux went to England with Eugène Lami and Gavarni to escape the October Revolution in 1848, and while there painted the picture *Loyalty,* which, by description, could almost be an homage to the English artist: "Profoundly British, entitled *Loyalty,* a pretentious painting in which, amid a romantic landscape copied from a page by Walter Scott, a Scottish greyhound seems to ponder in melancholy fashion by moonlight over the grave of his master."[48]

Other artists, most often of the fashionable Jockey Club circle, also took up Landseer to varying degrees. Louis-Godfroy Jadin (1805–1882), also a painter of animals and the hunt, in 1845 exhibited a dog subject entitled *Rich and Poor,* which was "flagrantly" dependent on Landseer's *Low Life* and *High Life* (nos. 58, 59).[49] In many of his works, which particularly pleased an aristocratic audience during the Second Empire, his similarity to Landseer is equally striking. Philippe Rousseau (1816–1887), perhaps the most distinguished of this group, included numerous domestic animals in anecdotal situations in his paintings. *Indiscretion* (fig. 41), with its comic encounter between a cat and unwary dogs, certainly echoes such works by Landseer as *The Barrier* (Tate Gallery, London), although the roles are reversed and Rousseau's humor depends more on narrative than on actual characterization.[50]

The French artist with whom Landseer was most often connected is, of course, Rosa Bonheur (1822–1899).[51] Her long-standing admiration for Landseer culminated in her triumphant visit to London in 1856, a year after she would have had full opportunity to view the artist's works at the Paris Salon.[52] The Belgian-born dealer Ernest Gambart, with whom Edwin Landseer suffered a long and often fractious relationship, staged her visit to coincide with the showing in his London gallery of her *Horse Fair*—a picture that Thomas Landseer was engraving at the time.

To follow Lady Eastlake's account, Bonheur's meeting with her mentor seems to have been one of considerable emotion:

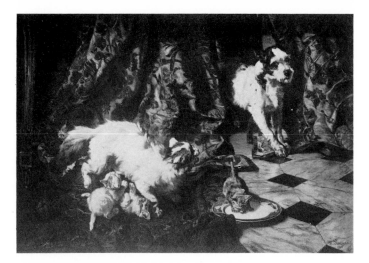

41. Philippe Rousseau (French, 1816–1887)
Indiscretion, 1850
Oil on canvas, 38⅛ x 51⅛"
Ministère des Finances, Paris

Her whole enthusiasm as a woman [has] been long given to Landseer. Engravings of his works were the first things she bought with the money she earned; and in his house, surrounded by the most exquisite specimens of his labour and his skill—studies without end of deer, horses, Highlanders, tops of Scotch mountains, &c: and with him pulling out one glorious thing after another, calling her first into one room and then into another . . . his dogs about him, and a horse, as tame as a dog, handed into the painting room—she was in a state of quiet ecstasy. Then he presented her with two engravings of his splendid "Night" and "Morning," writing her name with his upon them, and then pretended to call her attention to the excellence of his brother's work. This was too much for the little great-hearted woman . . . and her face crimsoned and eyes filled.[53]

Landseer's feelings on the occasion were not so vividly recorded, but it is known that he was particularly animated during her visit. At a dinner party given by the Eastlakes in Rosa Bonheur's honor, he proposed in jest that he become Sir Edwin Bonheur—a joke that seems to have gotten out of hand and appeared in the press the following morning as serious speculation. In turn, the popular press declared Rosa the "French Landseer." However, despite her great appreciation of his art, it seems to have had little influence on her work. Much later, during her showing in Paris in 1867 after a long absence from the Salon, some critics stated that she was influenced too much by Landseer;[54] late in her life, her student and friend Paul Chardin suggested that after seeing Landseer, her handling took on a greater refinement and she abandoned the broader manner of *The Horse Fair.*[55] But there was not any marked break in her style after 1856 and her progress toward a greater sense of finish evolved gradually during the 1860s. This is not to say that her admiration for Landseer ever waned. As late as 1897 she still noted that he would "remain the

greatest of his kind."[56] A few compositions do show his direct influence, one of the most striking being *The King of the Forest* (fig. 42) (engraved as *On the Alert*), done five years after Landseer's death. The splendor and regality of the work, executed on a large scale (unusual for Rosa in her stag pictures), are undoubtedly derived from *The Monarch of the Glen* (no. 124). However, despite its title, *The King of the Forest* is a plainly witnessed figure virtually uninterpreted. Rosa made no attempt to suggest a narrative context or to introduce other associative readings. Perhaps this was Ruskin's meaning when he crankily observed upon comparing the two artists that Rosa "developed in her art a woman's somewhat morbid love of animals, coupled with some Landseer-like talent. . . . [Her] feelings for animals were more akin to the menagerie keeper's love. Landseer was not so much an artist as one who studied dogs and knew their ways."[57]

Other animal painters were also compared to Landseer, especially by French critics; those most often mentioned were Constant Troyon (1810–1865), Jacques-Raymond Brascassat (1804–1867), and the Belgian Joseph Stevens (1819–1892).[58] However, their work is most often of a pastoral vein, confined almost exclusively to domestic beasts of the farmyard. Even Troyon's dogs, which in their animation and placement in dramatically lit spaces often continue a type of Romanticism most similar to Landseer's, are always of a neutral and observed quality quite distinct from those narrative features in Landseer which would sometimes charm,

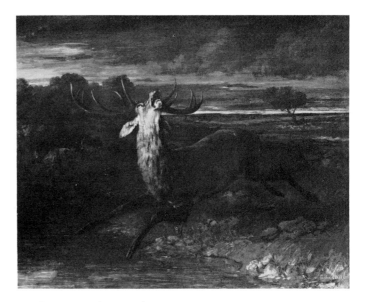

43. Gustave Courbet (French, 1819–1877)
The Hunted Stag, 1861
Oil on canvas, 86⅝ x 108¼"
Musée des Beaux-Arts, Marseilles

but more often perplex, his French critics. Like those of Jadin, Philippe Rousseau, and Dedreux, their sources are from the Rococo and not the seventeenth century, from Oudry and Desportes rather than Snyders and Rubens.

Alexandre-Gabriel Decamps (1803–1860), of whom it was said that he would prefer a hunting permit to the Legion d'Honneur, was also sometimes compared to Landseer,[59] yet even in his most closely observed dog pictures there is no concrete reference to the English artist. The sculptor Antoine-Louis Barye (1796–1875) was another figure to whom French critics drew parallels, but even in his numerous stag subjects there is little evidence of any awareness of Landseer. If there was any connection it may have been in reverse: the fame of the French artist may well have led Landseer into his few experiments with anecdotal sculpture, which, with rare exceptions, seem to have had rather disastrous results.[60]

With the exception of Rosa's large stag picture, the comparison drawn to French artists is primarily on the level of cabinet works, with the suggestion that the artist at his most grand and august was given little attention by his French contemporaries. However, for a long time there has been the temptation to see some influence of Landseer in the hunt subjects of Gustave Courbet (1819–1877)—in their grandeur and large scale and their unflinching candor in depicting the brutality of the chase. One document survives to demonstrate that Courbet did know the work of Landseer. In a letter of 1861 describing his picture *The Hunted Stag* (fig. 43), Courbet noted: "The expression of his head ought to please the English; it recalls the feeling of Landseer's animals."[61] This comment prompted Linda Nochlin to search further for visual references, and her argument

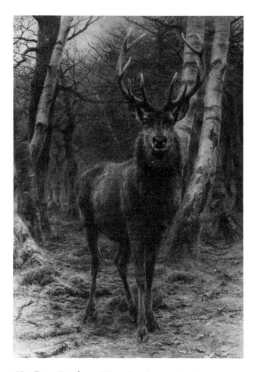

42. Rosa Bonheur (French, 1822–1899)
The King of the Forest, 1878
Oil on canvas, 97 x 68½"
The Warner Collection of Gulf States Paper Corporation,
Tuscaloosa

that Courbet knew Landseer's *Hunted Stag* (no. 38)—perhaps when illustrated in the *Magasin Pittoresque* in 1851[62]—is apt. Despite their disparity in scale, the figures are strikingly similar.

Certainly no French artist is as fundamentally akin to Landseer as Courbet. Provocative comparisons can be drawn between such pictures as *Fighting Stags: Rutting in Spring* (Louvre) and *Night* (see no. 128); *Pursued Doe, Winter Landscape* (private collection) and *A Random Shot* (no. 123); or even *Fox Caught in a Trap* (collection Matsukata, Tokyo) and *The Last Run* (no. 98), but in no case is there the kind of concrete evidence that one has with Courbet's *Hunted Stag*. Courbet's interest in Landseer may have stemmed quite simply from their shared respect for the stag. Certain descriptions of hunting by Courbet find nearly exact parallels in Landseer's own remarks on the pleasure of the chase: in the same letter in which he referred to Landseer, Courbet related his enthusiasm in witnessing two stags fighting during rutting season: "In these animals no muscle stands out; the fight is cold, the rage deep-seated, the thrusts are terrible, although it looks as if they hardly touched each other. You can understand this when you see their formidable armatures."[63] That he, unlike Rosa Bonheur, had no difficulty in extending to a subjective realm is suggested by Philippe Auquier's critical description of *The Hunted Stag*: "Under a twilight sky, heavy with clouds and which the last fires of the sun border with a strip of pale gold, a stag of natural grandeur dashes toward a pond. Panting, it rushes headlong, head raised to the sky, as though imploring supreme help. But already, in the distance, under a solitary tree on the right, a pack of dogs appears on the heels of the fugitive."[64] Courbet himself was not beyond a certain turn of anthropomorphic humor closely akin to that of Landseer, suggested by his description of *The Deer Gathering by a Stream* (Louvre) as "like a lady receiving company in her drawing room."[65] One cannot, of course, press this notion of influence too far. Drawing his ideas from many sources, Courbet turned them completely to his own ends, but in his willingness to extend beyond observed naturalism—firmly grounded in his realism as he may be—there is a harmony with Landseer that is far more striking than with any other French artist of the time.

Courbet's fame and influence in Germany—particularly through his hunt and animal pictures—suggest that perhaps Landseer had found a receptive audience there, even more so than in France. Certainly he was known in Germany, even though no pictures seem to have been purchased there during his lifetime and his paintings were not seen in the German-speaking world until the Vienna exhibition of 1873. Prints seem to have been in circulation there as early as they were in France, and by 1863 Gambart could complain bitterly against pirated lithographs after Landseer, in defiance of

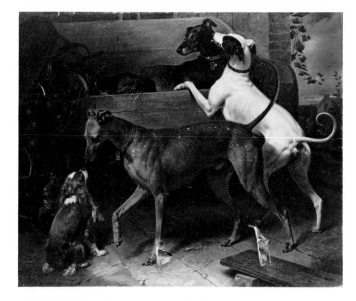

44. Franz Krüger (German, 1797–1857)
Krüger's Dogs, 1855
Oil on canvas, 49¾ x 62⅜"
Kunsthalle, Hamburg

copyright laws, entering England from Berlin, where they were freely circulating.[66]

Gustav Waagen, in his exhaustive survey of the holdings of art in England, begun in 1835, noted with amazing thoroughness all the Landseers he encountered, often speaking of his knowledge of them through the engravings. Of the Bowood *Return from the Staghunt* (no. 42) he noted: "The character of the men and dogs is admirable, the light keeping of the whole most masterly, the execution careful even in the accessories, and the colours transparent."[67] The more anecdotal dog pictures seem, however, to have appealed to him most:

Sir Edwin Landseer takes the first place in this branch of art. He distinguishes himself from other animal-painters, both of earlier and of present times, by his presenting to us his favourite animal, the dog, in those relations in which this animal exhibits a certain likeness to man, and even as playing a human part. . . . In order to accomplish this with the more success, Sir Edwin has so carefully studied the human race, that, but for the circumstances that animals, properly speaking, constitute the chief subjects of his art, I should have assigned to him a distinguished place among the subject-painters of England.[68]

Waagen's enthusiasm had considerable support from other German commentators. As early as 1831 the *Kunstblatt* praised Landseer's *Poacher's Cunning* for its depiction of an event so vital, true, and characteristic.[69] On his tour of English collections in 1834 Johann David Passavant noted several works with enthusiasm. He was particularly taken by the Scottish subjects: "We have only to take our station before one of Landseer's pictures, to be immediately transported in fancy to the native customs and scenes of the Highlanders."[70] The numerous pictures "confined entirely to dogs" per-

plexed Passavant more, but "these he represents so truly to nature, and in such peculiar and characteristic positions, as to render them invariably interesting." He concluded by heartily supporting his opinion of his English colleague: "Such is his lightness of touch, and charm of colouring, and chiaro-oscuro, that in these subjects he is surpassed by none of his fellow artists."[71]

That the landscape painter from Leipzig Carl Gustav Carus (1789–1869) showed great enthusiasm for Landseer in his published notes from his trip through England and Scotland in 1844[72] was particularly striking since he liked very little of the contemporary English painting that he saw. He remarked of *The Challenge* (no. 122): "One feels the cold of a clear still night, and rejoices at the noble beast in his chilly wild kingdom."[73]

German critical enthusiasm for Landseer continued, as reflected in various publications. The *Zeitschrift für Bildende Kunst,* for example, printed J. Beavington Atkinson's memorial to the artist, which far exceeded both in length and in degree of praise any notice given his death in the French press, suggesting the very high position in which Landseer was held in Germany. He was, for the power of his characterization of animals considered far in advance of Snyders and Rubens, a painter and poet, "a figure of great range. . . . One has no doubt that his international fame and stature, based on the universality of his genius, is completely assured."[74]

The fact that Frederick William Keyl (1823–1871)[75] came from Frankfurt to London in 1845 to work with Landseer is further evidence of the fame the artist had gained in Germany. Keyl was much favored by Landseer, who took him on—as it would develop—as his sole pupil. Landseer introduced him to his patrons, including Queen Victoria and the Prince Consort, for whom he would do several portraits of their dogs and horses. In

turn, Keyl would be a close friend and confidant until the end of his life. But it would be difficult to find in Keyl's pictures any clear merging of German and English elements, particularly since he studied briefly with the Belgian animal painter Eugène Verboeckhoven. Keyl's submission to the Royal Academy in 1847—*Fidelity*—suggests, however, the speed with which he adapted Landseer's ideas for subjects to his own ends. Another German artist whose immigration to England may have been at least partially prompted by an interest in Landseer is Joseph Wolf (died 1899).[76] After having been trained in Darmstadt he came to London in 1848 where he established a successful career as an illustrator and reproductive printmaker, whose work included prints after Landseer.

John William Bottomley (1815–1900),[77] an animal painter born of English parents who had settled in Hamburg, is sometimes compared to Landseer. He was popular in England, exhibiting regularly at the Royal Academy and the British Institution after the mid-1840s. Given his training, which was based in Düsseldorf but extended to Venice, Rome, and Paris, it is difficult to isolate a particularly "German" interpretation of his animal subjects, nor do they, beyond a superficial level, suggest a direct influence from Landseer. Other parallels were drawn by contemporary critics, the most illustrious comparison being with Franz Krüger (1797–1857),[78] professor at the Berlin Academy and court painter to the Kaiser. In its anecdotal quality, *Krüger's Dogs* (fig. 44) is reminiscent of Queen Victoria's dogs (no. 103), although for all its charm and elegance, it still remains within the restraints of pure observation, without the interpretive and characterizing features that distinguish the English painting.

Hunt subjects were then particularly popular in German painting, much more so even than in France.[79] Several artists working in this genre have been mentioned in connection with Landseer: Carl Steffeck (1818–1896),[80] who settled in Königsberg and whose *Dogs in the Antechamber* Duranty found reminiscent of (although inferior to) Landseer when it was shown in Paris in 1855;[81] and, from a later generation, Johann Christian Kröner (1838–1911),[82] a Düsseldorf painter of hunts and landscapes, and Carl Friedrich Deiker (1836–1892),[83] active in Karlsruhe and later Düsseldorf. From Munich, Atkinson noted Ludwig Voltz (1825–1911), Anton Braith (1836–1905), and Hermann Baisch (1846–1894) as competent artists in this idiom which, at least in that city, had not "proved so high in vocation as Landseer in England."[84]

In short, the appetite and the appreciation for Landseer was drawn, in part, from a shared interest in subjects, but there was little of the kind of direct influence that affected English/German artistic interaction in other areas.[85] That this was not restricted only to the animal and hunt subjects is suggested by the occurrence

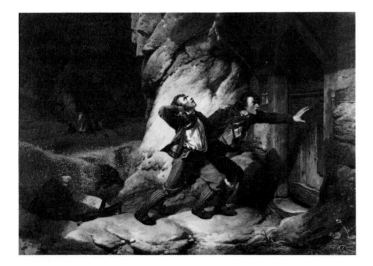

45. Carl Hübner (German, 1814–1879)
The Poachers, 1846
Oil on canvas, 37⅜ x 53⅜"
Kunstmuseum, Düsseldorf

of stalker and poacher subjects as illustrated by Carl Hübner's *Poachers* of 1846 (fig. 45),[86] which, while much more pointed in its social criticism than the work of Landseer, suggests the open receptivity which one of Landseer's treatments of these subjects (no. 35) was given when it was purchased by the Hamburg collector G. C. Schwabe sometime before 1886.

"Yet what a pity that, instead of using the pen, they have determined to employ the pencil," concluded Hippolyte Taine in his chapter on English painting and painters:[87]

> English painters have an affinity to the Dutch masters in some external particulars, by the small size of their canvases, by the choice of their subjects, by the taste for reality, by the exactness and minute treatment of details. But the spirit has changed, and their painting is no longer picturesque. Compare, for example, the animals of Potter with the carefully wrought and studied animals of Landseer, more particularly his deer and his dogs. The English painter does not love the animal for its own sake, as a living creature, nor yet on account of its form standing out in relief, or of its coloured shape harmonising with the surroundings; he looks deeper, he has meditated, and he refines. He humanises his animals; he has philosophic, moral, and sentimental ends in view. He desires to suggest a reflection; he acts the part of a fabulist. His painted scene is a species of enigma, of which the key is written below.[88]

This is an area reserved for literature, that art at which England excels but whose painters are so much more restricted, "a gnarled and stunted branch of the Flemish school."[89]

At a critical level abroad, Landseer would, even with occasional rushes of enthusiasm, present a nearly insurmountable aesthetic dilemma. That this artist of immense popularity and fame—a fame that spread throughout Europe—was an animal painter, which, for all but the most progressive critics on the Continent, was a 'minor genre within the established hierarchy of subjects, caused great consternation. Added to this was a frequent dissatisfaction with the way Landseer painted. Blunted by a foreknowledge of his compositions through engravings, the confrontation with actual works often came as a shock: the speed of execution, the restricted palette, the rapid working wet-in-wet, and the opaque glazes (Mantz's "gris poudre") were for many simply bad painting, ill trained and poorly controlled.

That a painter so far from the grand manner, both in his choice of subject and in his execution, should reach such critical heights in his own country could only have added to the perplexity abroad. How Ruskin, albeit before his radical shift in attitude toward the artist, could praise *The Old Shepherd's Chief Mourner* (no. 66)

as "one of the most perfect poems or pictures . . . which modern times have seen," showing a complete absence of concern with the separation of art and literature,[90] was beyond foreign comprehension. And the worldly, if sometimes giddy, Mrs. Jameson saying that Landseer was "the painter of life in every form, as dexterous and as accomplished in the use of his materials as Rubens himself,"[91] was certainly imponderable to many foreign ears.

Some, particularly the Germans, less concerned as they were with hierarchical notions of art, were more receptive; it is not surprising that Waagen, of all the foreign critics, came closest to understanding the extension within the artist's work from "mere" animal painting into the broader tradition of subject narrative—with all of its allegorical and poetical associations. It is a fundamental dilemma and one that richly illuminates the broader question of foreign attitudes toward English art in general. An absence of clear departmentalization was indeed one of the most distinguishing features of English artistic attitudes during much of the nineteenth century. Wilkie noted on his first trip abroad the striking absence in foreign collections of a mixture of the old and new, a frequent occurrence in England.[92] This was the very aspect of English taste that so sharpened Charles Blanc's ire at the 1857 Manchester exhibition. There was not yet in London a Luxembourg in which new works could be distanced from old, and while it would be wrong to press the point, an absence of hierarchical values—established both within a historical perspective and within the departmentalization of contemporary subjects—was equally noteworthy in the makeup of the Royal Academy compared to the equivalent body in Paris. All of this suggests a freedom from hierarchical categorization in London, where a more liberal, some would have argued, less disciplined, set of values held forth.

Many of the opinions of the foreign critics stood behind the shift in attitude that caused the decline in Landseer's reputation in our century. The fabulist voice of this "singer of ballads and teller of tales," so attuned to the desires of his own time, was silenced by more abstracted and idealized notions of the purpose of art. Through a reformation of taste and aesthetics by the early twentieth century, we had come to want a more universal attitude in painting, less merged with its subject. It is hoped that, in attempting to blur the severely defined line between the literary and the painted, to read Landseer's pictures anew without an overly sharp concern for a move into sentiment, we will be able to reestablish some of the pleasure and poetic insight so clearly felt by Gautier in his observation that, fundamentally, Landseer's art, with all its engaging narrative and breadth of vision, is not that of a "materialist" but rather, of a "spiritualist."

Joseph Rishel

Notes

1. Frederick W. Keyl's Papers, Royal Archives, London.

2. Jacques Desrosiers, "David Wilkie (Quelques extraits de sa correspondance)," *Gazette des Beaux-Arts*, 11th year, 2d ser., vol. 2 (1869), p. 242.

3. Paris, Palais des Beaux-Arts, *Exposition Universelle des Beaux-Arts [Salon de 1855]* (May 15–October 31, 1855), pp. 85–121.

4. *Ibid.*, pp. 98, 128–40. The paintings shown were *Islay et Macaw* [no. 103]; *Singes brésiliens* [no. 108]; *The Sanctuary* [no. 121]; *Animaux à la forge* [no. 134]; *Jack en faction* [no. 62]; *Le Déjeuner (Montagnes d'Ecosse)*; *Les Conducteurs de bestiaux (Montagnes d'Ecosse)* [no. 41]; *Le Bélier à l'attache*; and *Chiens au coin du feu*.

5. The awards were announced officially on the front page of the *Moniteur Universelle* (Paris), November 16, 1855.

6. Ruskin, 1903–12, vol. 3, p. 223.

7. *See*, for example, Charles Robert Leslie, *Autobiographical Recollections*, ed. Tom Taylor (London, 1860), vol. 1, pp. 38–39.

8. Benjamin Robert Haydon, *The Autobiography and Memoirs of Benjamin Robert Haydon (1786–1846)*, ed. Tom Taylor, new ed. (New York, [1926]), vol. 1, pp. 247–48.

9. John Landseer, *A Descriptive, Explanatory, and Critical Catalogue of Fifty of the Earliest Pictures Contained in the National Gallery of Great Britain* (London, 1834).

10. Svetlana Alpers, *The Decoration of the Torre de la Parada* (London, 1971), p. 144, fig. 13.

11. *See* Alfred Hentzen, "Abraham Hondius," *Jahrbuch der Hamburger Kunstsammlungen*, vol. 8 (1963), pp. 33–56.

12. Antwerp, Museum Mayer van den Bergh, *Catalogus I: Schilderijen, Verluchte, Handschriften, Tekeningen* (Antwerp, 1960), p. 73, no. 921.

13. *See* Château-Thierry, Musée Jean de La Fontaine, *Autòur de Jean de La Fontaine* (Château-Thierry, 1960).

14. Joost van den Vondel, *Vorstelijke Warande der Dieren* (1617; reprint, Soest [Netherlands], 1974), no. 51. I am grateful to Peter Sutton for bringing this illustration to my attention.

15. Waagen, 1854–57, vol. 2, p. 185.

16. Algernon Graves in his index to Waagen noted, for example, some 49 works by Snyders in English public and private collections. *See* Graves, *Summary of and Index to Waagen* (1912; reprint, London, 1970), pp. 198–99.

17. The picture is now in the National Gallery, London, where it is catalogued as a copy. *See* London, National Gallery, *The Flemish School: circa 1600–circa 1900* (London, 1970), pp. 230–33, no. 279.

18. W. Thoré-Bürger, "Exposition Générale des Beaux-Arts à Bruxelles," *Gazette des Beaux-Arts*, 2d year, vol. 8 (1860), p. 93.

19. John Forster, a friend of Landseer, stated that the artist was in Paris for the award ceremony in 1855 and that Landseer's "praise of Horace Vernet was nothing short of rapture." *See* Forster, *The Life of Charles Dickens*, new ed. (London, 1966), vol. 2, p. 435, no. 105.

20. Several of Landseer's travel sketches are illustrated in Monkhouse, 1879, pp. 90–102.

21. Edmond and Jules de Goncourt, *Journal: Mémoires de la vie littéraire, 1851–1863* (Paris, 1956), vol. 1, p. 568.

22. *Ibid.*, p. 500.

23. "Art Publications," *Art Journal* (1875), p. 31.

24. Duranty, "Exposition Universelle: Les Écoles étrangères de peinture—Belgique et Angleterre," *Gazette des Beaux-Arts*, 20th year, 2d ser., vol. 18 (1878), p. 298.

25. Charles Baudelaire, *Oeuvres complètes* (Paris, 1961), p. 695.

26. Théophile Gautier, *Les Beaux-Arts en Europe—1855* (Paris, 1855), vol. 1, pp. 72–77.

27. "French Criticism of English Art," *Art Journal* (1855), p. 281.

28. *Ibid.*, p. 299.

29. Maxime du Camp, *Les Beaux-Arts à l'Exposition Universelle de 1855* (Paris, 1855), pp. 310, 311–12.

30. Charles Blanc, *Les Trésors de l'art à Manchester* (Paris, 1857), p. 122.

31. W. Thoré-Bürger, *Trésors d'art en Angleterre*, 3rd ed. (Paris, 1865), pp. 432–33.

32. Thoré-Bürger, "Exposition Générale," p. 93.

33. Paul Mantz, "Artistes anglais: James Ward," *Gazette des Beaux-Arts*, 2d year, vol. 5 (1860), p. 172.

34. Paul Mantz, "Exposition de Londres: Peinture et sculpture," *Gazette des Beaux-Arts*, 4th year, vol. 13 (1862), p. 221.

35. Philippe Burty, "L'Exhibition de la Royal-Academy," *Gazette des Beaux-Arts*, 8th year, vol. 21 (1866), p. 92.

36. Philippe Burty, "Exposition de la Royal Academy," *Gazette des Beaux-Arts*, 11th year, 2d ser., vol. 2 (1869), p. 58.

37. Paris, Exposition Universelle 1867, *Catalogue of the British Section . . .* (London, 1868), part 2, p. 32, no. 59. For engravings and prints after Landseer, *see* p. 56, nos. 4a, 4e; p. 57, nos. 12, 12a, 12b, 12c.

38. John Dubouloz, "Lettres anglaises," *Gazette des Beaux-Arts*, 16th year, 2d ser., vol. 10 (1874), p. 175.

39. Paris, Champ de Mars, *Exposition Universelle Internationale 1878: Catalogue officiel* (1878), vol. 1, p. 175, nos. 126–31.

40. Duranty, "Exposition Universelle: Belgique et Angleterre," p. 303.

41. Hippolyte Taine, *Notes on England*, trans. W. F. Rae (New York, 1872), pp. 333–34.

42. Ernest Chesneau, *Le Peinture anglaise* (Paris, 1882), p. 177.

43. Charles Moreau-Vauthier, *Les Chefs-d'oeuvre des grands maîtres*, n.s. (Paris, n.d.), n.p.

44. Quoted in Charles Clément, "Géricault," *Gazette des Beaux-Arts*, 9th year, vol. 22 (1867), p. 456.

45. This tenuous but tempting relationship between Delacroix and Landseer prompted the organizers of the 1963 Bordeaux exhibition to include *The Battle of Chevy Chase* (no. 27) with works of Bonington, Constable, and Lawrence. *See* Bordeaux, Galerie des Beaux-Arts, *Delacroix: Ses Maîtres, ses amis, ses élèves* (May 17–September 30, 1963), pp. 133–34, no. 329.

46. *See* Jeanne Doin, "Alfred de Dreux (1810–1860)," *Gazette des Beaux-Arts*, 63rd year, 5th ser., vol. 4 (1921), pp. 237–51.

47. Charles Blanc, "Nécrologie: Alfred de Dreux," *Gazette des Beaux-Arts*, 2d year, vol. 6 (1860), p. 336.

48. *Ibid.*

49. Jeanne Doin noted: "La similitude entre *Low life—High life* et *Riche et pauvre* (Salon de 1845) est flagrante." Doin, "Alfred de Dreux," p. 244.

50. *See* Paris, Grand Palais, *Le Musée du Luxembourg en 1874: Peintures* (May 31–November 18, 1974), pp. 160–61, no. 208. *See also* Cleveland, The Cleveland Museum of Art, *The Realist Tradition: French Painting and Drawing, 1830–1900* (November 12, 1980–January 18, 1981), pp. 309–10.

51. *See* Dore Ashton and Denise Browne Hare, *Rosa Bonheur: A Life and a Legend* (New York, 1981).

52. The picture *A Stray Shot* (Sheffield City Art Galleries), inscribed "Étude de Sir Edwin Landseer de Madmse. Rosa Bonheur," has often led to speculation that the two artists collaborated; however, as Jeremy Maas has pointed out, the painting seems to have been an unfinished work by Landseer to which Gambart had Bonheur add the landscape. *See* Maas, *Gambart: Prince of the Victorian Art World* (London, 1975), p. 248.

53. Quoted in *ibid.*, pp. 74–75.

54. For a summary of this criticism, *see* Ashton and Hare, pp. 162, 193.

55. *Ibid.*, p. 113.

56. Quoted in Theodore Stanton, ed., *Reminiscences of Rosa Bonheur* (New York, 1910), p. 136.

57. Ruskin, 1903–12, vol. 34, p. 641.

58. *See* M. de Saint-Santin, "J.-R. Brascassat," *Gazette des Beaux-Arts*, 10th year, vol. 24 (1868), p. 578.

59. *See* Dewey Mosby, *Alexandre-Gabriel Decamps* (New York, 1977), vol. 1, p. 67. That Landseer may have been interested in the work of Decamps is suggested by the rather enigmatic letter to Landseer from the dealer Leave de Conches describing Decamps's *Turkish Patron*, then for sale (now Metropolitan Museum of Art, New York). *See* "Mouvement des arts et de la curiosité: Vente de tableaux modernes," *Gazette des Beaux-Arts*, 3rd year, vol. 9 (1861), p. 370.

60. For example, after seeing a Landseer sculpture at the Academy in 1866, Philippe Burty wrote: "Landseer, avec un aplomb imperturbable, a exposé un épisode de chasse vraiment comique: un cerf en plâtre colorié, tenant tête à deux chiens en plâtre non moins coloriés, pris à mi-pattes dans une glace qui imite l'eau." Burty, "L'Exhibition de la Royal-Academy," pp. 95–96.

61. Quoted in Pierre Courthion, ed., *Courbet raconté par lui-même et par ses amis* (Geneva, 1950), vol. 2, p. 92.

62. Linda Nochlin, "Gustave Courbet's *Meeting*: A Portrait of the Artist as a Wandering Jew," *Art Bulletin*, vol. 44, no. 3 (September 1967), p. 213.

63. Courthion, ed., *Courbet raconté*, vol. 2, p. 91.

64. Quoted in Robert Fernier, *La Vie et l'oeuvre de Gustave Courbet: Catalogue raisonné* (Lausanne, 1977), vol. 1, p. 168, no. 277.

65. Courthion, ed., *Courbet raconté* (Geneva, 1948), vol. 1, p. 222.

66. *See* Maas, *Gambart*, pp. 111–12.

67. Waagen, 1854–57, vol. 3, p. 164.

68. *Ibid.*, vol. 1, pp. 381–82.

69. *Kunstblatt* (1831), p. 368. For this reference and nn. 72 and 73 below, I am indebted to the unpublished paper of A. D. Potts, "English Romantic Art and Germany," kindly lent by Richard Ormond.

70. Johann David Passavant, *Tour of a German Artist in England. With Notices of Private Galleries, and Remarks on the State of the Art* (London, 1836), vol. 2, p. 258.

71. *Ibid.*, p. 259.

72. Carl Gustav Carus, *England und Schottland im Jahr 1844*, 2 vols. (Berlin, 1845).

73. *Ibid.*, vol. 1, p. 266.

74. J. Beavington Atkinson, "Sir Edwin Landseer," *Zeitschrift für Bildende Kunst*, vol. 10 (1875), pp. 132–33.

75. *See* Samuel Redgrave, *A Dictionary of Artists of the English School* . . . (1878; reprint, Amsterdam, 1970), s.v. "Keyl, Frederick William."

76. *See* Ulrich Thieme and Felix Becker, eds., *Allgemeines Lexikon der Bildenden Künstler von der Antike bis zur Gegenwart*, s.v. "Wolf, Joseph."

77. *Ibid.*, s.v. "Bottomley, John William." *See also* Eva Maria Krafft and Carl-Wolfgang Schümann, *Katalog der Meister des 19. Jahrhunderts in der Hamburger Kunsthalle* (Hamburg, 1969), pp. 23–24.

78. *See* Thieme and Becker, eds., *Allgemeines Lexikon*, s.v. "Krüger, Franz." *See also* Berlin (West), Staatliche Museen Preussischer Kulturbesitz, Nationalgalerie, *Verzeichnis der Gemälde und Skulpturen des 19. Jahrhunderts* (Berlin [West], 1977), pp. 211–16.

79. For a survey of German hunting imagery, *see* Fritz Skowronnek, *Die Jagd* (Bielefeld, 1901).

80. *See* Thieme and Becker, eds., *Allgemeines Lexikon*, s.v. "Steffeck, Carl Constantin Heinrich."

81. Duranty, "Exposition Universelle: Les Écoles étrangères de peinture—Allemange, Suède, Norvège, Danemark, Russie, Hollande," *Gazette des Beaux-Arts*, 20th year, 2d ser., vol. 18 (1878), p. 152.

82. *See* Thieme and Becker, eds., *Allgemeines Lexikon*, s.v. "Kröner, Christian."

83. *Ibid.*, s.v. "Deiker, Carl Friedrich."

84. J. Beavington Atkinson, *The Schools of Modern Art in Germany* (New York, 1881), p. 53.

85. *See* William Vaughan, *German Romanticism and English Art* (New Haven, 1979).

86. Düsseldorf, Kunstmuseum, *Die Düsseldorfer Malerschule* (May 13–July 8, 1979), p. 345, no. 111.

87. Taine, *Notes on England*, p. 334.

88. *Ibid.*, p. 333.

89. *Ibid.*, p. 328.

90. Ruskin, 1903–12, vol. 3, p. 88.

91. Mrs. Jameson, *Companion to the Most Celebrated Private Galleries of Art in London* . . . (London, 1844), p. xxxvi.

92. *Ibid.*, p. xxxv.

Catalogue of Works

Entries signed R.H. are the work of Robin Hamlyn; all others are by Richard Ormond.

Consult "Bibliographical Abbreviations" for full references of abbreviated citations. Unless otherwise indicated, newspapers and magazines were published in London and auction sales were held in London.

Height precedes width for all measurements.

The Youthful Prodigy, 1812-1827

THAT EDWIN LANDSEER chose to paint animals seems to have been a matter of chance and temperament. From the age of four or five he drew cows and horses and dogs, compulsively and instinctively. That led naturally to a career as an animal painter, which offered reasonable prospects of employment. While still a boy Landseer was drawing and etching farm animals for a succession of modest Essex patrons, chief among them W. W. Simpson. The barnyard scenes of violence and confrontation that he began to exhibit from 1818 grew out of his experience with farm animals. His drawings were sometimes etched by his brother Tom, notably *A French Hog* and *A British Boar* (nos. 7, 8), a Hogarthian contrast of national characteristics.

At the same time Landseer was also fascinated by wild animals, which he studied at the London menageries. He and his brother Tom collaborated on the set *Twenty Engravings of Lions, Tigers, Panthers...*, with a discursive text by their father, combining anecdotes with snippets of natural history. Landseer contributed five designs, including the frontispiece (no. 9) showing a famous lion from Senegal exhibited at the Exeter 'Change in London. Although the self-proclaimed aim of the book was to provide students with accurate studies of the animals in question, the plates, based on works by Stubbs, Rubens, Rembrandt, or Edwin Landseer himself, are often bizarre and farfetched. His brother later etched some grotesque monkey subjects under the title *Monkeyana*, in which he satirized the vices of mankind. The family's interest in natural history (Landseer's library included such works as Thomas Bell's *British Quadrupeds* and William Wood's *Zoography*) quickly burst over into fantasy and satire. Moralizing and storytelling were not in conflict with the spirit of scientific description. Landseer's superb anatomical drawings reveal how essential to his art was his knowledge of animal forms. From the beginning, it was the extraordinary naturalism of his works, quite as much as his technical facility, which so impressed his contemporaries. Such studies

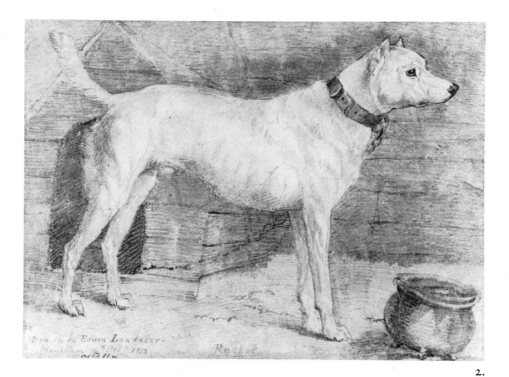

2.

THE DOG RACKET
1813
Pencil on paper, 6¼ x 9″ (16 x 23 cm)
Inscribed lower left: *Drawn by Edwin Landseer/Monkham 16th Oct^r 1813*;
center: *Racket*

Provenance: Robert Rawlinson; given to the Gallery by Miss G. H. Singers-Bigger, 1953
Exhibition: London, 1874, no. 139

2.

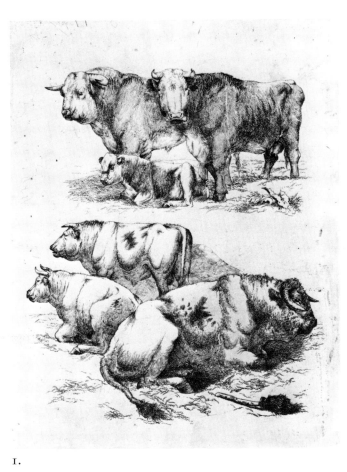

1.

gave him the assurance of a virtuoso style in which to explore his powers of imagination in painting.

It is the realm of Landseer's imagination that is most elusive. We know he read Sir Walter Scott and Lord Byron, that he was a friend of John Keats and Leigh Hunt, that he admired Henry Fuseli and William Blake, but the record of

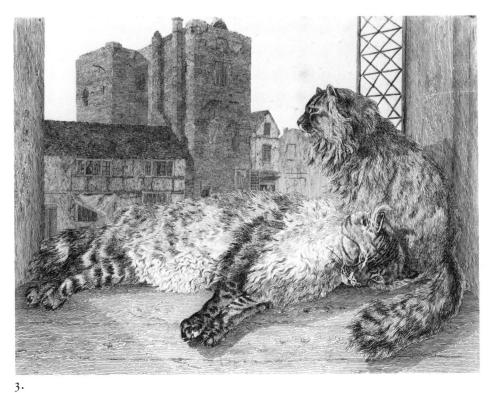

3.

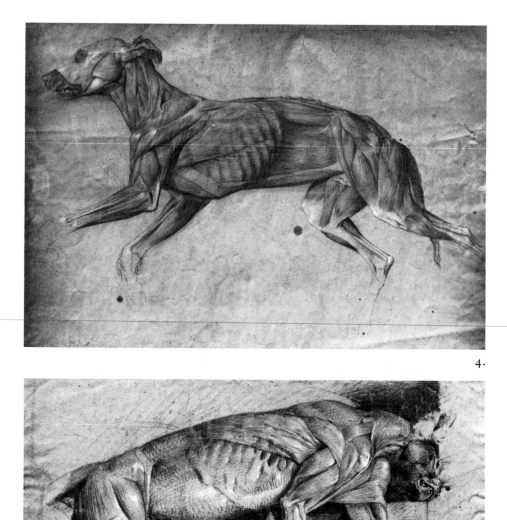

4.

4.

ECORCHÉ DRAWING OF A WHIPPET
Colored chalk on paper, 15 x 21¾"
(38 x 55.2 cm)
Provenance: Artist's sale, 1874, lot 981(?),
bt. grandfather of present owner
Exhibitions: London, 1961, no. 151;
Sheffield, 1972, no. 10
PRIVATE COLLECTION

5.

5.

ECORCHÉ DRAWING OF A CAT
1817
Colored chalk on paper, 11¼ x 18¾"
(28.6 x 47.6 cm)
Signed and dated: *E Landseer 1817/
from nature*
Provenance: Artist's sale, 1874, lot 981(?),
bt. grandfather of present owner
Exhibition: London, 1961, no. 146
PRIVATE COLLECTION

6.

ECORCHÉ DRAWING OF A HORSE'S HEAD
Colored chalk on paper, 19 x 11½"
(48.3 x 29.2 cm)
Provenance: Artist's sale, 1874, lot 981(?),
bt. grandfather of present owner
Exhibition: London, 1961, no. 149
PRIVATE COLLECTION

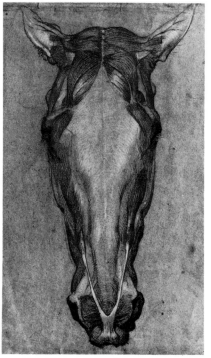

6.

his early life is so fragmentary that it is impossible to know in what context to judge such influences. He was a true romantic in his obsession with violence, his love of extremes, his combination of detail and breadth or the particular with the general, in his literary inspirations, his emotionalism, his fatalism. It was Benjamin R. Haydon, the apostle of history painting, who encouraged him to dissect animals, but who must also have imparted some of his own idealistic vision of art. Landseer's chosen field was animal painting, but within it his ambitions and expectations were pitched high. He looked to Rubens and Snyders as his mentors, and it was in the great tradition of sporting art that he conceived his major early works.

Analysis of Landseer's early style and technique remains largely speculative. What part did Haydon play in his education? How much did he learn at the Royal Academy schools? Which artists did he look at? One much-cited influence is that of James Ward, an older painter whose romantic and sometimes violent animal subjects often anticipate the themes of Landseer's early

7.

8.

works. Landseer's broad and coarse brushwork and his chalky palette recall Ward, but apart from a shared patron or two, nothing concretely links the two painters. An earlier artist whom Landseer admired was George Stubbs, whose anatomical drawings he owned, but less for the spirit of his work than for his knowledge of animals and his flawless surface textures. Among his contemporaries, Landseer's closest equivalent was John Frederick Lewis, a childhood friend and neighbor, whose work is strikingly similar in style and subject. Until he went to the Near East, Lewis was exhibiting pictures of Newfoundland dogs and Saint Bernards, lion and monkey subjects, scenes of deer hunting, gamekeepers and Highland interiors. Although Lewis painted chiefly in watercolor, his facility of hand is scarcely less remarkable than that of Landseer.

What it was that failed to satisfy Landseer in the tradition of sporting art is a more difficult question to answer. He became a storyteller, evoking in his scenes of animal life a world in which his audience could interpret their own emotions and values. That several of his early pictures should illustrate fables by Aesop and others underlines the anthropomorphic tendencies of his art. He seems to have pursued this very much on his own, for few of the many contemporary animal painters illustrated fables in the same way. Part of Landseer's success clearly lay in the novelty of his subject matter.

The enthusiastic contemporary response to his painting revealed as much about the expectations of his audience as about his own genius. The 1820s witnessed the development of popular narrative painting, in tune with the literary and historical preoccupations of the period. Such pictures appealed to the ideas, tastes, and feelings of ordinary men and women, and they opened up a new range of subjects. Like a schoolyard scene by William Mulready or an incident from Molière by Charles Robert Leslie, Landseer's pictures tell a story, communicate a drama, express a feeling; they are constructed to be carefully read and interpreted.

7.
A FRENCH HOG
Thomas Landseer after Edwin Landseer
By 1818
Etching, 12¾ x 18" (32.3 x 45.8 cm)
Literature: Graves, 1876, p. 4, no. 16
THE TRUSTEES OF THE BRITISH MUSEUM, LONDON

8.
A BRITISH BOAR
Thomas Landseer after Edwin Landseer
By 1818
Etching, 12¾ x 18" (32.3 x 45.8 cm)
Literature: Graves, 1876, p. 4, no. 18
THE TRUSTEES OF THE BRITISH MUSEUM, LONDON

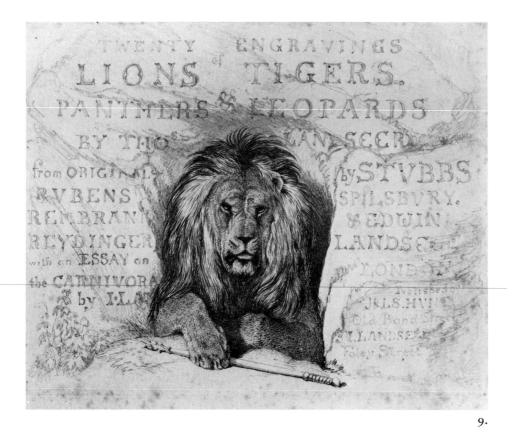

9.

9.

OLD LION NERO
Thomas Landseer after Edwin Landseer
By 1823
Frontispiece to *Twenty Engravings of Lions,
Tigers, Panthers and Leopards by Thomas
Landseer, from Originals by Stubbs, Rubens,
Spilsbury, Rembrandt, Reydinger and Edwin
Landseer, with an Essay on the Carnivora by
John Landseer* (London: J. and L. S. Hunt,
1823)
Etched proof with pencil additions, 6¾ x 8¾″
(17 x 22 cm)
Provenance: purchased from H. Graves & Co,
1897
Literature: Graves, 1876, p. 7, no. 62

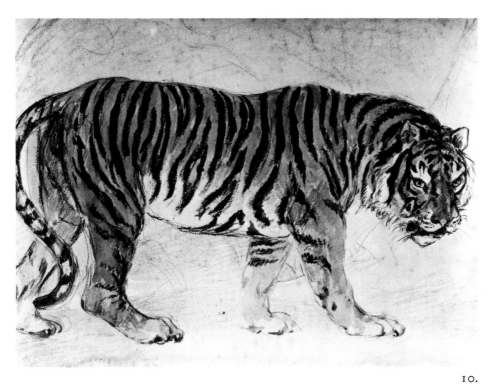

10.

10.

STUDY OF A TIGER
Watercolor on paper, 9½ x 13″ (24.1 x 33 cm)
Provenance: purchased from Algernon
Graves, 1907
Exhibitions: London, 1874(?), no. 20;
London, 1961, no. 172

Lions at a Kill

Landseer was a frequent visitor to the menageries of the Exeter 'Change and the Tower of London and was especially attracted to lions. He is known to have dissected them, but so far no anatomical studies of lions have been traced. Among his early drawings and etchings of lions is a series of plates he contributed to his brother's volume of twenty engravings of lions, tigers, panthers, etc. (*see* no. 9). One of Landseer's plates shows a lion, tiger, and leopard contending for the body of a doe, very similar in idea to this picture.

Landseer's early pictures of lions, exhibited at the Royal Academy and the British Institution, are sadly missing, for they constitute an important part of his early oeuvre. Common to all these pictures is the theme of confrontation over dead game, from which Landseer extracted the maximum dramatic possibilities. The attitude of the lions in this sketch is oddly unnatural and forced, the bared fangs rather too emphatic. The setting, too, apparently a cave, is spatially ambiguous. It is difficult to date the work with precision, but the crude and forceful brush strokes suggest a date well before 1820.

It is interesting to compare Landseer's lion subjects with those by his friend and contemporary John Frederick Lewis, which are very similar in depiction and style. In 1824 Lewis exhibited at the Royal Academy *Lion and Lioness, a Study from Nature* and in 1827 *An Eagle Disturbed at Her Prey by a Lioness*. Lions continued to hold fascination for Landseer, and his later lion subjects include *The Desert* of 1849 (Manchester City Art Gallery), the bronze sculptures in Trafalgar Square (*see* no. 150), and *The Lion and the Lamb* of 1872 (Johannesburg Art Gallery).

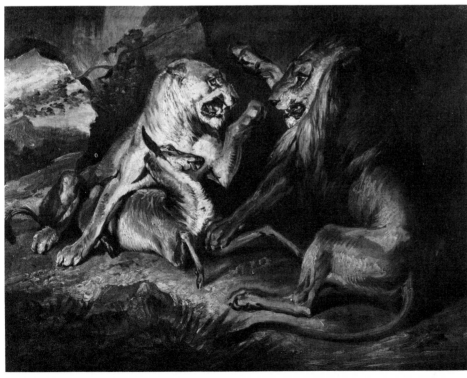

11.

11.
LIONS AT A KILL
By 1818
Oil on canvas, 13½ x 17¼" (34.3 x 43.8 cm)
Provenance: Joseph Fenton, his sale, Christie's, May 5, 1879, lot 173, bt. Hooper; Thomas Corns; his daughter, May, wife of the 1st Lord Camrose, by descent
Exhibitions: London, 1874, no. 271; London, 1961, no. 3; Sheffield, 1972, no. 4
VISCOUNT CAMROSE

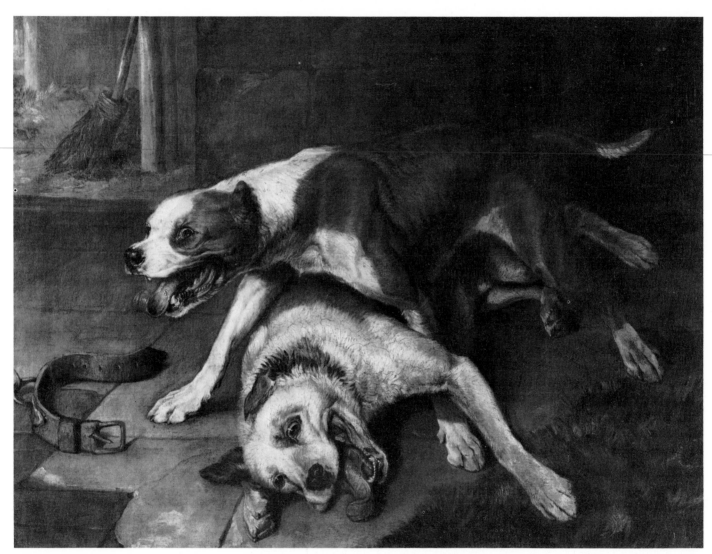

12.

Fighting Dogs Getting Wind

In this picture a mastiff-type dog, not unlike a Bullenbeisser, victoriously bestrides another dog of more nondescript breed. One of the dogs has clearly slipped his collar, shown attached to a ring on the left, no doubt to repel the intruder on his territory. The pose of the dogs is involved, the forelegs and back legs of the mastiff covering the other dog, and it suggests analogies with the famous classical statue of the two wrestlers in the Tribune in the Uffizi Gallery; this is not such a farfetched idea when one remembers the artist's involvement with the historically minded B. R. Haydon. The attitude of the underdog recalls some of Landseer's anatomical studies, and it was the knowledge gained through these that enabled him to give such convincing force to his conception of the animals. In true romantic fashion, they are depicted in terms of extreme physical effort, with tense and rippling muscles, bared teeth, panting tongues, and rolling eyes. The dogs are seen from a low viewpoint, with only the bottom of the doorframe visible, and they appear to be dramatically rolling forward out of the picture space.

The broadly impasted brush strokes and the chalky brick tones recall the work of James Ward, as does the violence of the subject. A more specific inspiration for Landseer's work may have been the painting of two terriers fighting over a piece of meat by Philip Reinagle, probably the picture exhibited at the British Institution in 1811 (28 x 35½", Sotheby's, March 19, 1978, lot 103), in which the dogs tear at each other's throats in a ferocious manner. Another famous picture of fighting dogs with two shepherd boys by Gainsborough (c. 1783) is at Kenwood, London. Landseer must also have had in mind the work of Flemish sporting artists such as Snyders, whose picture of two dogs fighting (Hermitage, Leningrad) is close in spirit.

Fighting Dogs was the first ambitious, independent sporting picture that Landseer exhibited. Admired by several fellow artists, including B. R. Haydon, John Constable, and David Wilkie, it was purchased by Sir George Beaumont, one of the great collectors and connoisseurs of the age, which sealed its success. It was Haydon who actually claimed the credit for advising Beaumont to buy the picture. Beaumont owned works by the Flemish masters and among his contemporary collection was James Ward's *Fighting Bulls* (Victoria and Albert Museum, London).

The critics, too, were impressed. Haydon's mouthpiece, the *Annals of the Fine Arts,* judged the picture to be as good as a Snyders, and the critic of the *Examiner* in 1818 wrote: "We hope that E. Landseer will not deviate from his large touch into a littleness of style. His may be called the great style of Animal Painting, as far as it relates to the execution and colour; and the natural, as far as it concerns their portraiture. Did we see only the Dog's collar, we should know that it was produced by no common hand, so good is it, and palpably true. But the gasping, and cavernous, and redly-stained mouths, the flaming eyes, the prostrate Dog and his antagonist standing exultingly over him . . . with the broad and bright relief of the objects, give a wonder-producing vitality to the canvas."

12.

FIGHTING DOGS GETTING WIND
By 1818
Oil on canvas, 29¾ x 40″ (75.6 x 101.6 cm)
Provenance: Sir George Beaumont, sold by his descendants, Sotheby's, June 30, 1948, lot 36, and November 14, 1951, lot 70
Exhibitions: London, Society of Painters in Oil and Watercolours, 1818, no. 140; London, B.I., 1819, no. 218; London, 1874, no. 422; London, 1961, no. 87; Sheffield, 1972, no. 5
Reviews: Examiner, no. 539, April 26, 1818, p. 269; *Annals of the Fine Arts for 1818,* vol. 3 (1819), pp. 162, 308; *Annals for 1819,* vol. 4 (1820), pp. 127–28, 279
Literature: Early Works, 1869, pp. 37–38; *Landseer Gallery,* 1871, p. 15; Dafforne, 1873, p. 6; Stephens, 1874, pp. 54–55; Graves, 1876, p. 5; Frith, 1887–88, vol. 3, p. 243; James Laurent Roget, *History of the Old Water-Colour Society* (London, 1891), p. 394; Manson, 1902, pp. 40–41; *Haydon Diary,* 1960–63, vol. 2, p. 466; *Constable Correspondence,* 1964, vol. 2, p. 235; Lennie, 1976, pp. 18–19, 25
Unpublished sources: Landseer's "MS list of pictures painted up to 1821" (V & A, Eng MS, 86 RR, vol. 3, no. 194)
PIERRE JEANNERAT

Alpine Mastiffs Reanimating a Distressed Traveler

The dangers of crossing the Alps had long provided a fruitful source of subject for romantic artists and writers. In his pamphlet accompanying the engraving after the picture, John Landseer, the artist's father, quoted extensively from William Brockedon's *Illustrations of Passes of the Alps* and from Samuel Rogers's poem "The Pass of the Saint Bernard."

Many legends had grown up around the great hospice almost at the summit of Saint Bernard Pass, linking Switzerland and Italy, where the monks went out of their way to assist travelers with the aid of their famous breed of Alpine mastiffs, or Saint Bernards, as they became known. The idea of serving god and man in such a remote setting held a strong appeal for the romantic imagination. And the enormous dogs, whose courage and tenacity in the service of man were proverbial, appeared as sublime philanthropists, "living life-boats," as John Landseer called them, "of those dreadful, desolate and tempestuous regions."

At the time Landseer painted the picture, Saint Bernards were a rarity in England. A few years earlier he had drawn one of the first such animals to arrive in the country (1815, Pennsylvania State University Art Gallery), and he seems to have been the only artist to exploit their pictorial potential. He had never been to Switzerland and the setting of his picture is rather theatrical and unconvincing, but the appearance of the dogs gave it enormous novelty value.

Wonderfully observed, with huge bodies and slobbering jaws, the dogs dominate the composition. They have just come upon the body of a man dressed in a green fur-lined jacket, with gloves and cap, who is buried in snow. In his pamphlet John Landseer surmised that he was a student of science, a mineralogist perhaps, who has become trapped by an avalanche while wandering in the mountains. The dogs "have evidently been for some short period of time at their work of disinterment and resuscitation: one of them is sounding forth his hoarse and solemn bark, to inform their masters that they have met with an adventure, while the other licks the hand, and steadfastly regards the eye of his patient, as the index of returning animation."

The dog on the right has a red blanket, initialed "St.B." in the corner, strapped to its body for use by victims, and a collar with signal bells, embossed

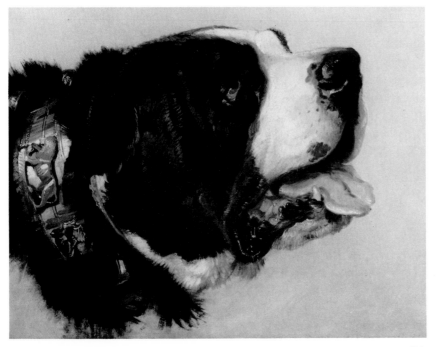

14.

13.
ALPINE MASTIFFS REANIMATING A
DISTRESSED TRAVELER
1820

Oil on canvas, 74 x 93" (188 x 236 cm)
Inscribed on reverse: *On original canvas, signed and painted in* 1820

Provenance: Jesse Watts Russell, his sale, Christie's, July 3, 1875, lot 29; Richard Peacock, his sale, Christie's, May 4, 1889, lot 65, and March 26, 1892, lot 118; Col. Ralph Peacock, his sale, Knight, Frank and Rutley, London, October 31, 1928; Wildenstein & Co., New York; Geraldine Rockefeller Dodge, her sale, Sotheby Parke-Bernet, New York, December 5, 1975, lot 54

Exhibitions: London, B.I., 1820, no. 277; Birmingham, Society of Artists, 1842, no. 250; Manchester, 1857, no. 391

Reviews: Annals of the Fine Arts for 1820, vol. 5 (1820), p. 153; *Examiner,* no. 631, January 31, 1820, p. 76, no. 642, April 16, 1820, p. 252, and no. 1253, February 5, 1832, pp. 84–85

Literature: John Landseer, "Some Account of the Dogs and of the Pass of the Great Saint Bernard, Intended to Accompany an Engraving after a Picture by Edwin Landseer, R.A. Elect (in the Collection of Jesse Watts Russell, Esq.) of Alpine Mastiffs Extricating an Overwhelmed Traveller from the Snow" (London, 1831); *Early Works,* 1869, p. 39; Stephens, 1874, pp. 59–60; Mann, 1874–77, vol. 2, p. 31; Graves, 1876, p. 6, no. 42; Monkhouse, 1879, pp. 38–39; Manson, 1902, pp. 41–42, 44; *Scott Letters,* 1932–37, vol. 6, p. 286; Jeremy Maas, "Rosa Bonheur and Sir Edwin Landseer: a Study in Mutual Admiration," *Art at Auction, the Year at Sotheby Parke Bernet,* 1975–76 (London, 1976), p. 68, repro. p. 69; Lennie, 1976, pp. 24–25

Unpublished sources: Landseer's "MS list of pictures painted up to 1821" (V & A, Eng MS, 86 RR, vol. 3, no. 194)

Prints after: engravings by John Landseer, 1831 (15⅜ x 19¾"); William Greatbach; G. S. Hunt for *Library Edition,* 1881–93, vol. 1, pl. 35 (*PSA,* 1892, vol. 1, p. 208); lithograph by G. A. Fitzwygram

Related works: replica or copy (18 x 24"), Joseph Gillott sale, Christie's, April 26, 1872, lot 223; oil sketch, *Alpine Dogs,* Christie's, February 27, 1845, lot 94; another, Artist's sale, 1874, lot 217; drawings, Artist's sale, 1874, lots 550, 747, 975

THE WARNER COLLECTION OF GULF STATES PAPER CORPORATION, TUSCALOOSA

14.

HEAD OF A SAINT BERNARD DOG FOR
"ALPINE MASTIFFS REANIMATING A
DISTRESSED TRAVELER"
By 1820

Oil on canvas, 16¾ x 20¾" (42.5 x 52.7 cm)

Provenance: Artist's sale, 1874, lot 141; J. Pierpont Morgan, his sale, Christie's, March 31, 1944, lot 78, bt. Franks; Scott & Fowles, New York, by 1951; Geraldine Rockefeller Dodge, her sale, Sotheby Parke-Bernet, New York, December 5, 1975, lot 55; M. Schweitzer, New York; Browse & Darby, London

Exhibition: London, 1874, no. 383

MARK BIRLEY, ESQ.

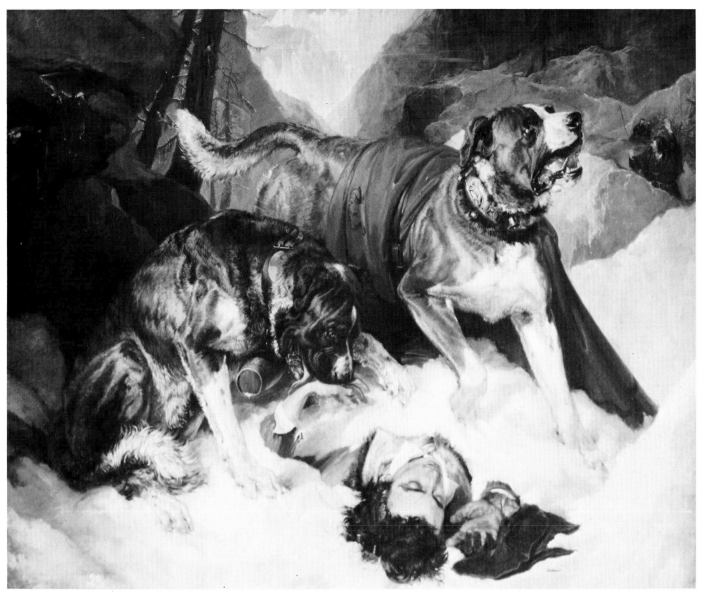

13.

with lions and sphinxes. The other dog has a small keg of brandy. John Landseer distinguished the first dog from a Saint Bernard sketched earlier by Landseer, whose name apparently was Lion. Algernon Graves called the other dog Caesar, son of Lion, but John Landseer identified it as a female dog, belonging to Landseer's fellow-artist Thomas Christmas.

In this work, Landseer's largest and most ambitious painting to date, the dogs form a monumental pyramid. The diagonal thrust of the bounding dog on the right is held in check by the rounded, static form of the other. The head of the man, seen dramatically upside down, as in mannerist art, closes the composition at the bottom, and his figure forms another diagonal line. In the background the eye is held by the yawning cleft in the mountains, representing the pass, and by the zigzag path on the right along which the monks are rushing. The color scheme is deep-toned and sonorous, with Landseer's favorite greens and reds standing out from the white snow.

The picture was well received at its 1820 exhibition at the British Institution. The *Annals of the Fine Arts for 1820* compared it to Snyders, "who never painted better than the heads of these dogs, could not have painted the dying traveller near so well, and never gave half the historical interest and elaboration to any of his pictures, unassisted by Rubens, as this possesses."

15.

Pointers

Exhibited in 1820, the same year as *Alpine Mastiffs Reanimating a Distressed Traveler* (no. 13), *Pointers* reveals Landseer as a more conventional sporting artist, in the manner of Philip Reinagle and Abraham Cooper. In 1867 Landseer's pupil Frederick W. Keyl recorded a conversation with Landseer that may shed light on the identities of these specific dogs: "He then said he had kept all sorts of Dogs—How he had two pointers . . . the best in all England—I suppose you once saw a picture I painted of them, life size, every hair was painted—Somebody gave me 60£ for it, it has been sold since I believe by Mr Flatow [for] 1200." Joseph Gillott, the Birmingham pen-nib manufacturer who owned it, had an important collection of paintings by contemporary artists.

Two pointers, favorite gun dogs with British sportsmen, are shown coming up over the edge of a bank. The significance of the three alternative titles, including *Pointers, To Ho! To Ho!*, is not clear, but "to ho" is a sporting cry used to halt the dogs. The dogs are shown in attitudes of compressed energy and excitement, necks extended, bodies low crouching and slinking forward so as not to disturb the game. They are carefully studied, with a degree of anatomical detail that surpassed Landseer's rivals, and reveal the thoroughness of his knowledge. Yet the dogs are rendered intensely alive at the same time.

The brightly lit animals are thrown into relief by the dark bank behind, with a distant view of trees and sky to the right. In the foreground are grasses, turnips, leafy fronds, and a small stream. Painted in the broad and vigorous style of Landseer's early work, the picture has considerable physical presence and dramatic power, although the surface has become somewhat flattened and shows evidence of having darkened.

15.
POINTERS (also called POINTERS, TO HO! TO HO! and TWO POINTERS IN A TURNIP FIELD, TO HO)
By 1820

Oil on canvas, 53 x 72½" (134.7 x 184.2 cm)
Provenance: Joseph Gillott, his sale, Christie's, April 26, 1872, lot 224; J. Duguid; sale, Christie's, June 9, 1877, lot 127, bt. Agnew; Lord Woolavington, by descent
Exhibitions: London, R.A., 1820, no. 406; London, B.I., 1821, no. 67; London, Society of British Artists, 1826, no. 187; London, 1874, no. 389
Review: Examiner, no. 687, March 4, 1821, p. 141
Literature: Early Works, 1869, p. 42; Stephens, 1874, p. 64; Mann, 1874–77, vol. 2, p. 105; Graves, 1876, p. 6, no. 43; Manson, 1902, p. 46; *Sporting Pictures at Lavington Park* [Collection of Lord Woolavington] (privately printed, 1927), pp. 148–49; G. Paget, *Sporting Pictures of England* (London, 1945), repro. facing p. 32; Lennie, 1976, p. 23
Unpublished sources: Frederick W. Keyl's Papers, April 9, 1867 (Royal Archives, London)
Prints after: engravings by Thomas Landseer, 1873 (23 x 32¾") (*PSA*, 1892, vol. 1, p. 379); C. A. Tomkins for *Library Edition*, 1881–93, vol. 1, pl. 93 (*PSA*, 1892, vol. 1, p. 209)
Related works: oil sketch (6¼ x 10¼"), Christie's, June 6, 1980, lot 85; pencil drawing, Monkhouse, 1879, example 4; drawings of pointers, Artist's sale, 1874, lots 377, 665–66
PRIVATE COLLECTION

16.

Rat Catchers

The rat catcher was a familiar figure in rural England, going from place to place practicing his profession as a picturesque itinerant. Although not included in Landseer's picture, he is a strongly felt presence. The dogs are his, as are the cage, the broken cart shaft for knocking the rats on the head, the leather belt decorated with a frieze of rats, the green bag, and bottle of poison.

The *Rat Catchers* is one of several barnyard scenes painted by Landseer in the early 1820s, in which animals of different species confront one another in violent situations. We see the scene, as usual, at dog's eye level, the bottom of a spade and broom giving us a measure of scale. Two rats lie dead, a third is in the cage, while the head of a fourth pokes up between the floorboards on the right, upended by the burrowing ferret. An old English rough white terrier, here a magnificently taut study of a dog in action, is poised to spring on the rat. The early type of Staffordshire bull terrier and the smaller terrier look at the ferret, focusing the attention of the viewer on this secondary point of interest.

The painting is enormously vital and dramatic, painted comparatively coarsely, in a range of rich and subdued colors. "With regard to the executive power with which he gives full effect to his science," wrote the critic of the *Examiner* in 1821, "and his strong sensibility to the peculiar looks and movements of animals, there can, or ought to be, but one opinion of admiration among Artists, and a similar opinion among unprofessional minds in relation to the sensibility alluded to." The French artist Théodore Géricault, who was then in London, was similarly impressed, writing that the picture was better than anything produced by the old masters in the same genre.

The three dogs belonged to Landseer, according to Algernon Graves. Brutus, the white terrier, features in a number of other early works, the bull terrier was Boxer, and the other dog Vixen. The rat-killing prowess of their respective dogs was a common subject of discussion among Landseer's friends.

16.
RAT CATCHERS
By 1821
Oil on panel, 11 x 15¼" (28 x 38.7 cm)
Signed on the cart shaft: *EL*
Provenance: Sir Francis Freeling(?), sale, Christie's, April 15, 1836, lot 83; Rev. Joseph Gott; the Earl of Durham; anonymous sale, Christie's, May 25, 1951, lot 88, bt. Nicholas Argenti, by descent
Exhibitions: London, R.A., 1821(?), no. 120; London, Society of British Artists, 1828(?), no. 186; London, 1874, no. 285; Newcastle, *Mining, Engineering and Industrial Exhibition,* 1887, no. 705; London, 1951, no. 139; London, 1961, no. 58; Sheffield, 1972, no. 14
Reviews: Examiner, no. 700, June 3, 1821, p. 347; *Morning Chronicle,* May 7, 1821, p. 2e
Literature: Early Works, 1869, pp. 40–42; Mann, 1874–77, vol. 2, pp. 153–54; Graves, 1876, p. 7, no. 51; *Géricault raconté par lui-même et par ses amis* (Geneva, 1947), pp. 103–4
Unpublished sources: payment for three "Rat Pictures" (£26.6.0 each) recorded in Landseer's "MS list of pictures painted up to 1821" (V & A, Eng MS, 86 RR, vol. 3, no. 194)
Prints after: engravings by Thomas Landseer, 1823 (11¼ x 15¼"); W. Roffe for *Library Edition,* 1881–93, vol. 2, pl. 78 (PSA, 1892, vol. 1, p. 209)
Related works: oil version (13¾ x 17⅛"), Christie's, January 24, 1913, lot 136; different work of same title of a rat catcher out-of-doors with his dogs, Berkeley Castle, Gloucestershire, exhibited London, R.A., 1822, no. 112; oil sketch and drawing of rat catching, Artist's sale, 1874, lots 199, 754
PRIVATE COLLECTION

17.

Arab Stallion with an Attendant

Although the early history of this picture is unknown, it may have been commissioned by the Hastings family, possibly the 16th baron. Certainly, Arab horses were popular at the time. The shah of Persia had presented a group to the Prince Regent, commemorated in a picture by H. B. Chalon of 1819 (Tate Gallery, London). Two pictures of Arab stallions in Eastern settings compare closely with Landseer's picture—*The Wellesley Gray Arabian Led Through the Desert* by James L. Agasse of c. 1810 and *Signal, a Gray Arab, with a Groom in the Desert* by David Dalby of 1829 (Paul Mellon Collection, Upperville, Virginia). Like these pictures, Landseer's is clearly a portrait of a specific horse, although the setting is imaginary. A related study for the Arab attendant suggests that Landseer painted the figure from a live model.

It is Landseer's knowledge of anatomy, coupled with his sensitive feeling for surface and texture, that distinguishes his work from that of more conventional sporting artists. It would be tempting to see a link between the spirited rendering and romantic mood of the picture and the work of French painters like Géricault, but the influence is likely to have traveled the other way, and superficial similarities should not blind one to the essentially English quality of Landseer's vision.

17.
ARAB STALLION WITH AN ATTENDANT
1824
Oil on canvas, 27½ x 35½" (69.9 x 90.2 cm)
Signed and dated lower right: *EL 1824*
Provenance: 22nd Baron Hastings, his sale, Sotheby's, February 1, 1950, lot 87; anonymous sale, Christie's, July 11, 1969, lot 123
Related works: version (same dimensions), anonymous sale, Sotheby's, March 21, 1979, lot 145, bt. Roy Miles; head of attendant (25 x 20½"), Sotheby's Belgravia, October 7, 1980, lot 170
PRIVATE COLLECTION

Sancho Panza and Dapple

Landseer's only known illustration to the Spanish seventeenth-century classic *Don Quixote*, by Cervantes, is of Sancho Panza and Dapple. His little sketch, full of character and humor, illustrates an incident in chapter 55, when Don Quixote's servant, Sancho Panza, falls into a pit with his ass: "Then taking a piece of bread out of the saddle-bag which had shared their unfortunate fall, he gave it to his ass, who did not dislike it. And his master said to him, as if he could understand: 'Bread is relief for all grief.'" *Don Quixote* was a popular source for literary subject painters in the early nineteenth century; apart from this Landseer, John Sheepshanks owned three *Don Quixote* subjects by Charles Robert Leslie.

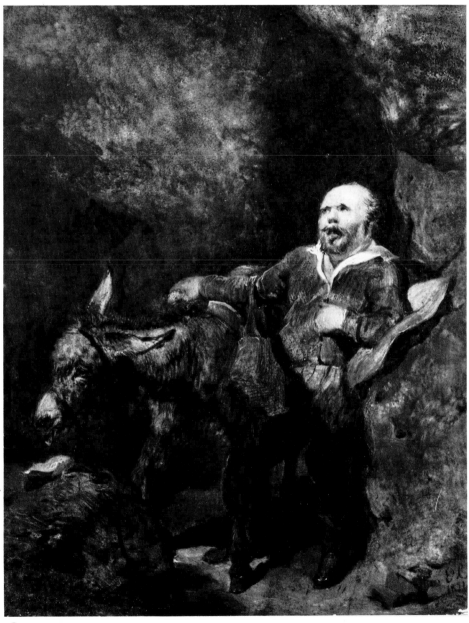

18.

18.
SANCHO PANZA AND DAPPLE
1824
Oil on panel, 7¾ x 6⅛" (19.7 x 15.6 cm)
Signed and dated lower right: *EL/1824*
Provenance: John Sheepshanks Bequest to the Museum, 1857
Literature: V & A Catalogues, 1857, p. 16, no. 96, 1877, p. 62, 1893, p. 85, 1907, p. 77; Mann, 1874–77, vol. 3, p. 168a; Graves, 1876, p. 9; *Art Journal* (1877), p. 304; Manson, 1902, p. 53
Prints after: engraving by C. G. Lewis for *Art Journal* (1877), pl. 23

VICTORIA AND ALBERT MUSEUM, LONDON

The Cat's Paw

One of Landseer's best known and most controversial paintings, *The Cat's Paw* attracted immediate attention when it was first exhibited, and it has continued to shock people ever since. Cited as an example of the sadistic streak in Landseer's imagination, it has been criticized for its anthropomorphic qualities and mawkish humor. Landseer was a fabulist, and it was natural that he should turn to authors like Aesop and La Fontaine as a source for subjects. La Fontaine's fable "The Monkey and the Cat" (book 9, no. 17) scarcely provides justification for the extreme violence of Landseer's picture. In the fable the monkey simply persuades the cat to reach the chestnuts off the stove, hence the saying "cat's paw" for someone who is used as a tool by another person.

Landseer's picture takes place in the ironing room of a well-to-do house. The monkey, a rhesus macaque, dangling his chain behind him, has evidently escaped and appears to have entered the room by way of the window, where the curtains are blowing about. Accessories are used to elucidate the sequence of events leading up to the fearful denouement: an overturned flowerpot on the ironing board, crumpled blankets, a spilled coal bucket, a broken plate with a piece of lemon peel under the stool, a disordered clothes basket with bits of wicker torn out, terrified and hissing kittens, the tablecloth wrapped around the cat itself.

The effect of disarray, indicating a violent chase and struggle, is accentuated by the steeply receding perspective and the dramatic diagonal lines of the composition. The square stove, with its circular base, is the anchor of the design. In the center of the picture the monkey holds the cat in an implacable and merciless grip, more suggestive of rape than ordinary assault, and forces its paw onto the red-hot stove to remove the chestnuts, several of which already lie on the floor. Some critics admired the twisted and agonized attitude of the cat—certainly one of Landseer's most extraordinary creations—while others found it unnatural. Naturalism, however, was scarcely Landseer's point here.

The picture continues the theme of animal confrontation and cruelty in fable form. Landseer must have known the monkey pictures by David Teniers and his school, and there are precedents for the design in a picture by Abraham Hondius (fig. 33) and an etching by the English seventeenth-century sporting artist Francis Barlow in his *Various Birds and Beasts* (1664). With its cabinet-size format and careful attention to detail, the picture is conceived very much in the spirit of Dutch and Flemish painting. And the fact that its cruel aspects attracted less attention from nineteenth-century critics than subsequent ones suggests that people then were a good deal less squeamish. In 1824 the reviewer of the *Examiner* wrote: "For it has not only all that is valuable in execution, but all that is exciting to our attention or our feelings in animal expression—a rare union. Its concord, solidity, and richness of chiaroscuro and of colour, would become even a higher class of Painting, and, were there no other merits, would render it highly attractive . . . the cream in the rich draught of graphic pleasure here presented to us . . . indubitably prove that the Painter is a pictorial Shakespeare of animal expression."

The picture appears in the background of a painting done twenty years later by Augustus Leopold Egg, *Scene from "Le Diable Boiteux"* (1844, Tate Gallery, London), also from the collection of the Earl of Essex.

19.

THE CAT'S PAW
By 1824
Oil on panel, 29¾ x 27½" (75.6 x 69.8 cm)
Provenance: the 5th Earl of Essex, Essex sale, Christie's, July 27, 1893, lot 44; Sir Bruce Seton, his sale, Christie's, March 2, 1912, lot 112, bt. Agnew; Sir Jeremiah Colman, his sale, Christie's, September 18, 1942, lot 87; R. W. Lloyd; anonymous sale, Sotheby's, November 5, 1974, lot 156; Oscar and Peter Johnston, London
Exhibitions: London, B.I., 1824, no. 185; Manchester, 1857, no. 379; London, 1874, no. 281; London, R.A., *Old Masters*, 1906, no. 50; London, 1961, no. 37
Reviews: Examiner, no. 839, January 29, 1824, pp. 139–40; *Somerset House Gazette* (London), vol. 1 (1824), p. 275; V & A Press Cuttings, vol. 5, pp. 1344, 1363
Literature: Early Works, 1869, pp. 44–46, pl. 1; *Landseer Gallery*, 1871, pl. 1; Stephens, 1874, pp. 66–69, 72, 74, pl. 2; Mann, 1874–77, vol. 1, p. 95; Graves, 1876, p. 9, no. 90; *Landseer Gallery*, 1878, pl. 2; Monkhouse, 1879, pp. 46–47; *Portfolio* (1885), p. 34; Manson, 1902, pp. 50–51; Boase, 1959, p. 167; *Haydon Diary*, 1960–63, vol. 2, p. 466; Lennie, 1976, pp. 31, 34, 42
Prints after: engravings by Robert Graves for *Forget-Me-Not* (London, 1830); C. G. Lewis, 1846 (25⅝ x 21¾"); C. J. Tomkins for *Library Edition*, 1881–93, vol. 1, pl. 4 (PSA, 1892, vol. 1, p. 208)
Related works: oil sketch, Artist's sale, 1874, lot 286, bt. Agnew; oil sketch of monkey's head (8" diameter), Christie's, March 25, 1979, lot 250; pen and ink drawing for composition, *Art Journal* (1875), repro. p. 289; pen and ink drawing of monkeys, V & A (PD 7350); pencil drawing, Artist's sale, 1874, lot 790; another (7¼ x 9¼"), formerly with Alister Matthews, Poole

DR. ROGER L. ANDERSON

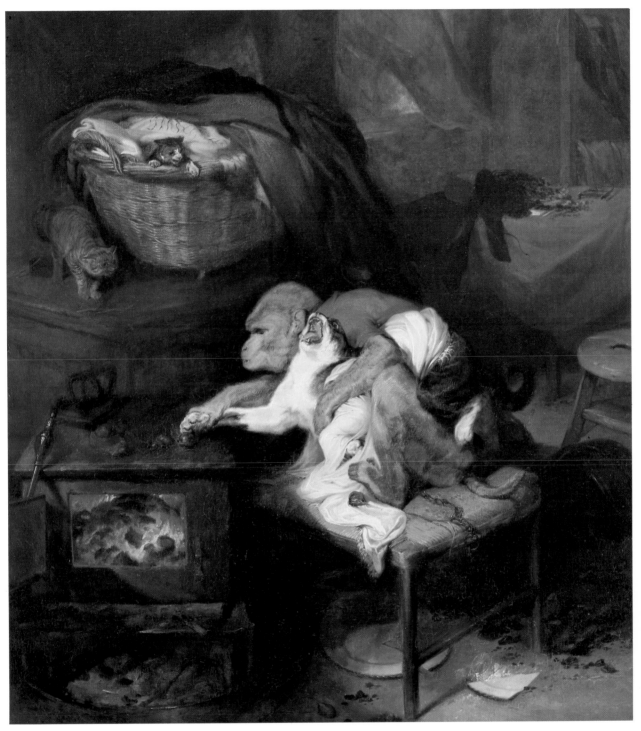

19.

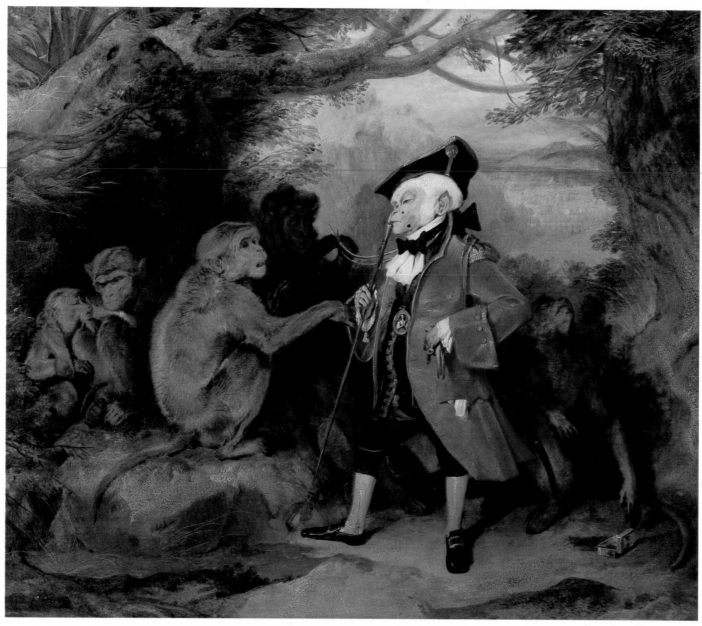

20.

The Monkey Who Had Seen the World

John Gay's fable tells the story of a monkey who travels to "bring politer manners home," is captured, serves a lady, becomes refined, and then escapes to join his fellows:

> The hairy sylvans round him press,
> Astonish'd at his strut and dress.
> Some praise his sleeve; and others glote
> Upon his rich embroider'd coat;
> His dapper periwig commending,
> With the black tail behind depending;
> His powder'd back, above, below,
> Like hoary frost, or fleecy snow.

In the tale from *Fables* the monkey goes on to recommend flattery, malice, wit, and scandal as a recipe for worldly success.

Landseer turned freely to fable as a source for his anthropomorphic subjects. Monkeys, long symbols of folly, cruelty, cunning, vice, and perverseness, had an especial attraction for him. Among his early monkey pictures are *The Dancing Lesson* (c. 1821, location unknown) in which an entertainer with a whip forces a monkey and a poodle to dance, *Impertinent Puppies Dismissed by a Monkey* (c. 1821, Christie's, February 13, 1976, lot 102), and *The Cat's Paw* (no. 19).

Monkeys were, of course, a common sight in England at this time, at fairs, in the street, and as pets. Their mimicry of man, in an age when the animal hierarchy was being questioned, had a decided irony. Even before Darwin, evolutionists were making the link between monkeys and man, to the horror of theologians and others. The oddities of animal behavior always delighted Landseer, especially when a human angle could be given. He and his brothers all studied monkeys, and Tom produced a humorous and satirical book of prints on the subject, *Monkeyana, or Men in Miniature* (London, 1827).

Inspired by an eighteenth-century literary source, Landseer's picture is painted, appropriately enough, in the spirit of rococo art. The hero of the fable is dressed in elegant eighteenth-century costume, with a cockaded hat and tiewig, cravat and bow tie, gloves and cane, and a miniature of his mistress hung on a ribbon. The gold epaulets suggest that the costume is a form of livery. Most of the monkeys are rhesus macaques, although the one in the background is closer to a brown capuchin, and the one on the right, taking snuff and about to sneeze, looks like a kind of baboon. The trees provide a framing device, isolating the central monkey against a distant view of the city, from which he has evidently traveled to join his friends. Painted in Landseer's most witty and sparkling style, the picture glows with color.

The work appeared to generally favorable reviews after its exhibition at the Royal Academy in 1827. The critic of the *Examiner* commented that it "has the Artist's vigorous hand in animal painting, and is admirable in its tricking the monkey out in the externals of beauism, which his beastly brethren are amazedly admiring."

20.

THE MONKEY WHO HAD SEEN THE WORLD (also called THE TRAVELED MONKEY)
By 1827
Oil on panel, 18½ x 21½" (47 x 54.6 cm)
Provenance: Gen. Sir Henry Bunbury, 7th Bart.; Thomas Baring, M.P.; Thomas Baring, 2nd Baron and 1st Earl of Northbrook; Charles Gassiot, his bequest to the Corporation of London, 1902
Exhibitions: London, R.A., 1827, no. 128; London, 1874, no. 369; Philadelphia, International Exhibition, 1876, no. 86
Reviews: Examiner, no. 1010, June 10, 1827, p. 357; *The Times,* May 5, 1827, p. 5e; V & A Press Cuttings, vol. 5, p. 1497
Literature: Waagen, 1854–57, vol. 2, p. 190; *Early Works,* 1869, p. 49; Stephens, 1874, p. 79; Mann, 1874–77, vol. 1, p. 117; Graves, 1876, p. 12, no. 131; Manson, 1902, pp. 65–66; *Catalogue of Works of Art Belonging to the Corporation of London* (London, 1910), p. 232, no. 690; Whitley, 1930, p. 129; Lennie, 1976, p. 42
Prints after: engravings by B. P. Gibbon for *The Anniversary* (London, 1828); A. W. or T. W. Huffam, 1859 (13⅜ x 15¾") (*PSA,* 1892, vol. 1, p. 382); J. C. Webb for *Library Edition,* 1881–93, vol. 1, pl. 95 (*PSA,* 1892, vol. 1, p. 209)
GUILDHALL ART GALLERY, LONDON

In the Highlands, 1824-1837

LANDSEER'S FIRST VISIT to Scotland in 1824 overwhelmed him. He was intoxicated by the scenery of the Highlands, its picturesque inhabitants, and the pleasures and excitements of deer hunting. He tramped up the glens, he drew the deer and the ghillies, attendants to chieftains or hunters, he painted ravishing landscape sketches, and his imagination burgeoned with ideas for hunting subjects and groups. He returned to Scotland every autumn, and from then on Scottish subjects dominated his oeuvre.

Landseer's first two large Highland subjects were both hunting scenes, painted for aristocratic patrons. *The Hunting of Chevy Chase* (no. 23) vividly recreates history of the borders between England and Scotland and *Death of the Stag in Glen Tilt* (no. 30) portrays a more conventional portrait group; on the one hand, historical romance, on the other, Highland sport in a contemporary setting. Both pictures appear to have been begun during or soon after Landseer's first visit to Scotland and they complement one another. The inspiration behind *Chevy Chase* came from the great hunting pictures by Rubens and Snyders. Here for the first time Landseer worked out a major picture with men and animals. The composition of the painting, with its subtle textures and transparent glazes, reflects Flemish influence and shows how far Landseer's technique had developed from the relatively coarse touch of *Fighting Dogs* (no. 12).

Landseer was one of the first artists to give visual expression to the romantic view of the Highlands, which still affects our attitudes today. At the time that he was painting, it was just becoming fashionable for wealthy and aristocratic Englishmen, such as his patron the Duke of Bedford, to take a hunting lodge for the autumn season. Sportsmen had been traveling north of the Scottish border in search of game from much earlier times, but the growing popularity of the Highlands as a place to relax sprang from a more general appreciation of its wild and sublime beauty. With the coming of the railways, the passion for Scotland would turn into a tourist boom. Fed on the novels of Sir Walter Scott, Englishmen came looking for the romantic way of life about which they had read. It is doubtful that many of them recognized the profound changes that were taking place in Highland society. There were still clans and chieftains, picturesquely dressed ghillies and crofters, or tenant farmers, and the appearance of age-old traditions. One read Scott and looked about, and the old Highland spirit, like its scenery, appeared unchanging. In fact, the coming of sheep, like the coming of sportsmen, had already led to enclosures and clearances to provide extensive tracts of country for grazing. The old clan system was falling apart. The chiefs were no longer leaders of their people but functioned as landlords intent upon exploiting their often impoverished estates. And the application of economic principles meant the displacement of unprotected tenants in favor of sheep runs and deer forests. The result was large-scale exodus of Highlanders, mass emigration abroad, and poverty for those who remained. This did not happen all at once and effects varied greatly from region to region, but the clearances left an indelible psychological scar.

It was not until later in the century that the impact of the clearances sank in and inspired a number of pictures like Thomas Faed's *The Last of the Clan*, of 1865 (private collection). Certainly in the 1820s it was not impossible to overlook what was happening, and there is little hint of economic or political comment in Landseer's pictures. On the other hand, Landseer was keenly perceptive of the poverty and hardship suffered by many of the resilient

characters he admired so much. His interiors paint a stark picture of living conditions in the crofts, or tenant farms, and the acuteness of his observation endows the simplest accessories with a telling sympathy. Long before the great realist painters like Courbet, Landseer used the grueling activity of stone breaking as a symbol of the soul-destroying effects of manual labor. No less powerful are his pictures of whisky distilling and poaching, illegal activities that flourished in such a deprived society. Such illicitness no doubt contributed to the romantic image of Highland life in the minds of outsiders. However dramatic the settings in which they appear, Landseer's poachers are seen as desperadoes, without property or place, amoral, cunning, and untamed.

Scenes of Highland life, as opposed to landscapes, are relatively rare before Landseer's time. In the wake of Scott's success one might expect to find a host of such subjects, but lists of pictures exhibited in the 1820s reveal relatively few. In many ways Landseer was breaking new ground and making, rather than following, a movement. His most significant precursor was David Wilkie, who had exhibited his celebrated picture *Pitlessie Fair* (National Gallery of Scotland, Edinburgh) as early as 1805. Wilkie's Scottish interiors anticipate Landseer's in their beautifully observed effects of light, their carefully painted still-life accessories, and their debt to seventeenth-century artists like David Teniers and Pieter de Hooch. Wilkie's Scottish subjects are, however, more literary and discursive than those by Landseer. They haven't the same grittiness of subject and texture.

Scotland aroused Landseer's imagination and his feelings, but whatever his sympathies toward the plight of the Highlanders he did not seek to change it. His later Highland subjects breathe a spirit of harmony and acceptance: the drovers he depicts on their way to the southern markets are following ancient traditions of droving and the Highlanders crossing a bridge on their way back from hunting on a golden afternoon are noble and picturesque. No one was more alive to the cruelty hunters inflicted on wild animals than Landseer; there is something infinitely pathetic about his dead stags and wounded ptarmigan. But, in nature conflict and death are inevitable, and beautiful animals are hunted to satisfy the sporting instincts of man.

Sir Walter Scott

This sketch was probably executed on the artist's first visit, in 1824, to Abbotsford, Sir Walter Scott's home. In spite of Scott's frustration with the demands imposed upon him by portrait painters (he had already sat to David Wilkie, Charles Robert Leslie, and Gilbert Stuart Newton), Scott did spare Landseer some time, writing to a friend on October 6, 1824: "Since that time my block has been traced by many a brush of eminence and at this very *now* while I am writing to you Mr Landseer who has drawn every dog in the House but myself is at work upon me under all the disadvantages which my employment puts him to" (*Scott Letters*, 1932–37, vol. 8, p. 392).

Landseer's sketch shows Scott seated in an armchair, the top of his cane resting in the crook of his elbow. He looks up from his writing, as if pausing in thought. The quill is probably a piece of artistic license, because by this date Scott was using Bramah's patent steel pens. The setting appears to be largely imaginary. The leg of armor inside a niche on the left may be the so-called Maximilian-type suit of armor at Abbotsford, said to have belonged to the tallest man present at the battle of Bosworth in 1485, but, in fact, later in date. The vertical strip with a coat of arms to the right of the armor is taken from the

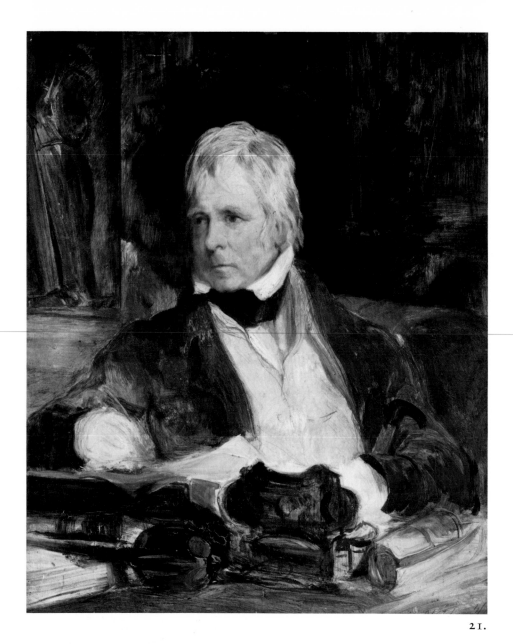

21.

SIR WALTER SCOTT
1824(?)
Oil on panel, 11½ x 9½" (29.2 x 24.2 cm)
Provenance: Artist's sale, 1874, lot 312, bt.
Agnew for Baron Albert Grant; his gift to
the Gallery, the same year
Exhibitions: London, 1874, no. 457; Kendal,
Abbot Hall Art Gallery, *Wordsworth: A
Bicentenary,* 1970, no. 53; Paris, 1972,
no. 152
Literature: Art Journal (1874), p. 191;
Manson, 1902, p. 75; *Connoisseur,* vol. 75
(1926), repro. p. 41; Lennie, 1976, p. 37;
London, National Portrait Gallery, *National
Portrait Gallery in Colour* (London, 1979),
p. 88; Richard Walker, *Catalogue of Regency
Portraits in the National Portrait Gallery*
(London, forthcoming)

NATIONAL PORTRAIT GALLERY, LONDON

21.

entrance hall at Abbotsford. The desk has not been identified but is neither the Morrut desk nor the Montrose cabinet at Abbotsford. There is a basket-hilted broadsword in front of Scott, an open inkwell, possibly identical with one shown in portraits of him by Sir William Allan and Sir John Watson Gordon, and a rolled deed or document to the right.

The portrait is painted with great dexterity and fluidity, and with the familiar juxtaposition of red and green, and it retains a quality of spontaneous life lacking in the more formal portraits of the novelist, one of the most painted men of his day. It shows Scott still at the height of his powers, before the financial disaster that darkened his last years.

Another oil sketch of Scott, probably painted at the same time as this sketch, shows him in a plaid seated beside a saddle (24 x 20", Walker Art Gallery, Liverpool) and relates more directly than this sketch to the imposing, post-humous full-length picture *Sir Walter Scott in the Rhymer's Glen* (60 x 48", exhibited London, Royal Academy, 1833, no. 351, last recorded with Knoedler, New York, c. 1930).

Portrait of Lord Cosmo Russell

Lord Cosmo Russell was the ninth son of the 6th Duke of Bedford by his second wife, Georgiana. This picture of him at the age of seven was the first of many portraits of the Russell children that Landseer painted during the 1820s and 1830s. A portrait of Lord Cosmo's younger brother Lord Alexander Russell on his pony Emerald was exhibited under the title *The First Leap* in 1829 (Guildhall Art Gallery, London), and later engraved as a companion work to this picture.

The portrait of Lord Cosmo in Highland costume conveys his youthful dash in a most feeling and romantic way. In perfect control of his spirited pony, he is every inch a duke's son. The *Examiner* in 1825 compared the portrait of him on his "bounding steed" to Velázquez, and the analogy is a good one. The famous equestrian portrait of *Don Balthazar Carlos* by Velázquez in the Prado Museum, Madrid, exhibits the same prancing movement and sense of command. The *Examiner* also praised the inclusion of the spaniel in Landseer's picture, which enhances "the fine effect of rapid motion." Even the heather seems to be swept in the same direction as the boy and the pony.

The landscape setting was the fruit of Landseer's first visit to the Highlands in 1824. There is no record of his staying at the Duke of Bedford's hunting lodge at the Doune that year, but he may well have done so. On the other hand, he may have painted Lord Cosmo in London, and fabricated the landscape from his Scottish sketches. This seems less likely, for the picture breathes the spirit of exhilaration that Landseer discovered in the Highlands. And if the landscape lacks the direct naturalism and clear tones of his landscape studies, it does convey the wildness of the country, the dramatic effects of light, and a great feeling of space.

The Duke of Bedford was pleased with the portrait, and its success may have prompted the commission for *Chevy Chase* (no. 23). On April 3, 1825, the duke wrote to the artist: "You say nothing of Lord Cosmo but I think he is gone or is going to Somerset House [the Royal Academy exhibition]." In July

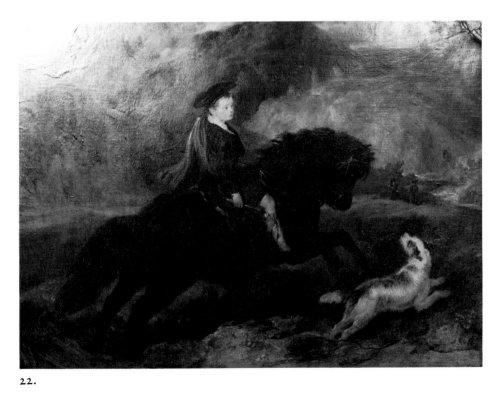

22.

22.

PORTRAIT OF LORD COSMO RUSSELL (also called LORD COSMO RUSSELL ON HIS PONY FINGALL and THE YOUNG MOUNTAINEER)
1824

Oil on panel, 17½ x 23½" (44.5 x 59.7 cm)
Provenance: the 6th Duke of Bedford; his widow, Georgiana, Duchess of Bedford; her daughter Louisa, Duchess of Abercorn, by descent
Exhibitions: London, R.A., 1825, no. 42; London, 1874, no. 290; London, 1961, no. 31
Reviews: Examiner, no. 907, June 19, 1825, p. 385; *The Times*, April 30, 1825, p. 6c
Literature: Stephens, 1874, p. 76; Mann, 1874–77, vol. 1, p. 41; Graves, 1876, p. 10, no. 99
Unpublished sources: the Duke of Bedford to Landseer, April 3, 1825, July 28, 1825, December 6, 1829 (V & A, Eng MS, 86 RR, vol. 1, nos. 23, 24, 29); long and acrimonious correspondence between Landseer and C. G. Lewis about the prints (British Library, London, Add MSS 38608, f. 35 ff.); drawn and recorded in the dressing room at Chesterfield House, 1869, by George Scharf (National Portrait Gallery Archives, London, "SSB Notebooks," vol. 83, p. 69)
Prints after: etching by Lady Elizabeth Russell, 1825; lithograph by R. J. Lane, 1832; engravings by C. G. Lewis, 1857 (PSA, 1892, vol. 1, p. 125); J. B. Pratt for *Library Edition*, 1881–93, vol. 1, pl. 83 (PSA, 1892, vol. 1, p. 208)
Related works: pencil study (5 x 7"), collection of the Duke of Abercorn; another, Artist's sale, 1874, lot 882

THE DUKE OF ABERCORN

1825 he wrote that he presumed the picture had been repainted and revarnished and asked for it to be forwarded; the nature of these early alterations is not known. In December 1829 the duke gave permission for prints of this work and the companion picture of Lord Alexander to be engraved, but there was a considerable delay before they were finished. The inordinate length of time that Charles Lewis took to finish the later prints, begun in 1850, was one of the causes of the acrimonious rift that developed between Lewis and Landseer.

The Hunting of Chevy Chase

This, the most important work inspired by Landseer's discovery of Scotland, is a history painting steeped in the wild and chivalric atmosphere of the borders between England and Scotland as well as a heroic sporting work in the seventeenth-century tradition of Peter Paul Rubens and Frans Snyders. The "Ballad of Chevy Chase," one of the best-known border ballads, was published by Thomas Percy in his *Reliques of Ancient English Poetry* (London, 1765) from a medieval manuscript. The Royal Academy catalogue for 1826, when the painting was exhibited, combined the first two lines of verses two and four from the sixteenth-century version of the ballad: "To drive the deere with hound and horse/Erle Percy took his way;/The chiefest harts in Chevy Chace/To kill and beare away." The ballad records a battle between the leaders of two great border families, proverbial enemies for many generations, the English Earl of Northumberland and the Scottish Earl Douglas. This scene is not a specific, recorded historical incident, but is typical of the constant state of armed conflict existing on the borders between England and Scotland in the later Middle Ages. According to the poem, Percy, Earl of Northumberland issued a challenge that he intended to hunt across land claimed by Douglas. The latter met him with a force of armed men, and in the ensuing battle both leaders and most of their men were killed.

In 1824 Landseer had visited Sir Walter Scott at Abbotsford in the border region, and he may have stayed at Chillingham Castle, close to the supposed scene of the battle. The picture is permeated by the romantic imagery of Scott's novels and poems, the sense of great deeds in a picturesque and highly charged atmosphere. Significantly, Landseer does not show the battle itself, nor the climax of the ballad, but the preceding hunt.

For all its martial spirit and air of impending tragedy, the picture was conceived as a sporting subject. Landseer, attracted to hunting themes long before he visited Scotland, had already exhibited, in 1821, *The Seizure of a Boar* (formerly Marquess of Lansdowne collection, Bowood, Wiltshire) and painted the oil sketch *Bull Attacked by Dogs*, 1821 (*see* fig. 30) in the same period; one of the dogs crushed by the bull directly anticipates the pose of the dog under the stag's head. A much closer parallel is the earlier *Hunting Scene* (no. 24), where the central motif of the stag and the dogs is already worked out. In comparison with *Chevy Chase*, the style of that work is coarse and consciously old masterish, and it must date from before 1820. The composition for the large *Chevy Chase* went through a further stage of refinement in the spirited color sketch (no. 25).

During the long process of the picture's gestation, Landseer enriched his vocabulary of animal forms in violent action. The individual studies of dogs, mouths gaping, bodies twisted and writhing, must have been supplied in part by the detailed anatomical drawings of his youth (*see* nos. 4–6). But the pattern of dynamic, undulating forms created by the dogs as they bring the

23.
THE HUNTING OF CHEVY CHASE
1825–26
Oil on canvas, 56¼ x 67¼" (143 x 170.8 cm)
Provenance: commissioned by the 6th Duke of Bedford; Bedford sale, Christie's, January 19, 1951, lot 186, bt. National Art-Collections Fund, presented to Birmingham, 1952
Exhibitions: London, R.A., 1826, no. 292; London, B.I., 1827, no. 36; London, 1951, no. 145; London, Tate Gallery, *The Romantic Movement*, 1959, no. 240; London, 1961, no. 76; Paris, 1972, no. 153
Reviews: Examiner, no. 955, May 21, 1826, p. 323, no. 994, February 18, 1827, p. 99; *The Times*, April 29, 1826, p. 3b
Literature: Waagen, 1854–57, vol. 3, p. 466, vol. 4, p. 332; Colnaghi and McKay, *Catalogue of Pictures . . . at Woburn Abbey* (London, 1868), no. 408; Dafforne, 1873, pp. 7–9; Stephens, 1874, pp. 77–78; Mann, 1874–77, vol. 3, p. 110; Graves, 1876, p. 11, no. 119; George Scharf, *Catalogue of the Collection of Pictures at Woburn Abbey* (London, 1877), p. 236, no. 395 (London, 1889), p. 246, no. 395; Monkhouse, 1879, pp. 61–63; Manson, 1902, pp. 56–57; Basil Taylor, *Animal Painting in England from Barlow to Landseer* (London, 1955), p. 60, pl. 63; Boase, 1959, pp. 167–68, pl. 25a; Birmingham, City Museums and Art Gallery, *Catalogue of Paintings* (Birmingham, 1960), p. 86; Lennie, 1976, pp. 40–41
Unpublished sources: the Duke of Bedford to Landseer, April 3, 1825, July 20, 1825, July 21, 1825 (V & A, Eng MS, 86 RR, vol. 1, nos. 23–25)
Prints after: etching by C. G. Lewis, 1835; engraving by C. G. Lewis for *Art Journal* (1876), pl. 10
Related works: chalk drawing, Artist's sale, 1874, lot 988; pencil drawing, Charles Landseer's sale, Christie's, April 14–17, 1880, lot 340

CITY MUSEUMS AND ART GALLERY, BIRMINGHAM

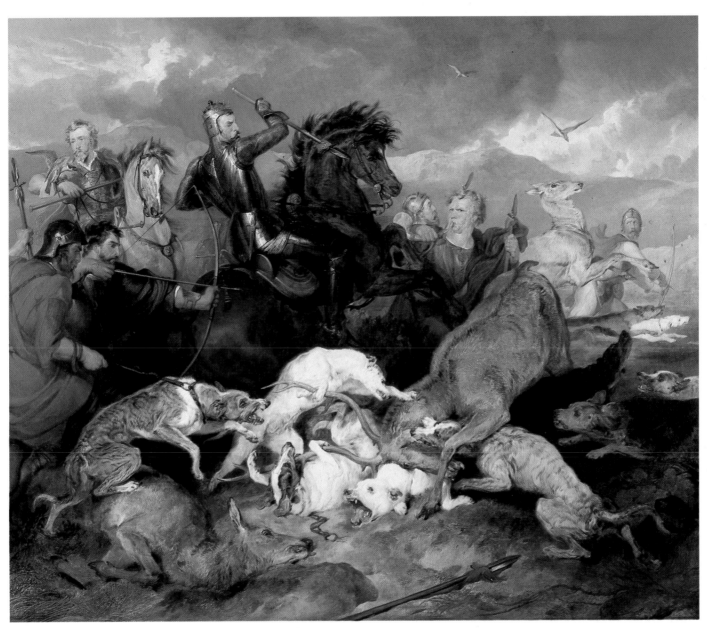

stag to bay is of fine imaginative design; the dogs on each side force the eye towards the sinuous rhythms of the central group. The reality of this cruel and violent scene is brought home powerfully by Landseer's brushwork, his sparkling and transparent effects of light, so reminiscent of Rubens, and his tactile surface texture.

The monumental composition of the picture comes out of the seventeenth-century tradition of Flemish sporting art, which was immensely popular in the romantic period. The leaping hind on the right is borrowed from Snyders's *Staghunt (see* fig. 28), versions of which were owned by the Duke of Northumberland and the Earl of Darnley. Earl Percy's rearing horse and the man with a hunting horn are adapted from Rubens's *Wild Boar Hunt,* a version of which also belonged to the Earl of Darnley. In his catalogue of the collection at Woburn Abbey, George Scharf suggested that the figure of the knight with a hawk on the left looked rather like a portrait of Rubens himself. Unlike the animals, the figures appear stilted, as if they were stock figures from a historical repertoire; they reflect Landseer's weaknesses as a figure draftsman and his lack of a strong historical imagination.

The armor is of mixed periods. Earl Percy wears a fifteenth-century cuirass over chain mail, his leg pieces are early sixteenth century with fifteenth-century toes, and his basinet with an open crown is fourteenth century. He holds a short bear spear, a cross-hilted dagger hangs from his waist, and the hilt of a sword is visible at his side. The helmet of the man on the left appears to be an imaginary fabrication, like those of the men on the right. The archer draws a longbow, a glove on his hand, a bow bracer on his wrist, with a buckler just visible at his side. The man with the horn has a crescent, the Percy badge, on his tunic.

Landseer's decision to paint a historical picture on this scale no doubt reflected in part the wishes of his patron. The Duke of Bedford commissioned several history pictures from contemporary artists, and he was always en-

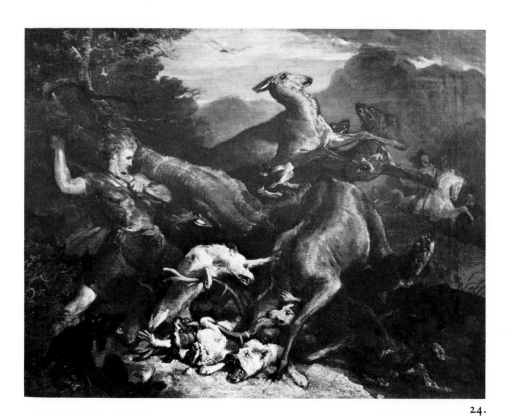

24.
A HUNTING SCENE
By 1820
Oil on canvas, 21½ x 28¼" (54.5 x 71.7 cm)
Provenance: Artist's sale, 1874, lot 271(?); bt. from W. G. Herbert by George Holt; Emma Holt Bequest to Liverpool, 1944
Exhibition: London, 1961, no. 77
Literature: George Holt's MS catalogue (inaccurately given as E. L. 1833); *Sudley,* 1971, p. 41, no. 250
WALKER ART GALLERY, LIVERPOOL

24.

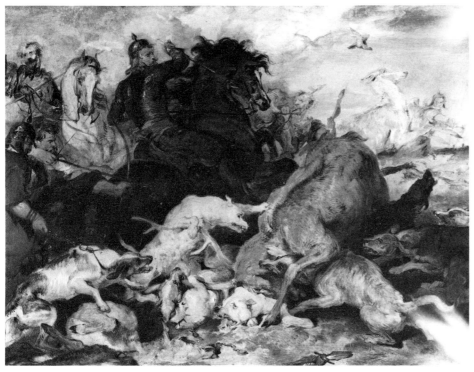

25.

25.
STUDY FOR "THE HUNTING OF CHEVY CHASE"
1825–26
Oil on panel, 18 x 24" (45.8 x 61 cm)
Provenance: Artist's sale, 1874, lot 119(?), bt.
grandfather of present owner
Exhibitions: London, 1874, no. 166 (either
this sketch or no. 27); London, 1961, no. 75;
Sheffield, 1972, no. 23
PRIVATE COLLECTION

couraging Landseer to devote himself to serious subjects. In a letter advising
the artist of the sum he should ask for *Taking a Buck* (*see* no. 26), the duke
wrote, "I have no doubt it will prove an excellent preparatory study for my
picture." That painting, in which a fallow buck is brought down by a ghillie
with the aid of his hounds, was the first of Landseer's large Highland hunting
scenes and is an obvious prototype for *Chevy Chase.* Later in July 1825 the
duke wrote at length about the question of which species of deer Landseer

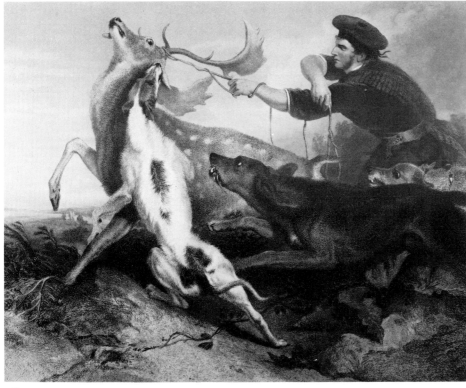

26.

26.
TAKING A BUCK
Thomas Landseer after Edwin Landseer
Picture by 1825, print 1875
Engraving, 23 1/4 x 28 3/4" (59 x 73 cm)
Provenance: acquired by Queen Victoria
Literature: Graves, 1876, p. 10, no. 100;
PSA, 1892, vol. 1, p. 373
Related works: oil painting (67 x 84"),
exhibited London, R.A., 1825, no. 190, last
recorded at Christie's, May 30, 1930, lot 57,
bt. Mitchell
HER MAJESTY QUEEN ELIZABETH II

should include in his picture. The ballad talked of fallow deer, but the duke was clear that "the principal deer in your picture should undoubtedly be the powerful red stag, and all the others should be of the same species, as it would be an incongruity and indeed an anomaly, to have an indiscriminate slaughter of red and fallow deer, as the two species do not herd together—Moreover the red deer, stags and hinds, are much finer subjects for a picture than the fallow, Bucks and does—We must therefore have all the deer in your picture, of the red species, but we must give it some other name than 'Chevy Chase.' Persuaded as I am that this stag hunt will be one of the finest pictures in my collection I naturally feel a more than common anxiety about it, and for your credit and fame wish it could have been ready for Somerset House next year, but that is now quite out of the question." The duke was knowledgeable about deer and had a famous herd at Woburn (*see* no. 118), but his objections were apparently overruled; the animals are red deer, the title remained, and Landseer did finish the picture in time for the 1826 Royal Academy exhibition.

Contemporary critics greeted the picture with enthusiasm. The reviewer of the *Examiner* called it "the most perfect picture, of its class, that has yet been seen in this country, and that may fairly companion any of its size in any other; for the manual development of it in all that addresses the eye has proceeded from an adroitness and a mastery that co-operate with all that more deeply addresses the mind, so as to produce that rarest of all graphic works, an approximation to perfection." The verdict of later critics was more ambivalent. Waagen called it "extravagant in the attitudes, and less true than his pictures usually are" (1854–57, vol. 3, p. 466) and both Monkhouse (1879, pp. 61–63) and Manson (1902, pp. 56–57) regarded it as a failure.

The Battle of Chevy Chase

This sketch suggests that Landseer intended to paint a sequel to the large *Hunting of Chevy Chase* (no. 23), probably on the same scale. The sketch represents the scene of carnage after the battle and illustrates the closing stanzas of the medieval ballad of Chevy Chase, although the time of day represented seems to be evening rather than morning:

> Next day did many widows come,
> Their husbands to bewail;
> They washed their wounds in brinish tears,
> But all would not prevail.
> Their bodies, bathed in purple blood,
> They bore with them away:
> They kissed them dead a thousand times,
> Ere they were clad in clay.

This well-known border ballad, published in Thomas Percy's *Reliques of Ancient English Poetry* (London, 1765), tells of the border conflicts between England and Scotland in the later Middle Ages. The identity of the dead knight lying beside his horse in Landseer's sketch is not certain. Presumably, he is one of the two leaders slain in the battle, the Scottish Earl Douglas, who was killed by an arrow, or the English Earl of Northumberland, who died from a spear wound.

The two scenes from the ballad that Landseer chose to paint contrast before and after the battle, life and action opposed to death and grief. This sketch is no less a celebration of the hunt than the large *Hunting of Chevy Chase,* for the dead game and animals play a more convincing role in the composition than

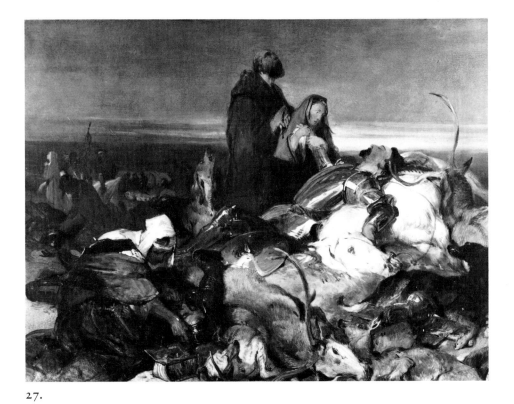

27.

27.

THE BATTLE OF CHEVY CHASE
1825–26
Oil on panel, 18 x 23¾″ (45.7 x 60.3 cm)
Provenance: Artist's sale, 1874, lot 271(?);
John Mappin Bequest to Sheffield, 1884
Exhibitions: London, 1874, no. 166 (either
this sketch or no. 25); Arts Council, England,
British Subject and Narrative Pictures,
1800–1848, 1955, no. 20; Bordeaux,
Delacroix, ses maîtres, ses amis, ses élèves,
1963, no. 329; Sheffield, 1972, no. 24
Literature: Gaunt, 1972, pl. 43
SHEFFIELD CITY ART GALLERIES

the figures. They are heaped up like trophies on the right-hand side, and sprawled across them are the bodies of two knights; the dramatic pose of the one on the left recalls that of the distressed Alpine traveler (no. 13). This knight and his widow form the lower end of the long diagonal line running from left to right and the base of the central pyramid shape, the apex of which is formed by the melodramatic figures of a second widow and her attendant monk. Like the antlers of the stag, these two figures are silhouetted dramatically against the dark sky. In the background on the left, shadowy figures tend the dead and the wounded; one group led by a figure who looks like a nun bears away one of the bodies. Beyond, the landscape merges into a darkness suggesting desolate infinity.

The sketch is soaked in the imagery of Sir Walter Scott, and Landseer used some of the motifs in subsequent works: the dead leader, horse, and howling dog for his diploma picture of 1830 in the Royal Academy, London, *The Dead Warrior;* the dog on the right for an illustration of the wounded hound (Graves, 1876, p. 16) from Scott's novel *The Talisman.* Though the ballad of Chevy Chase was immensely popular, there appear to be almost no precedents for Landseer's treatment, except for a picture by Edward Bird, *Chevy Chace,* exhibited at the British Institution in 1812 (London, no. 121). Bird sent an oil sketch for the composition to Sir Walter Scott (Wolverhampton Art Gallery), and Landseer may have seen this sketch hanging in Scott's home, Abbotsford. Bird's picture is a more ambitious figure composition than Landseer's sketch, without animals, but it anticipates Landseer's composition in the pose of the dead knight sprawled in the foreground, the groups of bodies and distracted mourners rising along an extended diagonal line, and the wild setting. Later treatments of the Chevy Chase theme include a sketch by Frank Howard, exhibited at the Royal Academy in 1830 (London, no. 806), illustrations to the *Book of British Ballads* (London, 1842), by John Franklin, a series of murals in the Guard Chamber at Alnwick Castle, Northumberland, by Francis Gotzenberger, another series by William Bell Scott in the hall at Wallington,

Northumberland, and a sideboard by Gerrard Robinson in the Grosvenor Hotel, Shaftesbury, Dorset.

Several critics have claimed to see in Landseer's sketch the influence of Delacroix, especially his *Massacre at Chios* of 1824 (Louvre, Paris), but there is no evidence to support this. Landseer did not visit Paris until 1840, and the roots of *Chevy Chase* lie in the native tradition of history painting.

Highland Whisky Still

Illegal distilling and poaching often went hand in hand. Like game laws, excise duties on alcohol were regarded as a provocation by the freebooting and fiercely independent Highlanders, and they felt little compunction in evading them. Both poaching and distilling feature prominently in books on the Highlands and were regarded with sympathetic indulgence by the authors, if not by the authorities. Relating his early days in the Highlands, Landseer wrote to Edward J. Coleman: "There were but one or two really well managed *Deer Forests in the Highlands* and no *railroads,* but lots of whisky stills and Poachers to be found" (September 4, 1866, collection of B.D.J. Walsh, London).

Landseer's picture is one of a sequence of works in which he explored aspects of Highland life. The bleak conditions of their lives give some indication why a family like the one represented in this picture should turn lawless. The rough shelter, built into the side of a bank, and the pathetically primitive utensils summon up an image of harsh poverty, albeit treated here in a picturesque manner. The fierce and free spirit of the Highlander is echoed in the wild landscape and the storm-laden sky.

Underlying the picture is a moral theme: the degrading effect of vice and depravity on innocence. The truculent and villainous-looking father, with glass in hand, seated on a stag he had just poached, and his conniving, crone-like mother, confront two innocent children. The boy, holding a blackcock behind him, hangs his head as if in shame, while his pretty sister leans forlornly against a barrel. Significantly, there is no sign of the Highlander's wife, and we may perhaps assume that the children are motherless. The whisky still itself is relegated to the dark interior of the shelter, a location that one reviewer felt underlined the absence of dramatic emphasis in the treatment of the subject. When David Wilkie came to paint his *Irish Whisky Still* (National Gallery of Scotland, Edinburgh), he placed the still prominently in the center.

By comparison, Landseer's composition is more static. The figures are arranged as if on a stage. Framed by the triangular shape of the hut, they form a series of subsidiary triangles. The dark void in the center of the design is perhaps intended to suggest the evils of drink. The distilling apparatus consists of a water butt and two connecting copper cisterns, one of them heated by a fire underneath; the distiller himself holds other pieces of equipment. On the left are a rod and a gaff to indicate salmon poaching, and hung over another water butt on the right is a sheep's fleece. The wooden pail with a board and a knife on it and, below, the head of a bird, feathers, and a turnip, and the potatoes in the luggie, or Highland pail, suggest preparations for a simple meal. The accessories and figures are painted with the artist's usual attention to surface texture and detail.

Campbell Lennie quoted a letter from Sir Walter Scott to the Duke of Wellington in 1824 recommending Landseer to the duke (1976, p. 37).

28.

AN ILLICIT WHISKY STILL IN THE HIGHLANDS (also called HIGHLAND WHISKY STILL) 1826–29

Oil on panel, 31½ x 39½" (80 x 100.4 cm)

Provenance: commissioned by the 1st Duke of Wellington; gift of the 7th Duke of Wellington, 1947

Exhibitions: London, R.A., 1829, no. 20; Birmingham, Society of Artists, 1829; London, R.A., *Old Masters,* 1890, no. 12; London, Earl's Court, *Victorian Era Exhibition,* 1897, "Fine Art Section," no. 31; London, 1961, no. 93; Sheffield, 1972, no. 32

Reviews: Athenaeum, no. 83, May 27, 1829, p. 331, no. 775, September 3, 1842, p. 791, no. 3253, March 1, 1890, p. 282; *Examiner,* no. 1111, May 17, 1829, p. 309; *Gentleman's Magazine,* vol. 99 (1829), part 1, p. 536; *The Times,* May 5, 1829, p. 3e; V & A Press Cuttings, vol. 6, pp. 1556, 1560; *Art-Union* (1842), pp. 169–70

Literature: Johann David Passavant, *Tour of a German Artist in England* (London, 1836), vol. 1, p. 172; *Quarterly Review,* vol. 92 (1852–53), p. 459; Waagen, 1854–57, vol. 2, p. 274; Dafforne, 1873, pp. 9–10; Stephens, 1874, p. 80; Mann, 1874–77, vol. 1, p. 159; Graves, 1876, p. 13, no. 151; Monkhouse, 1879, pp. 58–61; *A Descriptive & Historical Catalogue of Apsley House* (London, 1901), vol. 2, pp. 243–45, no. 104; Manson, 1902, pp. 68–69; Lennie, 1976, p. 52

Unpublished sources: Landseer to the Duke of Wellington, five letters from April 4, 1829, to March 11, 1830, and the duke to Landseer, July 21, 1829 (Stratfield Saye Archives, Berkshire); the Duke of Bedford to Landseer, September 30, 1827, April 30, 1829 (V & A, Eng MS, 86 RR, vol. 1, nos. 26, 28); copyright receipt for 100 guineas from Hodgson & Graves, July 24, 1839 (British Library, London, Add MS, 46140, f. 123)

Prints after: engravings by Robert Graves, 1842 (15⅞ x 20¼"); according to Graves an engraving by James Stephenson was in progress, 1874; G. S. Hunt for *Library Edition,* 1881–93, vol. 2, pl. 59 (PSA, 1892, vol. 1, p. 209); girl on the right, as "Rustic Beauty," W. H. Simmons, 1849 (PSA, 1892, vol. 1, p. 328)

Related works: oil sketch (17 x 20"), private collection, Scotland, Artist's sale, 1874(?), lot 103; drawing of the girl, sold Humberts, Taunton, November 29, 1979, lot 401; various oil sketches and drawings of whisky stills, Artist's sale, 1874, lots 14, 74, 372, 396, 441, 887

VICTORIA AND ALBERT MUSEUM, FROM APSLEY HOUSE, LONDON

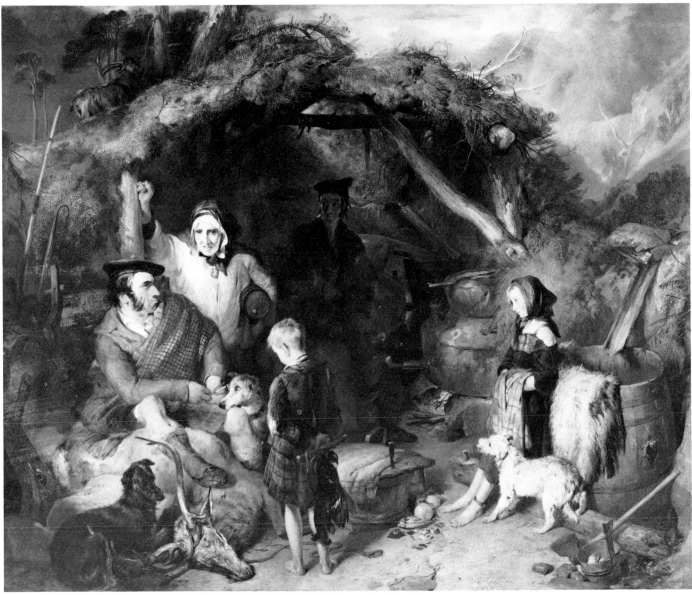

28.

Highland Whisky Still was one of a relatively small number of contemporary works owned by the duke, who later commissioned a picture of Isaac Van Amburgh, the animal performer (c. 1848, Yale Center for British Art, New Haven). In his first extant letter to the duke, on April 4, 1829, Landseer informed his patron of this picture's completion, reminded him of the subject, which had been decided upon three years earlier, and asked for permission to exhibit it. The picture was a great success at the Royal Academy in 1829. The *Examiner* called it "picturesque, nationally characteristic, well coloured, and wild as the Highlands in which the scene is placed," while the critic of *The Times* wrote: "The details are beautifully painted, and the arrangement of the colour very judicious, but the great charm of the picture is its uncommonly striking effect."

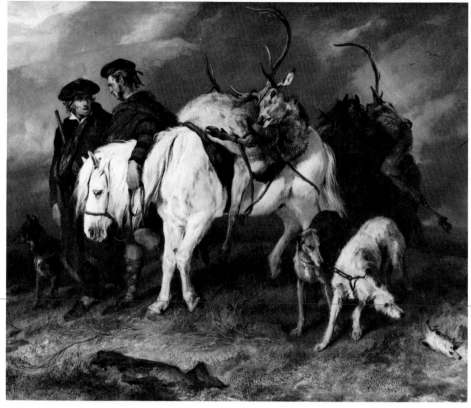

29.

29.

HIGHLANDERS RETURNING FROM
DEERSTALKING (also called DEERSTALKERS'
RETURN and RETURN FROM DEERSTALKING)
1827

Oil on panel, 23¾ x 28¾" (60.3 x 73 cm)
Signed and dated lower left: EL A.R.A./1827
Provenance: probably commissioned by the
3rd Duke of Northumberland, by descent
Exhibitions: London, R.A., 1827, no. 25;
London, B.I., 1829, no. 10; London, 1874,
no. 276
Reviews: Examiner, no. 1010, June 10, 1827,
p. 357, no. 1098, February 15, 1829, p. 100;
The Times, May 5, 1827, p. 5e, February 2,
1829, p. 2f; *Athenaeum,* no. 67, February 11,
1829, p. 93
Literature: Waagen, 1854–57, vol. 4, p. 266;
Early Works, 1869, p. 48, pl. 3; Dafforne,
1873, p. 8; *Athenaeum,* no. 2392, August 30,
1873, p. 279; Stephens, 1874, pp. 78–79,
pl. 4; Mann, 1874–77, vol. 1, p. 116; Graves,
1876, p. 11, no. 128; *Landseer Gallery,* 1878,
pl. 4; Manson, 1902, p. 64; "Catalogue of the
Northumberland Collection," typescript
(c. 1930, National Portrait Gallery, London),
p. 91, no. 431, p. 207
Unpublished sources: Landseer to the Duke
of Northumberland, July 17, 1827 (quoted
in "Catalogue of the Northumberland
Collection," typescript, c. 1930); Landseer to
unnamed correspondent, April 22, 1850
(Humanities Research Center, University of
Texas at Austin)
Prints after: engravings by William Finden,
1840, for *Royal Gallery of British Art;* H. T.
Ryall, 1854 (22½ x 28⅜"); C. E. Wagstaff,
1874 (*PSA,* 1892, vol. 1, p. 85); J. B. Pratt for
Library Edition, 1881–93, vol. 2, pl. 45 (*PSA,*
1892, vol. 1, p. 210)
Related works: replica (same dimensions),
collection of William Wells, last sold
Sotheby's, Gleneagles Hotel, August 29–30,
1974, lot 234; oil sketch (17¼ x 23½"),
Artist's sale, 1874, lot 287; pencil sketches,
Artist's sale, lots 845, 999

THE DUKE OF NORTHUMBERLAND

Highlanders Returning from Deerstalking

Landseer was absorbed in all aspects of deerstalking and deeply impressed
by the character of the ghillies, or attendants to hunters and chieftains, with
whom he hunted. The subject of Highlanders with ponies and dead deer
especially attracted the artist at this date and he produced numerous drawings
and sketches. In 1826 he etched a very similar composition of this same elderly
ghillie with two ponies and hounds.

The composition of the picture is simply massed and effective. The men and
animals stand isolated on a strongly lit grassy knoll, like a platform, with the
ground falling away behind and a view of stormy sky and two birds sweeping
away on the right. An atmosphere of rugged strength and somber desolation
surrounds the two ghillies, well-contrasted types of Highlanders: an old,
gray-faced man with wispy hair, dressed in tartan trousers and a plaid, and his
young, ruddy companion in a kilt. Also contrasted is the vigorous young colt
with the beautifully observed weary, white pony, carefully feeling its way
down. But it is the image of the stags that gives the picture its deeper meaning;
their bodies are pathetically strapped down, their arching antlers silhouetted
against the sky. The theme of mortality is further emphasized by two dead
woodcock carried by the white pony and by the sheep's skull to the right,
which the deerhounds sniff. The excitement of the hunt is here recollected in
tranquility, and it is the tragic elements that come to the fore, vividly illustrat-
ing Landseer's divided feelings as a hunter and an artist.

The picture is painted in clear, transparent tones, with strongly contrasted
textures, careful finish, and a dramatic sense of light. The figures are set off by
the rough, heathery foreground, painted quite broadly. The men and animals
are much more carefully delineated, and the background shades into wonder-
fully free and stormy effects of light and dark.

Death of the Stag in Glen Tilt

The 4th Duke of Atholl, one of the great Highland chieftains and landowners, dominates Landseer's picture. Already in his seventies in the 1820s and described by a contemporary as "the greatest deer killer in Scotland," he had an insatiable passion for hunting and was noted for his great size, physical stamina, and courage. Holding his arm in a touching gesture of trust and affection, excitedly pointing out a distant herd of deer, is his young grandson, the Honorable George Murray, later 6th Duke of Atholl, dressed in a kilt of Atholl tartan, with a sporran, or purse, in front, a red Tullibardine plaid, and a blue bonnet with eagles' feathers. On the other side, spyglass clapped to his eye, is the duke's head keeper, John Crerar, who died in 1843, another legendary sportsman, and a famous fiddler, about whom many stories are told. Like the duke he is dressed in more conventional hunting costume, with a deerstalking hat, a powderhorn slung around his body, and a rifle beside him. On the left is old Crerar's son and successor, Charles, wearing a kilt and plaid of Atholl tartan and a badger's-head sporran, with a cap and telescope beside him. He holds out his knife to the duke in a gesture of submission before gralloching, or disemboweling, the stag, while the third keeper, Donald McIntyre, also in Atholl tartan, holds down its haunches. The picture was painted near Mar Lodge, in the lower part of Glen Tilt, the long and beautiful valley running from the duke's castle at Blair Atholl to the high Grampians. The background is romantic and atmospheric, a shower of rain scudding in from the right, while faint sunlight falls on the clouds to the left.

Landseer visited Blair Atholl on his first journey to Scotland in the autumn of 1824, and he must have been given the commission for the group at that time, as his sketches of the duke and his keepers date from that year (*see* no. 32). Landseer is known to have visited Blair Atholl also during the autumns of 1825 and 1826. From Blair Atholl, Landseer wrote to the miniature painter William Ross that he had been hard at work painting and he described the duke as a "fine old chieftain—but very little else,—and particularly kind to me—the Duchess is really quite a mother" (September 24, 1825, Humanities Research Center, University of Texas at Austin).

There is little doubt that the artist devoted a great deal of thought to the development of the portrait. The oil sketch (no. 31) shows that he originally conceived the work as a heroic group full of drama and movement in the spirit of Rubens. Men and animals are intertwined at the climax of the hunt; one stag is dead, another is being brought down, while the duke waits, gun in hand, to deliver the *coup de grâce*. The sketch is exciting and suggests that Landseer thought of the group as a complement to *Chevy Chase* (no. 23). In any event he abandoned this idea for a much more conventional group portrait, either at the instigation of his patron or because he felt incapable of carrying out such an ambitious composition on a large scale. A group of figures in action like this would have exposed his deficiencies even more than *Chevy Chase*.

The finished picture shows the duke at the apex of a shallow, triangular composition, rising on the left from the heads of the keepers to the pony, the duke, and his grandson, and falling more steeply on the right. The duke looks down at the stag, his two companions look across, the arm of his grandson and John Crerar's spyglass providing a dramatic horizontal line, complemented by the outstretched arm of Charles Crerar.

The picture belongs to the tradition of the sporting conversation piece, which has a history dating from the eighteenth century and earlier. But

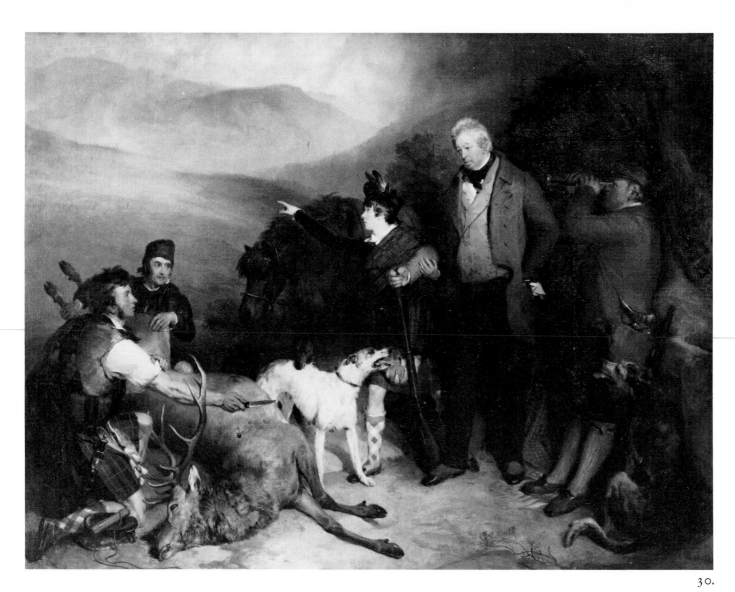

30.

PORTRAITS OF HIS GRACE THE DUKE OF
ATHOLL AND GEORGE MURRAY ATTENDED BY
HIS HEAD FORESTER JOHN CRERAR AND
KEEPERS (also called DEATH OF THE STAG IN
GLEN TILT)
1824–30
Oil on canvas, 59 x 79" (149.8 x 200.8 cm)
Provenance: commissioned by the 4th Duke of
Atholl, by descent
Exhibition: London, R.A., 1830, no. 313
Reviews: Morning Chronicle, May 17, 1830,
p. 2e; *Morning Post,* June 1, 1830, p. 3d; *The
Times,* May 4, 1830, p. 3e; *Athenaeum,*
no. 136, June 5, 1830, p. 348; unidentified

review, The Anderdon Royal Academy
catalogues, Dept. of Prints and Drawings,
British Museum, London
Literature: Mann, 1874–77, vol. 2, p. 81;
Graves, 1876, p. 13, no. 148; the 7th Duke
of Atholl, *Chronicles of the Atholl and
Tullibardine Families* (Edinburgh, 1908), vol.
4, p. 359; Manson, 1902, p. 68; Lennie, 1976,
pp. 39, 40; Lindsay Errington, "Monarchs of
Glen Tilt," *Connoisseur,* vol. 196 (November
1977), p. 208, repro. p. 206
Unpublished sources: the Duke and Duchess
of Atholl to Landseer, 1825–38 (Mackenzie

collection, nos. 740–51)
Prints after: engravings by John Bromley,
1833 (22 x 27¼"); George Zobel, 1862;
James Scott for *Library Edition,* 1881–93,
vol. 2, pl. 44 (*PSA,* 1892, vol. 1, p. 211)
Related works: oil sketch, Artist's sale, 1874,
lot 320; oil sketch of the Duke of Atholl with
John Crerar, Colin Young sale, Christie's, July
18, 1874, lot 29; oil sketch of Donald
McIntyre, Yale Center for British Art, New
Haven; drawing of red deer at Blair Atholl,
Artist's sale, 1874, lot 674

THE DUKE OF ATHOLL

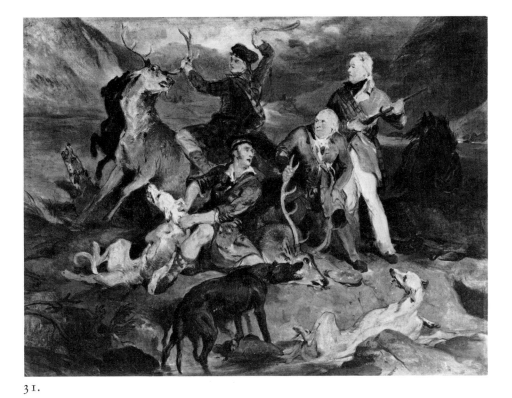

31.

31.
SKETCH FOR "DEATH OF THE STAG IN
GLEN TILT"
1824–25
Oil on millboard, 19 x 25" (48.2 x 63.4 cm)
Provenance: Artist's sale, 1874, lot 124,
bt. Agnew; John Heugh, his sale, Christie's,
March 17, 1877, lot 46, bt. Polak; George
Holt; Emma Holt Bequest to Liverpool, 1944
Exhibitions: London, 1874, no. 179;
Manchester, 1887, no. 637; London,
Guildhall, *Loan Collection of Pictures*, 1892,
no. 153
Literature: Sudley, 1971, pp. 41–42, no. 251
WALKER ART GALLERY, LIVERPOOL

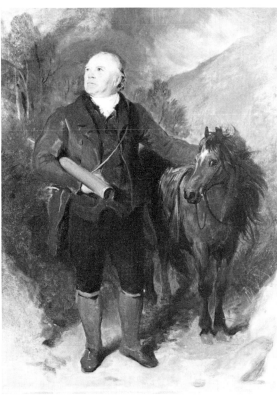

32.

32.
THE KEEPER JOHN CRERAR
1824
Oil on board, 23 x 17½" (58.5 x 44.5 cm)
Inscribed and dated on label on reverse: *Four
sketches by Landseer/painted at Blair Atholl in
1824/Keeper John Crerar with pony*
Provenance: anonymous sale, Christie's,
March 17, 1877, lot 95; R. W. Smith, his sale,
Christie's, February 6, 1880, lot 61;
anonymous sale, Christie's, May 17, 1945, lot
68; Scott & Fowles, New York, by 1951;
anonymous sale, Sotheby Parke-Bernet,
New York, November 10, 1975, lot 376;
anonymous sale, Sotheby's, Gleneagles Hotel,
August 28–29, 1978, lot 583
PERTH AND KINROSS DISTRICT COUNCIL MUSEUM
AND ART GALLERY, SCOTLAND

Landseer's figures are conceived in more monumental terms than most sporting groups. Comparing Landseer's picture with David Allan's *Atholl Family Group* (Blair Atholl), which shows the 4th Duke with his family forty years earlier, Lindsay Errington perceptively notes that "Between Allan's lighthearted and Landseer's tragic picture lies, however, far more than the lifetime of the ageing nobleman, for they span the complete shift in sentiment between the era of lighthearted picturesque and that of a massive and serious minded romanticism."

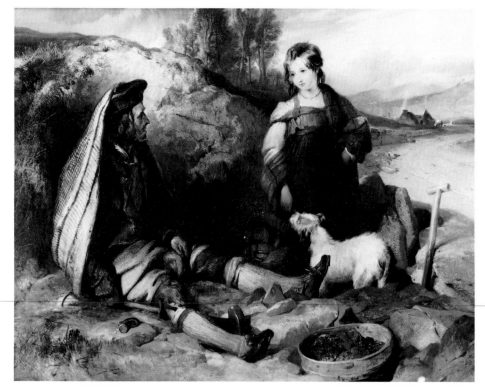

33.

33.

THE STONE BREAKER (also called THE
STONE-BREAKER'S DAUGHTER)
By 1830
Oil on panel, 18 x 23" (45.8 x 58.5 cm)
Provenance: William Wells of Redleaf, his
sale, Christie's, April 27, 1860, lot 12, bt.
Wallis; John Jones Bequest to the Museum,
1882
Exhibitions: London, B.I., 1830, no. 53;
London, 1874, no. 447
Reviews: Athenaeum, no. 119, February 6,
1830, p. 76; *Examiner,* no. 1149, February 7,
1830, p. 83
Literature: Stephens, 1874, p. 88; Mann,
1874–77, vol. 2, pp. 103–4; Graves, 1876,
p. 14, no. 158; V & A Catalogues, 1893,
p. 86, 1907, p. 77; G. Reynolds, *Victorian
Painting* (London, 1966), pp. 68–69; Lennie,
1976, p. 63; Lionel Lambourne, "Sir Edwin
Landseer's 'The Stonebreaker and his
Daughter,'" *Victoria and Albert Museum
Masterpieces* (London, 1978), sheet 17
Prints after: engravings by John Burnet, 1844
(18¼ x 24⅛"); F. G. Stevenson for *Library
Edition,* 1881–93, vol. 2, pl. 84 (*PSA,* 1892,
vol. 1, p. 209)
VICTORIA AND ALBERT MUSEUM, LONDON

The Stone Breaker

One of Landseer's most memorable studies of Highland character, this old man, a stone breaker, is painted with deep sympathy and with great truth. No attempt is made to disguise the toll that labor and poverty have exacted from him: his gaunt, sunken face, straggly hair and beard, bowed attitude, quiet, resigned hands, slightly raised and no-doubt rheumatic knees, stiffly extended legs, and simple clothes. The rocks and stones which surround him and which have broken him underscore his own rugged character. It is a harsh and remarkable image, sustained by Landseer's sense of the density and reality of textures: the rough plaid, the battered shoes, the ram's-horn snuffbox, hammer, sieve, spade, basket, and the angular gray and buff rocks themselves.

The stone-breaker's granddaughter, rather than his daughter, who brings his lunch in a basket, is more consciously idealized, and the contrast between her innocent freshness and his gaunt appearance is somewhat forced. Yet the picture is about relationships as well as about individuals: the tenderness of an old man for his granddaughter, the bond between the man and his terrier, who also waits expectantly for lunch, and the connection between the figures and the cottage in the background, which bespeaks the homely, domestic virtues of the Highland family and hearth.

Stone breaking in the early nineteenth century was an inescapable task of road building. Yet, the image of stone crushing as an expression of the tedium and inhumanity of work in an industrial society is one associated with the later realist school. Gustave Courbet's famous *Stone-Breakers* of 1851 (formerly Dresden) at once springs to mind, as well as John Brett's Pre-Raphaelite masterpiece *The Stone-Breaker* (1857–58, Walker Art Gallery, Liverpool) and Henry Wallis's picture of the same title of 1858 (City Museum and Art Gallery, Birmingham), in which the man is shown dead, exhausted by his labor. That Landseer should have painted the same subject twenty years earlier, and with a message not so very different, evidences his originality in choice and treatment of subject matter.

Interior of a Highlander's House

Between 1830 and 1834 Landseer exhibited no less than seven pictures of Highland interiors. Their meticulously rendered settings and accessories, in which one can almost feel the rough and grainy textures, serve to elucidate the simple lives and characters of the Highlanders, for whom the artist felt such sympathy. Detail is used to build up and enrich the human and narrative associations of the scenes and to underline the extent to which people are the products of their environments. Unlike the bothy of the poacher (no. 35), this appears to be the home of a ghillie, or hunter's attendant, surrounded by the fruits of the hunt, a roe buck, a hare, ptarmigan, and grouse. The atmosphere is peaceful and heartwarming, the day's activity recollected in the quiet of the evening. The beautifully painted earthenware bowl and jar on the left, the bunch of heather, the kippers hanging over the stove, and the Bible on the dresser suggest a simple and well-ordered existence. The Highlander, sitting on an upturned tub, is taking his ease, a rug wrapped around him, a pipe in one hand, and a beer tankard beside him. He holds a biscuit for the begging terrier and their intent eye contact forms the point of psychological focus. Between their profiles is the full-face figure of the man's pretty daughter, in turn bringing him food as a reward for the day's exertions.

The group is tightly designed for emotional effect and set close to the front of the picture plane, in contrast to the receding perspective of the interior. The eye is led along the wooden walls and rough-hewn floor to the kneeling figure of the wife, seen bending over the stove. The skylight above gives the end of the room a mysterious quality. With its balancing vertical and horizontal lines, the cabin serves as a tight frame for the composition; the suspended hook at the back reads almost like a plumb line. By comparison with Landseer's informal sketches of interiors, this picture is carefully planned and painted with the most careful and delicate finish. David Wilkie's *Return of the Highland Warrior* of 1824 (Metropolitan Museum of Art, New York) shows a similar scene of domestic contentment.

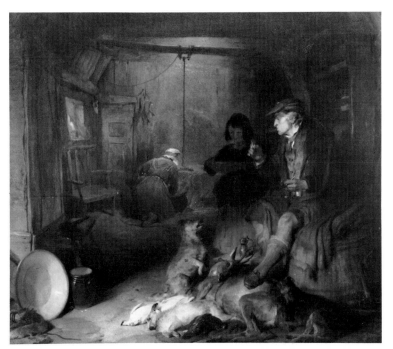

34.

34.

INTERIOR OF A HIGHLANDER'S HOUSE (also called HIGHLAND INTERIOR)
By 1831
Oil on panel, 27½ x 33½" (69.8 x 85 cm)
Provenance: William Wells of Redleaf; Wells sale, Christie's, May 10, 1890, lot 32; Lord Masham; by descent to the Countess of Swinton; sold from Swinton House, Christie's, November 21, 1975, lot 74, and February 19, 1979, lot 21
Exhibitions: London, R.A., 1831, no. 86; London, B.I., 1832, no. 75; Manchester, 1857, no. 204; London, 1874, no. 342; London, 1890, no. 10; Sheffield, 1972, no. 38
Reviews: Athenaeum, no. 224, February 11, 1832, p. 99; *Examiner,* no. 1216, May 15, 1831, p. 309; *Gentleman's Magazine,* vol. 101 (1831), part 1, p. 447
Literature: Early Works, 1869, pl. 2; Mann, 1874–77, vol. 1, p. 64; Graves, 1876, p. 15, no. 169; Lennie, 1976, p. 53
Prints after: engravings by William Finden for *Royal Gallery of British Art* (London, 1839); H. T. Ryall, 1868 (22½ x 28½") (*PSA,* 1892, vol. 1, p. 168); William Roffe for *Library Edition,* 1881–93, vol. 2, pl. 57 (*PSA,* 1892, vol. 1, p. 211)
Related work: version (10¾ x 13¼"), private collection, London
PRIVATE COLLECTION

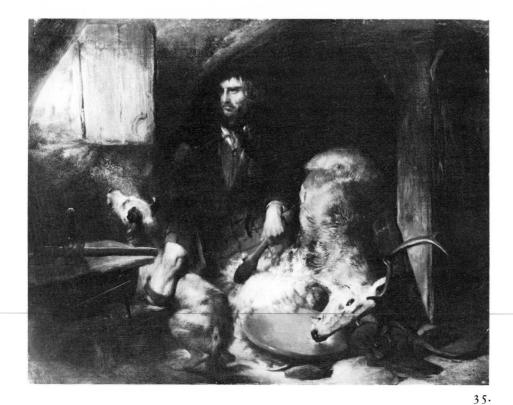

35.
THE POACHER'S BOTHY
By 1831
Oil on panel, 17¾ x 24" (45.2 x 61 cm)
Provenance: E. A. Holden of Aston Hall;
Edward Rodgett, his sale, Christie's, May 14,
1859, lot 87, bt. Wallis; David Chapman; G.
C. Schwabe, his gift to the Kunsthalle, 1886
Exhibition: London, R.A., 1831, no. 293
Reviews: Examiner, no. 1216, May 15, 1831,
p. 309; *Kunstblatt* (Stuttgart, 1831), p. 368
Literature: Mann, 1874–77, vol. 2, p. 168;
Graves, 1876, p. 15, no. 174; J. Theodor
Schultz, *Die Gemälde der Schwabe-Stiftung in
der Hamburger Kunsthalle* (Hamburg, 1888);
F. v. Boetticher, *Malerwerke* (Dresden,
1891–98), no. 4; Manson, 1902, p. 77; Eva
Maria Krafft and Carl W. Schümann, *Katalog
der Meister des 19. Jahrhunderts in der
Hamburger Kunsthalle* (Hamburg, 1969),
p. 168, no. 1836
Unpublished sources: James Norris to
Landseer, June 20, 1832, enclosing a draft for
260 guineas on behalf of E. A. Holden (V & A,
Eng MS, 86 RR, vol. 4, no. 228)
Prints after: engravings by Charles Fox, 1838
(14⅜ x 20"); James Scott for *Library Edition,*
1881–93, vol. 2, pl. 75 (*PSA,* 1912,
unpaginated)
HAMBURGER KUNSTHALLE

35.

The Poacher's Bothy

This is the most dramatic and highly charged of Landseer's Highland interiors and it offers an interesting contrast to the *Interior of a Highlander's House* (no. 34). Here is the violent, illicit side of Highland life and the picture might be described as the poacher at bay. In the act of gralloching, or disemboweling, a stolen ten-point stag, the wild-eyed, ashen-faced desperado suddenly becomes conscious of approaching danger. He and his hound gaze tensely towards the light and the unknown menace outside. The figure of the man, who bestrides the stag, crowded in under the low beams of the bothy, suggests immense, suppressed physical energy. At any moment he and the dog will leap up to confront the danger.

The axis of the design is formed by a series of intersecting diagonals, drawing the dog, stag, and man into a tight parallelogram in the center, in which the round bowl plays an important role. The fitful lighting, playing on the foreground and leaving the background in deep shadow, underscores the ominous and dramatic nature of the subject. Accessories are sparsely used, but with telling effect. A whisky bottle and an ax lie on top of the tub at the left, a knife sticks into the stool in front, a half horseshoe hangs on the shutter, a cap dangles from a hook on the right, and a fleece and skull under the bowl suggest stolen sheep as well as poached deer.

There is no false sentiment about the nature of poaching, but it is impossible not to feel some sympathy for the wild and uncompromising spirit of the poacher himself. Stories of Highland poachers were legendary, and there is no doubt that Landseer, like his friends, had a sneaking respect for the daring expertise of these lawless outsiders who refused to accept the rules of property as related to game. In the same year as this picture, Landseer exhibited two outdoor poaching scenes, *How to Get the Deer Home?* (Sotheby's, Hopetoun House, November 12–13, 1979, lot 283) and *Getting a Shot* (Sotheby Parke-Bernet, New York, May 14, 1976, lot 63), the latter with portraits of two famous poachers, Charles Mackintosh and Malcolm Clarke.

Landseer was not alone in his liking for poaching scenes. The act of poaching, with all its elements of risk and adventure, was a naturally dramatic subject, and the idea of the poacher himself as an outsider pursuing his natural instincts appealed strongly to romantic artists. A picture of two poachers, desperately trying to evade their pursuers, by Carl W. Hübner, of 1846, is in a German collection (see fig. 45).

Ptarmigan

Ptarmigan, a form of grouse whose plumage turns white in winter, nest in the rocky hilltops of the Highlands. For Landseer they represented one of the wildest and most beautiful species of game bird, and he included them in several of his sporting pictures, from the early *Ptarmigan and Roebuck* of c. 1830 (collection of Henry P. McIlhenny, Philadelphia) to the late and impressive *Ptarmigan Hill* of 1869 (no. 157).

Landseer painted at least seven pictures of mostly dead game birds for William Wells at this period, among them studies of pheasant, grouse, woodcock, partridge, and wild duck. The sense of shock that the spectator experiences at the destruction of these beautiful creatures is heightened by Landseer's exquisite touch and brilliant color. Sensibility goes with acute powers of observation in these simple and very direct studies. Related to the series of studies of dead game that Landseer painted in the early 1830s is a superb still-life study of a red-legged partridge, three ptarmigan, a blackcock, and a gray hen (no. 36). That work, painted with remarkable objectivity, is unusual in that the game is shown indoors, under a strong, even light.

Ptarmigan (no. 37) was almost certainly painted in the hills above Glenfeshie, probably in the autumn of 1832. The actor C. J. Mathews, who was staying with the Duke and Duchess of Bedford at the Doune, described an expedition from there to the Glenfeshie huts in September 1833, in company with Landseer and others: "Leaving the ladies to get there their own way, we gentlemen . . . set off on our shaggy ponies with the intention of shooting our way over the mountain tops to the glen. . . . After a most fatiguing ascent we reached the ptarmigan hills, where the party dispersed in various directions in quest of game" (C. Dickens, *Life of Charles J. Mathews,* London, 1879, vol. 2, p. 48).

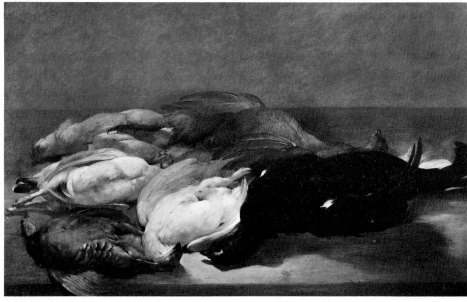

36.

36.
DEAD GAME
1832
Oil on canvas, 22 ½ x 35 ½" (57.2 x 90.2 cm)
Signed and dated lower left: *EL* 32
PRIVATE COLLECTION

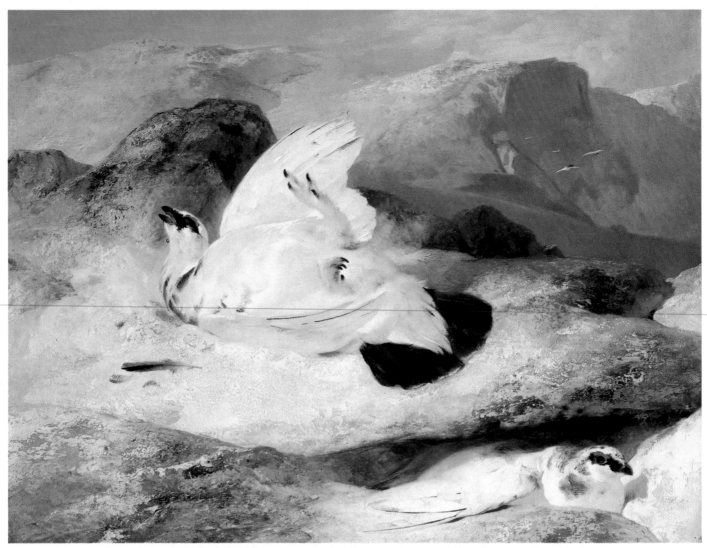

Landseer's picture, a brilliant study in whites, was no doubt inspired by such an expedition. The birds are treated with all the care and delicacy of a still-life motif, the left-hand bird especially laid out for detailed examination. The rendering of the feathers is minutely finished and marvelously tactile, and it is combined with a firm sense of drawing and anatomy. The snowy rocks, which serve to set off the birds and to define the strong diagonal lines of the composition, are painted with similar virtuosity.

Landseer, of course, was not content simply to portray the injured ptarmigan. The bird on the left, head twisted in mute appeal and one leg stiffly extended, takes on the sublime nobility of a wounded hero, while his mate, also apparently wounded, continues to guard the nest—in a heroic echo of the theme of the widow, Hector and Andromache, and the world of human emotion. The other ptarmigan, sweeping across the great space behind (and the landscape is pitched in a high, romantic key) to the scene of the disaster, appear like a Greek chorus as harbingers of tragedy.

37.

PTARMIGAN
By 1833
Oil on panel, 19¾ x 26" (50.2 x 66 cm)
Provenance: William Wells of Redleaf; Wells sale, Christie's, May 10, 1890, lot 34, bt. Agnew; Mrs. Robert Frank, London, from whom acquired by the present owner
Exhibitions: London, B.I., 1833, no. 129; London, 1874, no. 352 (as "Blackcock"); London, 1890, no. 164; London, 1961, no. 62; Detroit, 1968, no. 173
Review: Examiner, no. 1307, February 24, 1833, p. 117
Literature: Graves, 1876, p. 17; John Canaday, *Mainstreams of Modern Art* (New York, 1959), p. 142, fig. 160
HENRY P. McILHENNY

Deer and Deerhounds in a Mountain Torrent

This picture is the first of a notable line of stags at bay. After *Chevy Chase* (no. 23), Landseer's pictures and drawings of deer are largely of dead animals, and it is not until the 1840s that he attempted the same kind of subject, as in the famous *Stag at Bay* (by 1846, private collection), and then on a much larger scale. In this dramatically conceived picture, one senses the illusion that at any moment the exhausted and terrified stag will be swept forward by the torrent, out of the picture space. It is far from clear, however, that the stag is the only victim, for while the farther hound, apparently unaware of the danger, maintains its grip on the ear of the stag, the other is already submerged under the leg of its adversary. The setting for the violent conflict between the dogs and the stag, on the one hand, and between the animals and the forces of nature, on the other, is gloomy and awesome. Behind the stag, the lake stretches, black and indistinct, to a great amphitheater of hills, lit at the top by a burst of afternoon sunlight. Light falls dramatically in the foreground from another *coup de soleil,* accentuating the harsh surfaces of the rocks, which frame the central group, the soft and furry textures of the animals, and the milky translucency of the water. Indeed, the foreground passages are among Landseer's most subtle pieces of painting, with glazes seemingly floated over each other and a lovely tone of dove gray on top.

When exhibited, the picture attracted less attention than *A Jack in Office* (no. 62), but it was praised by the reviewer of the *Athenaeum* for its "truth exalted by feeling and skill."

38.

DEER AND DEERHOUNDS IN A MOUNTAIN TORRENT (also called THE MOUNTAIN TORRENT and THE HUNTED STAG)
By 1833
Oil on panel, 27½ x 35½" (69.9 x 90.2 cm)
Provenance: Robert Vernon, gift to the National Gallery, 1847; transferred to the Tate Gallery, 1900
Exhibitions: London, R.A., 1833, no. 268; London, B.I., 1834, no. 156
Reviews: Athenaeum, no. 291, May 25, 1833, p. 329, no. 328, February 8, 1834, p. 107; *Gentleman's Magazine,* n.s., vol. 1 (1834), p. 308; *The Times,* February 5, 1834, p. 4e
Literature: Art Journal (1851), p. 4; Waagen, 1854–57, vol. 1, p. 382; Dafforne, 1873, pp. 30–32; Mann, 1874–77, vol. 1, p. 123; Graves, 1876, p. 16, no. 190; National Gallery Catalogue, 1888, p. 85; Tate Gallery Catalogue, 1913, p. 137; Boase, 1959, pl. 25b; Gaunt, 1972, pl. 54
Unpublished source: Henry Graves to the director of the National Gallery, October 16, 1848, seeking permission to engrave the picture, as agreed with Robert Vernon and Landseer (National Gallery Archives, London)
Prints after: engravings by Frederick Stacpoole, 1850 (20⅜ x 26½") (PSA, 1892, vol. 1, p. 176); John Cousen for Dafforne, 1873, pl. 10; J. B. Pratt for *Library Edition,* 1881–93, vol. 1, pl. 70 (PSA, 1892, vol. 1, p. 208)

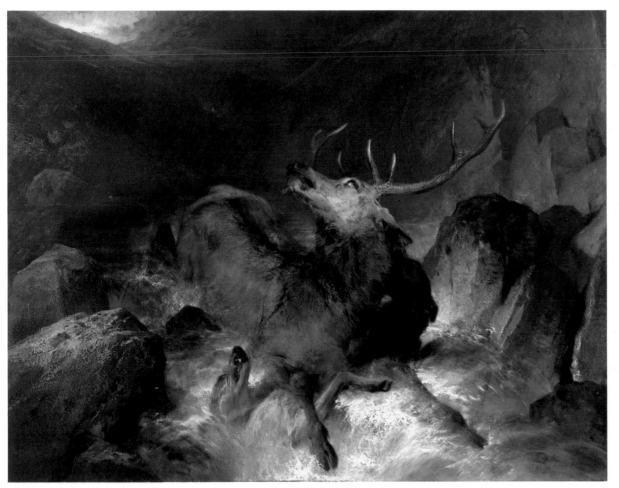

38.

A Highland Breakfast

This is one of Landseer's most beautiful Highland interiors. A mother breast feeds her baby, while the dogs of the bothy eat their breakfast from a large wooden tub. Human and canine behavior is juxtaposed. One of the terriers is suckling her puppies in emulation of the Highland mother; beside her is another terrier seen from behind. On the far side of the tub is a third terrier looking keenly at a deerhound and collie who are disputing over a bone.

Light enters the cool interior from a window at the left and from the chimney opening on the right, throwing the rough stone hearth into relief and casting highlights on the end of the crib, the tub, the mother's cap, the bowl with her breakfast, and the wall cupboard behind. The furniture and accessories provide a telling picture of simple conditions of life. But the mother herself, so tender and so pretty, and the characterful dogs invest the interior with an atmosphere of quiet contentment and fulfillment. Landseer sketched a sympathetic chalk study of the nursing mother (no. 39). Two other Highland interiors showing dogs feeding out of wooden tubs with single figures are *Highland Music* (c. 1830, Tate Gallery, London) and *Too Hot* (c. 1831, private collection).

40.

A HIGHLAND BREAKFAST
By 1834
Oil on panel, 20 x 26" (50.8 x 66 cm)
Provenance: John Sheepshanks Bequest to the Museum, 1857
Exhibitions: London, R.A., 1834, no. 96; Paris, Exposition Universelle, 1855, no. 860; Sheffield, 1972, no. 45
Review: Theophile Gautier, *Les Beaux-Arts en Europe—1855* (Paris, 1855), p. 76
Literature: Waagen, 1854–57, vol. 2, p. 300; V & A Catalogues, 1857, p. 16, no. 87, 1907, p. 76; Dafforne, 1873, p. 13; Stephens, 1874, pp. 95–96, pl. 10; Mann, 1874–77, vol. 1, p. 24; Graves, 1876, p. 17, no. 200; Manson, 1902, p. 79; Lennie, 1976, p. 53
Unpublished source: note in Landseer's hand, probably at the time of the 1855 Paris exhibition, that the picture is to be carefully washed and varnished (Royal Institution, London)
Prints after: engraving by John Outrim, 1840 (12½ x 16½")
Related works: oil sketch, Monkhouse, 1879, pl. 15; oil sketch of the mother and baby (7⅞ x 6⅝"), Spink & Son, London, 1978

VICTORIA AND ALBERT MUSEUM, LONDON

39.

STUDY OF THE NURSING MOTHER FOR "A HIGHLAND BREAKFAST"
By 1834
Colored chalk on paper, 13½ x 9¾" (34.3 x 24.8 cm)
Provenance: S. C. Turner Bequest to the Trust, 1948

NATIONAL LOAN COLLECTION TRUST

39.

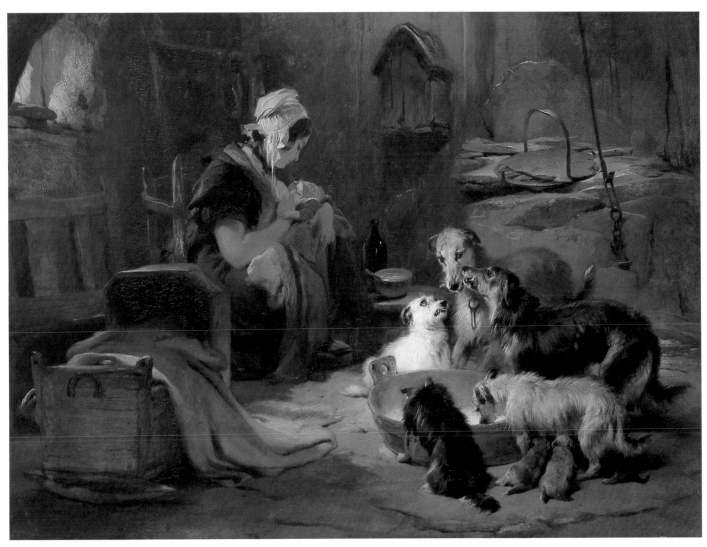

40.

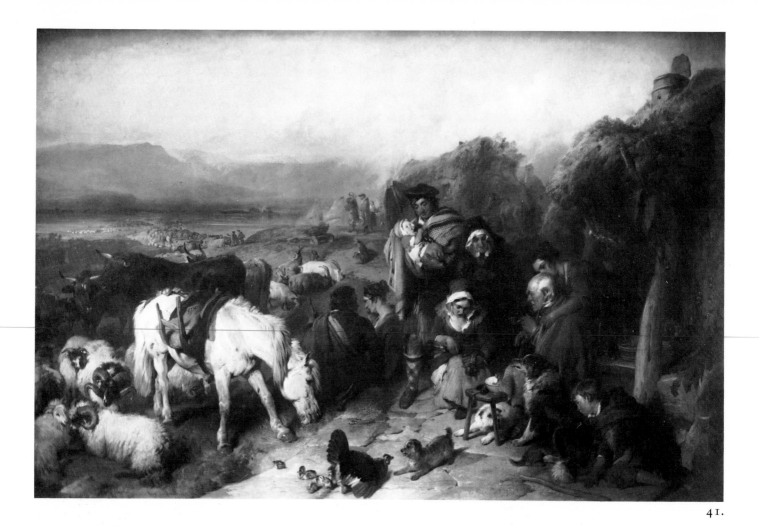

41.

A Scene in the Grampians—The Drovers' Departure

This was one of Landseer's major successes at the Royal Academy, where it was exhibited in 1835. W. T. Whitley records how difficult it was to see because of the crowds milling in front of it, and several reviews describe it as the star attraction of the year. The largest, as well as one of the last of Landseer's scenes of Highland life, it pulls together many of the themes that had occupied him during the previous decade.

Like *Return from the Staghunt* (no. 42) it draws on traditions that were already passing away rapidly. The great drives of Highland cattle and sheep south to the English markets were part of the reassuring myth of Highland adventurousness and self-sufficiency perpetuated by Sir Walter Scott and other romantic writers, but, in fact, economic conditions were far bleaker. Highland droving was declining (*see* A.R.B. Haldane, *The Drove Roads of Scotland,* London, 1952).

A typical Highland drove was described in a pamphlet of c. 1841 circulated with the print engraved after the picture: "The cattle which form the drove, are gathered together on a set day and at an appointed place—the foot of a mountain, the side of a lake, or near a castle . . . herdsmen are selected to conduct the different portions into which the drove is divided, while over all, a confidential person, a sort of chief, topsman as he is called in the lowlands, presides, who directs all the movements, makes all the bargains, and is responsible to the owners for the profits" (p. 3).

In the foreground of Landseer's picture, the topsman can be seen taking leave of his family on the morning of departure. The foreground groups

symbolize not only types of Highland character but also the ages of man. The grandfather, said to have been modeled from the artist's father, smokes a pipe, while his unmarried daughter wraps his plaid firmly about his shoulders and his married daughter fills his horn with whisky for the topsman. Behind stands a fidgety grandmother, and to the left, at the apex of a pyramidal design, the topsman himself, proudly holding his offspring, who plays with his dirk. To the left, with their backs turned, tenderly holding hands, are two young lovers, and on the right a young boy, said to be one of the sons of the painter Charles Robert Leslie, watching the confrontation between a terrier puppy and a chicken fiercely defending her young. We learn not only about the individuals, but also about the web of feelings, duties, and responsibilities that binds them so closely together. Their surroundings may be primitive, but there can be no doubt that they lead full and contented lives.

The animal groups mirror the human; a collie, worried by a white terrier, suckles her puppy; a sheep rests with its lamb, guarded by a ram; a black ox stands by a cow and a calf; there are goats and kids farther back; and on the right a mare and a foal. Prominent in the foreground is one of those tumble-down Highland ponies, which only Landseer could paint with such feeling.

As always in pictures of this kind, the artist employed accessories for narrative and descriptive effect, to build up a picture of a way of life, which may be as poignantly told in the rendering of a rough stool with a bowl and a piece of bread as in the expression of a face. On the right is a simple turf-covered bothy, with a rain-water barrel on top, various luggies and spoons visible in the interior, smoked sides of salmon and kipper above. Another bothy stands in the middle distance and in front of it a primitive cart.

According to the pamphlet on Highland drovers of c. 1841, which accompanied the print, the hills in the background are the Ochil range, which runs southwest from Perth; they do not look very much like the gently rounded Ochil Hills, however. Neither the lake or firth on the right nor the romantic-looking castle has yet been identified. Winding down the valley is a long file of men and animals. The exhilarating sense of space opening up in the background of the picture admirably expresses the wanderlust of the drovers.

The picture was criticized when it was first exhibited for being too crowded with incident and detail, and it is true that some of the earlier scenes of Highland life have more powerful impact because the narrative is simpler and more direct. At the same time, the picture is not in the least confused, nor does it read visually as a jumble. "In the present instance," wrote one unidentified reviewer, "the genius and powers of Mr Landseer have thrown a charm over that which would otherwise seem to be a common and uninteresting occurrence; and have imparted to it the most touching sentiment and pathos. We hardly know whether to admire more the skill with which the figures and the cattle, &c are painted, or the ingenuity with which the numerous details growing out of the subject are managed. Every thing seems to have been thought of and provided for the occasion" (The Anderdon Royal Academy catalogues, vol. 22, p. 174). The reviewer of the Athenaeum wrote that "Words cannot convey a sense of the glory of colours, nor do justice to the expression of the pencil. . . . The animal nature is, we fear, too strong for the human nature: the clucking-hen is equal to the highland wife; and there is a black bull which some prefer to the man who drives him."

41.

A SCENE IN THE GRAMPIANS—THE DROVERS' DEPARTURE (also called HIGHLAND DROVERS' DEPARTURE)
By 1835
Oil on canvas, 49½ x 75¼" (125.8 x 191.2 cm)
Provenance: commissioned by the 6th Duke of Bedford; John Sheepshanks Bequest to the Museum, 1857
Exhibitions: London, R.A., 1835, no. 167; Paris, Exposition Universelle, 1855, no. 861
Reviews: Athenaeum, no. 394, May 16, 1835, p. 379; The Times, May 23, 1835, p. 5f, February 1, 1842, p. 5f; three newspaper cuttings, The Anderdon Royal Academy catalogues, Royal Academy Library, London, vol. 22, 1835, p. 174; Art-Union (1839), pp. 6, 149 (1841), pp. 127, 141; Art Journal (1855), p. 281; Theophile Gautier, Les Beaux-Arts en Europe —1855 (Paris, 1855), p. 75
Literature: "The Highland Drovers," pamphlet produced by Hodgson & Graves in connection with the print (London, c. 1841); Waagen, 1854–57, vol. 2, p. 300; V & A Catalogues, 1857, p. 16, no. 88, 1877, pp. 52–53, 1893, pp. 83–84, 1907, p. 76; Early Works, 1869, p. 57, pl. 12; Landseer Gallery, 1871, pl. 21; Dafforne, 1873, pp. 13–14; Stephens, 1874, pp. 96–97, pl. 11; Mann, 1874–77, vol. 1, p. 105; Graves, 1876, p. 18, no. 207; Landseer Gallery, 1878, pl. 14; Philip Gilbert Hamerton, Graphic Arts (London, 1882), pp. 242–43; Frith, 1887–88, vol. 1, pp. 204–5; Manson, 1902, pp. 79, 81–82; Whitley, 1930, p. 299; Lennie, 1976, pp. 54–55, 82
Unpublished sources: J. H. Watt to Landseer, June 24, 1837 (V & A, Eng MS, 86 RR, vol. 5, no. 318); two receipts made out to Watt (British Library, London, Add MS, 46140, f. 55, 74)
Prints after: engravings by J. H. Watt, 1841 (18¾ x 28⅝"); Herbert Davis, 1859 (PSA, 1892, vol. 1, p. 168); William Roffe for Library Edition, 1881–93, vol. 2, pl. 56 (PSA, 1892, vol. 1, p. 209); hen and chicks, as "The Defense," C. G. Lewis, 1852 (PSA, 1892, vol. 1, p. 85); etching by John Burnet
Related works: oil sketch of white pony, with a Highlander and his daughter (11⅜ x 17"), Wallace Collection, London

VICTORIA AND ALBERT MUSEUM, LONDON

42.

Return from the Staghunt

This long, processional picture celebrates the pleasures of Highland sport and scenery in a nostalgic and picturesque vein. The chieftain, fourth from the left, the leader of his people, brings home the spoils of the noblest of sports. He is preceded by a ghillie with two hounds, a bagpiper piping him home, a collie and a hound, and a little boy who is perhaps his son and heir. The chief is flanked by two more retainers and followed by two of those characterful, shambling Highland ponies, bearing the dead stags; the somber and fateful mood of mortality in the earlier *Highlanders Returning from Deerstalking* (no. 29) is gone. Behind the ponies come two deerhounds, one of them Landseer's Hafed, their heads silhouetted against water with heroic effect. Then a pair of amorous ghillies, flanking two pretty gleaners, are watched by an old crone; this is a motif of rustic courtship in which masculine and feminine qualities are contrasted. From this group the eye is led on past two old ladies in white bonnets, down the road where farther groups of figures can be seen, and into the depth of the picture space, to the trees and rocks, the hazy hillside, the still blue water, the majestic peaks, one on the right capped with snow, and the golden sky. Human beings and nature seem at one in this distilled and luminous late-afternoon landscape.

Landseer's picture is an image drawn from the romantic past, celebrating the ideals rather than the actualities of Highland life. Significantly, the figure of the chieftain is a portrait of the artist's close friend the 2nd Marquess of Abercorn, later 1st Duke of Abercorn, who shared his passion for the Highlands. The setting is almost certainly Loch Laggan, with a view from the east end, but the bridge has not been identified. The Abercorns had a lodge on Loch Laggan, at Ardvereike, where Landseer often stayed.

The picture's unusual format must have been dictated by an architectural space it was painted to fit, but this has not been identified, either at Lansdowne House in London, or at Bowood, the now largely demolished country seat of the Lansdownes in Wiltshire. Until the present exhibition, the picture had not been identified as the work exhibited in 1837 as "The Highlands"; Algernon Graves and all later authorities had dated the picture 1834. The reviews of the picture in 1837 are, however, unambiguous.

Unfortunately no correspondence between Landseer and his patron, who also owned the early *Boar Hunt* (1821, location unknown), has yet come to light in the Lansdowne archives. The 3rd Marquess was a prominent statesman, serving in successive Whig administrations, and a noted collector and patron of the arts.

42.

THE HIGHLANDS (also called CROSSING THE BRIDGE and RETURN FROM THE STAGHUNT)
By 1837
Oil on canvas, 14 x 63″ (35.5 x 160 cm)
Provenance: the 3rd Marquess of Lansdowne, by descent
Exhibitions: London, R.A., 1837, no. 160; Liverpool Academy, Autumn Exhibition, 1838, no. 48; London, 1874, no. 437; Sheffield, 1972, no. 47
Reviews: Athenaeum, no. 497, May 6, 1837, p. 330; *Gentleman's Magazine,* n.s., vol. 7, part 1 (1837), p. 629; *Morning Post,* May 15, 1837, p. 6b
Literature: Mrs. Jameson, *Companion to the Most Celebrated Private Galleries of Art in London* (London, 1844), p. 325, no. 135; Waagen, 1854–57, vol. 3, p. 164; Mann, 1874–77, vol. 2, p. 62; Graves, 1876, p. 17, no. 198; Manson, 1902, p. 81; *Catalogue of the Collection of Pictures . . . at Lansdowne House* (London, 1897), p. 51, no. 205; Lindsay Errington, "Monarchs of Glen Tilt," *Connoisseur,* vol. 196 (November 1977), p. 211, repro. pp. 210–11
Prints after: engravings by James T. Willimore, 1847 (11½ x 38¼″) and 1859 (9 x 30″); C. G. Lewis, 1850; T. A. Prior, 1881 (all *PSA,* 1892, vol. 1, p. 73); William Roffe for *Library Edition,* 1881–93, vol. 2, pl. 40 (*PSA,* 1892, vol. 1, p. 209)
Related works: head of Hafed, Landseer's deerhound (17¼ x 23″), private collection, Scotland, from the Miller Collection, Christie's, April 26, 1946, lot 59 (there are numerous versions and copies of this head)
PRIVATE COLLECTION

Landscapes

The sale of Landseer's works in 1874 included more than a hundred small landscape sketches, most of them Highland scenes. Almost none of them had been exhibited, and they are not stressed at all in contemporary literature about the artist. He seems to have done them purely for his own pleasure, during his early trips to Scotland. Few can be dated with any certainty, but close stylistic affinities suggest a burst of activity between approximately 1825 and 1835.

Landseer is not generally thought of as a landscapist at all. Among his early drawings, however, are a considerable number of views, including a sketchbook in the Royal Collection with soft, chalky landscapes rather in the Dutch manner. There is little to link them with the later Scottish studies. The specific influences at work here are more difficult to determine. They are less composed than the views of contemporary landscapists, and there are few obvious parallels for their qualities of directness and transparency. Although painted on a small scale, they convey an atmosphere of space and breadth.

The landscapes are mostly mountain views, wild and solitary places, only rarely with any human or animal presence. The foreground may be accentuated by a dead tree or a fallen branch, but the eye is led into distant perspectives, often framed by mountain slopes sweeping into a valley. There are views across lakes, treated in a flatter, more layered composition, such as the view of Shelter Stone Cross across Loch Avon in the Cairngorms (no. 44). He sketched close-up views of streams with tumbling rocks and an occasional picturesque bank with a tree on top. There are also more self-conscious set-pieces like Dunrobin Castle (no. 48) and the Emperor Fountain at Chatsworth (no. 47). Dunrobin, the seat of the dukes of Sutherland on the east coast of Scotland, which Landseer sketched when he came to stay at the castle to paint the 2nd Duke's children, also appears in the background of their portrait (no. 79). The Emperor Fountain, which has a spectacular shoot of

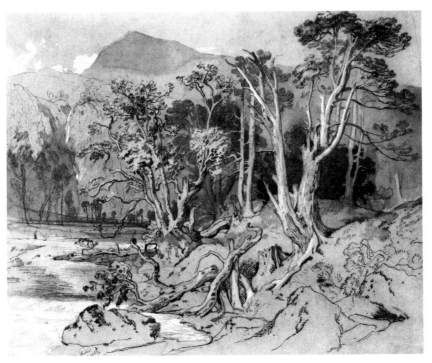

43.

43.
GLENFESHIE
1827
Pen and ink, heightened with white chalk, on paper, 10⅜ x 12¾" (26.4 x 32.5 cm)
Inscribed and dated lower left: *Glen Fishie*/1827
Provenance: Holbrook Gaskell sale, Christie's, June 24–25, 1909(?), lot 213 (as "Glenfeshie," 10 x 14"); Spink & Son, London
Exhibition: London, Spink & Son, *English Watercolour Drawings*, 1979, no. 76
PRIVATE COLLECTION

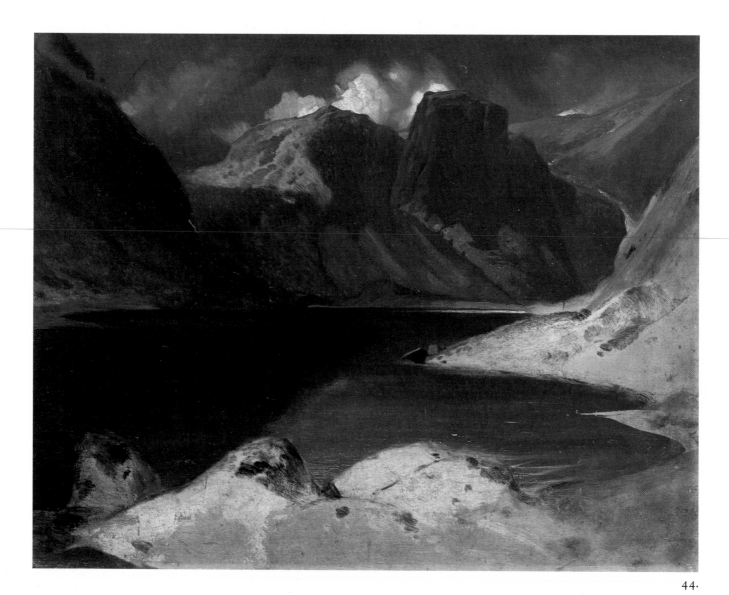

44.

44.

A LAKE SCENE: EFFECT OF A STORM
1833(?)
Oil on panel, 14 x 17½″ (35.5 x 44.5 cm)
Provenance: Artist's sale, 1874, lot 66;
anonymous sale, Christie's, July 11, 1947, lot
99; purchased by the Gallery, the same year
Exhibitions: London, 1961, no. 21;
Edinburgh, National Gallery of Scotland,
The Discovery of Scotland, 1978, no. 93
Literature: Gaunt, 1972, pl. 59

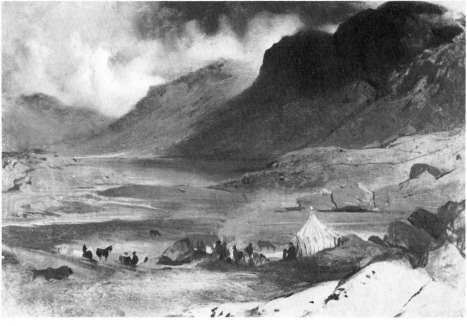

45.

45.

ENCAMPMENT ON LOCH AVON
1833
Oil on board, 8½ x 12¼" (21.5 x 31 cm)
Signed lower right: *EL*
Inscribed and dated on reverse: *Loch Avon 9 Sept 1833*
Provenance: Artist's sale, 1874, lot 17 (as "Head of a Highland valley: effect of storm"); H. W. Eaton, later Lord Cheylesmore, his sale, Christie's, May 7, 1892, lot 36; bt. Palser Gallery, London, c. 1938, from a country-house sale near Cromer, Norfolk; Robert Frank, London; Nicholas Argenti, 1946, by descent
Exhibitions: London, 1961, no. 17; Sheffield, 1972, no. 43
PRIVATE COLLECTION

water, was installed by the 6th Duke of Devonshire, with the assistance of Joseph Paxton, in the canal pond to the south of Chatsworth, where Landseer, who painted *Bolton Abbey* (no. 73) and *Laying Down the Law* (no. 140) for the duke, was a regular guest from the early 1830s. Presumably, when Landseer was at work on *Bolton Abbey,* in the early 1830s, he painted the distant view of the ruined abbey on the banks of the river, with a heron crossing a wide and luminous pool, conveying a haunting sense of solitude (no. 46). Apart from the Highlands, Landseer is known to have painted pictures at the Duke of Bedford's houses in Devonshire, Endsleigh, in the Lake District, and in Ireland.

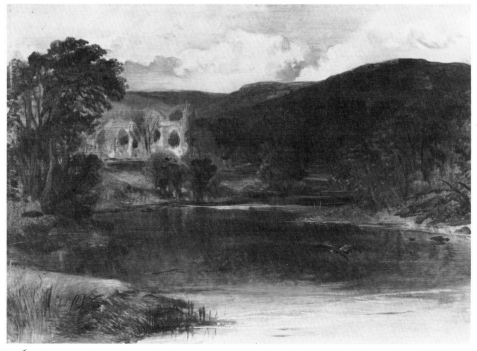

46.

46.

BOLTON ABBEY
Oil on millboard, 10 x 14" (25.5 x 35.5 cm)
Provenance: Artist's sale, 1874, lot 28; Thomas Agnew & Son; Dr. Lloyd Roberts, by 1901; his bequest to the Gallery, 1920
Exhibitions: Glasgow, International Exhibition, 1901, no. 26; Manchester, City Art Galleries, *Paintings, Prints and Drawings in the Lloyd Roberts Bequest,* 1921, no. 212; Sheffield, 1972, no. 28
CITY OF MANCHESTER ART GALLERIES

47.

47.

THE EMPEROR FOUNTAIN, CHATSWORTH
Oil on board, 10 x 14" (25.5 x 35.5 cm)
Provenance: Artist's sale, 1874(?), lot 235
(as "A View at Chatsworth"); A. Myers,
1879; Hazlitt, Gooden & Fox, London
Literature: Art Journal (1876), p. 290, and
Monkhouse, 1879, p. 73, fig. 51 (as a
woodcut)
PRIVATE COLLECTION

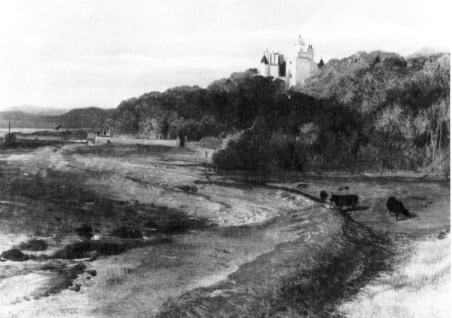

48.

48.

LANDSCAPE WITH DUNROBIN CASTLE
c. 1835
Oil on board, 10⅜ x 14⅜" (26.4 x 36.5 cm)
Provenance: Artist's sale, 1874(?), lot 60
(as "Dunrobin")
Exhibition: London, 1961, no. 39
PRIVATE COLLECTION

Of all the places where Landseer painted, his favorite sketching ground was the remote valley of Glenfeshie. The steep and distinctive shape of its hills can be seen in the backgrounds of many of the sketches *(see no. 50).* It was here that Landseer spent so much time with the Duchess of Bedford, who had constructed a series of rough huts as a retreat. Landseer's sketch (no. 49) shows the entrance to one of the duchess's huts, decorated with stags' heads, with a Highlander leaning against the turf-covered walls. Inside the hut is a trunk or box, a chest of drawers, a silver chafing dish with candlesticks, and a glass decanter, suggesting greater luxury than that of the hut's rude construction. One expedition by the Duchess of Bedford and her party from Glenfeshie to Loch Avon in the Cairngorms, in September 1833, is described at length by

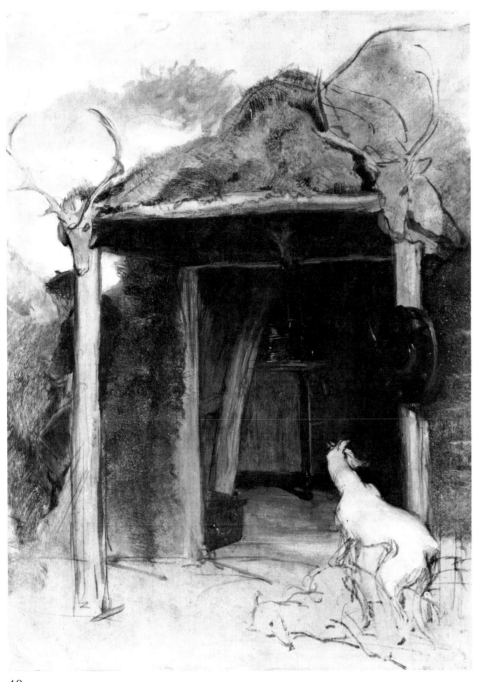

49.

49.
EXTERIOR OF THE DUCHESS OF BEDFORD'S
HUT AT GLENFESHIE
Oil on board, 24 x 18" (61 x 45.8 cm)
Provenance: Artist's sale, 1874(?), lot 41
(as "Study of a Doorway"); Leicester
Galleries, London
Exhibition: London, 1961, no. 46
HENRY P. MCILHENNY

Lord Ossulston, later the 6th Earl of Tankerville, in his pamphlet, "The Chillingham Wild Cattle. Reminiscences of Life in the Highlands" (privately printed, 1891, pp. 25–30). He wrote that a tent was carried for use by the women, while the men slept rough in a cave above the loch. They passed the evening around a camp fire, entertaining one another with ballads, glees, and reels. Landseer recorded the encampment in an oil sketch (no. 45).

The prevailing tonality of the landscape sketches is gray and somber, broken and stormy effects of cloud and sky, but shot through with brilliant passages of light. Nature is recorded in its most fleeting and dramatic circumstances, the weather sweeping across wild expanses of country, and vividly experienced. The sketches are painted very rapidly, in subtle, transparent glazes, and it is impossible to believe that they were not executed out-of-doors in front of the motif. Those that have been identified, especially the group of Glenfeshie

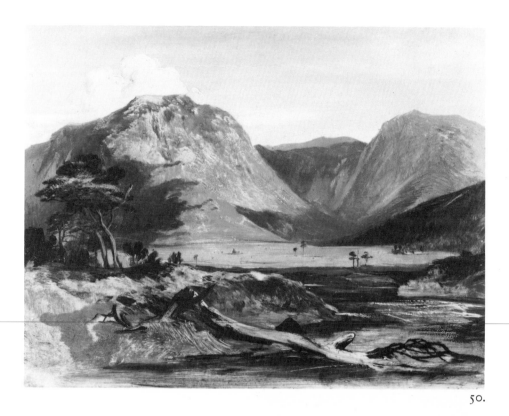

50.

50.

GLENFESHIE
Oil on board, 10½ x 13¼" (26.7 x 33.7 cm)
Provenance: Hazlitt, Gooden & Fox, London
LORD DULVERTON

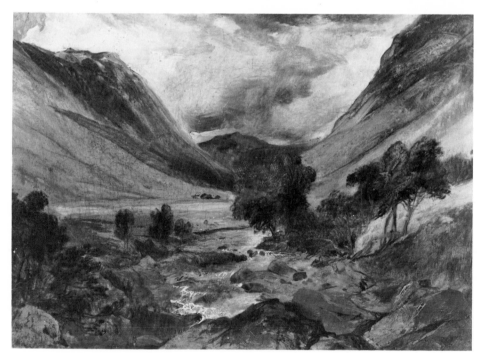

51.

51.

HIGHLAND LANDSCAPE
Oil on board, 10 x 13½" (25.5 x 34.3 cm)
Provenance: Artist's sale, 1874, lot 45 (as "A
Highland River Scene"); said to have been sold
at Christie's, c. 1924; H. Nicholson, his sale,
Christie's, March 22, 1968, lot 100; Leggatt
Brothers, London
LORD DULVERTON

views, suggest that Landseer painted very accurately what he saw and did not rearrange the scenes to suit his compositions. They record the pleasure and excitement that he experienced in Highland scenery, and do not seem to have been painted at the time for use in his finished subject paintings, although he may have drawn a view of Loch Laggan (no. 53) on a visit in 1847 for his conversation piece of Queen Victoria, with her children, sketching at Loch Laggan (no. 111). His impressionable and romantic temperament is as keenly felt in his landscapes as in his other work.

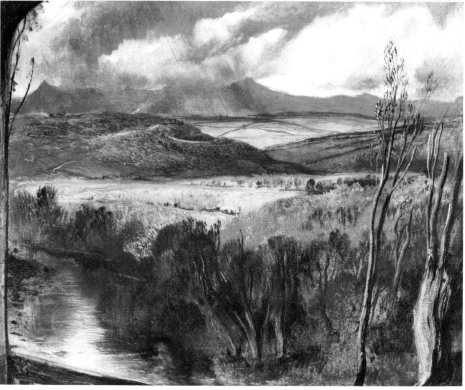

52.

52.

HIGHLAND LANDSCAPE

Oil on board, 8 x 10" (20.3 x 25.5 cm)
Signed lower left: *EL*

Provenance: Artist's sale, 1874, lot number
not identified; Lord Armstrong, his sale,
Christie's, June 24, 1910, lot 71; Thomas
Agnew & Sons; anonymous sale, Christie's,
January 25, 1974, lot 34, bt. Roy Miles;
Paul Mellon

Exhibition: London, Thomas Agnew & Sons,
Victorian Painting, 1961, no. 40

YALE CENTER FOR BRITISH ART, NEW HAVEN

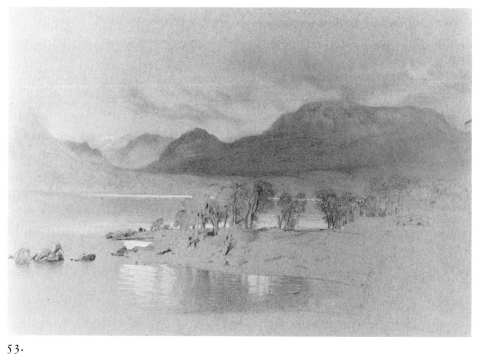

53.

53.

LOCH LAGGAN

1847(?)

Colored chalk on paper, 9¾ x 14¼" (24.8 x
36.2 cm)

Provenance: acquired by Queen Victoria
Literature: Art Journal (1877), p. 193,
and Monkhouse, 1879, p. 101, fig. 70
(as a woodcut)

HER MAJESTY QUEEN ELIZABETH II

The Noble Dog—Early Subjects, 1826-1839

LANDSEER'S DOG PAINTINGS of the 1830s constitute one of the high points of his art and form a coherent group of work by virtue of their subject matter and the narrative and imaginative ideas that are common to them. They include some of his most popular works, if not his largest or most important. Of the paintings of dogs, about half were commissioned portraits, the others independent subject pictures. The portraits are generally on the scale of life, and the animals are more self-consciously posed. The subject pictures tend to be cabinet works, with more narrative content and greater range of feeling. But whether commissioned or not, each picture has its own story and mood. The earlier dog pictures are relatively straightforward, often showing confrontations between dogs and absurdly small creatures like rats, frogs, or hedgehogs. With *Low Life* and *High Life* (nos. 58, 59) and *The Poor Dog* (no. 61) a new element is introduced. Through the character of the dogs and the settings in which they are placed, we are led to speculate about their absent owners, whose status and occupations they reflect; on the nature of the relationship between man and dog; and, by extension, on the human values that the animals represent. In *The Poor Dog* and *Attachment* (no. 60), we see dogs in situations of extreme self-sacrifice and devotion, and the love they display is all the more poignant because they are dumb and powerless. *A Jack in Office* (no. 62) is an anthropomorphic fable, in which we interpret modes of canine behavior in terms of their human equivalents; the eternal battle between the haves and the have-nots. These pictures revolve around narrative situations, which provoke speculation without satisfying it. In *Suspense* (no. 63), we are left wondering what has happened, where, and to whom, as in an unsolved mystery. Even in a commissioned work as filled with personal allusions as *Mustard* (no. 65), Landseer cannot resist putting a cat among the woodcock. In paintings from the end of the decade, like *Dignity and Impudence* (no. 68) and the groups of royal pets, he develops a more humorous and satirical vein.

As an animal painter Landseer stands on his own. Contemporary sporting artists obstinately remained sporting artists, and it was not until the 1840s that Landseer's brand of animal painting began to attract a following. Landseer's links are with the genre and literary painters of the period in his ability as a storyteller; like theirs, his pictures are concerned with moralities and feelings. The image of the dog that Landseer presents has parallels in contemporary literature; dogs figure largely in the novels of Sir Walter Scott and Charles Dickens, for example, as creatures of feeling and intelligence. In Renaissance literature the image of the dog was invariably used for something base and unclean. The emergence of the dog in the role of the devoted companion of man is a phenomenon of the eighteenth century and the age of sentiment. The dog was no longer a scavenger or an adjunct to sport but had become endowed with noble qualities. The cult of the pet was an emanation of the romantic imagination, which suffused human emotions with the world of nature. Allied to this was the growing popular interest in natural history and in animal character and behavior. Landseer's detailed anatomical knowledge—his wonderful feeling for the character and texture of animal life—satisfied the quasi-scientific outlook of his audience, while his visual stories allowed uninhibited enjoyment of loving and faithful dogs in a wide range of dramatic situations.

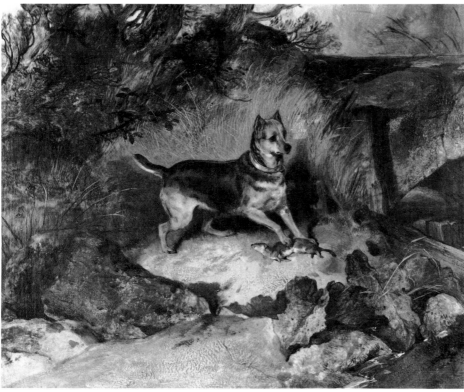

54.

54.
ZIPPIN
1826
Oil on panel, 14 x 18″ (35.6 x 45.8 cm)
Signed and dated on plank lower right:
EL 1826
Provenance: Countess of Ellesmere, by
descent
Exhibition: London, 1961, no. 8
Literature: Gaunt, 1972, pl. 28
Shown only in London
THE DUKE OF SUTHERLAND

Zippin

Zippin was a smooth-coated, old English black-and-tan terrier belonging to Lady Harriet Leveson-Gower, later Countess of Ellesmere. No correspondence about the commission has yet come to light, but Landseer later painted the Ellesmere family in a group entitled *Return from Hawking* (by 1837, collection of the Duke of Sutherland).

The study of Zippin is one of the most beautiful of Landseer's early, small-scale studies of dogs. The dog is shown in a taut and springy pose, his paw resting in triumph on a stoat he has just killed. (The hunting prowess of their respective dogs was frequently discussed by the painter and his friends.) Zippin looks up eagerly, perhaps on the alert for another stoat, or possibly for the approach of his owner. The landscape elements are seen close at hand, serving as a frame for the dog rather than assuming an independent function as in the earlier *The Dog and the Shadow* of 1822 (Victoria and Albert Museum, London). The terrier is highlighted in the center of the composition, as if on a stage. The scale of the work is perfectly adapted to its subject, and the quality of painting is clear and transparent. Other outdoor studies of dogs in the same idiom include *Puppy Teasing a Frog* (1823, Harris Art Gallery, Preston), *Bob, a Favorite Terrier with a Rat* (1824, private collection), and *Jocko with a Hedgehog* (no. 57).

A Scene at Abbotsford

This picture vividly conveys the atmosphere of Sir Walter Scott's house at Abbotsford, in the border region of Scotland, which Landseer had first visited in 1824. Lying on a deerskin rug is Scott's senile deerhound, Maida, another deerhound stands on the left, and scattered about are various historical and sporting objects of the kind with which Scott loved to surround himself: a stool with a velvet cushion on which stands an etched Italian close helmet of

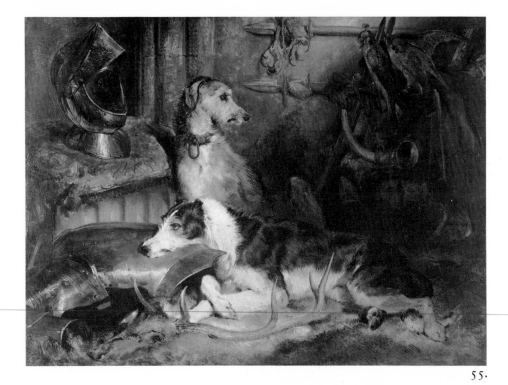

55.

55.
A SCENE AT ABBOTSFORD
By 1827
Oil on panel, 17½ x 23½" (44.5 x 59.7 cm)
Provenance: presented by the 6th Duke of
Bedford to William Adam, of Blair Adam,
Lord Chief Commissioner of the Jury Court of
Scotland; Sir Henry Tate, his gift to the
Gallery, 1894
Exhibitions: London, B.I., 1827, no. 313;
Edinburgh, Institution for the Encouragement
of the Fine Arts in Scotland, 1828, no. 30
Literature: The Keepsake (London, 1829),
pp. 258–261; Stephens, 1874, p. 80; Mann,
1874–77, vol. 2, p. 121c; Graves, 1876, p. 11,
no. 127; *Journal of Sir Walter Scott* (London,
1890), vol. 2, pp. 118, 121; Tate Gallery
Catalogue, 1898, pp. 77–79; Manson, 1902,
p. 76; *Scott Letters,* 1932–37, vol. 8, p. 392,
vol. 10, p. 155, vol. 12, p. 19
Unpublished sources: the Duke of Bedford to
William Adam, June 11, 1827 (Adam Papers,
Blair Adam, Scotland)
Prints after: engraving by Charles Westwood
for *The Keepsake,* London, 1829
THE TRUSTEES OF THE TATE GALLERY, LONDON

c. 1570; a breastplate, right arm, and shoulder of a sixteenth-century Italian white armor, together with a Scotch cap; on the right is an eighteenth-century-style armchair, with two arms ending in carved male heads, over one of which is looped an antique hunting horn, not unlike one that Scott himself owned; leaning against the chair are two short spears with green tassles, and on the arm is one hooded and one unhooded falcon, together with a voluminous cloak; on the wall behind are two boar spears, one draped with eagle's talons; on the floor is an unusual deerskin rug incorporating the head and antlers of a stag.

Scott discussed the picture at length in the text accompanying *The Keepsake* engraving (London, 1829), which was apparently done at his request. Maida, of immense size and weight, was a cross between a Pyrenean sheep dog and a Scottish greyhound. He had been bred by the eccentric Highland chieftain Macdonnell of Glengarry, who gave the dog to Scott, "with whom he lived many years, and whom he seldom quitted. As Maida always attended his master when travelling, he was, when in a strange town, usually surrounded by a crowd of amateurs, whose curiosity he indulged with great patience until it began to be troublesome, when a single short bark gave warning that he must be urged no further. . . . He was as sagacious as he was high-spirited and beautiful, and had some odd habits peculiar to himself. One of the most whimsical was a peculiar aversion to artists of every description. . . . When Mr. Landseer saw Maida, he was in the last stage of weakness and debility, as the artist has admirably expressed in his fading eye and extenuated limbs. He died about six weeks afterwards. . . . The armour and military weapons are characteristic of the antiquarian humour of the owner of the mansion. . . . The hawks are the gratuitous donation of Mr Landseer, whose imagination conferred them on a scene where he judged they would be appropriate. . . . The other dog represented in the picture is a deerhound, the property of the artist, and given to him by the Duke of Atholl. . . . In the principal figure especially, it would be difficult to point out a finer exemplification of age and its consequences acting upon an animal of such beauty and strength" (*The Keepsake,* London, 1829, pp. 259–61).

Writing at the time of Landseer's visit to Abbotsford in October 1824, Scott told a friend: "He has drawn old Maida in particular with much spirit indeed and it is odd enough that though I sincerely wish old Mai had been younger I never thought of wishing the same advantage for myself" (*Scott Letters*, 1932–37, vol. 8, p. 392). Later he called it "a beautiful study by Landseer made at Abbotsford quite to my mind with dogs and armour" (vol. 10, p. 155), and he recorded how much it was admired at the Edinburgh exhibition of 1828. Writing to William Adam to give him the picture, the Duke of Bedford added a few details: "It was begun in his [Scott's] study at Abbotsford some years ago, and has been finished this year . . . the whole thing forms a sort of historical record as connected with so celebrated a writer" (June 11, 1827, Adam Papers, Blair Adam, Scotland).

Like Landseer's later dog subjects, the picture suggests intriguing narrative possibilities. The way in which Maida lies on the breastplate recalls *The Old Shepherd's Chief Mourner* (no. 66), and the picture could be read as a memorial to a dead warrior. Discarded armor is also a traditional emblem of Mars with Venus.

An oil sketch of Maida lying down in an attitude similar to that shown in this picture was etched by the artist in 1824 (9½ x 13⅝", exhibited London, 1874, no. 458). Maida also appears in the posthumous full-length portrait of Scott by Landseer (Royal Academy, London, 1833, no. 351) and in the later *Extract from My Journal Whilst at Abbotsford* (British Institution, London, 1858, no. 4).

Bashaw

Bashaw was a favorite Newfoundland dog belonging to the 1st Earl of Dudley, of the black-and-white variety known as a Landseer, after the artist. These big dogs were very much in vogue during the early nineteenth century, and they often figure in sporting pictures and family groups. Lord Dudley must

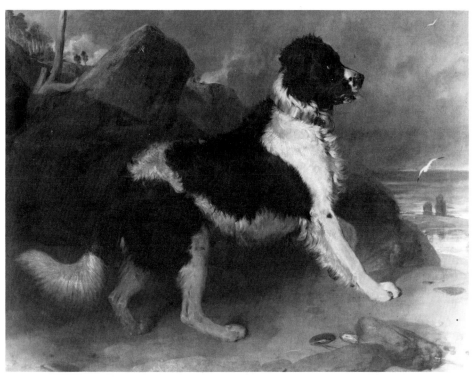

56.

56.

BASHAW, THE PROPERTY OF THE RIGHT HONORABLE EARL OF DUDLEY (also called OFF TO THE RESCUE)
1827
Oil on canvas, 53 x 71" (134.7 x 180.3 cm)
Provenance: commissioned by the 1st Earl of Dudley; Dudley sale, Christie's, June 16, 1900, lot 40, bt. Davis; the 5th Earl of Carysfoot, by descent
Exhibition: London, R.A., 1829, no. 291
Reviews: Gentleman's Magazine, vol. 99, part 1 (1829), p. 537; *Athenaeum*, no. 83, May 27, 1829, p. 331
Literature: Mann, 1874–77, vol. 2, p. 72; Graves, 1876, p. 13, no. 152; Tancred Borenius and Rev. J. V. Hodgson, *A Catalogue of the Pictures at Elton Hall* (London, 1924), p. 97, no. 121; *see* John Harris, "The Story of the Marble Dog," *Country Life* (London), vol. 122 (November 21, 1957), p. 1085
Unpublished sources: the Earl of Dudley to Landseer, July 14, 1827, December 15, 1827, discussing sittings, the completion of the picture, and the amount of his debt (V & A, Eng MS, 86 RR, vol. 2, nos. 100–101)
Prints after: engravings by Thomas Landseer, 1858 (23¼ x 29⅞"); Alfred Lucas, 1874 (both *PSA*, 1892, vol. 1, p. 265); C. A. Tomkins for *Library Edition*, 1881–93, vol. 2, pl. 73 (*PSA*, 1892, vol. 1, p. 210)
PRIVATE COLLECTION

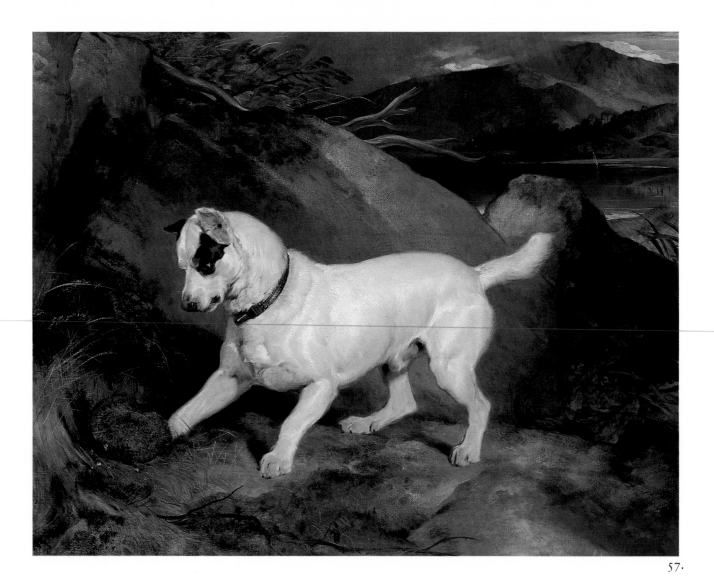

57.

have been devoted to Bashaw, because in addition to the Landseer, he commissioned from Matthew Cotes Wyatt an elaborate and expensive multicolored-marble statue of the dog trampling on a snake, which is now in the Victoria and Albert Museum, London.

The lifesaving abilities of Newfoundland dogs, like those of the Saint Bernard, were well known. Landseer hinted at this by showing the dog on the seashore, apparently on the verge of leaping into action. The heroic scale of the work and the profile pose recall some life-size studies of dogs by the eighteenth-century painter George Stubbs. The picture is a closely observed animal study, but full of movement and feeling. Landseer had painted a similar picture of a Newfoundland dog named Lion in 1823 for William H. de Merle, now in the Victoria and Albert Museum. His most famous rendering of the breed is the *Distinguished Member of the Humane Society (see no. 67)*.

Jocko with a Hedgehog

This picture continues the theme of *Zippin* (no. 54), but on a larger scale, and in a much more dramatic style. Landseer needed incident and narrative to bring his commissioned portraits of dogs to life. The fox terrier, eagerly eyeing the hedgehog and waiting for a chance to pounce, is painted with great force. His vibrant and gleaming white body stands out with startling effect from the grayish brown rocks and ferns. The stormy landscape beyond, perhaps

57.

PORTRAIT OF A TERRIER, THE PROPERTY OF OWEN WILLIAMS, ESQ., M.P. (also called JOCKO WITH A HEDGEHOG)
1828

Oil on canvas, 40 x 50" (102 x 127 cm)
Signed and dated lower right: EL/1828
Provenance: Owen Williams; his son, Col. Thomas Peers Williams; Gen. Owen Williams; anonymous sale, Christie's, June 15, 1891, lot 65; anonymous sale, Robinson & Fisher, London, November 19, 1908, lot 127; given to the Museum by Erwin C. Uihlein, 1967
Exhibitions: London, R.A., 1828, no. 454; London, 1874, no. 438; London, R.A., *Old Masters,* 1890, no. 15
Reviews: The Times, May 20, 1828, p. 3e; *Athenaeum,* no. 3253, March 1, 1890, p. 282
Literature: Graves, 1876, p. 13
Prints after: engraving by T. L. Atkinson, 1889 (PSA, 1892, vol. 1, p. 190); lithograph by Edmund Havell, Jr.
Related works: replica, signed and dated 1828, Sotheby's Belgravia, April 9, 1980, lot 9, bt. Spink; drawing of two dogs attacking a hedgehog, private collection, Wales (Monkhouse, 1879, pl. 32)
MILWAUKEE ART MUSEUM, GIFT OF ERWIN C. UIHLEIN

98

painted at Loch Laggan, heightens the drama in the foreground and pitches the work in a high, romantic key. A typical Landseer motif is the bare, projecting branch in the center, along which the light plays. Action and stillness, light and dark, nearness and distance—these are the contrasts around which the picture is constructed.

The first owner of the picture was Owen Williams, of Temple House, Bucks, a landowner and member of Parliament.

Low Life and High Life

Humorous contrasts of types, characters, and styles of life lay at the very root of Landseer's imagination. Among his earliest etchings were pairs of lean French hogs and fat British boars (nos. 7, 8). There is a long literary and pictorial tradition behind the idea of such contrasts, which usually have a moral or religious purpose—vice and virtue, the chosen and the damned. In seventeenth- and eighteenth-century plays and novels, the amorality and the frivolity of fashionable London life are often set against the simple virtues of the country.

In Landseer's pictures the two dogs stand for totally different worlds: upper and lower class, pedigree and low breeding, wealth and poverty, past and present, evening and morning, country and town. The contrast is one of character rather than one of morality; we are not expected to take sides but to see the dogs as representatives of their absent owners, each with his own values. The deerhound in *High Life* (no. 59) reflects the chivalric and aristocratic world of the past. The interior, with a glimpse of a castellated tower through the window, is reminiscent of Sir Walter Scott's house at Abbotsford in the Scottish borders. One source erroneously identified the dog as Scott's favorite Maida, but in pose and coloring it is much closer to Landseer's own deerhound, which appeared with Maida in the *Scene at Abbotsford* (no. 55). The chair is contemporary, but scattered about are various historical props that conjure up a romantic and luxurious atmosphere: hawking gloves, two rapiers, a sixteenth-century-style helmet and breastplate, a standing cup, old leather-bound books, a partially unrolled document, a quill pen, a candlestick made from an eagle's talon, and a bellpull.

The battle-scarred terrier, with cropped ears, in *Low Life* (no. 58) fiercely guards his master's shop. He represents the tough, plebeian, urban values of "John Bull." His Hogarthian pugnacity is matched to the surrounding accessories, which are painted with telling realism and feeling for the subtleties of light: the rough and weathered stone step and doorway, the scarred butcher's block with a knife and a bottle on it, the absent butcher's top hat and worn boots, his beer tankard and clay pipe, his whip and key hanging on a hook on the right. In the etching of 1822 (Graves, 1876, p. 7, no. 55), which anticipates *Low Life,* the dog is identified as Jack, and he belongs to the tradition of Landseer's rambunctious, low-life, early dog subjects. Several later critics were to regret the gradual disappearance of this element in his work, although there were to be some notable successors in the genre, among them *A Jack in Office* (no. 62), which may be the same dog.

58.
LOW LIFE
59.
HIGH LIFE
1829
Both oil on panel, 18 x 13 ½" (45.7 x 34.3 cm), in one frame
Both signed and dated lower right: *EL. 1829*
Provenance: purchased by William Wells of Redleaf, according to the *Examiner*, no. 1204, February 27, 1831, p. 132; Robert Vernon, his gift to the National Gallery, 1847, transferred to the Tate Gallery, 1900
Exhibition: London, B.I., 1831, no. 248
Reviews: Examiner, no. 1204, February 27, 1831, p. 132; *Kunstblatt* (1831), p. 357
Literature: Art Journal (1849), p. 370; Waagen, 1854–57, vol. 1, p. 382; *Early Works*, 1869, p. 50, pls. 4, 5; *Landseer Gallery*, 1871, pls. 7, 8; Dafforne, 1873, pp. 24, 26; Stephens, 1874, pp. 80, 81, pls. 5, 6; Mann, 1874–77, vol. 1, pp. 147–48; Graves, 1876, p. 13, nos. 149, 150; *Landseer Gallery*, 1878, pls. 5, 6; Monkhouse, 1879, p. 63; National Gallery Catalogue, 1888, p. 85; Manson, 1902, p. 67; Ruskin, 1903–12, vol. 7, p. 349; Tate Gallery Catalogue, 1913, p. 136; Lennie, 1976, pp. 51, 89
Unpublished sources: Landseer to R. J. Lane, August 3, 1834, praising his lithographs (Lane MS, National Portrait Gallery Archives, London)
Prints after: engravings by H. S. Beckwith for *Art Journal* (1849), pls. 24, 25; C. C. Hollyer, 1873 (PSA, 1892, vol. 1, p. 169); C. J. Tomkins for *Library Edition*, 1881–93, vol. 2, pls. 14, 19 (PSA, 1892, vol. 1, p. 209); lithographs by R. J. Lane, 1834, in reverse (15 x 11¾")
Related works: drawing for *High Life, Art Journal* (1876), repro. p. 196; etching, 1822, anticipating *Low Life*, Graves, 1876, p. 7, no. 55; oil sketch of dog's head in *Low Life* (11½" diameter), Lady Lever Art Gallery, Port Sunlight, from the James Orrock sale, Christie's, June 6, 1904, lot 268
THE TRUSTEES OF THE TATE GALLERY, LONDON

99

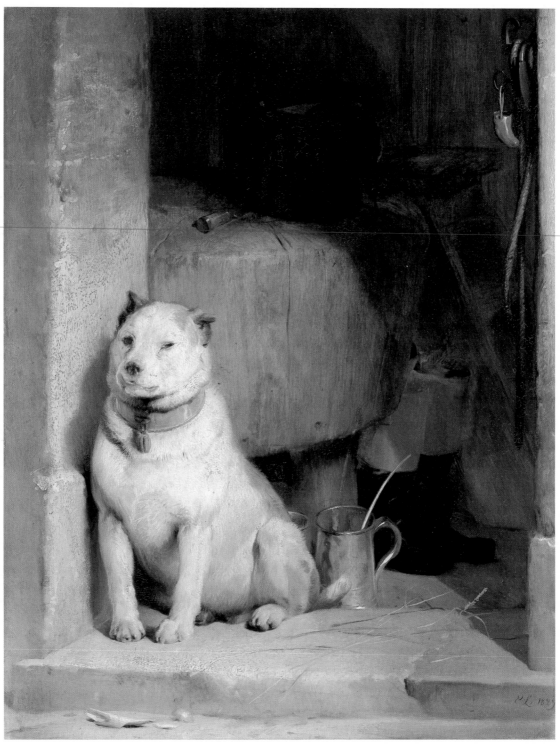

58.

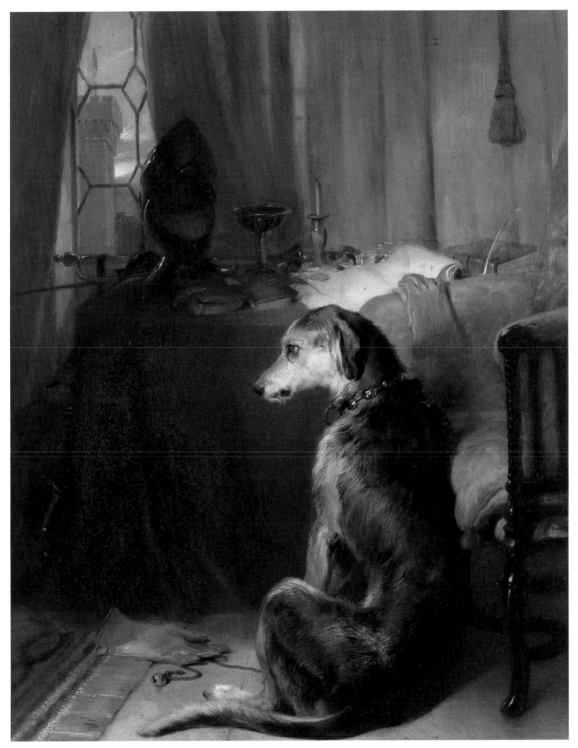

59.

Attachment

This picture illustrates Sir Walter Scott's short poem "Helvellyn," which recalls the death of a young man in 1805, who suffered an accident while climbing the mountain of that name in the Lake District and whose body lay undiscovered for three months, during which time his faithful terrier kept guard:

> Dark green was the spot mid the brown mountain-heather,
> Where the Pilgrim of Nature lay stretch'd in decay,
> Like the corpse of an outcast abandon'd to weather,
> Till the mountain-winds wasted the tenantless clay.
> Nor yet quite deserted, though lonely extended,
> For, faithful in death, his mute favourite attended,
> The much-loved remains of her master defended,
> And chased the hill-fox and the raven away.
> How long didst thou think that his silence was slumber?
> When the wind waved his garment, how oft didst thou start?
> How many long days and long weeks didst thou number,
> Ere he faded before thee, the friend of thy heart? . . .

When the painting was exhibited in 1830, the quotation in the Royal Academy catalogue (no. 342) inaccurately transcribed part of this poem and Scott's introduction to it. So far an independent account of the accident and the name of the person involved has not come to light.

Landseer's picture was described by Cathy Gordon as "an example of the tangential approach favoured by later illustrators of Scott," but it is, in fact, very close to the spirit of the original poem. The image of the lover lying prostrate on the remains of the beloved is a familiar romantic image. Landseer exploited the emotions associated with such an image and gave them new meaning by applying them to the relationship between a man and his dog. The faithful terrier, pawing at the body in a pitiable way as if seeking signs of life, takes the place of the wife or mistress, in a parody of human grief. The accident has evidently happened recently, because the corpse shows no weather stains or signs of decomposition. The pose of the man is contorted and rather theatrical; he is wedged in a cleft of the rocks, arms flung back, cap lying nearby, cloak wrapped around him like a winding sheet. The dramatically foreshortened view of the figure, a back view of the head from upside down, recalls the pose of the traveler in Landseer's earlier picture of a mountain disaster (no. 13). Although the general mood and theme of the two pictures are similar, *Attachment* is more poignant in the depth of the relationship revealed.

Landseer made the most of the disaster itself, posing the figures in a daring way at the bottom of the composition and suggesting in the spiraling shadow on the cliff the fall itself. It is the contrast of light and dark, the powerful treatment of the rocks, the sense of vertiginous heights and plunging depths in the mountainscape, which give the picture its imaginative force and prevent the composition from appearing empty and unbalanced. The figures of the man and the dog, framed by the rocks like a vignette, have a static, emblematic quality, like a tomb relief, amid the wild surroundings.

Attachment and *The Poor Dog* (no. 61) are among the earliest examples of a new genre in Landseer's work, and in Romantic art in general—canine love and loyalty for a man in the face of death. A contemporary example in a historical vein is Landseer's diploma work, *A Faithful Hound*, 1830 (Royal Academy, London). Another picture illustrating Scott's poem by H. Irvine was exhibited in London (British Institution, 1813, no. 169).

60.
ATTACHMENT
1829
Oil on canvas, 39 x 31¼" (99.1 x 79.5 cm)
Signed and dated: *EL 1829*
Provenance: purchased by Edward Rose Tunno; his sale, Christie's, July 11, 1863, lot 136, bt. Haines; William Delafield, his sale, Christie's, April 30, 1870, lot 87, bt. Agnew; R. K. Hodgson, his sale, Christie's, November 21, 1924, lot 17, bt. Sampson; anonymous sale, Sotheby's, July 12, 1967, lot 145, May 29, 1968, lot 170, bt. Lowndes Lodge Gallery, from whom acquired by present owner
Exhibitions: London, R.A., 1830, no. 342; Auckland, New Zealand, *British Taste in the 19th Century*, 1962, no. 33
Reviews: Athenaeum, no. 136, June 5, 1830, p. 348; *Examiner*, no. 1169, June 27, 1830, p. 403; *Morning Chronicle*, May 17, 1830, p. 2e; *Morning Post*, June 1, 1830, p. 3d
Literature: Dafforne, 1873, p. 10; Graves, 1876, p. 13; Catherine Gordon, "The Illustration of Sir Walter Scott," *Journal of the Warburg and Courtauld Institutes*, vol. 34 (1971), p. 305, pl. 47c
Unpublished source: Landseer to an unnamed correspondent, presumably E. R. Tunno, July 28, 1830 (Humanities Research Center, University of Texas at Austin)
PRIVATE COLLECTION

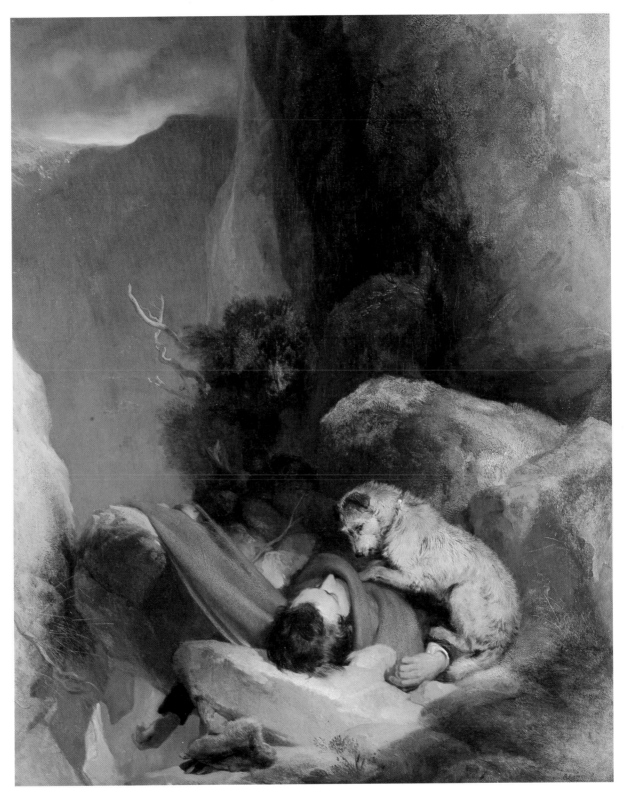

60.

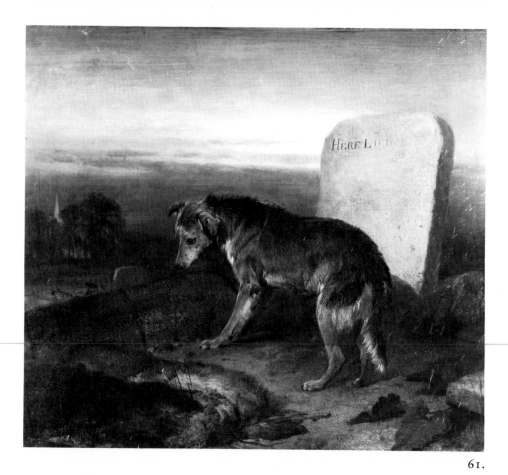

61.

61.

THE POOR DOG (also called THE SHEPHERD'S
GRAVE)
By 1829
Oil on panel, 12½ x 14½" (31.8 x 36.8 cm)
Provenance: William Wells of Redleaf; Wells
sale, Christie's, May 10, 1890, lot 42;
anonymous sale, Sotheby's, November 19,
1968, lot 155
Exhibitions: London, B.I., 1829, no. 256;
Manchester, 1857, no. 345; London, 1874,
no. 362
Reviews: The Times, February 2, 1829, p. 2f;
Athenaeum, no. 67, February 11, 1829, p. 93;
Examiner, no. 1098, February 15, 1829,
p. 100
Literature: Landseer Gallery, 1871, pl. 14;
Mann, 1874–77, vol. 1, p. 112; Graves, 1876,
p. 20, no. 232; *Landseer Gallery,* 1878, pl. 17;
Magazine of Art (1891), p. 388; Manson,
1902, pp. 90–91; Lennie, 1976, pp. 91–92
Unpublished source: John Sheepshanks to
Landseer, undated, asking permission for B. P.
Gibbon to engrave the picture and asking for a
picture of similar size for himself (V & A, Eng
MS, 86 RR, vol. 5, no. 298)
Prints after: engravings by B. P. Gibbon, 1838
(10¼ x 12¼"), as a pair to *The Old
Shepherd's Chief Mourner* (no. 66); Frederick
Hollyer, 1869 (*PSA,* 1892, vol. 1, p. 344);
G. S. Hunt for *Library Edition,* 1881–93, vol.
1, pl. 88 (*PSA,* 1892, vol. 1, p. 207)
MARK BIRLEY, ESQ.

The Poor Dog

This work is a forerunner of *The Old Shepherd's Chief Mourner* (no. 66), the most famous of Landseer's pictures of this kind. The freshly cut sods of the grave, the still-unfinished inscription on the headstone indicate the recent death of the shepherd. He is mourned only by his faithful collie, who crouches in an attitude of grief like that of the dog in *Attachment* (no. 60). The fact that his is the only real affection that the shepherd has inspired lends pathos and simplicity to the scene. There is a sense of solitude and desolation, emphasized by the flat landscape stretching away behind, a church on the left, and storm clouds. Pathos is implicit, too, in the artist's observation of the texture of the stone, the clods, and the dog's coat.

In his catalogue Algernon Graves confused this 1829 painting with another title and dated *The Shepherd's Grave* to 1837. Contemporary reviews of the 1829 exhibition, however, make it clear that *The Poor Dog* and *The Shepherd's Grave* are one and the same. The reviewer of *The Times* in 1829 spoke of the powerful and eloquent manner in which Landseer had conveyed the attitude of the dog and praised the way in which by connecting his subjects "with human thoughts and passions," he gave them "an interest and power which they could not otherwise excite."

A Jack in Office

Landseer's picture takes its title from a figure of common speech meaning a self-important petty official. The painting represents the barrow of a cat- and dog-meat salesman, left by its owner in an alleyway, and guarded by a large terrier, similar to the dog in *Low Life* (no. 58). Grouped around the barrow are four mangy, obsequious, and predatory dogs, hoping by guile or force to share in the spoils of the barrow.

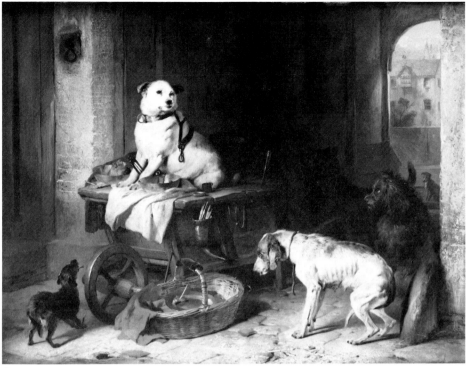

62.

62.

A JACK IN OFFICE
By 1833
Oil on panel, 19¾ x 26" (50.2 x 66 cm)
Provenance: John Sheepshanks Bequest to the
Museum, 1857
Exhibitions: London, R.A., 1833, no. 170;
Paris, Exposition Universelle, 1855, no. 859
Reviews: Athenaeum, no. 289, May 11, 1833,
p. 298; *Examiner,* no. 1320, May 19, 1833, p.
309; *Gentleman's Magazine,* vol. 103, part 1
(1833), p. 541; Theophile Gautier, *Les
Beaux-Arts en Europe—1855* (Paris, 1855),
pp. 76–77; *Art Journal* (1855), p. 281 (1856),
p. 79 (1857), p. 240
Literature: Waagen, 1854–57, vol. 2, p. 306;
V & A Catalogues, 1857, p. 16, no. 96, 1877,
p. 56, 1893, p. 83, 1907, p. 77; *Art Journal*
(1869), p. 334; Francis Turner Palgrave, *Gems
of English Art* (London, 1869), pp. 1–2; *Early
Works,* 1869, pp. 53–55, pl. 8; *Landseer
Gallery,* 1871, pl. 10; Dafforne, 1873, pp.
34–35; Stephens, 1874, pp. 89–91, pl. 7;
Mann, 1874–77, vol. 1, pp. 140a, 141a, 148a,
151; Graves, 1876, p. 16, no. 191;
Monkhouse, 1879, p. 144; Frith, 1887–88,
vol. 1, p. 205; F. M. Redgrave, *Richard
Redgrave: A Memoir* (London, 1891), pp.
168–69; Manson, 1902, pp. 78–79; Lennie,
1976, pp. 51, 82, 88, 89, 95, 161
Prints after: engravings by B. P. Gibbon, 1834
(12⅝ x 16"); C. G. Lewis, 1850 (PSA, 1892,
vol. 1, p. 187); the same or a new plate by
Lewis for *Art Journal* (1869), pl. 21; G. S.
Hunt for *Library Edition,* 1881–93, vol. 1,
pl. 63 (PSA, 1892, vol. 1, p. 208)
VICTORIA AND ALBERT MUSEUM, LONDON

In the foreground is a mongrel puppy, chewing on half a skewer it has broken, who looks up expectantly. To the right an emaciated pointer, a halter around its neck suggesting that it has an owner, gazes hypnotically at the piece of meat in the basket: "His drivelling mouth, sunk chaps, nervous and imploring eyes, shaking limbs and quivering tail, powerfully suggest the idea of a born gentleman driven to implore charity," as described by F. G. Stephens. Further to the right is another mongrel, on its haunches in a begging attitude, its eyes turned to the Jack in mute appeal. Behind comes a more self-confident dog, its collar denoting a respectable background, and at the entrance to the alley a fifth dog peeps in.

The picture was enormously popular, providing fable, parody, humor, and narrative in a single image. It can be read in a number of different ways. What has happened and what is going to happen? Why has the salesman gone off? Is he delivering to a house, as a bellpull is prominent on the left, or is he drinking in a tavern, as one critic suggested? Are any of the dogs going to make a move or not? And if they do how will the Jack defend the barrow? The spectator is left in suspense as to the outcome of the confrontation, although judging from the uncompromising attitude of the Jack, the other dogs have little chance of success.

Each of the individual dogs is an essay in canine character, and the critics expatiated on them at length. Their exaggerated attitudes and expressions are consciously anthropomorphic, so that we quickly substitute human for animal values. The picture might well have been inspired by a fable; indeed, there are similarities between Landseer's subject and La Fontaine's fable of the dog that carried his master's dinner, although in that story the dog gives in to superior force and is the first to snap up his master's meat.

The moral in Landseer's picture is less clear. We can scarcely be expected to approve of the terrier's assumption of superiority, his arrogant indifference to anything but the protection of his master's property. In theory such loyalty might be admired, but we see too clearly the character of the salesman through his dog, the hardheartedness of those who have a little towards those who

have nothing. The other dogs excite our pity, but can hardly be said to represent an alternative morality beyond their abject need for sustenance. The picture is an allegory of human behavior, the eternal conflict between the haves and the have-nots, and the emotions aroused in both. More specifically, it is an allegory of urban existence, and one glimpses Landseer's radical side in the grim picture of poverty and deprivation that he paints. The house in the background, with dovecot, and the church tower suggest some cathedral city, but there is nothing ingratiating about the alleyway, with its rough-textured walls and cobblestones. The care that Landseer expended on the slightest detail is the means by which he gives his vision concrete reality; and every detail is carefully thought out to play its part in the design and meaning of the work. The picture is highly finished and beautifully painted, with a feeling for light and atmosphere worthy of a Dutch master.

Suspense

A huge bloodhound, with a heavy collar, looks intently and forlornly towards an old-fashioned, heavily studded door. Drops of blood and what appears to be an ostrich feather are visible on the floor, a pair of gauntlets lie on the table—clues that a terrible tragedy has taken place, and it is the dog's response that is the subject of the picture. Clearly Landseer intended to provoke and to tantalize the feelings of his audience by dropping hints but leaving the central issue open to speculation. Has the dog's master been wounded in battle and brought into the room beyond the door? Has he met with an accident? Is he being murdered? Or is there some other explanation for the dog's anxiety? At least two contemporary critics misread the dog's attitude and the scene as a whole: the critic of the *Athenaeum* in 1834 assumed, "a dog watches, with eyes bright with longing, and chops impatient to be employed by the hole of a door, through which he expects prey to come: a bloody feather lies beside him, and we imagine we hear the cackling of cocks and hens."

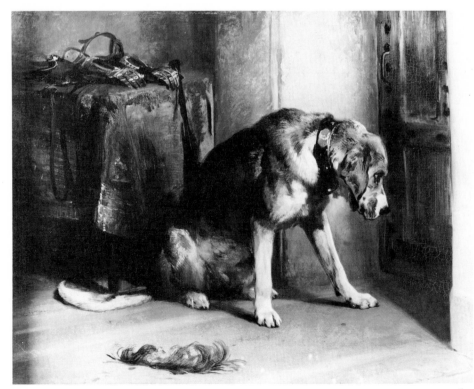

63.

63.
SUSPENSE (also called THE FRIEND IN SUSPENSE)
By 1834
Oil on panel, 27½ x 35¾" (70 x 91 cm)
Provenance: John Sheepshanks Bequest to the Museum, 1857
Exhibition: London, B.I., 1834, no. 144
Reviews: The Times, February 5, 1834, p. 4e; *Athenaeum*, no. 328, February 8, 1834, p. 107; *Gentleman's Magazine*, n.s., vol. 1, part 1 (1834), p. 308 (1869), pp. 55–56
Literature: V & A Catalogues, 1857, p. 16, no. 99, 1877, p. 59, 1893, p. 86, 1907, p. 77; *Weldon's Register* (London, 1862), p. 129; *Art Journal* (1868), p. 232; *Early Works*, 1869, pp. 55–56, pl. 9; *Landseer Gallery*, 1871, pl. 11; Dafforne, 1873, pp. 22–23; Anne Thackeray [Ritchie], "Sir Edwin Landseer," *Cornhill Magazine*, vol. 29 (1874), p. 87; Stephens, 1874, pp. 93–94, pl. 8; Mann, 1874–77, vol. 1, p. 128; Graves, 1876, p. 18, no. 205; *Landseer Gallery*, 1878, pl. 13; Monkhouse, 1879, p. 74; Manson, 1902, p. 83; Lennie, 1976, pp. 89–90
Prints after: engravings by B. P. Gibbon, 1837 (15⅝ x 20"); C. G. Lewis, 1852 (PSA, 1892, vol. 1, p. 369); the same or a new plate by Lewis for *Art Journal* (1868), pl. 22; J. C. Webb, 1879 (PSA, 1892, vol. 1, p. 369); Webb, smaller print for *Library Edition*, 1881–93, vol. 1, pl. 92 (PSA, 1892, vol. 1, p. 206); lithograph by Jacob Bell
VICTORIA AND ALBERT MUSEUM, LONDON

The feather has clearly been torn from a hat or helmet, evoking, like the gauntlets, the romantic and chivalrous past. It is not the historical context of the picture that is important, but the element of drama, the sheer vitality of the bloodhound, and the feelings of loyalty and love that he displays towards his absent master. The relationship of man and his dog lies at the center of the subject. The splayed feet and rippling back muscles suggest the enormous power of the animal, temporarily held in check, but ready to spring into action at a moment's notice. Few of Landseer's canine subjects are painted with such power—the paint surface heavily impasted and broadly handled. The accessories are treated in the same taut and simple style. The low, dog's-eye viewpoint is typical of Landseer's dog subjects.

The Sleeping Bloodhound

The picture represents Countess, a favorite bloodhound belonging to Jacob Bell, who commissioned the artist to paint his dog. The story of how Landseer came to paint the bloodhound has been told in various versions, some more dramatic than others. The artist was slow in beginning the commission, and one source relates, one night the bloodhound, who slept on a balcony outside her master's room, overbalanced, fell to the ground, and died. According to another story, the dog, waiting up for Bell, heard the wheels of his gig, jumped from the balcony, and missed her footing. J. P. Francis, however, stated that Bell had shown him the spot where the dog had leaped out of a hayloft; other versions of the story are given in *The Times* (October 1873). In any event, Countess had died, and Bell took the carcass of the dog around to Landseer's studio the next morning, which was a Monday, braving the displeasure of the artist, who hated to be disturbed. "This is an opportunity not to be lost," was Landseer's laconic response to the tragedy. "Go away. Come on Thursday at two o'clock." He set the dog up, as he would have been used to doing from

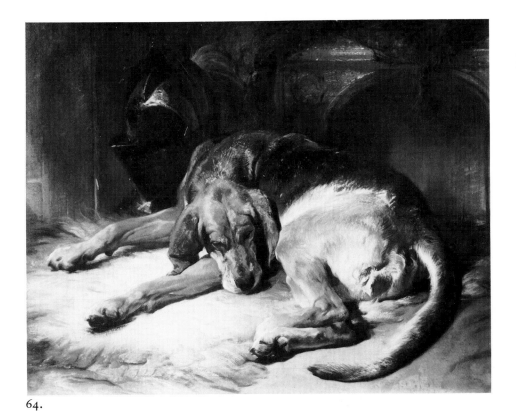

64.

64.

THE SLEEPING BLOODHOUND
By 1835
Oil on canvas, 39 x 49" (99.1 x 124.5 cm)
Provenance: commissioned by Jacob Bell; his bequest to the National Gallery, 1859; transferred to the Tate Gallery, 1919
Exhibitions: London, B.I., 1835, no. 73; Edinburgh, Royal Scottish Academy, 1847, no. 133; Liverpool Academy, Autumn Exhibition, 1854, no. 103; Manchester, 1857, no. 497; Dublin, International Exhibition, 1865, no. 57
Reviews: The Times, February 10, 1835, p. 3a; *Examiner,* no. 1414, March 8, 1835, pp. 149–50
Literature: Landseer Gallery, 1871, pl. 12; *Art Journal* (1871), p. 244; Dafforne, 1873, pp. 42–43; *The Times,* October 11, 1873, p. 6, October 14, 1873, p. 6; Stephens, 1874, pp. 97–98; Mann, 1874–77, vol. 1, p. 158; Graves, 1876, p. 18, no. 209; *Landseer Gallery,* 1878, pl. 15; Monkhouse, 1879, p. 83; *Reminiscences of Solomon Alexander Hart,* ed. Alexander Brodie (London, 1882), p. 110; National Gallery Catalogues, 1888, p. 86, 1913, pp. 373–74; Manson, 1902, pp. 83–84; Lennie, 1976, p. 90
Unpublished sources: Landseer to Bell, August 2, 1834, discussing his looking forward to beginning Bell's bloodhound picture and that he is delighted in the subject (Royal Institution, London); Landseer to Bell, 1836, that his brother has begun work on the engraving; copy of Graves, 1876, annotated by J. D. Francis (Tate Gallery Archives, London)
Prints after: engravings by Thomas Landseer, 1837 (15½ x 20"); C. G. Lewis, 1852 (*PSA,* 1892, vol. 1, p. 369), the same or another plate for *Art Journal* (1871), pl. 20; J. C. Webb, 1879 (*PSA,* 1892, vol. 1, p. 351); Webb for *Library Edition,* 1881–93, vol. 1, pl. 89 (5½ x 8") (*PSA,* 1892, vol. 1, p. 206)

his anatomical studies, and when Bell returned on Thursday the picture was finished.

There is more than a hint of rigor mortis in the dog's stiff legs, and a general air of decrepitude not inconsistent with death. The picture is one of Landseer's most moving studies of dogs, simple and monumental in idea, and painted with surprising breadth and freedom for a work of this period. The bloodhound lies on a thick white rug; a close helmet from the sixteenth century and a medieval-style stool loom out of the background. The atmosphere of the picture, with its dramatic contrasts of light and dark, is somber and haunting. Landseer's sympathy with his subject has an elegiac quality, a lament for death and old age in general. The reviewer for the *Examiner* (March 8, 1835) wrote: "The animal is dashed upon the canvass, and lies sleeping there, and, as it were, unconsciously heaving its weighty and potent majesty of frame. The picture is unequalled for vigour and simple grandeur."

A passion for animals was one of the links between Landseer and Bell. Much of their correspondence is taken up with discussing the merits and vicissitudes of their respective dogs and horses, and they relied heavily on one another's advice. The period of Landseer's dependence on, and intimacy with, Bell, however, belongs to a later time. In 1835 Bell was still a young man and *The Sleeping Bloodhound* was the first of a major collection of Landseer's pictures that he commissioned and bequeathed to the nation.

Mustard, the Son of Pepper

The dogs of artists are a relatively rare pictorial subject. One is irresistibly reminded of Hogarth's famous self-portrait with his pug (Tate Gallery, London). Landseer's picture of the studio of Sir Francis Chantrey is far more crowded with allusions and details than Hogarth's, evoking the world of the absent sculptor through his works and animals. The setting is a corner of the sculptor's studio, presumably at Belgrave Place, Pimlico, with a window on the left, a wall behind, and possibly a doorframe on the right. At the center and in proud possession of his master's table sits the self-confident Mustard, one of the breed of Dandie Dinmont terriers made famous by Sir Walter Scott in his novel *Guy Mannering* (1815). Scott had given the dog to Chantrey as a present in May 1825, and the dog, according to George Jones, "each succeeding year smoothed his coat and increased his bulk, and he became a striking example of the effects of luxury and repletion, yet his obesity and indolence did not diminish his devotion to his master and Lady Chantrey" (*Sir Francis Chantrey*, London, 1849, p. 158).

Behind Mustard is the ghostly presence of Scott himself—an unfinished model for a bust. Scott had sat to Chantrey in 1820 for the marble bust now at Abbotsford, and a copy of this was commissioned by the Duke of Wellington. A second marble bust was completed for Sir Robert Peel in 1828 with the aid of fresh sittings. The model in Landseer's picture remains to be identified; it differs from these busts as well as from the plaster cast in the Ashmolean Museum, Oxford, in the pose of the head and the arrangement of the draperies. Before the bust are an assortment of modeling tools, a portcrayon, a brush, and a silver snuffbox, and leaning against the table is a portfolio of prints.

The two woodcock, supported by the pulled-out drawer of the table, represent another of Chantrey's achievements. The sculptor was a keen sportsman, and while staying with the Earl of Leicester at Holkham Hall in

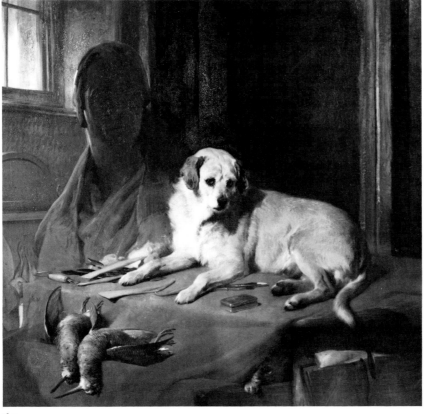

65.

65.

MUSTARD, THE SON OF PEPPER; GIVEN BY THE
LATE SIR WALTER SCOTT TO SIR FRANCIS
CHANTREY, R.A. (also called PEN, BRUSH, AND
CHISEL and THE STUDIO OF SIR FRANCIS
CHANTREY)
By 1836
Oil on canvas, 42 x 44¾" (106.7 x 113.7 cm)
Provenance: commissioned by Sir Francis
Chantrey; presented by his widow to Queen
Victoria, 1842
Exhibitions: London, R.A., 1836, no. 339;
Liverpool Academy, Autumn Exhibition,
1836, no. 58; London, 1874, no. 316
Reviews: Athenaeum, no. 445, May 7, 1836,
p. 331; *The Times,* May 11, 1836, p. 7b
Literature: Critic, vol. 23, October 5, 1861, p.
359; *Building News,* October 18, 1861, p.
844; Mann, 1874–77, vol. 2, p. 122; Graves,
1876, p. 19, no. 219; Manson, 1902, p. 88;
Harold Armitage, *Francis Chantrey* (London,
1915), pp. 162–64; Lennie, 1976, pp. 90–91
Unpublished sources: Mustard to Landseer,
April 14, 1835 (Mackenzie collection, no.
1110); Chantrey to Landseer, July 22, 1836,
July 30, 1836 (V & A, Eng MS, 86 RR, vol. 1,
nos. 69, 70); Landseer's stamped receipt,
exhibited London, 1874, no. 17; Queen
Victoria's Journal, July 18, 1836
Prints after: engravings by Thomas Landseer,
1861 (23½ x 24¾") (PSA, 1892, vol. 1, p. 51);
A. C. Alais for *Library Edition,* 1881–93,
vol. 2, pl. 24 (PSA, 1892, vol. 1, p. 210)
HER MAJESTY QUEEN ELIZABETH II

Norfolk in 1830, he killed a brace of woodcock with a single shot. This notable
feat inspired a number of epigrams in English, French, Latin, and Greek from
Chantrey's friends, later collected and published under the title *Winged Words
on Chantrey's Woodcocks* (London, 1857). The sculptor carved a marble
relief of the woodcock for the Earl of Leicester, which is still at Holkham, and
this appears on the left-hand side of Landseer's picture; a version of this relief
was included in the sale of the contents of Landseer's home (Daniel Smith, Son
& Oakley, July 28–30, 1874, lot 238). The two birds are arranged as they
appear in the relief, as if the sculptor had been temporarily interrupted in the
act of modeling them.

Typically, Landseer's picture is a narrative of time present as well as an
allegory of time past. The dogs, birds, and the wonderfully observed cat, with
its bright eye peering around the edge of the tablecloth, form a dramatic
triangle. The dog looks down towards the open drawer, determined to protect
its master's models from the depredations of the cat. It is just the kind of
unresolved animal confrontation that appealed to Landseer's imagination,
and it brings the picture to life.

The picture was commissioned in April 1835, with Chantrey sending Land-
seer a humorous letter signed Mustard and requesting his services. In his letter
of July 22, 1836, Chantrey insisted on paying for the picture before taking
possession of it: "Now on the score of money—a delicate question to a high
spirited young Dandy who can live on Air—I have to request that you will do
yourself & your profession *justice* without one word about friendship, deli-
cacy or *stuff.*" Later in the month he agreed that it would be "injudicious" to
withdraw the picture from the Liverpool exhibition: "I am more than satisfied
you have produced a picture of my faithful dog Mustard that stands without a
rival. I always expected that the proper & [illegible] price would at least have
been two hundred guineas—you say one hundred & fifty!"

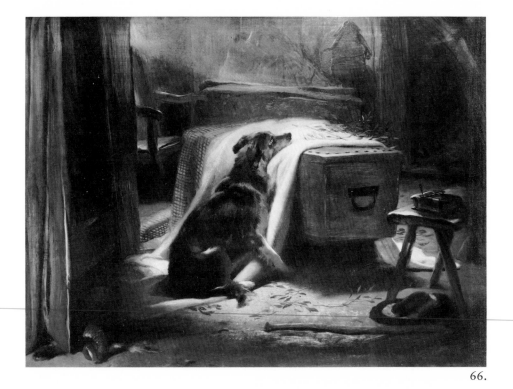

66.

66.

THE OLD SHEPHERD'S CHIEF MOURNER
By 1837
Oil on panel, 18 x 24" (45.8 x 61 cm)
Provenance: John Sheepshanks Bequest to the Museum, 1857
Exhibitions: London, R.A., 1837, no. 112; Dublin, International Exhibition, 1865, no. 19; London, R.A., Bicentenary Exhibition, 1968–69, no. 231; Paris, 1972, no. 155; London, Arts Council, *Great Victorian Pictures,* 1978, no. 25; Munich, *Zwei Jahrhunderts Englische Malerei,* 1979–80, no. 364
Review: Athenaeum, no. 497, May 6, 1837, p. 330
Literature: Waagen, 1854–57, vol. 2, p. 306; V & A Catalogues, 1857, p. 16, no. 93, 1877, p. 54, 1893, p. 85, 1907, p. 77; *Early Works,* 1869, p. 58, pl. 13; *Landseer Gallery,* 1871, pl. 15; Dafforne, 1873, pp. 16–17; Stephens, 1874, pp. 99–100, pl. 12; Anne Thackeray [Ritchie], "Sir Edwin Landseer," *Cornhill Magazine,* vol. 29 (1874), p. 87; Mann, 1874–77, vol. 1, pp. 134–35a; Graves, 1876, p. 20, no. 233; *Landseer Gallery,* 1878, pl. 18; Monkhouse, 1879, pp. 83–86; Rudolf Lehmann, *An Artist's Reminiscences* (London, 1894), pp. 251–52; Manson, 1902, pp. 89–91; Ruskin, 1903–12, vol. 3, pp. xlvi, 88–89, 114, 160, vol. 4, pp. 302, 334, vol. 7, pp. 337–38, vol. 23, p. 270, vol. 33, p. 310; Mrs. Edward Matthew Ward, *Memories of Ninety Years* (London, 1924), p. 280; Graham Reynolds, *Victorian Painting* (London, 1966), pp. 15, 20, 27, fig. 8; Lennie, 1976, pp. 83, 91, 130, 131, 133, 149
Unpublished sources: Landseer to Jacob Bell, undated, perhaps referring to this work, requesting a sketch of a poor man's coffin (Royal Institution, London); Sheepshanks to Landseer, November 20, 1837, about the print (Mackenzie collection, no. 1233)
Prints after: engravings by B. P. Gibbon, 1838 (10¼ x 12¼"), as a pair to *The Shepherd's Grave* (no. 61); Frederick Hollyer, 1869 (*PSA,* 1892, vol. 1, p. 344); G. S. Hunt for *Library Edition,* 1881–93, vol. 1, pl. 87 (*PSA,* 1892, vol. 1, p. 207); lithograph by Jacob Bell
Related works: oil sketch, Christie's, April 20, 1885, lot 55; drawing in a sketchbook, Artist's sale, 1874, lot 1001

VICTORIA AND ALBERT MUSEUM, LONDON

In its critique of the picture the *Building News* analyzed its formal and tonal elements in exhaustive detail: "The triangular hole from which the cat is peeping, varies the form of the right angle on the opposite side, and is repeated and opposed by the triangular corner of the portfolio close to it. The wood-work of the window is repeated in form and material by the door-frame in the background, the uncovered portion of the table and the partly opened drawer from which the cat's head is issuing, and the square forms are also repeated by the portfolios, close to it in the right-hand corner of the picture. . . . The mild and delicate grey of the daylight is infused amongst the white and lighter yellow of the dog's hide, and very skilfully spread over the red cloth . . . the yellowish tint of the dog re-appears slightly on the window-frames and on the modelling tools lying near him. The grey also finds a key-point in the beauti-fully painted silver snuff-box. The red of the tablecover blends with the cooler parts of the picture by being of a mulberry tone, which implies a mixture of blue. It is contrasted and thrown into space and air by the rather decided form and color of the leather corner of the portfolio, and agrees with the brown as a companion warm color" (October 18, 1861, p. 844).

The Old Shepherd's Chief Mourner

This is one of Landseer's most famous works and the subject of a much quoted eulogy by Ruskin. Like the earlier *Poor Dog* (no. 61), with which it was engraved as a pair, it transposes an image associated with human grief—the inconsolable lover lying on the bier of the beloved—for one of canine devotion. The collie, resting its head on the simply draped coffin of its master, is a moving and entirely original conception. The scattered boughs suggest that the human mourners have gone, leaving alone in his despairing vigil the one being who really cares. It was the dog whom the shepherd loved, his faithful helpmate and the companion of his solitude.

The setting is one of those somber Highland bothies which the artist loved to paint. The wooden uprights and the beams provide a firm geometry for the distilled, receding space. The few, well-chosen accessories evoke the life and

character of the dead man: the stick and the cap lying on the floor, the Bible and the spectacles on the rough-hewn stool, the ram's-horn flask, the empty armchair in the background. A shaft of sunlight falls dramatically on the coffin from a window at the left, and the muted color scheme of browns and grays is in sympathy with the poignant mood of the subject, evoking a hard and austere life lived with stoical faith and quiet dignity. The pathos of the lonely shepherd's obscure death is borne through the grieving pose of the dog. It is the restraint, the understatement, of Landseer's treatment which makes the point so effective.

The picture was admired at its first exhibition, although overshadowed by *Return from Hawking* (by 1837, collection of the Duke of Sutherland). The *Athenaeum* in 1837 called it "one of the most simply pathetic things in the Exhibition," but it was not until Ruskin's eulogy in *Modern Painters* that it acquired its legendary status: "Here the exquisite execution of the glossy and crisp hair of the dog, the bright sharp touching of the green bough beside it, the clear painting of the wood of the coffin and the folds of the blanket, are language—language clear and expressive in the highest degree. But the close pressure of the dog's breast against the wood, the convulsive clinging of the paws, which has dragged the blanket off the trestle, the total powerlessness of the head laid, close and motionless, upon its folds, the fixed and tearful fall of the eye in its utter hopelessness, the rigidity of repose which marks that there has been no motion nor change in the trance of agony since the last blow was struck on the coffin-lid, the quietness and gloom of the chamber, the spectacles marking the place where the Bible was last closed, indicating how lonely has been the life, how unwatched the departure of him, who is now laid solitary in his sleep;—these are all thoughts—thoughts by which the picture is separated at once from hundreds of equal merit, as far as mere painting goes, by which it ranks as a work of high art, and stamps its author, not as the neat imitator of the texture of a skin, or the fold of a drapery, but as the Man of Mind" (London, 1851, vol. 1, p. 8).

A Distinguished Member of the Humane Society

One of Landseer's most popular and famous dog subjects of the 1830s, this large Newfoundland dog, of a breed famous for their lifesaving abilities, sits proudly and nobly on the quay by the water's edge. This black-and-white

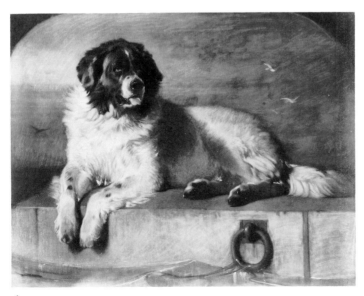

67.

67.

A DISTINGUISHED MEMBER OF THE HUMANE SOCIETY
Thomas Landseer after Edwin Landseer, with extensive retouching by Edwin Landseer
Picture by 1838, print 1839
Engraving, 19 x 24 1/4" (48.3 x 61.5 cm)
Provenance: the Duke of Buccleuch, his sale, Christie's, March 8–10, 1887, lot 108; given to the Museum by E. E. Leggatt, 1916
Literature: Graves, 1876, p. 20, no. 247
Related work: oil painting (42 1/2 x 55"), Tate Gallery, London, exhibited London, R.A., 1838, no. 462

Newfoundland, of the variety known as a Landseer, after the painter, was named Paul Pry and belonged to Mrs. Newman Smith. The extensive retouchings on the proof are the work of Landseer himself, who went to endless pains to ensure that engravings after his work were as faithful to the original as possible.

Dignity and Impudence

The two dogs belonged to Jacob Bell, who commissioned the picture. The bloodhound was called Grafton and, according to Graves, was a habitué of artists' studios. On one occasion he was locked in a stable with another dog. In the morning he and the other dog were found in opposite corners, severely wounded, the walls spattered with blood. Grafton was left to die but, in fact, recovered, Bell threatening to shoot him if he misbehaved again. Scratch was a Scotch terrier. Bell is said to have made a wager with the owner of a poodle that his terrier was the more attractive of the two. The issue was to be decided by Landseer's spontaneous reaction to the dogs the next day. "Oh what a beauty!" exclaimed the painter when he saw Scratch, and Bell won his bet.

The picture's composition is almost a parody of Dutch scenes in which a figure is framed by a window, and where a hand or an arm, like the ingratiating paw of the dog, illusionistically extends over the edge. This piece of visual punning draws attention to the anthropomorphic qualities of the subject. Both dogs are looking out, their attention apparently attracted by someone's approach. Grafton is watchful but unperturbed, while Scratch looks as if he might spring out and start barking at any second. The chain in the foreground emphasizes that the kennel belongs to the bloodhound. The humorous contrast in size and character between the two animals is further drawn out in Landseer's treatment of them; the larger painted in smooth, variegated textures, the smaller in a few sharp and witty strokes.

Landseer had painted heads as sensitively as that of Grafton before, for example, the bloodhound *Odin* (c. 1836, private collection), but this picture represents a new type of subject in its comical treatment of canine relationships. *Lion and Dash* and *Lion Dog* (both c. 1840, Badminton, Gloucestershire, and Royal Collection, respectively) are further essays in the stately and the ridiculous, the first contrasting a Saint Bernard with a King Charles spaniel, the second a Saint Bernard with a Maltese dog.

Dignity and Impudence was, and remains, one of Landseer's most popular works. The critic of the *Art-Union* in 1839 summarized the nature of its appeal: "One of the noble hounds, which he places living and breathing upon the canvas, flings a paw, massive as iron, across the ledge of his kennel. It is impossible to imagine anything finer than the perfect repose and dignity of the magnificent animal, who does not condescend to notice a minikin white Scotch terrier, whose brilliant restless eyes indicate an anxiety to spring upon any 'varmint' that may chance to come within its reach."

68.
DIGNITY AND IMPUDENCE
By 1839
Oil on canvas, 35½ x 27½" (90.2 x 70 cm)
Provenance: commissioned by Jacob Bell, his bequest to the National Gallery, 1859; transferred to the Tate Gallery, 1929
Exhibitions: London, B.I., 1839, no. 119, as "Dogs"; Birmingham, Society of Artists, 1842, no. 38; Liverpool Academy, Autumn Exhibition, 1854, no. 335; Manchester, 1857, no. 337
Reviews: The Times, February 4, 1839, p. 3; *Athenaeum,* no. 589, February 9, 1839, p. 112; *Art-Union,* 1839, p. 21
Literature: Early Works, 1869, p. 59, pl. 16; *Landseer Gallery,* 1871, pl. 19; Dafforne, 1873, p. 19; Stephens, 1874, p. 102, pl. 15; Mann, 1874–77, vol. I, p. 19; Graves, 1876, p. 21, no. 260; *Landseer Gallery,* 1878, pl. 23; Monkhouse, 1879, pp. 89–90; National Gallery Catalogues, 1888, p. 85, 1913, p. 374; Manson, 1902, p. 99; Jeremy S. Maas, *Victorian Painters* (London, 1969), p. 81; Lennie, 1976, pp. 77, 88, 94–95
Prints after: engravings by Thomas Landseer, 1841 (24⅛ x 23½"); W. T. Davey, 1851; G. Zobel, 1871 (*PSA,* 1892, vol. I, p. 90); C. A. Tomkins for *Library Edition,* 1881–93, vol. I, pl. 9 (*PSA,* 1892, vol. I, p. 207)
THE TRUSTEES OF THE TATE GALLERY, LONDON

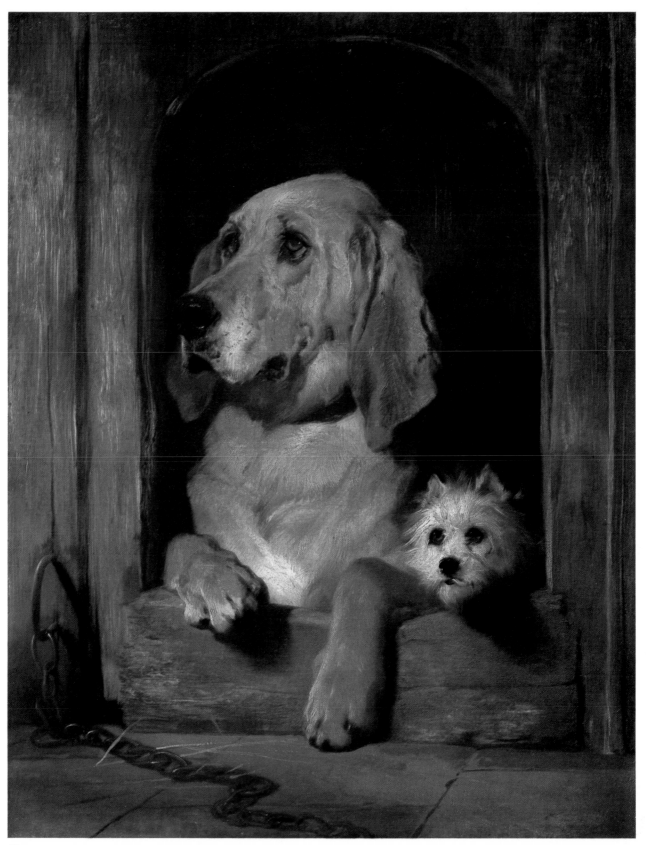

68.

History Pictures, 1830-1834

POPULAR SCENES from history became the rage in the early nineteenth century. Responding to a passionate enthusiasm for the past, which the Romantic movement had fostered, artists depicted historical events and characters in a way that made them real and tangible. Edward III and the burghers of Calais, the murders of the princes in the Tower of London, the execution of Mary, Queen of Scots, Charles I taking leave of his children—these were the kinds of subjects that were exhibited again and again and that reached their apotheosis in the schemes of decoration for the new Houses of Parliament. In re-creating the past, artists became increasingly concerned with the need for period accuracy, studying historical styles of architecture and dress in order to make their pictures more convincing. Uncovering the past in this way was a new and exciting experience for an audience with an inexhaustible appetite for historical romance.

Many of Landseer's historical subjects were drawn not from history books, but from novels and poems of Sir Walter Scott. Apart from Shakespeare, Scott was the most illustrated author of the age. This is understandable because he, more than any other writer, had brought the past alive through his exciting historical novels, with their sharply drawn characters and period settings. Scott is the index not only to the types of subjects that Landseer painted, but also to their shading and atmosphere. *Chevy Chase* (no. 23) is set in Scott's beloved border country, in the Middle Ages a wild and lawless society, also capable of rising to heights of heroism. *Hawking* (no. 72), another hunting scene, evokes the lost world of Scottish chivalry and romance. Hawking is rich in historical associations, and there are several notable descriptions of the sport in Scott's writings, one of them illustrated by Landseer. The young noblemen, who built castles and aspired to the ideals of medieval society, took up hawking in the same spirit. Nothing illustrates this so well as Landseer's pseudo-historical portrait of the Earl of Ellesmere and his family entitled *Return from Hawking* (by 1837, collection of the Duke of Sutherland). A number of other artists exhibited hawking subjects during the early nineteenth century, including Andrew Geddes, Gilbert Stuart Newton, and Richard Barrett Davis.

Although not specifically a subject from Scott, Landseer's historical painting *Bolton Abbey in the Olden Time* (no. 73) is so reminiscent of Scott's novels as to have been created in the same spirit. Here was the quiet faith and settled order of the Middle Ages, the picturesque and natural world, which inspired the contemporary neo-Gothic movement. Landseer was in tune with the aspirations and ideals of his age and with its central artistic concerns. That *Bolton Abbey* remained something of an isolated experiment can probably be attributed to the limited nature of Landseer's historical involvement and to his lack of confidence as a figure draftsman. He later produced some notable history works, chief among them *Rent Day in the Wilderness (see* no. 155), but for the most part Landseer turned away from the tradition of history painting. On the other hand, his pictures of animals abound in historical props. He can place a horse in the courtyard of an old house, with a gauntlet and a breastplate beside it, and we are at once transported back in time, so strong are the ties of these associations.

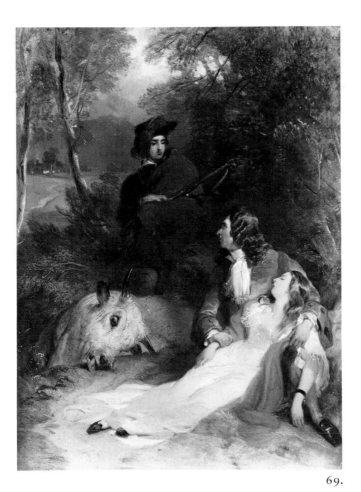

69.

69.
THE BRIDE OF LAMMERMOOR
By 1830
Oil on panel, 13 ½ x 9″ (34.3 x 23 cm)
Provenance: Artist's sale, 1874, lot 113; purchased from Thomas Agnew & Son by the present owner, c. 1955
Literature: Mann, 1874–77, vol. 2, p. 115; Graves, 1876, p. 14, no. 155; *see* Catherine Gordon, "The Illustration of Sir Walter Scott," *Journal of the Warburg and Courtauld Institutes,* vol. 34 (1971), pp. 309–10
Prints after: engraving by William Finden for frontispiece to Sir Walter Scott, *The Bride of Lammermoor* (vol. 14, Edinburgh, Waverley edition, 1830)
HENRY P. MCILHENNY

The Bride of Lammermoor

Set in Scotland in the late seventeenth century, Sir Walter Scott's famous novel *The Bride of Lammermoor* (first published 1818) tells the tragic love story of the Master of Ravenswood, heir of a ruined family, and Lucy Ashton, the daughter of the man who has dispossessed him of his lands. The scene illustrated by Landseer, for the engraved frontispiece to the later Waverley edition of the novel (1830), is from the first part, when Ravenswood saves Lucy in the most dramatic circumstances and falls in love with her. While walking the grounds of the castle, Lucy and her father, Sir William Ashton, are attacked by a wild bull, "the descendants of the ancient herds which anciently roamed free in the Caledonian forests." As the bull charges, a shot rings out from a thicket, the bull falls dead, and Lucy faints. Her father, Sir William, unaware of the identity of their deliverer, whom he mistakes for a forester, asks for assistance and the Master of Ravenswood approaches. Scott does not linger on the details of this first confrontation, and there is no authority in the text for the exchange of antagonistic looks between the two enemies, which is the dramatic keynote of Landseer's illustration. But, the contrast between the worldly, scheming lawyer and the untamed protagonist is well given.

Scott did not describe the clothing of Sir William or Lucy in any detail, except for her scarlet mantle, which may have provoked the bull. Sir William is shown in a late-seventeenth-century full-bottomed wig, a fashionable coat of the same period, cravat, stockings, and buckled shoes, and his daughter's white dress is a generalized, nondatable garment, of the type often pictured in early nineteenth-century history paintings. Ravenswood's costume, on the other hand, is described at some length in the novel—the shooting dress of dark color, the loose brown cloak, and his montero cap with feather.

Ravenswood's knee rests on a white bull from the famous herd of wild cattle preserved at Chillingham Castle, to which Scott alludes in his text. Landseer's enthusiasm for the cattle no doubt inspired him to choose this particular scene in Scott's novel to illustrate, and it anticipates the theme of his famous picture *Death of the Wild Bull* (no. 78), exhibited some years later. The figure of Ravenswood forms the apex of a tight, pyramid-shaped design. Balancing the body of the bull and forming the lower half of an oval at the base of the design is the recumbent figure of Lucy Ashton, treated in a rather conventional manner. The picture is vivid in touch and brilliant in color and reveals how much better Landseer's figure compositions work on this scale.

The Waverley edition of Scott's works in forty-eight volumes (1829–34) was a largely commercial enterprise, prompted by the novelist's need to pay his debts. Illustration was considered essential to sell the edition, and each volume carried an engraved frontispiece and a vignette on the title page, contributed by various artists, most of them friends of Scott, including Sir David Wilkie, Charles Robert Leslie, Richard Parkes Bonington, and Clarkson Stanfield. The choice of subject seems to have been determined largely by consultation between the artists and the publisher Robert Cadell. Of Landseer's seven contributions, four were frontispieces, the others vignettes, and they span a wide range of novels. All were executed as small, finished oil paintings, similar in scale and treatment to this one. Scott's correspondence with Cadell of July 1828 briefly mentions Landseer's work for the edition, and in that year Landseer himself wrote at length to the novelist about his illustration of David Gellatley (National Library of Scotland, Edinburgh, MS 3907, f. 285).

Death of Elspeth Mucklebackit

This sketch illustrates a scene from Sir Walter Scott's novel *The Antiquary,* published in 1816. The novel concerns the love story of Isabella Wardour and

70.

70.
DEATH OF ELSPETH MUCKLEBACKIT
c. 1830
Oil on board, 19 x 24" (48.2 x 61 cm)
Provenance: Artist's sale, 1874, lot 82(?), as "Interior of a Highland Cottage with Four Figures," bt. grandfather of present owner
Exhibition: Sheffield, 1972, no. 40
PRIVATE COLLECTION

Major Neville, alias Lovel, who is revealed to be the son and heir of the Earl of Glenallan. Much of the charm of the book lies in the character of the antiquary, a neighbor of Isabella's father, and that of Edie Ochiltree, the king's beadsman, who helps to thwart the machinations of a charlatan.

Landseer's sketch shows the death of Elspeth Mucklebackit, who was formerly in the service of the Glenallans and who knows the truth of Neville's origin. She dies in the arms of Edie Ochiltree, watched by the antiquary and his nephew. The sketch is very similar to Landseer's scenes of Highland interiors, and Elspeth herself is one of a notable line of Highland crones whom the artist depicted. Landseer presumably painted the sketch as a possible illustration for the Waverley edition of Scott's novels. In any event, he contributed a vignette of Edie Ochiltree alone for the title page of *The Antiquary* for the Waverley edition in 1829.

A Visit to the Falconer's

This sketch is close in spirit to Landseer's illustrations for the Waverley edition of Sir Walter Scott's novels (*see* no. 69). No passage in Scott's novels precisely describes this scene, although there are similarities. In chapter 4 of *The Abbot* (1820), a violent quarrel takes place between Roland Graeme and Adam Woodcock, the falconer of Avenel, in the falcon house, but no ladies are present. Chapter 23 of *The Betrothed* (1825) opens with a scene in the mews, where old Raoul keeps his falcons, but, again, the figures in Landseer's sketch do not tally with Scott's description.

Landseer's picture represents two ladies of the castle, attired in a romantic version of sixteenth-century dress, visiting the falcon house. A husband or escort stands at the door, while a page boy seated on a chair holds one of the birds, with the old falconer looking over his shoulder. The other birds are on two long benches, the dead herons in the foreground indicating a recent outing. In the room are shields, a breastplate, pieces of hawking equipment,

71.

71.
A VISIT TO THE FALCONER'S
c. 1830
Oil on board, 13 x 16½" (33 x 42 cm)
Provenance: Artist's sale, 1874, lot 288, bt. grandfather of present owner
Exhibition: Sheffield, 1972, no. 44
Literature: Graves, 1876, p. 17
PRIVATE COLLECTION

and dogs. The posts supporting the roof provide a framework for the figures, and the lovely reds and greens of Landseer's palette sing out from the brown tones of the interior.

Hawking

This, the first of Landseer's major hawking subjects, is a work of unusual design and powerful effect. The contrast between the birds in the foreground and the immensity of the skyscape is visually dramatic. Like *Chevy Chase* (no. 23), the work is also a history painting, intended to evoke the chivalric and romantic past.

Landseer's picture of hawking is dominated by the two birds, united in a tightly knit, circular design. The falling heron is upside down, the falcon superimposed on top. The pattern of their wings is eloquent—those of the hawk arched and sweeping upward, those of the heron plunging down. Similarly, the beaks and talons of the two birds express contrasting states of aggression and passivity, predator and victim locked in a fatal embrace. The bell and red string attached to the leg of the falcon are telling accents and draw attention to the brutal action of the talons. The sheer beauty with which the birds are painted, the accuracy of anatomical detail, and the delicacy of the plumage, like that of a still-life painting, endow the scene with a hallucinatory quality. The violent destruction of one beautiful animal by another suggests the immutable application of natural law. As in *Highlanders Returning from Deerstalking* (no. 29), the stormy and desolate landscape emphasizes the theme of mortality, and pitches the subject in a high romantic key. The rough sandy bank in front, with its dragged brushwork, effectively contrasts with the smooth, gray storm clouds.

Unlike *Chevy Chase*, the figures are relegated to a subservient position. They come up the side of a low rise in the middle distance and are partly cut off by the line of the hill. The leading figure, on a white horse, is a young prince or nobleman, ancestor of those gilded aristocrats like Lord Ellesmere and Lord Ossulston, whom Landseer so liked and admired. The nobleman is dressed in a romantic version of sixteenth-century costume with doublet and hose. He has just released a second hawk, and is whirling a live pigeon around his head as a lure for the first to release its prey. Beside him is the falconer or cadger, holding in one hand a hawk, ready to pass it to his master. Another bird is visible on the field cadge, which he carries suspended from his shoulders. Behind these two figures is an older man in armor, a woman in red velvet riding sidesaddle, and a second attendant with lance and pennant. The party has ridden out from the castle visible in the background, almost certainly a Scottish castle, with two large tents beside it and a concourse of figures. The castle is clearly *en fête,* with hunting and festivities for guests.

The picture created quite a stir when it was first exhibited in 1832. The *Athenaeum* called it a "wonderful piece of painting, and boldly conceived, too," but questioned whether a hawk would bring down a heron in that way. Both *Gentleman's Magazine* and *The Times* praised the rendering of the birds, but criticized the other parts of the picture, especially the figures, which have not even "the merit of originality." The first owner of the picture was Samuel Cartwright, a prominent London dentist.

72.
HAWKING (also called HAWKING IN THE OLDEN TIME)
By 1832
Oil on canvas, 60 x 72" (152.5 x 183 cm)
Provenance: Samuel Cartwright; John Naylor; Henry McConnel, 1863, his sale, Christie's, March 27, 1886, lot 71, bt. Thomas Agnew & Son; purchased by Sir Edward Guinness, later 1st Earl of Iveagh, 1888; Iveagh Bequest, Kenwood, 1927
Exhibitions: London, R.A., 1832, no. 346; London, B.I., 1833, no. 137; Liverpool, Town Hall, 1854, no. 27; Sheffield, 1972, no. 41
Reviews: The Times, May 24, 1832, p. 3 f, February 4, 1833, p. 2e; *Athenaeum,* no. 242, June 16, 1832, p. 387, no. 276, February 9, 1833, p. 91; *Examiner,* no. 1271, June 10, 1832, p. 373; *Gentleman's Magazine,* vol. 102, part 1 (1832), p. 440; V & A Press Cuttings, vol. 6, p. 1634
Literature: Art-Union (1839), p. 122; Mann, 1874–77, vol. 4, p. 111; Graves, 1876, p. 16, no. 187; *Iveagh Bequest, Kenwood, Catalogue of Paintings* (London, 1965), p. 21, no. 11; Edward Morris, "John Naylor . . . ," *Annual Report and Bulletin of the Walker Art Gallery, Liverpool* (Liverpool, 1974–75), vol. 5, p. 88, no. 73
Unpublished sources: Landseer to C. G. Lewis, August 25, 1840 (British Library, London, Add MS 38608, f. 20); Lewis to Landseer, about the state of the plate, August 28, 1840 (V & A, Eng MS, 86 RR, vol. 3, no. 202)
Prints after: engravings by C. G. Lewis, 1842 (22 3/8 x 27 3/4"); C. A. Tomkins for *Library Edition,* 1881–93, vol. 1, pl. 56 (PSA, 1892, vol. 1, p. 208)
Related works: version or copy (24 1/2 x 29 3/4"), Museum of Fine Arts, Springfield, Mass.; drawing by C. G. Lewis for the print, British Museum, London

THE IVEAGH BEQUEST, KENWOOD, LONDON

72.

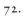

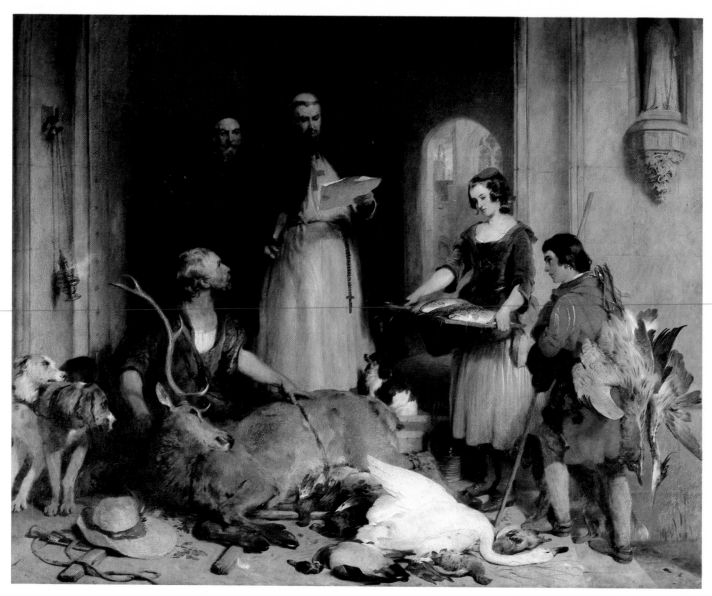

73.

73.

SCENE IN THE OLDEN TIME AT BOLTON
ABBEY (also called BOLTON ABBEY IN THE
OLDEN TIME)
By 1834
Oil on canvas, 61 x 76" (155 x 193 cm)
Provenance: commissioned by the 6th Duke of
Devonshire, by descent
Exhibitions: London, R.A., 1834, no. 13;
London, International Exhibition, 1862, no.
407; Leeds, *National Exhibition of Works of
Art,* 1868, no. 1372; London, 1874, no. 214;
Sheffield, 1972, no. 48
Reviews: The Times, May 8, 1834, p. 6b;
Athenaeum, no. 341, May 10, 1834, p. 355;
Morning Chronicle, May 12, 1834, p. 3d;
V & A Press Cuttings, vol. 6, p. 170
Literature: the 6th Duke of Devonshire,
Handbook of Chatsworth and Hardwick
(privately printed, 1845), p. 61; Waagen,
1854–57, vol. 3, pp. 351–52; *Early Works,*
1869, pp. 56–57, pl. 11; *Landseer Gallery,*
1871, pl. 13; Dafforne, 1873, pp. 12–13;
Stephens, 1874, pp. 94–95, pl. 9; Mann,

1874–77, vol. 1, pp. 79, 162–63; Graves,
1876, p. 17, no. 196; *Athenaeum,* no. 2662,
November 2, 1878, p. 569; *Landseer Gallery,*
1878, pl. 9; Manson, 1902, p. 78; Lennie,
1976, pp. 158, 213
Unpublished sources: Landseer to the Duke of
Devonshire, June 20, 1853 (Chatsworth
Archives, Derbyshire)
Prints after: engravings by Samuel Cousins,
1837 (26 x 30¼"); W. T. Davey, 1856; J. R.
Jackson, 1858 (last two, *PSA,* 1892, vol. 1,
p. 34); Richard Josey for *Library Edition,*
1881–93, vol. 1, pl. 37 (*PSA,* 1892, vol. 1, p.
207); figure of girl by William Finden as "The
Angler's Daughter"; young man by William
Chevalier as "The Falconer's Son"
Related works: various studies, Artist's sale,
1874, lots 58, 87, 221, 270, 583, 589; study,
Cheylesmore sale, Christie's, May 7, 1892,
lot 32; study, sold American Art Association,
New York, April 22–23, 1920, lot 20

THE TRUSTEES OF THE CHATSWORTH
SETTLEMENT

Bolton Abbey in the Olden Time

Bolton Abbey, one of Landseer's few history pictures, was and remains among his most famous works. The commission reflects the high-minded taste of his patron the 6th Duke of Devonshire, who, like the Duke of Bedford, encouraged him to undertake only the most serious subjects. Writing to the Duke of Devonshire many years later, in 1853, Landseer expressed his gratitude in overflowing terms: "the first time you gave me leave to visit you here [Chatsworth]—I brought two Sketches or schemes for Pictures, Bolton Abbey was selected—You made me the fashion!—I feel like a horrid impostor—amidst the *real* treasures of Art you have here—Years—many years have vanished, what have I achieved since the success of 'Bolton Abbey'?" (Chatsworth Archives, Derbyshire).

Bolton Abbey lies in parkland on the banks of the Wharfe in the West Riding of Yorkshire, surrounded by wild and beautiful moorland. Founded in the twelfth century as an Augustinian priory and later owned by the Devonshire family, it is now a picturesque ruin, apart from the west end of the nave, which serves as a parish church. Landseer painted a view of the abbey itself (no. 46), a picture of the interior, and a study for the composition (no. 75), but in the absence of surviving correspondence, it is not known how often he visited the place, or when he began work on the commission.

As finished, the picture is very different from the spirit of the original commission. In the handbook to Chatsworth, the duke wrote that only the immense success of the work "reconciled me to his not having made what I gave him the commission for—namely, a representation of the place." The architectural features in Landseer's work are, to say the least, summary. The setting appears to be the original gatehouse for the priory, now used by the dukes of Devonshire as their residence, with a view of the tower through an archway; there is no longer any sign, however, of the statuette on the right of Landseer's picture.

Landseer's picture is not specifically a portrait of Bolton Abbey at all, but a more general evocation of monastic life in the Middle Ages. Three figures bring to the abbot the spoils of the hunt as a form of tribute. The forester, his knife and straw hat beside him, humbly kneels and points out the dead game—stag lying on a trestle, whooper swan, mallard duck, grouse, and gray

74.

74.

SIR AUGUSTUS WALL CALLCOTT (STUDY FOR THE HEAD OF THE ABBOT IN "BOLTON ABBEY IN THE OLDEN TIME")
By 1834
Oil on millboard, 14 x 9⅞" (35.5 x 25.1 cm)
Provenance: J. Bickerstaff; Col. Bickerstaff, his sale, Christie's, November 29, 1902, lot 45, bt. Maple; purchased by the Gallery from F. Dent, 1947
Exhibitions: Manchester, 1857, no. 307; London, 1874, no. 221
Literature: Graves, 1876, p. 17; Lennie, 1976, p. 158; R. Walker, *Catalogue of Regency Portraits in the National Portrait Gallery* (London, forthcoming)
NATIONAL PORTRAIT GALLERY, LONDON

75.

75.

STUDY FOR "BOLTON ABBEY IN THE OLDEN TIME"
By 1834
Oil on panel, 13 x 16¼" (33 x 41.3 cm)
Provenance: Artist's sale, 1874, lot 110, bt. Mrs. Mackenzie; Hazlitt, Gooden & Fox, London, from whom purchased by present owner
IAN D. MALCOLMSON

partridge. The falconer's son or assistant, booted and spurred, and wearing a form of livery, carries a dead heron and a bittern. The fisherman's daughter brings a platter of trout and a large jar; she is dressed in stockings, short skirt, and kirtle, very much like the costume worn by contemporary fishergirls on the east coast of Scotland. The abbot, dressed in the white order of an Augustinian, with a cloak, a Bible in one hand, and a rosary suspended from his belt, appears to be checking off from a list the items laid before him.

The step between the two groups of figures divides them literally and symbolically. The forester and his companions represent the simple virtues of the natural world. In contrast to this image of rude life stands the civilized, spiritual, and powerful figure of the abbot. The accessories reinforce this contrast—the incense burner, the elegant wineglass and the decanter, the abbot's spaniel, so different from the forester's hounds straining at the leash, the shadowy doorway suggesting the cool and withdrawn atmosphere of the monastery.

It would be easy to read a satirical meaning into Landseer's picture, and to see the abbot as the representative of a greedy and cynical church exploiting the people, whose natural way of life is an indictment of his own. Certainly, monasteries were not viewed with great enthusiasm in contemporary history books, written mostly, of course, by ardent Protestants. In his *View of the State of Europe* (London, 1818), Henry Hallam found it impossible to "extenuate the general corruption of these institutions . . . the whole scheme of hypocritical austerities . . . [and their] extreme licentiousness," and it was this aspect of late monasticism that caught the popular imagination. In his novel *The Monastery* (1820) and its sequel *The Abbot* (1820), Sir Walter Scott gives a telling, although not entirely hostile, account of a border abbey in the mid-sixteenth century. It is not clear from what sources Landseer drew his picture of monastic customs, but he does not seem to suggest that the relationship between the monks and their dependents is wrong or unnatural. They belong to different worlds and are dependent on each other: the monks for raw materials, the huntsmen for spiritual guidance and protection. Landseer's abbot is a stronger and more benevolent-looking character than the abbot of Scott's novel. What lies at the root of Landseer's picture is nostalgia for the good days, when society was at peace with itself, when people accepted and enjoyed their lot, when the monastic ideal meant something, and when the forests and rivers teemed with game.

The picture is crowded and busy but reads clearly. The abbot, slightly off center, forms the apex of a solid, figurative pyramid, which contains the piled-up game, rendered here in a superb passage of still-life painting. The sheer virtuosity of Landseer's animal painting, the appealing youth and charm of the girl and boy, and the picturesque and romantic setting of the picture caught the public's imagination and made this one of Landseer's great successes. Although the background has darkened, and some of the detail is lost, the picture remains surprisingly light in tone, with deep, transparent glazes. The picture is highly finished, but Landseer's touch remains bright and vivid. He is known to have made use of a number of friends as models for the figures: the painter Sir Augustus Wall Callcott for the head of the abbot (no. 74); a Russian serf whom the Duke of Devonshire brought back with him from Saint Petersburg for the forester; Jacob Bell for the falconer; and Landseer's sister Jessica for the fishergirl.

Portraits and Caricatures, 1830-1857

PORTRAITURE was not Landseer's natural métier, and he resented its demands. In view of his reputation as a sporting artist, it was, however, inevitable that he would be asked to undertake portraits of his patrons in the hunting field. For the Duke of Atholl he painted the impressive group *Death of the Stag in Glen Tilt* (no. 30), a portrait of a great Highland chieftain accompanied by his grandson and his keepers with a trophy of his favorite sport at his feet. Contemporary is *Scene in the Highlands* (private collection), a large picture of the Duke of Gordon bestriding a stag, with his daughter the Duchess of Bedford and his grandson Lord Alexander Russell. The culmination of these early sporting groups is *Death of the Wild Bull* (no. 78), in which the life-size figures and animals dominate the space in a monumental composition. His later hunting groups, such as *Return from Hawking* (by 1837, collection of the Duke of Sutherland) and *Windsor Castle in Modern Times* (no. 105), are tamer and more domesticated.

Landseer's portraits of children, for which he became famous, exhibit a similar tendency towards more formal composition. His earliest portraits of children, such as the equestrian portrait of Lord Cosmo Russell in the Highlands (no. 22), are small in scale and full of spontaneous and naturalistic effects. Other early examples include the companion portrait of Lord Alexander Russell on his pony, called *The First Leap* (Guildhall Art Gallery, London), the Duke of Atholl's grandson the Honorable James Murray with a keeper and a fawn (by 1827, Blair Atholl, Perthshire), and the Duke of Devonshire's cousin Lord Richard Cavendish with a greyhound and a hawk (by 1828, Chatsworth, Derbyshire). In the early 1830s Landseer experimented with a new type of child portraiture; the children are still shown with favorite pets in settings full of suggestive clues but as life-size figures in formal compositions. A new seriousness and self-consciousness become apparent in Landseer's child portraiture, as in other aspects of his work. The first of these groups is of the Abercorn children (by 1834, Barons Court, Northern Ireland), a picture of the elder daughters of the Duke and Duchess of Abercorn, one of whom is in a cradle guarded by a bloodhound. This group was followed by a succession of similar works: the Sutherland children (no. 79); the Bathurst children feeding rabbits (by 1839, Cirencester Park, Gloucestershire); Princess Mary of Cambridge balancing a biscuit on the nose of a huge Newfoundland dog (by 1839, Royal Collection); and *Return from the Warren,* a portrait of the Honorable A.J.G. Ponsonby on his pony with dead rabbits (by 1843, Rossie Priory, Scotland).

No sooner had Landseer established a name as a portraitist—and he was constantly in demand—than he began to tire of it. His later career is littered with a succession of uncompleted commissions: the state portrait of Queen Victoria on horseback (no. 101), the so-called Balmoral boat picture (no. 112), which cost him so much anguish, Charles Sheridan with his sister-in-law and nephew (no. 81), the Duke of Devonshire, and others. In fairness to Landseer it should be said that he often tried to avoid portrait commissions. He told the Duke of Devonshire in 1854 that he was more of an animal painter than a portraitist and that he could consider doing portraits only when "combined with the picturesque or with a sort of Story." As time passed, however, stories were no longer sufficient incentive to grapple with the problems of likeness and composition.

The sense of likeness, which Landseer struggled to achieve in his formal

portraits, came to him effortlessly in his sketches. He could put down the essentials of a personality in a few strokes. The immediacy of his images is directly related to their economy of means—that quick, impressionable quality of hand and eye. His portrait sketches have the same brilliant, translucent quality of light as his landscapes, the same freshness and pleasure in painting for painting's sake. In these sketches Landseer could choose his own sitters, and they are drawn from the circle of his close friends and patrons: Sir Walter Scott, the Duchess of Bedford, the Duchess of Abercorn, Lady Rachel Russell and other members of the Russell clan, Lord Melbourne, Sir Augustus Wall Callcott, and Caroline Norton. More finished and idealized, although still within this informal orbit, are Landseer's cabinet-sized portraits or conversation pieces, also of friends, such as Lady FitzHarris, the Holland House historian William Allen (1836, National Portrait Gallery, London), and Lady Theresa Lewis in a mantilla (by 1836, private collection), several of which were engraved for the keepsake annuals of the day. Landseer continued to paint portrait sketches long after he had abandoned more formal types of portraiture, among them impressive studies of his father (by 1848, National Portrait Gallery, London) and of the sculptor John Gibson (no. 82).

The Duchess of Bedford

Landseer drew and painted Georgiana, the Duchess of Bedford, on many occasions. Georgiana, daughter of the 4th Duke of Gordon, married the 6th Duke of Bedford as his second wife and had ten children. Her intimate

76.
THE DUCHESS OF BEDFORD
c. 1830
Oil on board, 17½ x 10½" (44.5 x 26.7 cm)
Provenance: her daughter, the Duchess of Abercorn, by descent
Exhibition: London, 1961, no. 72
THE DUKE OF ABERCORN

76.

124

77.

77.
THE VISCOUNTESS FITZHARRIS
1834
Oil on panel, 16¾ x 21" (42.6 x 53.4 cm)
Inscribed on reverse of panel: *Portrait of the Viscountess FitzHarris/daughter of the Earl of Tankerville/painted at Chillingham Castle,/in 1834. By Edwin Landseer*
Provenance: by descent in family
Exhibition: London, R.A., 1838, no. 147
Review: Athenaeum, no. 551, May 19, 1838, p. 363
Literature: Frith, 1887–88, vol. 3, p. 81
THE EARL OF MALMESBURY

friendship with Landseer lasted from the 1820s until her death in Nice in 1853.

This portrait of her in a black bonnet and dress is subdued, almost melancholy in mood, but conveys the imposing carriage and the formidable character of the duchess in a most sensitive and moving way. A more formal portrait of her is at Woburn Abbey, Bedfordshire, and a similar version of that was engraved in 1829 (not in 1823 as stated by Graves, 1876, p. 8, no. 68, and other authorities). Another oil sketch of her is at Barons Court, Northern Ireland, together with a more formal portrait of her husband.

The Viscountess FitzHarris

This portrait of the artist's close friend Lady FitzHarris is a charming and seductive image of high life. The lady is resting or convalescing, but her expression is lively and intent as she sews a lace handkerchief. Dressed in the height of fashion in a velvet dress and ermine-edged pelisse, she is shown in a luxurious interior, the details of which Landseer clearly enjoyed painting: green curtains, light-colored paneling, floorboards set off by a purplish rug, armchair with red velvet cushions and matching footstool, pedestal table with a shawl and fur tippet on it, workbasket lined in green, and vase with a single flower. The window opens onto the hills, suggesting that the sitter is not only a creature of the boudoir but also a lover of nature. This contrast is emphasized by the deerhound, who is looking out of the window, and the King Charles spaniel in her lap, who is looking towards its mistress. A portrait that verges on being a genre scene, it is charmingly observed and freshly painted.

Landseer painted two other oil portraits of Lady FitzHarris: one showing her standing on the ramparts of her family home at Chillingham Castle in Northumberland, the second a sketch of her reading. Henry Graves mistook the first of these portraits for the one exhibited at the Royal Academy in 1838, which, however, was clearly the picture exhibited here, as described by the review in the *Athenaeum* (May 19, 1838).

Death of the Wild Bull

In his short essay of reminiscences of life in the Highlands, Lord Ossulston, later the 6th Earl of Tankerville, records meeting Landseer for the first time at Glenfeshie about 1829. Ossulston also mentions the actor C. J. Mathews as one of the party, a discrepancy from other sources which make it clear that Mathews's first and only visit there was in 1833. Landseer had certainly drawn and painted the Chillingham wild cattle before that date (*see* no. 69), and a letter of February 1833 from the 5th Earl of Tankerville, who apparently commissioned the painting, implies that the picture had already been in progress for some time.

According to Ossulston's account, he took Landseer back with him from Glenfeshie to Chillingham, "where he at once devoted himself to the wild cattle as keenly as he had done to his beloved deer, observing them with his glass for days from some hiding place." Like the Chartley and Cadzow cattle, the famous Chillingham herd is descended from native breeds of wild cattle and owes its survival to the remoteness of the border country. The animals are almost pure white and very distinctive in shape.

To allow Landseer a closer look at the cattle, a decision was made to shoot one of the bulls. A keeper was placed in ambush beside a gate, which he was to shut on one of the bulls when the main herd went through. The plan went wrong, the keeper was thrown by the angry bull, and his life was saved only by the prompt action of Ossulston's deerhound, Bran, which held the bull off the body. Ossulston recorded that the keeper, called Barnes, survived his wounds and lived to be eighty: "Of course the bull was forthwith shot, and, together with Bran and the other personages concerned, was the subject of Landseer's picture of the 'Dead Bull.'"

The incident became a *cause célèbre,* and there are numerous drawings by Landseer of the bull throwing the keeper. Algernon Graves wrote that the second figure in the picture was William Wells of Redleaf, but Landseer described him as a keeper in his letter to his sister Emma, and John Guille Millais identified him as the head keeper, Coles. The picture is monumental in scale, and the figures are much larger in relation to the picture space than in Landseer's previous sporting groups. Ossulston, the epitome of the elegant, aristocratic type, dominates the composition, in which his head is the apex of a pyramid. Figures and animals are grouped in a semicircle around the prostrate body of the bull, whose massive form creates a dramatic counter curve. Coles holds Bran on the left; a bloodhound beyond imitates its master by putting a paw on the bull; in the center of the design is the romantically painted head of Ossulston's pony Hotspur; and another hound closes off the composition to the right.

The picture is painted in a remarkably light key and glows with color. Passages such as the head and neck of the bull are painted in a subtle range of pinks, grays, and beiges. Although the impasto shows signs of having been flattened, and there are damages from bitumen in the dark colors, the picture surface still exhibits the panache and virtuosity of Landseer's brushwork. Ossulston described him at work: "It was most interesting to watch his unerring hand and eye guiding the brush with faultless precision, from the broadest to the minutest touches; for, though dashed in with marvellous rapidity they never were retouched."

At the end of his life, Landseer painted companion pictures of the Chillingham deer and cattle to hang opposite this picture in the dining room at Chillingham Castle (nos. 153, 154).

78.
SCENE IN CHILLINGHAM PARK: PORTRAIT OF LORD OSSULSTON (also called DEATH OF THE WILD BULL)
Before 1833–1836
Oil on canvas, 88 x 87¾" (223.5 x 223 cm)
Provenance: apparently commissioned by the 5th Earl of Tankerville, by descent; Oscar and Peter Johnston, London, by c. 1967, from whom acquired by present owner
Exhibition: London, R.A., 1836, no. 14
Reviews: Morning Post, May 3, 1836, p. 5e; *The Times,* May 4, 1836, p. 5f; *Athenaeum,* no. 445, May 7, 1836, p. 331
Literature: Dafforne, 1873, p. 16; Mann, 1874–77, vol. 3, p. 64; Graves, 1876, p. 19, no. 217; the 6th Earl of Tankerville, "The Chillingham Wild Cattle. Reminiscences of Life in the Highlands" (privately printed, 1891), pp. 31–32; Manson, 1902, pp. 168–69; John Guille Millais, *Mammals of Great Britain and Ireland* (London, 1904–6), vol. 3, p. 202; Whitley, 1930, p. 317; Lennie, 1976, p. 221
Unpublished sources: the 5th Earl of Tankerville to Landseer, February 26, 1833, hoping that he will return to Chillingham to proceed with the picture (V & A, Eng MS, 86 RR, vol. 5, no. 311); Landseer to his sister Emma, undated, saying he is making good progress on a picture of "Ld Osston", Horse, three Dogs, dead Bull, and Keeper, all as large as life" (Sims & Reed, catalogue no. 23, London, 1979, no. A115); Queen Victoria's Journal, July 18, 1836, praising the picture at the Academy; copyright agreement between Landseer and Henry Graves, August 20, 1867 (British Library, London, Add MS, 46140, f. 289)
Prints after: engravings by Thomas Landseer, 1874 (24½ x 23¾") (PSA, 1892, vol. 1, p. 83); A. C. Alais for *Library Edition,* 1881–93, vol. 2, pl. 10 (PSA, 1912, unpaginated)
Related works: oil sketch for composition (16 x 18¾"), anonymous sale, Christie's, May 8, 1959, lot 29, bt. Leggatt
TENNANT HOLDINGS LIMITED

78.

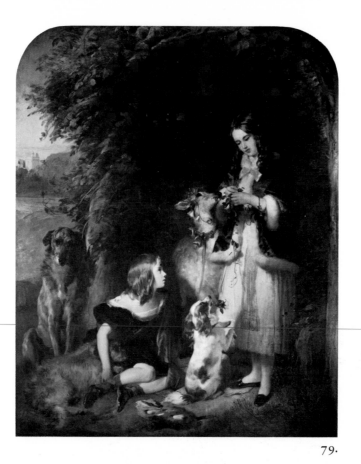

79.

79.

THE MARQUESS OF STAFFORD AND THE LADY
EVELYN GOWER WITH DUNROBIN CASTLE IN
THE DISTANCE (also called THE SUTHERLAND
CHILDREN)
1835–38
Oil on canvas, 80 x 64" (203.3 x 162.5 cm)
Provenance: commissioned by the 2nd Duke
of Sutherland, by descent
Exhibitions: London, R.A., 1838, no. 49;
London, 1874, no. 249; London, Christie's,
*Thirty Pictures in the Collection of the Duke
of Sutherland,* 1958, p. 17
Reviews: Morning Post, May 8, 1838, p. 3e;
Athenaeum, no. 551, May 19, 1838, p. 363
Literature: Mrs. Jameson, *Companion to the
Most Celebrated Galleries in London*
(London, 1844), p. 215, no. 181; Dafforne,
1873, p. 18; Stephens, 1874, p. 100; Mann,
1874–77, vol. 1, p. 93; Graves, 1876, p. 21,
no. 250; *Landseer Gallery,* 1878, pl. 21; Frith,
1887–88, vol. 3, p. 81; *Catalogue of Pictures
in Stafford House* (privately printed, 1908),
p. 46, no. 192; *Catalogue of the Pictures in
Dunrobin Castle* (privately printed, 1921),
p. 25, no. 110; Lennie, 1976, pp. 59, 63
Unpublished sources: the Duchess of
Sutherland to Landseer, undated, arranging
for Lady Evelyn to sit (V & A, Eng MS, 86 RR,
vol. 5, no. 344); the Duke and Duchess of
Sutherland to Landseer, 1835, March 1, 1838,
March 28, 1841, April 3, 1841, and undated,
concerning sittings, props, and the print
(Mackenzie collection, nos. 856–59, 867);
Landseer to Henry Graves, April 18, 1841
(V & A, Eng MS, 86 JJ, Box 2, no. 14);
J. L. Heath to Landseer, December 26, 1837,
about engraving the picture (V & A, Eng MS,
86 RR, vol. 3, no. 170); Landseer's copyright
receipt to Hodgson & Graves (300 guineas),
July 10, 1839 (British Library, London, Add
MS, 46140, f. 122); Landseer to C. G.
Lewis and F. C. Lewis, October 10, 1839,
November 15, 1839, concerning the print
(British Library, London, Add MS, 38608,
f. 12, 14)
Prints after: engravings by Samuel Cousins,
1841 (22 x 17½"); C. J. Tomkins for *Library
Edition,* 1881–93, vol. 1, pl. 32 (PSA, 1892,
vol. 1, p. 207)
Related works: version or copy (24 x 20"), J. B.
Speed Art Museum, Louisville, Kentucky;
version or copy (30 x 25"), Scott & Fowles,
New York, 1951; version or copy (17½ x
16½"), Christie's, July 16, 1925, lot 135; the
marquess with two dogs (50 x 60"), American
Art Association, New York, March 5, 1913,
lot 78; chalk drawing of the marquess, Artist's
sale, 1874, lot 993
PRIVATE COLLECTION

The Marquess of Stafford and the Lady Evelyn Gower

This portrait is of the two elder children of the 2nd Duke of Sutherland: the Marquess of Stafford, who succeeded to the title as 3rd Duke in 1861, and his elder sister, Lady Evelyn, who married the 12th Lord Blantyre in 1843. They are in a bower near the seashore, and the view behind shows Dunrobin Castle (*see* no. 48), the seat of the Sutherlands on the eastern coast of Scotland, with its square Norman keep, prior to the Victorian rebuilding which transformed it into one of the grandest houses in Scotland.

The picture was begun about 1835, when the boy was seven and the girl ten. Landseer may well have owed his introduction to the duke to the latter's cousin Lord Francis Egerton, later the 1st Earl of Ellesmere, for whom he painted *Return from Hawking* (by 1837, collection of the Duke of Sutherland). The picture is one of Landseer's most appealing inventions, capturing the theme of youth and innocence in the children and in the animals who complement them. Lady Evelyn, charmingly dressed in white with a blue fur-lined pelisse, is the focus of attention and the mainstay of the composition. Everyone, except the old deerhound on the left, gazes up at her with adoration: her pretty brother, with long ringlets and still in nursery clothes, wearing a green dress and cloak; the terrier under his arm; the toy spaniel, proffering her a white rose; and her tame deer with a collar and ribbon, whose head she is decorating with columbine. The old deerhound stands apart, in the role of faithful guardian of his master's children. On the ground lies the sheath of a double hunting dirk (the larger dirk is missing) as well as a magnificent badger's-head sporran, or pouch, symbols of Highland rank, to which, like the castle, the boy is heir; the responsibilities of a great name and position await him.

The arching branches of the tree on the right and the creepers climbing the tree or stump on the left frame the central group like the border of a contempo-

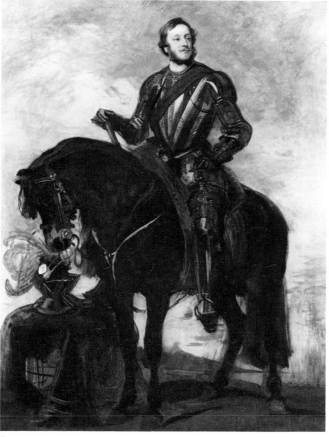

80.

80.

THE DUKE OF BEAUFORT ON HORSEBACK
1839-42(?)
Oil on canvas, 35 x 27" (89 x 68.6 cm)
Provenance: Artist's sale, 1874, lot 308;
acquired by the 8th Duke of Beaufort(?),
by descent
Exhibitions: London, 1874, no. 375; London,
R.A., *British Portraits,* 1955-56, no. 388;
London, 1961, no. 96
Literature: Graves, 1876, p. 27, as 1845

THE DUKE OF BEAUFORT

rary book illustration. Here is the secure, enclosed, and enchanted world of childhood. That it is transient is suggested not only by Landseer's tender treatment of the animals and children but also by the dark space behind them, more like the entrance to a cave than a bower, which creates a mood of mystery and otherworldliness. In the same period as this group, Landseer also painted matching oval portraits of the Marquess of Stafford and his three sisters as the Four Seasons for a scheme of decoration at Stafford House, London (now at Dunrobin, Scotland).

The Duke of Beaufort on Horseback

This is a portrait of the 7th Duke of Beaufort, a passionate sportsman. When this painting was exhibited in London in 1961, the exhibition catalogue stated, erroneously, that the duke was dressed in the armor he wore at the 1839 Eglinton Tournament. This tournament, inspired by a romantic and chivalric vision of the Middle Ages, has become synonymous with the medieval revival. It was organized, with no expense spared, by the hugely wealthy and eccentric 13th Earl of Eglinton. Extravagant suits of armor were hired and fitted out by each contestant, mostly from the dealer Samuel Pratt. At the appointed time in late August vast crowds descended on Eglinton Castle in Scotland, where a full-scale medieval tournament was reenacted, with elaborate jousts, banquets, and processions of knights, ladies, and attendants in historical costumes. The event was nearly washed out by rain, which introduced a note of farce into the proceedings, but Eglinton pursued his dream in the teeth of the weather. The story is well told by Ian Anstruther in a book aptly entitled *The Knight and the Umbrella* (London, 1963; *see also* Edinburgh, Scottish National Portrait Gallery, *Van Dyck in Check Trousers,* 1978, pp. 104-14). In fact, however, the duke did not take part in the Eglinton

Tournament in August 1839, although he had attended rehearsals in London and may have planned to go. He was present at the famous medieval costume ball at Buckingham Palace in May 1842 (*see* no. 109). Landseer does not appear to have attended the tournament either, although he was certainly in sympathy with the spirit of the event. In a letter of August 17, 1839, he wrote to Captain Bagot that he would be unable to get away from London until late autumn: "I suppose you won't trust the weather till after the tournament" (J. S. Maas Gallery, London).

This portrait of the duke was perhaps a sketch for a larger commissioned work. In a letter to Landseer of December 8, 1841, the Duchess of Beaufort made a fleeting reference to "cavaliers on horseback," and on April 16, 1842, the duke himself complained about being unable to prevail upon Landseer to let him sit (V & A, Eng MS, 86 RR, vol. 1, nos. 21, 32). Another knight who had himself painted in armor, but not on horseback, was Charles Lambe, who commissioned a three-quarter-length portrait by Sir Francis Grant (location unknown).

This portrait derives most closely from Van Dyck's equestrian portrait of Charles I of England, in the National Gallery, London. Landseer has reinterpreted in a romantic spirit a monumental type of equestrian design dating to the Renaissance. The spirited treatment of the sketch and the sense of movement and energy that is communicated are again Flemish in inspiration. The duke is presented in the guise of a great commander, surveying the world from a lofty eminence. He wears a blue sash across his left shoulder, possibly the Order of the Garter, which he received in 1842, his right hand rests on a baton, and his plumed helmet is placed, somewhat incongruously, on a stool by the horse's head. He is wearing an elaborate Italian foot armor of the 1580s, with bands of gilt and chased decoration.

Here Landseer was experimenting with plans for a male equestrian composition shortly after he had begun work on the big, state portrait of Queen Victoria on horseback (*see* no. 101). The Duke of Beaufort also commissioned a group portrait of his children, which is unfinished, and a large picture of his dogs, *Lion and Dash* (both at Badminton, Gloucestershire). A number of caricatures of people and animals, dating mostly from 1837, record Landseer's visits to the duke's seat, Badminton.

Charles Sheridan with Mrs. Richard Sheridan and Child

Charles Kinnaird Sheridan, a diplomat, was the brother of Richard Brinsley Sheridan and of Caroline Norton. He died from the effects of tuberculosis in the British Embassy in Paris on May 30, 1847, at the age of thirty. He is shown with his sister-in-law Maria and her eldest son, Richard.

When Landseer began the picture, which was a commission from Richard Sheridan, is not certain but whether painted posthumously or not, it was clearly conceived as a memorial work. Landseer had been deeply touched by the death of the young man and its effects on a family for whom he had great affection. Charles is shown in an invalid's chair in the last stages of his illness. Wrapped in a warm dressing gown, his tall elegant figure droops listlessly. His large, soulful eyes are accentuated by the pallor and wasting effects of his disease. Unconscious of his surroundings, Sheridan gazes into space with an expression of extreme sadness and calmness, facing eternity without fear. Neither his sister-in-law reading, nor the spaniel in his lap trying to gain his attention, nor the landscape outside can distract his mind from the things of the spirit.

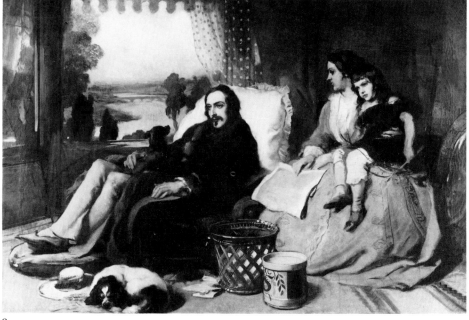

81.

81.

CHARLES SHERIDAN WITH MRS. RICHARD
SHERIDAN AND CHILD
From 1847
Oil on canvas, 42 x 66" (106.8 x 167.8 cm)
Provenance: Artist's sale, 1874, lot 122,
purchased for the Gallery
Exhibition: London, 1874, no. 147
Literature: Anne Thackeray [Ritchie], "Sir
Edwin Landseer," *Cornhill Magazine,* vol. 29
(1874), p. 90; Graves, 1876, p. 28; *Catalogue
of Pictures in the National Gallery and the
National Portrait Gallery, Ireland* (Dublin,
1908), p. 409, no. 309 (1928 edition), p. 353
Unpublished sources: Landseer to Richard B.
Sheridan, November 13, 1861 (collection of
Kenneth Lohf, New York)

NATIONAL GALLERY OF IRELAND, DUBLIN

In contrast to the lassitude of the dying man is the vitality of his nephew, perched on his mother's lap, holding a drumstick. He, at least, is not overborne by the atmosphere of mortality, and it is surely not a coincidence that his drum should stand beside his uncle's wastepaper basket. The presence of this last accessory in the very center of a triangular composition cannot be accidental; the wastebasket seems to stand there to suggest not only the end of human affairs but also of life itself. The drum can sound a note of hope and of play; but it is also an instrument associated with funerals. The sleeping King Charles spaniel on the floor and the straw hat suggest, like the softly billowing curtain, a spring or summer day, on which death appears all the more grim.

Richard Sheridan lived at Frampton Court near Dorchester on the river Frome, but the bridge and the river scene in the background do not seem to have been painted there. The only nearby bridge, the Peacock Bridge, would not have been visible from the court and has only three spans.

Like most of Landseer's late portraits this one was never finished. Although it may have been begun in 1847, the loose style of painting suggests a considerably later date. On at least three occasions, November 14, 1847, January 27, and September 20, 1848, Landseer wrote to Sheridan and his wife to postpone visits to Frampton, possibly in connection with the commission (collection of Kenneth Lohf, New York, and Sotheby's, July 6, 1977, lot 288). In one letter he wrote that he hoped "my beautiful subject has not altered much," and in another gave his "blessing to the beautiful boy," perhaps in reference to the youthful model in the picture. On November 13, 1861, he wrote to Sheridan: "The Picture gets on. I do not regret my seeming coldness in lingering as long over the composition. Sincerely I believe the Picture will gain by years of experience, mournful as our associations may be with the treatment of the subject. I hope it may engage *a pleasing Melancholy.* I am making an effort for the two Exhibitions, the '62 National Show and our R. Academy annual collection—and require all my time all my energy and Health—*your* Picture is the work of Heart—others belong chiefly to Art."

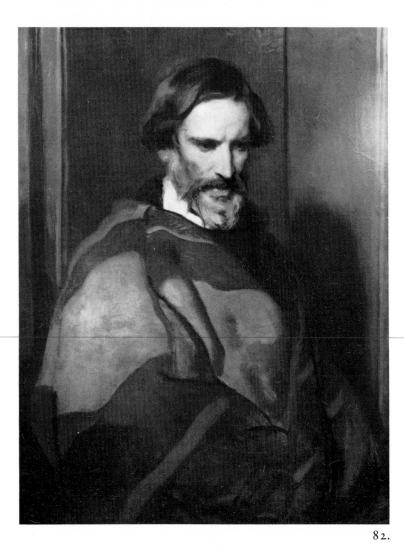

82.
JOHN GIBSON
c. 1850
Oil on canvas, 35 x 27" (89 x 68.6 cm)
Provenance: given to the Academy by the
artist's executors, 1874
Exhibitions: London, 1874, no. 189; London,
R.A., *Old Masters,* 1903, no. 118; London,
R.A., *Exhibition of British Art,* 1934, no. 674;
London, R.A., *British Portraits,* 1956–57, no.
365; London, 1961, no. 78; Sheffield, 1972,
no. 77
Literature: Anne Thackeray [Ritchie], "Sir
Edwin Landseer," *Cornhill Magazine,* vol. 29
(1874), p. 90; C. H. Collins Baker and
Montague R. James, *British Painting*
(London, 1933), pl. 125; Gaunt, 1972, pl. 64;
Ormond, 1973, vol. 1, p. 187, vol. 2, pl. 351;
Mary Bennett, *Walker Art Gallery, Liverpool,
Merseyside Painters, People and Places,
Catalogue of Oil Paintings* (Liverpool, 1978),
vol. 1, p. 136
Related work: version or copy (36⅛ x 28"),
Walker Art Gallery, Liverpool
ROYAL ACADEMY OF ARTS, LONDON

82.

John Gibson

This portrait is of the veteran sculptor John Gibson, who had lived in Rome since 1817, following in the footsteps of the two greatest neo-classical sculptors of the age, Canova and Thorwaldsen. Gibson's marble groups, including *Psyche and the Zephyrs, Hylas and the Nymphs,* and his celebrated *Tinted Venus,* are marked by high-mindedness, classical purity of form, and great delicacy of surface texture. Dedicated to his art, proud of his simple origins, fiercely individualistic and uncompromising, Gibson was revered and respected as the greatest British sculptor of the age.

Landseer never visited Rome, and this portrait must have been executed on one of Gibson's infrequent visits to England, where he returned in 1844 and again in 1850. Comparison with other recorded portraits of him points to the later date as the more likely. A common meeting ground for the artist and his sitter would have been the home of Sir Charles and Lady Eastlake, with whom both men were friendly. However, the circumstances by which Landseer came to paint Gibson are not known.

Gibson is represented in the portrait without any obvious marks of his profession, wrapped in a rough Italian cloak, like a shepherd of the Campagna, looking down in an attitude of deep thought. The characterization is powerful, expressing Gibson's rough simplicity of manner, his strong and intractable personality, and the force of his mind. This is one of Landseer's simplest and most penetrating portraits, painted simply and directly in a sitting or two.

Caricatures

No account of Landseer's gifts as a portraitist would be complete without considering his caricatures, the witty pen-and-ink sketches he drew so effortlessly and prolifically. Such sketches were his contribution to the fun and games of house parties and he invariably left the results with his host and hostess. There are over three hundred drawings of the Russells and their friends at Barons Court, Northern Ireland, a hundred or more in the Redleaf albums (private collection, London), a similar number from a Chillingham Castle album (Christie's, July 11, 1972, lot 23), and another group from the Ellice family (Sotheby's, June 24, 1971, lots 29–38), to name only the most obvious sources. The same personalities occur again and again: the Duchess of Bedford greeting guests at a reception, gardening, at a picnic, on a pony (no. 88), as a milkmaid, having her leg rubbed after a sprain; Lord Cosmo Russell "as he will be," with a medal and an armless sleeve; Lady Georgiana Russell as a country girl; Edward Ellice and Lord Brougham deerstalking; Jane Ellice

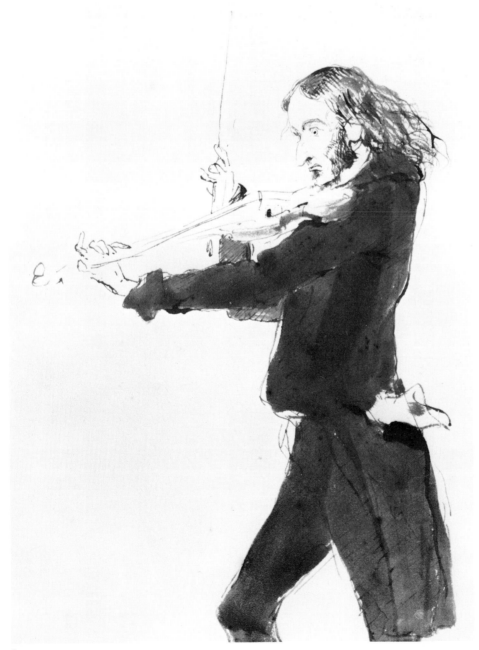

83.

83.

NICCOLO PAGANINI
Before 1840
Pen, sepia ink, and wash on paper, 8¾ x 7″ (22.2 x 17.8 cm)
Provenance: Dr. Pick; Frederick Behrens, given to the Gallery by his nephews, 1945
Exhibitions: London, 1874, no. 93; *The Behrens Collection:* Birmingham, 1933, no. 140, Cambridge, 1938, no. 140, and British Council, 1945, no. 135; Sheffield, 1972, no. 71
Literature: Mann, 1874–77, vol. 3, p. 145, vol. 4, p. 83; Graves, 1876, p. 23, no. 284; Monkhouse, 1879, p. 111, pl. 26; *Catalogue of the Frederick Behrens Collection* (Manchester, 1945), p. 49, no. 140
Related works: companion drawing of Paganini bowing, City of Manchester Art Galleries; Countess of Blessington's sale, Phillips, London, May 7–26, 1849, lot 1181; Sir Hope Grant, exhibited London, 1874, no. 92; Mrs. Yehudi Menhuin, from the Ellice collection, Sotheby's, June 24, 1971, lot 30; Redleaf albums, private collection, London

CITY OF MANCHESTER ART GALLERIES

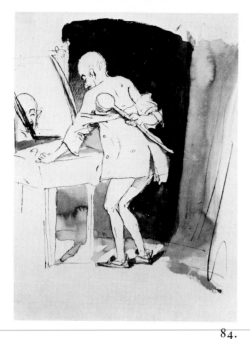

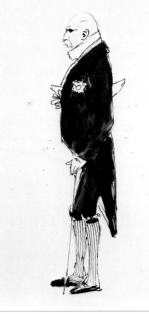

84.

85.

86.

84.

SAMUEL ROGERS SCRATCHING HIS BACK
Pen, sepia ink, and wash on paper, 9⅜ x 7½"
(23.8 x 19.1 cm)
Provenance: from album of drawings
organized by Lady Ida, daughter of the 6th
Earl of Tankerville, and later Countess of
Dalhousie; by descent to David Ramsay; sold
by him, Christie's, July 11, 1972, lot 23, no.
34, bt. Agnew, from whom acquired by the
Gallery

NATIONAL PORTRAIT GALLERY, LONDON

85.

WILLIAM MAKEPEACE THACKERAY
1857
Pen, sepia ink, and wash on paper, 4⅝ x 3⅞"
(11.7 x 9.8 cm)
Inscribed on reverse of original backboard:
*Mr Thackeray Sketched at/South Park by Sir
Edwin Landseer/in 1857/F.G.* [Francis Grant]
Provenance: Sir Francis Grant; by descent to
his granddaughter, the Honorable Mrs.
Walsh; sale, Christie's, January 28, 1955,
lot 4, bt. Colnaghi, from whom acquired by
the Gallery
Exhibition: London, 1961, no. 100
Literature: Ormond, 1973, vol. 1, p. 460,
vol. 2, pl. 915

NATIONAL PORTRAIT GALLERY, LONDON

86.

UNIDENTIFIED KNIGHT OF THE GARTER
Pen, sepia ink, and wash, with chalk, on paper,
11⅝ x 7½" (29.5 x 19.1 cm)
Provenance: presumably acquired by
Queen Victoria
Literature: Studio, vol. 107 (1934); p. 147
HER MAJESTY QUEEN ELIZABETH II

holding a flower; the portly Lord Alvanley playing billiards; Lord Ossulston, Lord Abercorn, and Mr. Bagot contemplating a stag in the larder at Ardvereike; Landseer leaving Chillingham in tears; Sir Massey Storey out hunting with a turtle, and then cooking it.

Landseer sketched the most famous violinist of his age, Paganini, a self-acknowledged genius with an international reputation, often credited as a musician with diabolical powers (no. 83). When Paganini made his debut in London on June 3, 1831, at the King's Theatre, he wrote: "Scores of portraits of me made by different artists have appeared in all the print shops." Paganini died in 1840, the year Algernon Graves had assigned to Landseer's drawings of him, but they must have been done earlier. Landseer caricatured Sydney Smith, a canon of Saint Paul's and a famous wit, with a devil (no. 87); Samuel Rogers, whose eccentric behavior made him a good subject, scratching his back (no. 84); and Lady Holland, the famous political hostess and *grande dame,* in her bath chair (no. 89). Landseer also sketched William Thackeray (no. 85) at South Park, the home of the 2nd Viscount Hardinge, where the artist spent a great deal of time in his last years. His amusing caricature of an elderly man in court dress with the star of the Garter (no. 86) has been called the Duke of Cambridge, but the gentleman's identity is uncertain. These sharp but private caricatures belong to the tradition of English satirical illustration, and reveal Landseer as a deft observer of the social scene.

87.

87.

SYDNEY SMITH WITH A MONK AND A DEVIL
Pen, sepia ink, and wash on paper, 9⅜ x 7½"
(23.8 x 19.1 cm)
Provenance: same as no. 84, except Christie's,
July 11, 1972, lot 23, no. 14
NATIONAL PORTRAIT GALLERY, LONDON

88.

88.

THE DUCHESS OF BEDFORD ON A PONY
Pen, sepia ink, and wash on paper, 7 x 8″
(17.8 x 20.3 cm)
Provenance: the 1st Duke and Duchess of
Abercorn, by descent
THE DUKE OF ABERCORN

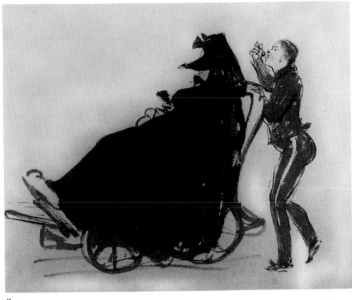

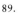

89.

89.

LADY HOLLAND IN A BATH CHAIR WITH A PAGE
Pen, sepia ink, and wash on paper, 7 x 8½″
(17.8 x 21.6 cm)
Provenance: the 1st Duke and Duchess of
Abercorn, by descent
Exhibition: London, 1961, no. 131
THE DUKE OF ABERCORN

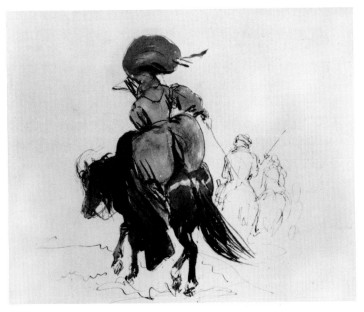

90.

90.

MISS MASON ON A PONY
Pen, sepia ink, and wash on paper, 7 x 7¾″
(17.8 x 19.8 cm)
Provenance: the 1st Duke and Duchess of
Abercorn, by descent
Exhibition: London, 1961, no. 144
THE DUKE OF ABERCORN

Animal Subjects, 1830-1851

LANDSEER'S INTEREST in animals extended beyond dogs and deer. In the course of his career he sketched and painted a wide range of breeds. He was a compulsive sketcher, his interest easily aroused by unusual species. Landseer continued painting straightforward sporting pictures throughout his life; however, the majority of his animal studies are independent sketches, uncon- nected with larger works. His range of styles is as varied as the breeds of animals, from the Dürer-like finish and delicacy of *Ferret and Dead Hare* (no. 93) to the pen-and-ink squiggles of the hippopotamus (no. 97). The late chalk drawings combine breadth of effect with fine precision, and Landseer's ability to evoke the forms and textures of animal life in this medium is often astonishing. The most unusual sporting item is the silver salver that Landseer designed (no. 96), although the designs are not in the least typical of his work. Only the fact that the Duke of Bedford requested it of him made him overcome his natural reluctance to undertake design work of this kind.

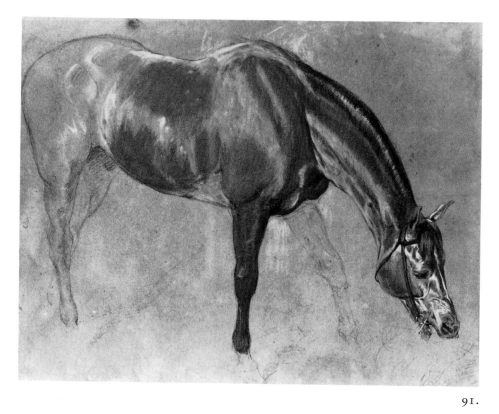

91.
HORSE
Watercolor, and black and white chalk on paper, 10⅞ x 14½" (27.8 x 36.9 cm)
Signed lower right: *EL*
Provenance: purchased from Colnaghi by Louis Clarke, his bequest to the Museum, 1961
FITZWILLIAM MUSEUM, CAMBRIDGE

91.

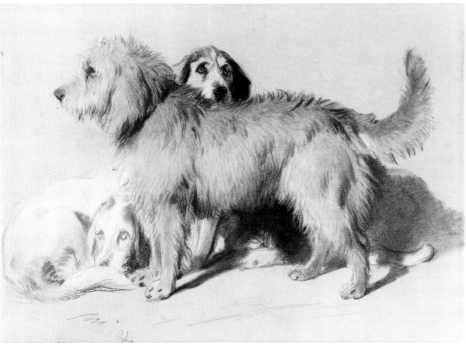

92.

92.

THREE DOGS

Colored chalk on paper, 14 x 20"
(35.6 x 50.8 cm)
Signed lower left: *EL*

Provenance: presented to the Museum by
Col. A. Utterson, 1946
Literature: Art Journal (1876), p. 272
Prints after: engraving by Charles Mottram
for *Art Journal* (1876), pl. 24

THE TRUSTEES OF THE BRITISH MUSEUM,
LONDON

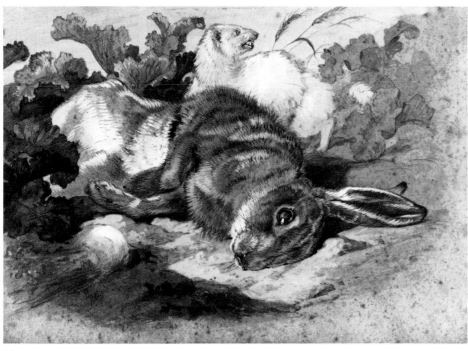

93.

93.

FERRET AND DEAD HARE
1830

Watercolor and pencil, heightened with
Chinese white, on paper, 8 x 11½"
(20.3 x 29.2 cm)
Signed and dated lower left: *EL/1830*

Provenance: Artist's sale, 1874, lot 449, bt.
grandfather of present owner
Literature: Art Journal (1875), p. 257,
and Monkhouse, 1879, p. 125, pl. 30
(as a woodcut)

PRIVATE COLLECTION

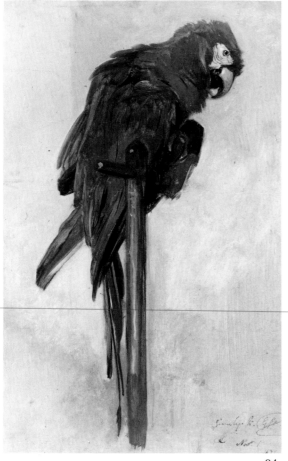

94.

94.

STUDY OF A PARROT (MACAW)
1837
Oil on board, 20 x 14½" (50.8 x 36.8 cm)
Inscribed lower right: *Given by. to. GH/EL
Nov.! 1./1837*
Provenance: George Hayter(?)
Exhibition: London, 1961, no. 9
PRIVATE COLLECTION

95A.
FALCON (also called THE HAWK and HAWK
UNHOODED)
95B.
HOODED FALCON (also called PEREGRINE
FALCON)
By 1837
Both oil on panel, 23 ¾ x 16" (60.4 x 40.7 cm)
Provenance: William Wells of Redleaf; Wells
sale, Christie's, May 10, 1890, lots 44–45, bt.
Agnew; Mrs. Anthony Crossley, from whom
acquired by present owner
Exhibitions: London, R.A., 1837, nos. 28, 34;
London, 1874, nos. 349, 346; London, 1961,
nos. 91, 89
Literature: Mann, 1874–77, vol. 1, p. 66, vol.
3, p. 151; Graves, 1876, p. 19, nos. 230–31
Prints after: engravings of both by C. G.
Lewis, 1843 (22 ⅜ x 15 ⅛"); C. A. Tomkins for
Library Edition, 1881–93, vol. 1, pls. 13, 11
(*PSA,* 1892, vol. 1, p. 206)
PRIVATE COLLECTION

Falcons

In the same year that *Return from Hawking* (by 1837, collection of the
Duke of Sutherland) was shown at the Academy, Landseer also exhibited two
striking studies of falcons, one hooded and one unhooded (nos. 95A,B), which
are among his finest paintings of birds. Hawking was a popular pastime in the
circle of Landseer's sporting friends, and the pair he painted may well have
belonged to William Wells. They certainly seem to be portraits of a pair of
particular hawks and exhibit contrasting types.

Landseer had drawn and painted hawks throughout the 1830s, but never
with such precision and virtuosity. Although the birds are studied with scien-
tific detail, especially the unhooded hawk, they are immensely characterful
and alive. There is no attempt to endow the birds with human characteristics
or to create a story, but both works are decoratively designed. Each bird
occupies about half the height of the picture space, and the blocks, in the form
of a T, provide strong horizontal and vertical axes. This is emphasized in the
picture of the unhooded hawk by the ledge behind, with a row of hoods, by the
blocks of stone above, and by the edge of the red cloth below. The hooded
hawk is dramatically silhouetted against the sky. The color scheme of both
works is brilliant and vivid.

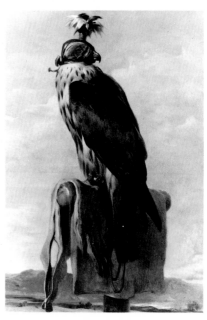

95B.

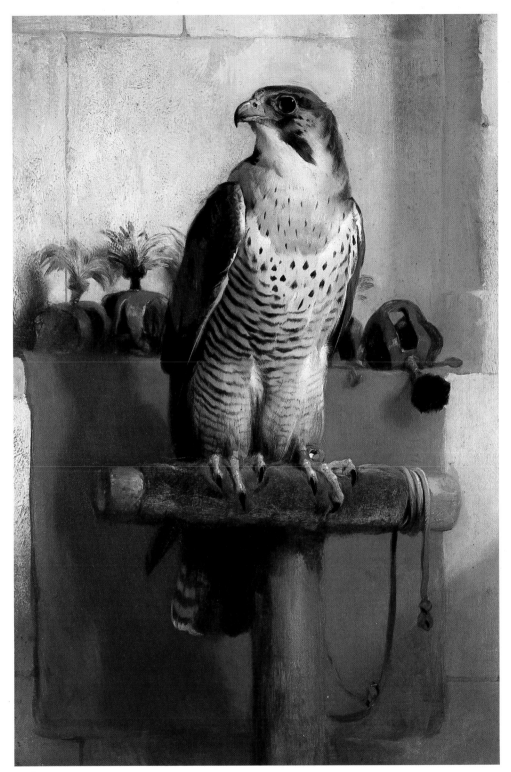

95A.

Commemorative Salver

This salver commemorates the achievements of the 5th and 6th dukes of Bedford as livestock breeders. Landseer was called on to provide designs, the models were executed by Edward Cotterill, and the commission was entrusted to the silversmith W. H. Osborn, who in turn employed Benjamin Preston, of Clerkenwell. Cotterill voiced his misgivings to Landseer about the competence of Osborn and Preston, whom he felt were insufficiently experienced for such a lavish piece: "I have made enquiries as to the capabilities of Mr. Preston and have ascertained that he is in a very small way of business and never executed any but common plate objects—Mr. Osborne is not in the slightest way aware of what the model is to be . . . the work can only be satisfactorily done by first rate persons" (Cotterill to Landseer, undated, Mackenzie collection).

The 6th Duke of Bedford took a keen interest in the progress of the salver. In September 1836, Landseer sent him two ideas for the border of the salver. Like the artist, he preferred the simpler one, writing that "the *outline* of the salver should not be broken." He also gave strict instructions about the placing of the medallion of his brother and the coat of arms: "the medallion should be enclosed by a *close oak leave* border; but no coronet over it—classical and heraldic matter should not be intermingled."

Landseer's design for the frieze consists of various groups of prize animals—horses, pigs, sheep, cows, and scenes of harvesting and shepherding.

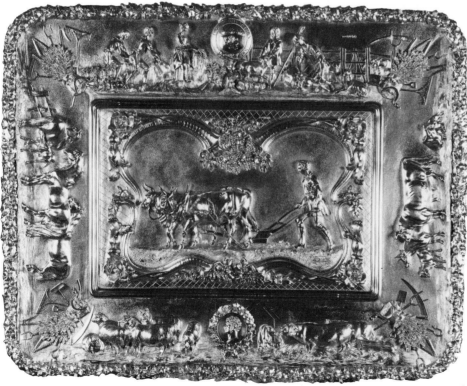

96.

96.

COMMEMORATIVE SALVER
Benjamin Preston after designs by Landseer
1837
Silver, 26 x 32" (66 x 81.3 cm)
Hallmarks: 1837/B.P.
Inscribed on reverse: *This salver was formed from various cups and other pieces of plate obtained as premiums by Francis Duke of Bedford and awarded to him at Agricultural meetings in 1799, 1800 and 1802 and by John Duke of Bedford, his successor, in 1802, 1803, 1804, 1805, 1806, 1807, 1808, 1809, 1810 and 1811 for livestock, cattle sheep and swine, for ploughing and for cloth manufactured from wool grown at the Park Farm at Woburn. 1837/Designed by Edwin Landseer R.A. Executed by W. H. Osborn, Great Russell Street, Bloomsbury.*
Provenance: commissioned by the 6th Duke of Bedford, by descent
Literature: Arthur Grimwade, "Family Silver of Three Centuries," *Apollo,* vol. 82 (1965), p. 505, repro. p. 504
Unpublished sources: the Duke of Bedford to Landseer, September 2, 1836, December 1, 1836, March 6, 1837, March 12, 1837 (V & A, Eng MS, 86 RR, vol. 1, nos. 35, 36, 39, 41); Edward Cotterill to Landseer, undated (Mackenzie collection, no. 1001)
THE MARQUESS OF TAVISTOCK

97.

97.
STUDIES OF A YOUNG HIPPOPOTAMUS
1850
Pen, sepia ink, and wash on paper, 6½ x 8⅝"
(16.5 x 22 cm)
Provenance: acquired by Queen Victoria
Exhibitions: London, 1961, no. 107; London,
Buckingham Palace, Queen's Gallery,
Animal Painting, 1966–67, no. 65
HER MAJESTY QUEEN ELIZABETH II

In the center of the salver is the figure of a man plowing. In the corners are decorative trophies with sheaves of corn and farm implements. At the top center is the Bedford coat of arms and, below, a medallion of the 5th Duke of Bedford after a bust by Joseph Nollekens. Arthur Grimwade called it "an opulent image of one of the peak moments of English agricultural history."

Landseer's work as a designer seems to have been very limited. However, designs for a silver claret jug are mentioned in a letter of December 16, 1837, to him from a Mr. Edington (Mackenzie collection, no. 902).

A Young Hippopotamus

These studies were presumably drawn by Landseer at the London Zoo, where a young hippopotamus arrived from the upper reaches of the White Nile in May 1850. Queen Victoria wrote in her Journal for June 10, 1850: "It is a very sagacious animal, & so attached to its various keepers, that it screams if they leave it, & that the man is obliged to sleep next to it!" On July 1 she went to the zoo with her children and wrote: "We had an excellent sight of this truly extraordinary animal. It is only ten months old & its new teeth are only just coming through. Its eyes are very intelligent. It was in the water, rolling about like a porpoise, occasionally disappearing entirely."

The Last Run of the Season

One of the most psychologically savage of Landseer's late animal studies is this painting of a fox brought to bay in a ditch. The viewpoint is from above the fox, looking down like the hunters, nearly on top of the animal, a moment or two before it is killed. Landseer extracted the maximum drama and tension from this situation. Half on its side, quivering with exhaustion, wet and mud stained, its back legs splayed, the fox turns to face its pursuers, with rolling eyes and mouth wide stretched. Driven to extremes it gives vent to the violence and cunning of its nature in a final horrendous snarl. But those cruel and terrifying fangs are not the symbol of the aggressor but of the victim. It is the fox's soft and tactile fur that is about to be torn apart by the teeth of the hounds.

A strong light pitilessly isolates the fox from its dark surroundings. There are indications of water on the right, a hole covered by briars above, a bank to the left, and a few scattered grasses in the foreground. It is a grim and sordid setting for death, even for an animal as stealthy as the fox.

In contrast, Landseer's dying stags are placed in wild and beautiful surroundings, which emphasize the heroic qualities of nature. Landseer was less sentimental about foxes, who invariably appear in his work as poachers and predators. But although this image of the fox is scarcely ingratiating, it is impossible not to feel sympathy for a living animal so exposed and helpless. The artist's own sympathy is visible in the tender, marvelously tactile rendering of fur with its soft scumbled effects.

The first owner of this picture, Joseph Starkey, of The Hall, Huttons Ambo, Yorkshire, was a landowner and justice of the peace.

98.

THE LAST RUN OF THE SEASON (also called BEST RUN OF THE SEASON)
By 1851

Oil on canvas, 34½ x 61¼" (87.6 x 155.5 cm)
Provenance: Joseph Starkey; Miss Starkey, her sale, Christie's, May 13, 1897, lot 78, and July 2, 1898, lot 54, bt. Tooth; Sir Bernard Eckstein, Bart.; Leger Galleries, London, from whom acquired by present owner, 1968
Exhibitions: London, R.A., 1851, no. 588; London, 1874, no. 268
Reviews: Art Journal (1851), p. 159; *The Times,* May 3, 1851, p. 8a; *Athenaeum,* no. 1229, May 17, 1851, p. 530
Literature: Dafforne, 1873, p. 39; Stephens, 1874, p. 122; Mann, 1874–77, vol. 1, p. 89; Graves, 1876, p. 30, no. 374
Unpublished sources: Starkey to Landseer, December 9, 1850, asking the artist to paint a picture for him or to offer him first refusal on one already finished (V & A, Eng MS, 86 RR, vol. 5, no. 310); payment of £100 from Starkey recorded in Landseer's Bank Accounts, May 29, 1851
Prints after: engravings by Thomas Landseer, 1853 (21¾ x 33¾") (PSA, 1892, vol. 1, p. 29); G. S. Hunt for *Library Edition,* 1881–93, vol. 1, pl. 36 (PSA, 1892, vol. 1, p. 207)
Related work: watercolor study (8⅜ x 11⅞"), dated 1850, Christie's, July 23, 1974, lot 150
C. H. PITTAWAY

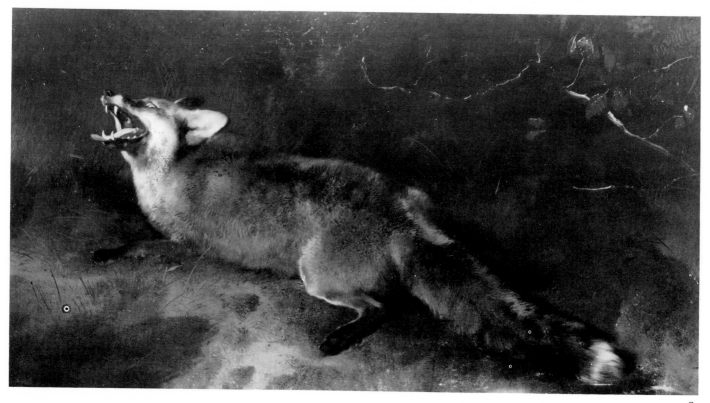

98.

The Artist at Court, 1836-1872

LANDSEER ADDED a new dimension to the history of royal image making, depicting Queen Victoria and Prince Albert and the royal family in their private and domestic life but with no loss of *noblesse oblige*. He gave expression to the idealism of the young couple, and they responded to the storytelling elements of his art and the spirited naturalism of his style.

Landseer came to court as an animal painter, a role in which he remained successful. From the 1836 sketch of Dash (no. 99) to the late picture of Boz with a dead hare (1867, Royal Collection), he painted more than a dozen royal dogs—and his inventive skill never deserted him. His royal pets ape the lives and manners of their masters in a witty take-off of the conventions of the conversation piece. From this it was only a short step to conversation pieces of the royal family: posing with dead game in Windsor Castle (no. 105); dressing up as medieval monarchs for a costume ball (no. 109); pursuing Highland sports in a romantic setting (no. 112). But it was as a portrait painter that Landseer failed. The great equestrian picture of Queen Victoria, which would have rivaled the state portraits of Sir David Wilkie and Sir George Hayter, remained unfinished (no. 101). In the four years Landseer took to complete *Windsor Castle in Modern Times* (no. 105), the new luminary Franz-Xaver Winterhalter had appeared at court, and it was this German portraitist who stole Landseer's thunder with his imposing royal family group of 1846. Landseer's smaller family groups and sketches of Queen Victoria and her children, often with pets, as well as more than half the studies of dogs were painted between 1841 and 1843—before Winterhalter's reputation in England was firmly established. Landseer owed the majority of his later commissions to the Scottish connection. Prince Albert had been given *The Sanctuary* (no. 121) in 1842, and his subsequent purchases of subject pictures were of Highland scenes—*Deer Drive, Free Kirk,* and so forth. In 1847 Landseer painted Queen Victoria and her two eldest children at Loch Laggan (no. 111) and three years later began work on *Royal Sports* (see no. 112). This monumental work, Landseer's single largest royal commission, was intended as a glorification of the royal family in the Highlands. With its demise, Landseer fell from royal favor, until Queen Victoria's nostalgic revival of patronage in the mid-1860s.

It is often said that royal patronage exercised a baleful influence on Landseer's work, encouraging the slick and sentimental side of his art. There is no evidence for this. The extravagant qualities of the royal animal groups are paralleled elsewhere, as is the artist's adoption of a smooth, carefully finished technique, which is a development observable in his work of the 1840s in general and not the result of specific influence from the palace. The royal couple certainly took more than proprietorial interest in Landseer's pictures of themselves, and he often felt hemmed in by their demands. But had he enjoyed a freer hand, it is doubtful that the character of his royal commissions would have been significantly different. In his early works, especially, he responded to the challenge of court art in a very positive and creative spirit.

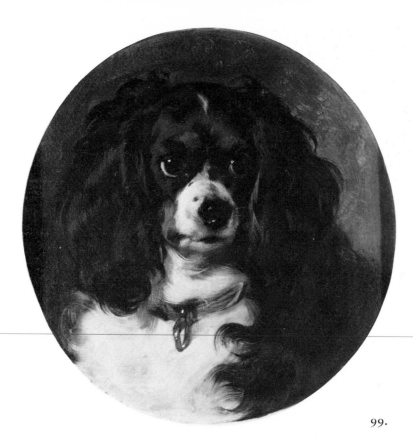

99.

Dash

This was Landseer's first royal commission, and it paved his way to court. Dash was Princess Victoria's beloved King Charles spaniel, whom she had owned since February 1833. There are numerous references to him in Victoria's Journal, and his death on December 24, 1840, upset her: "I was so fond of the poor little fellow, & he was so attached to me. I had had him since the beginning of Feb: 1833." He was buried on the grounds of Adelaide Cottage, Windsor Park, with an epitaph commending his virtues—attachment without selfishness, playfulness without malice, and fidelity without deceit.

Landseer's sketch of Dash was given to the Princess for her birthday, May 24, 1836, as recorded in her Journal: "After my lesson Mamma gave me a portrait of dear Dash's head, the size of life, most beautifully painted by Edwin Landseer. It is extremely like." The portrait is one of Landseer's most expressive canine studies, and although he was later to paint many royal dogs, none have such wit and vivacity as this. Dash figures prominently on a footstool in the group *Her Majesty's Favorite Dogs and Parrot* (no. 100).

Her Majesty's Favorite Dogs and Parrot

The success of the sketch of Dash (no. 99) led to more ambitious royal commissions of which this was the first fruit. In her Journal for November 24, 1837, Queen Victoria described "the beautiful little sketch," which Landseer had done that morning, "of a picture he is to paint for me of Hector and Dash." Five days later he brought the picture itself to show her, "with the dogs only sketched in, but quite beautifully." In January 1838 she called it "a most splendid picture exquisitely painted of Dash, Hector, and Nero." On April 9, 1838, Landseer delivered "the picture of the dogs and Lory *finished;* it is the most *beautiful* thing imaginable."

Landseer's ability to create a mood and story in his pictures of dogs made

99.

DASH
1836

Oil on panel, 12 x 11 ¼" (30.5 x 28.6 cm), oval
Inscribed on reverse: *LANDSEER/DASH*

Provenance: given to Princess, later Queen, Victoria, on her birthday by her mother, the Duchess of Kent, 1836
Exhibitions: London, 1874, no. 262; London, Buckingham Palace, Queen's Gallery, *Animal Painting,* 1966–67, no. 52; Sheffield, 1972, no. 60
Literature: Mann, 1874–77, vol. 2, p. 49, vol. 4, p. 133; Graves, 1876, p. 18, no. 212; *Osborne Catalogue* (privately printed, 1876), p. 12; Manson, 1902, p. 87; Millar, 1977, p. 169, pl. 191
Unpublished source: Queen Victoria's Journal, May 23, 1836
Prints after: engravings by Charles Mottram, 1874, for "Her Majesty's Pets" (PSA, 1892, vol. 1, p. 79); J. W. Josey for *Library Edition,* 1881–93, vol. 2, pl. 9 (PSA, 1892, vol. 1, p. 211); lithograph by Lowes Dickinson, 1836 (10" diameter)

HER MAJESTY QUEEN ELIZABETH II

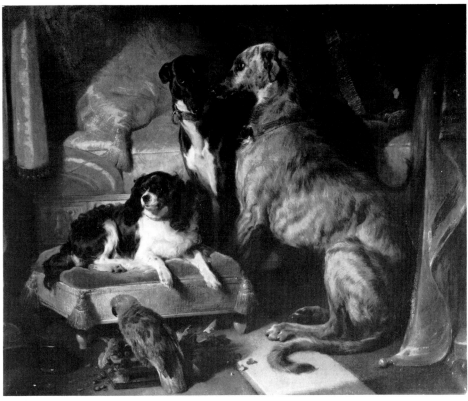

100.

him an ideal painter of royal pets. Here was an even grander vision of high life to explore, and he developed a canine iconography appropriate to the status of his patrons. Enthroned like a prince on a footstool sits Queen Victoria's beloved King Charles spaniel Dash, the image of pampered luxury. A precedent for the treatment of the dog is in the work of James Ward, who painted a King Charles spaniel lying on a velvet cushion in 1809 (Sotheby's, March 23, 1977, lot 104). Flanking Dash are two proud and noble hounds, representing the outdoor world of hunting, opposed to the lapdog world of the palace. On the right is the huge Scottish deerhound Nero, squatting on its haunches like a heraldic emblem and very close in pose to that of a deerhound in the contemporary picture *The Two Dogs* (exhibited London, British Institution, 1838, no. 372; Dodge sale, Sotheby Parke-Bernet, New York, May 14, 1976, lot 61). Behind Nero is the long and sleek greyhound Hector, with a firm and soulful expression. Landseer exploited the disparity in scale between the dogs and the parrot with amusing effect, contrasting the air of majestic decorum of the dogs with the insouciance of the bird. Perched on a stand and oblivious of the grand surroundings, Lory scatters nutshells across the carpet. The animals were all favorite pets, and it was no doubt Queen Victoria who decided on their inclusion, although the composition and the motif are entirely Landseer's invention.

100.
HER MAJESTY'S FAVORITE DOGS AND PARROT (also called DASH, HECTOR, NERO, AND LORY) 1837–38
Oil on canvas, 47½ x 59⅛" (120.7 x 150.2 cm)
Provenance: commissioned by Queen Victoria
Exhibitions: London, R.A., 1838, no. 90; London, 1874, no. 213
Reviews: Athenaeum, no. 511, May 19, 1838, p. 363, no. 775, September 3, 1842, p. 791; W. M. Thackeray, *Essays, Reviews* (London, 1906), p. 114
Literature: Mann, 1874–77, vol. 1, p. 58, vol. 4, p. 134; Graves, 1876, p. 20, no. 248; *Osborne Catalogue* (privately printed, 1876), p. 12; *Landseer Gallery,* 1878, pl. 20; Millar, 1977, p. 169
Unpublished sources: Queen Victoria's Journal, November 24, 1837, November 29, 1837, January 23, 1838, April 9, 1838, January 9, 1839
Prints after: engravings by Frederick Bacon, 1842 (22 x 28"); George Zobel, 1877, for "Her Majesty's Pets" (PSA, 1892, vol. 1, p. 80); H. Sedcole for *Library Edition,* 1881–93, vol. 2, pl. 43 (PSA, 1892, vol. 1, p. 210)
Related works: oil sketch of Lory, December 22, 1837 (19½ x 15¼", Royal Collection); oil sketch of Dash (?) on a red cushion (7 x 7¼"), Sotheby Parke-Bernet, New York, January 25, 1980, lot 313
HER MAJESTY QUEEN ELIZABETH II

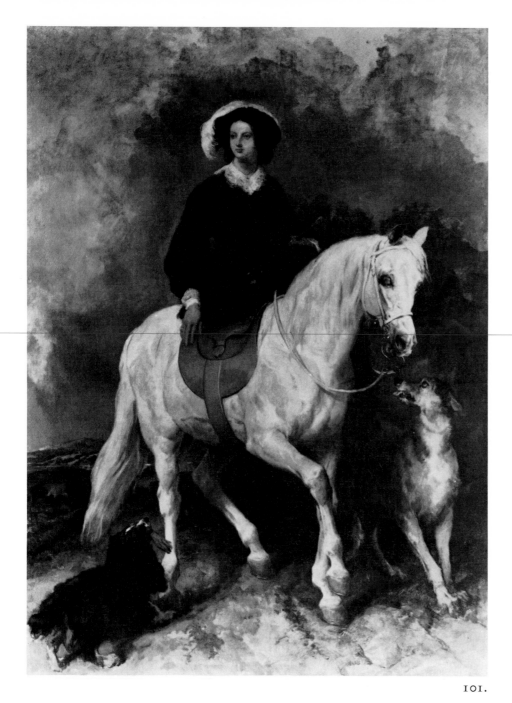

101.

QUEEN VICTORIA ON HORSEBACK
1838–72
Oil on canvas, 115 x 87″ (292 x 221 cm)
Provenance: purchased by H. W. Eaton, later
Lord Cheylesmore, 1873, his sale, Christie's,
May 7, 1892, lot 55, bought in; acquired from
the 4th Lord Cheylesmore by the 1st Lord
Fairhaven (now on loan to Ashridge
Management College, Hertfordshire)
Exhibitions: London, R.A., 1873, no. 256,
as "Sketch of her Majesty the Queen
(unfinished)"; London, 1874, no. 277;
London, 1961, no. 82
Reviews: Art Journal (1873), p. 170;
The Times, May 19, 1873, p. 6d
Literature: Mann, 1874–77, vol. 4, p. 125;
Graves, 1876, p. 36, no. 434; Monkhouse,
1879, pp. 88–89; Manson, 1902, p. 107;
Ormond, 1973, vol. 1, p. 482
Unpublished sources: Queen Victoria's
Journal, recording sittings, May 22, 28, 29,
June 6, and August 13 and 14, 1838; Landseer
to Jacob Bell, October 26, 1845 (Royal
Institution, London); correspondence
between Landseer and Sir Thomas Biddulph,
Keeper of the Queen's Privy Purse, 1872–73
(Royal Archives, PP Vic 13635 [1873], Add
MSS T/116–117, Add MSS Z.200/92); Sir
Francis Grant to Biddulph, two letters, April
1873 (Royal Archives, PP Vic 13868 [1873]);
Thomas Landseer to Biddulph, February 1876
(Royal Archives, PP Vic 20465 [1876]);
Biddulph to Thomas Landseer, February 25,
1877 (Royal Archives, PP Vic 20465 [1877])
Prints after: engraving by Thomas Landseer,
1875 (28½ x 21″) (PSA, 1892, vol. 1, p. 227)
Related works: painting of Leopold coming
through a gateway, finished by Sir J. E. Millais,
with a portrait of Nell Gwynne (125 x 91″,
Tate Gallery, London); for others *see*
Ormond, 1973, vol. 1, p. 482
LORD FAIRHAVEN

101.

Queen Victoria on Horseback

Landseer's first major royal commission was this full-blown equestrian state
portrait. On January 23, 1838, Queen Victoria went to see some "exquisite
sketches" by Landseer "intended for the picture he is to paint of me on
horseback," and she recorded in her Journal the first sitting four months later
on May 22, 1838: "At a ¼ to 2 I went downstairs dressed in my habit, and sat
for an hour, *on horseback,* in the *Library* to Landseer; I sat on Leopold who
really behaved so well and was so good and quiet, I then sat for a little while
not on horseback." She sat on five other occasions, the last on August 14,
1838: "Dressed in my Velvet Habit and sat to Landseer again on horseback."
Leopold, who was blind in the right eye, was Queen Victoria's favorite white
horse.

The most obvious source for Landseer's composition is Van Dyck's eques-
trian portrait of Charles I of England riding through an archway attended by
Monsieur Saint Antoine (Royal Collection). It is significant that a related

painting by Landseer, in the Tate Gallery, London, which is nearly the same size as this picture, shows Leopold emerging from under a massive gateway and may represent an earlier stage or an alternative version of the final design. Landseer abandoned this idea for a landscape setting.

Queen Victoria is dressed in a black velvet riding habit trimmed with lace and a feathered hat *à la cavalier*. She wears the blue sash of the Order of the Garter over her left shoulder, part of her long skirt is gathered over her left arm, and she holds the reins and a riding crop in her left hand. She is attended by a black spaniel, possibly Dash (*see* no. 99), playfully cavorting with one of her gloves, and by a deerhound, looking up with an expression of loyalty and devotion. The rough track in the foreground, the gorse bushes and rocks on the right, and the hilly landscape with a lake suggest a northern terrain, possibly Scotland, although Queen Victoria had not yet visited that country. The stormy sky sets the portrait in a somber and romantic key. Something tender as well as majestic suffuses the image of this graceful young woman riding alone through a landscape of haunting beauty and wildness.

The big picture was never finished. The large number of surviving sketches shows how much thought went into its composition. All the sketches picture Queen Victoria in black, riding on a white horse, but with wide variations in pose and setting. The artist explored various ideas for a picture of Queen Victoria at Windsor Castle (*see* no. 102) before settling on the much more arresting design of her riding alone. The figure of Leopold is one of Landseer's most strongly observed and sympathetic studies of an aged horse, comparable to some of the shooting ponies in his earlier scenes of Highland sport. Leopold, like the dogs, was probably painted during the early stages of the work in 1838. The figure of Queen Victoria, on the other hand, is quite unresolved and shows everywhere, especially in the head and hands, the fluffy touch of Landseer's late manner. The landscape and sky, treated in soft gray and lavender tones, were probably touched on at various periods.

Landseer's overanxiety to produce a masterpiece portrait readily explains his failure to finish the picture. As time passed, his inability to achieve a convincing likeness of Queen Victoria became more marked, and it was she who insisted on the quite inaccurate entry in the 1873 Royal Academy exhibition catalogue stating that she had never sat for it.

In 1845 Landseer objected to the proposed design of an equestrian portrait of Queen Victoria by Sir Francis Grant because it conflicted with his own. Grant's commission came from Christ's Hospital (now at West Horsham), and as a result of Landseer's objection he changed his picture to show Queen Victoria, in profile, on a rearing horse. Grant subsequently carried out his first idea for a portrait (Army and Navy Club, London) showing Queen Victoria in an attitude very similar to that of Landseer's picture. Largely at Grant's instigation, the Royal Academy showed Landseer's unfinished portrait in 1873. In a letter to Queen Victoria, Grant described it as beautiful and interesting (April 9, 1873, Royal Archives, PP Vic 13868 [1873]), and he regarded the fact that it had never been finished as a national disaster.

The portrait remained in Landseer's studio throughout his lifetime, and it was one of the unfinished works which weighed most heavily on his conscience. On August 11, 1872, Sir Thomas Biddulph informed Queen Victoria that the portrait was nearly completed, apart from the figure, and he recommended that this should be carried out by another artist. He told a different story after visiting the artist a few days later: "With regard to the great Picture of Your Majesty on horseback, Sir Thomas fears it will never be satisfactory.

102.

102.
SKETCH FOR "QUEEN VICTORIA ON HORSEBACK"
Oil on canvas, 20½ x 17" (52 x 43.2 cm)
Provenance: given to Queen Victoria by the artist's family, 1874
Exhibitions: London, R.A., *The King's Pictures*, 1946–47, no. 49; London, 1961, no. 24; London, Buckingham Palace, Queen's Gallery, *Silver Jubilee Exhibition*, 1977, no. 50
Literature: Millar, 1977, p. 170, pl. 195
Unpublished sources: T. H. Hills to Sir Thomas Biddulph, and Biddulph to Hills, February 2, 1874, March 5, 1874 (Royal Archives, PP Vic 14974 [1873])
HER MAJESTY QUEEN ELIZABETH II

The horse, a large grey, is well done and there are 2 dogs which he says were Your Majesty's, a spaniel & a Deerhound. But the figure of Your Majesty in a black velvet habit with a Hat of feathers is totally unlike. Sir Thomas did not well understand how the Picture originated as Sir Edwin was very wandering on the subject" (August 29, 1872, Royal Archives, Z.200/92). Later in November he warned Queen Victoria that Landseer was refusing to give up the picture, and that he needed watching in case he tried to sell it. In any event, Queen Victoria decided not to purchase it, and it went to join Lord Cheylesmore's large and distinguished collection of the artist's work. In a letter from Sir Thomas Biddulph, the Queen told the artist's brother Tom that she admired the picture as a work of art, but "the likeness is no longer striking." Reviewers took a similar line.

Macaw, Love Birds, Terrier, and Spaniel Puppies

This painting, the second of Landseer's groups of royal pets, combines dogs and birds, although in a more fanciful and contrived design. The macaw is not known by name, but Queen Victoria was devoted to her parrots and took Lord Melbourne to see a new one on November 16, 1838, as she recorded in her Journal, "which he now admires very much and thinks his plumage and his pink breast beautiful." Landseer himself went to see the parrots on March 9, 1839. Of the dogs, the Skye terrier Islay was a favorite. He arrived in 1839 and Queen Victoria was to lament his death on April 26, 1844: "my faithful little companion of more than five years . . . I was much shocked & distressed." His pose in the picture was evidently a natural one, because Landseer was to paint him begging in *Windsor Castle in Modern Times* (no. 105) and in later drawings; a separate oil painting of Islay was painted in 1840 (16 x 12", Royal Collection). Tilco was a black-and-tan toy spaniel, but little is recorded about him.

Blackwood's Magazine noted perceptively that "His [Landseer's] are not mere animals; they tell a story. You see them not only alive, but you see their biography, and know what they do, and if the expression be allowed, what they think" (1840, p. 378). Although the macaw is the only animal chained, he is the "jack in office," the dominant animal both because he holds the biscuit and by force of age and character. Clearly it is his stand, his broken nutshells are scattered around, and the others are there uninvited. He appears not only to be tantalizing the others with the biscuit, but also to be lecturing, like a schoolmaster at the top of the class, Tilco, with a pen in his mouth like a dunce. Clearly this was how *Punch* read it, substituting Wellington for the macaw in their parody, looking down on Sir Robert Peel and W. E. Gladstone (July 7, 1844, p. 38). The stand in Landseer's picture is a brilliant compositional device, separating the various animals hierarchically and drawing out the absurd contrasts in scale between them. The macaw looms above the love birds and looks down on Islay, the epitome of the fawning courtier. Tilco is a caricature of the man of affairs, chewing up his mistress's pen and tearing up her envelope in delinquent fashion. The picture is also about youth and age, the behavior of individual animals, the improbable relationship between them, and the human parallels. It is unusually vivid and light in tone, with the animals shown against the paneling of one of the rooms at Buckingham Palace.

103.
MACAW, LOVE BIRDS, TERRIER, AND SPANIEL PUPPIES, BELONGING TO HER MAJESTY (also called ISLAY AND TILCO WITH A RED MACAW AND TWO LOVE BIRDS)
1839
Oil on canvas, 51¼ x 28⅛" (130.2 x 71.4 cm)
Provenance: commissioned by Queen Victoria
Exhibitions: London, R.A., 1840, no. 139; Paris, Exposition Universelle, 1855, no. 855; London, 1874, no. 263; London, Buckingham Palace, Queen's Gallery, *Animal Painting*, 1966–67, no. 53
Reviews: Art-Union (1840), p. 74; *Blackwood's Magazine*, vol. 48 (1840), pp. 378–79; *Art Journal* (1855), p. 281; W. M. Thackeray, *Essays, Reviews* (London, 1906), p. 142
Literature: Dafforne, 1873, p. 20; Mann, 1874–77, vol. 1, p. 84, vol. 4, p. 137; Graves, 1876, p. 21, no. 263; *Osborne Catalogue* (privately printed, 1876), p. 10
Unpublished sources: Queen Victoria's Journal, March 9, 1839; Baroness Lehzen to Landseer, March 10, 1840, enclosed in a letter from Landseer to Count d'Orsay, March 13, 1840 (Houghton Library, Harvard University, MS Eng 1272, no. 3 a); Landseer to Jacob Bell, September 1842 (V & A, Eng MS, 86 RR, vol. 1, no. 47); Landseer to C. G. Lewis, December 29, 1843, January 30, 1844 (British Library, London, Add MS, 38608, f. 27, 18)
Prints after: engravings by C. G. Lewis, 1844 (18¾ x 11⅝"); W. T. Davey, 1851; George Zobel, 1877, for "Her Majesty's Pets" (PSA, 1892, vol. 1, p. 185)
Related works: oil sketch of Tilco, as "Dash" (13¾ x 10⅞", Fairhaven Collection, Anglesey Abbey, Cambridgeshire, National Trust); embroidered firescreen after the picture, Sotheby's Belgravia, September 24, 1980, lot 305, bt. Roy Miles
HER MAJESTY QUEEN ELIZABETH II

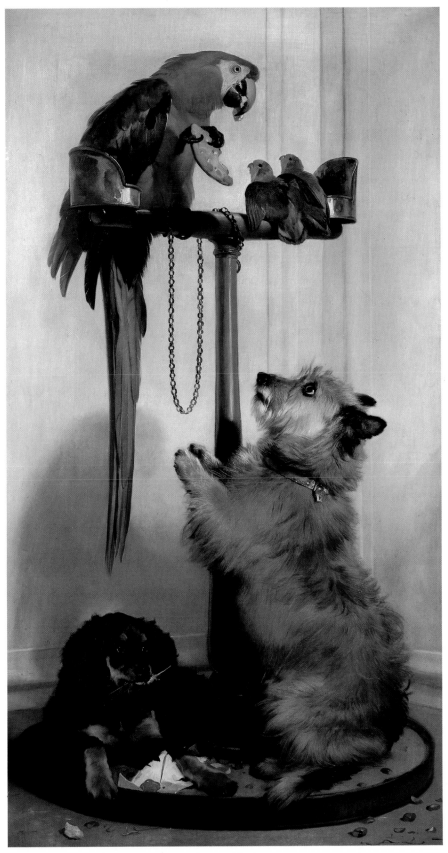

103.

Princess Victoire

This is an enchanting back view of Queen Victoria's much-loved cousin, Princess Victoire of Saxe-Coburg-Gotha. She later married the Duc de Nemours, the second son of Louis-Philippe of France. In her Journal for September 10, 1839, Queen Victoria mentioned Princess Victoire sitting to Landseer: "Lehzen brought in a lovely sketch in oils Landseer has done of Victoire's back, as a surprise for me; it is so like,—such a treasure—just the figure of that Angel." Landseer wittily played off mistress and spaniel, the ringlets of the one matching the drooping ears of the other.

Windsor Castle in Modern Times

The scene represents the green Drawing Room at Windsor Castle as it was in 1842. The sofa on which Prince Albert sits corresponds to those made by Morel and Seddon in the late 1820s for the Windsor Castle redecorations, except that it is backless. The stool below the window is almost certainly one now in the Garter Throne Room at Windsor.

Queen Victoria, in an evening gown trimmed with lace, has just entered the room to greet her husband on his return from hunting. Prince Albert sits on a sofa taking his ease, his costume suggesting the hero of some contemporary opera—Weber's *Freischütz,* for example—rather than a hard-worked sports-man at the end of the day. His favorite greyhound, Eos, is at his knee (*see* no. 107), the terrier Dandie is beside him, with Islay begging as in an earlier picture of royal pets (no. 103), and beyond is Cairnach. Queen Victoria looks

104.

105.

WINDSOR CASTLE IN MODERN TIMES
1841–45
Oil on canvas, 44⅝ x 56⅞" (113.3 x 144.5 cm)
Provenance: commissioned by Queen Victoria
Exhibitions: London, International Exhibition, 1862, no. 480; London, 1874, no. 173; London, R.A., *The King's Pictures,* 1946–47, no. 52; Brussels, *Queen Victoria and King Leopold,* 1953, no. 188; London, 1961, no. 95; Sheffield, 1972, no. 79; London, Arts Council, *British Sporting Painting,* 1974, no. 187
Literature: Mann, 1874–77, vol. 2, p. 51; Graves, 1876, p. 25, no. 318; *Diaries of W. C. Macready,* ed. W. Toynbee (London, 1912), vol. 2, p. 201; Winslow Ames, *Prince Albert and Victorian Taste* (London, 1967), pp. 201–2, pl. 7; Gaunt, 1972, pl. 62; Christopher Wood, *Victorian Panorama* (London, 1976), p. 22, fig. 10; Millar, 1977, p. 172, col. pl. 40; Richard L. Ormond, *The Face of Monarchy* (London, 1977), p. 196, pl. 124; David Coombs, *Sport and the Countryside* (London, 1978), repro. p. 179
Unpublished sources: Queen Victoria's Journal, from June 12, 1841, to October 2, 1845; George Anson, Prince Albert's secretary, to Jacob Bell, May 29, 1845 (Royal Institution, London)
Prints after: engravings by T. L. Atkinson, 1850 (22¼ x 28¼"); J. R. Jackson, 1862 (both PSA, 1892, vol. 1, p. 419); R. Josey for *Library Edition,* 1881–93, vol. 2, pl. 98 (PSA, 1892, vol. 1, p. 209)
Related works: oil sketch of Queen Victoria and Prince Albert (35 x 27¼", Royal Collection); chalk drawings of Eos and Cairnach (Royal Collection)
HER MAJESTY QUEEN ELIZABETH II

104.

PRINCESS VICTOIRE
1839
Oil on canvas, 17½ x 14" (44.5 x 35.6 cm)
Inscribed, signed, and dated lower left on base of balustrade: *Sketch/EL* 1839
Provenance: acquired by Queen Victoria, 1839
Exhibitions: London, 1874, no. 395; Nottingham University, *Victorian Painting,* 1959, no. 33; London, 1961, no. 59; Ottawa, National Gallery of Canada, *An Exhibition of Paintings and Drawings by Victorian Artists in England,* 1965, no. 70; Sheffield, 1972, no. 69
Literature: John Woodward, *Connoisseur Period Guides, Early Victorian* (London, 1958), p. 55, pl. 35b
Unpublished source: Queen Victoria's Journal, September 10, 1839
HER MAJESTY QUEEN ELIZABETH II

105.

down at her beloved eldest child, Victoria, the Princess Royal, then a little over a year old, who holds a dead kingfisher. A pheasant and a white game bird lie on the footstool; the latter looks too large to be a ptarmigan, which would never, in any case, be found near Windsor, and it may be a white pheasant. A mallard duck and a jay lie on the floor by the prince's shooting bag. Outside is a charming view of the east terrace, with a cluster of Windsor oaks in the background. Just visible in the garden are the diminutive figures of a footman and two ladies-in-waiting escorting the bath chair of Queen Victoria's aged mother, the Duchess of Kent. A similar picture of Prince Albert's brother, Ernest II of Saxe-Coburg, being greeted by his wife at the end of a day's sport, by Prinz von Java Raden Saleh Ben Jaggia (dated 1844), is at Schloss Ehrenburg, Coburg; it was presumably inspired by Landseer.

Windsor Castle in Modern Times belongs to the tradition of the royal conversation piece, and it provokes comparisons with the pictures painted by Johann Zoffany for George III, especially that of Queen Charlotte at her dressing table. Despite its air of studied informality, it is carefully constructed and stage-managed. No self-respecting sportsman would leave his game scattered about the drawing room; the inclusion of the game, however, is intrinsic to the theme of the picture. Not only has hunting always been a princely occupation—and one could compare the picture to earlier royal sporting scenes—but it is also here identified with the simple and wholesome pursuits of

the countryside. The game is a natural touch amidst the splendors of the palace interior. Prince Albert is shown engaged in appropriately masculine, outdoor activities, while his wife, holding a posy, represents the feminine virtues of the home. Yet it is she who stands and dominates the composition by right of her position.

The picture is one of the few later group portraits that Landseer managed to finish, and it cost him the usual strains and problems. On June 12, 1841, Queen Victoria recorded in her Journal: "We saw Landseer, & settled about his picture of us." Half a dozen sittings took place later that same month; Queen Victoria writing, characteristically, on June 25: "He has made a good portrait of me, which is only a study for the real picture." On August 30, Landseer brought the large canvas to Windsor Castle so that he could have a sitting from Albert, as Queen Victoria recorded in her Journal: "It is not nearly finished, but is quite beautiful so far." There were further sittings in May and July 1842, again in March 1843, and in August 1843, when the Queen noted that the picture was "nearly finished." She was oversanguine, because for the next eighteen months Landseer appears to have done virtually nothing, returning to the work only in March 1845, when Queen Victoria remarked on its exquisite finish and lifelike qualities. On October 2, in her Journal, she announced its completion: "Landseer's Game Picture (begun in 1840!!) . . . is at last hung up in our sitting room here [Windsor] & is [a] very beautiful picture, & altogether very cheerful & pleasing."

Eos, a Favorite Greyhound

Eos, an Italian greyhound bitch, was Prince Albert's favorite dog, whom he had brought with him from Germany. In January 1842 she was accidentally shot by Queen Victoria's uncle Ferdinand of Saxe-Coburg-Gotha in a shooting party at Windsor Castle but survived her wounds. Her death two and a half years later was a severe blow: "I could see by his look that there was bad news," Queen Victoria wrote in her Journal on July 31, 1844, "She had been

106.
EOS, A FAVORITE GREYHOUND, THE PROPERTY OF H.R.H. PRINCE ALBERT
1841
Oil on canvas, 44 x 56" (111.8 x 142.3 cm)
Provenance: commissioned by Queen Victoria as a Christmas present for Prince Albert, 1841
Exhibitions: London, R.A., 1842, no. 266; London, 1874, no. 323
Review: Exhibition Catalogue of the Royal Academy, with Critical and Descriptive Remarks (London, 1842), p. 21
Literature: Stephens, 1874, p. 111; Mann, 1874–77, vol. 2, p. 57, vol. 4, p. 145; Graves, 1876, p. 24, no. 311; *Landseer Gallery,* 1878, pl. 34; Monkhouse, 1879, pp. 88–89; Manson, 1902, pp. 107–8; Lennie, 1976, pp. 100–101
Unpublished sources: Queen Victoria's Journal, August 12, 1841, December 24, 1841; Miss Skerrett to Landseer, July 8, 1841 (Royal Archives, Add C/4/4); "Christmas Presents," 1841, listing the price as 150 guineas (Royal Archives, Add O/68/13); Queen Victoria's "Private Accounts Pictures" (Royal Archives, Add T. 231/6); Prince Albert's "Acquisitions" (Royal Archives, no. 81); Sir Henry Wheatley, Keeper of the Queen's Privy Purse, to Landseer, undated (V & A, Eng MS, 86 RR, vol. 5, no. 327); Baroness Lehzen to Landseer, March 13, 1840 (Houghton Library, Harvard University, MS Eng 1274, no. 3a)
Prints after: engravings by Thomas Landseer, 1843 (18 x 24¼"); J. B. Hunt, 1877, for "Her Majesty's Pets" (*PSA,* 1892, vol. 1, p. 109); C. A. Tomkins for *Library Edition,* 1881–93, vol. 1, pl. 49 (*PSA,* 1892, vol. 1, p. 209)
HER MAJESTY QUEEN ELIZABETH II

107.

107.
STUDY OF EOS
1841
Pastel on paper, 19½ x 14" (49.5 x 35.5 cm)
Provenance: acquired by Queen Victoria
Exhibitions: London, 1874, no. 109; London, Buckingham Palace, Queen's Gallery, *Animal Painting,* 1966–67, no. 62
Unpublished source: Queen Victoria's Journal, August 12, 1841
Shown only in London
HER MAJESTY QUEEN ELIZABETH II

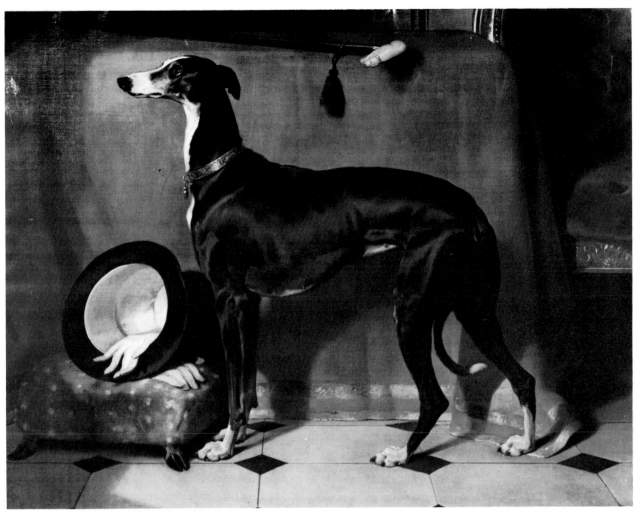

106.

his constant & faithful companion for 10 & ½ years and she was only six months old, when he first had her. She was connected with the happiest years of his life, & I cannot somehow imagine him without her. She was such a beautiful & sweet creature & used to play so much with the Children, & be so full of tricks. . . . As for poor dear Albert, he feels it too terribly, & I grieve so for him. It is quite like losing a friend." The bronze memorial statuette of Eos on her tomb in the gardens of Windsor Castle was modeled from Landseer's picture. The prince's passion for his dog did not go unnoticed outside court circles; *Punch* published, in dubious taste, a spoof inquest on Eos (August 24, 1844, p. 85).

Eos is shown in the setting of Buckingham Palace, guarding her master's property and looking up with an expression of devotion. On the table is Prince Albert's cane; his opera hat and gloves lie, less explicably, on a deerskin footstool. A similar footstool, with the same hoof feet but different upholstery, is at Osborne House. It is not clear whether the prince has just come in or is about to go out and whether the dog is seeing her master off or has waited up for his return, but there is no doubt of the place that she occupies in his heart. Monkhouse recorded that Landseer had borrowed the prince's hat and gloves without his knowledge, as the picture was to be a surprise: "great was the bustle when a groom rode up, on a horse all in lather, for the hat and gloves, as the Prince was going out, and must not miss his hat."

Greyhounds, creatures of high breeding and natural nobility, have been

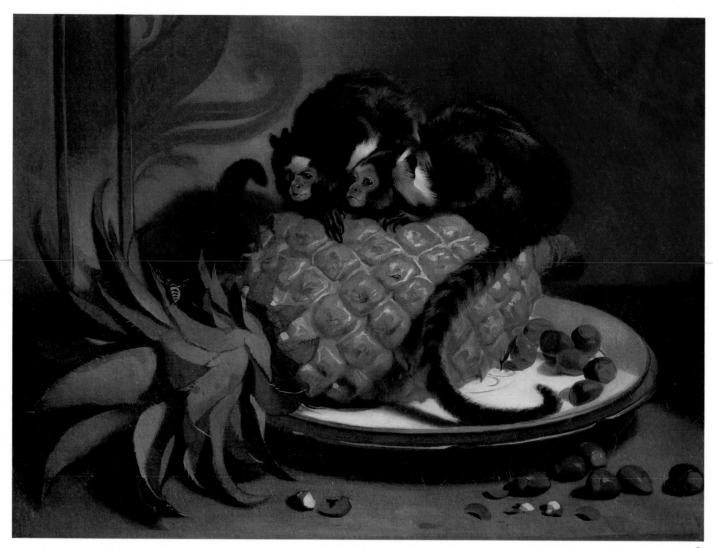

108.

favorites of princes since earliest times and invaluable companions in the hunting field. They often feature in royal and aristocratic portraits, and Landseer consciously drew on these iconographic associations, without needing to include Prince Albert himself. The picture of Eos is the largest of Landseer's single pictures of royal pets; its dimensions are the same as *Windsor Castle in Modern Times* (no. 105), and the two may have been intended to hang as a pair at Windsor Castle. The heroic profile pose of the dog is emphasized by the rich, red tablecloth behind, which sets off the black sheen of the coat so magnificently. The dog is one of Landseer's finest animal studies, tense and tactile at the same time, full of movement and feeling. Contemporary reviewers were less equanimous, either passing over the picture in silence or making it the occasion for snide references to Prince Albert. The latter was genuinely surprised and delighted when it was unveiled on Christmas Eve.

Eos features in several other pictures by Landseer: at Prince Albert's knee in *Windsor Castle in Modern Times,* and guarding the infant Princess Royal, with Princess Alice (1841 and 1844, respectively, Royal Collection).

Brazilian Marmosets

These monkeys, the one on the right a common marmoset, the other a black-eared or black-plumed marmoset, have been interrupted by the arrival of a wasp in their raid on a plate containing a pineapple and nuts. They have crept up to the fruit to gaze at the intruder, although whether from fear, curiosity, or as a launching pad against the wasp is not clear. They are crouched on top, peering forward intently, their bodies coiled like springs. The contrast in size between the monkeys and the large pineapple, and between the monkeys and the wasp, is intentionally humorous. The picture is a riot of curves playing wittily against each other—the curling tails of the monkeys, the leaves of the fruit, the curving shape of the dish, and the swirling patterns of the fabric behind. Queen Victoria does not mention the monkeys or the picture in her Journal, but Miss Skerrett related to Landseer on May 25, 1858, that Queen Victoria would be happy to have returned "the pine apple Monkeys, one of the most beautiful of your smaller pieces." The reviewers of *The Times* and the *Athenaeum* admitted the picture's cleverness, but bewailed the waste of Landseer's talent on such a trivial subject.

Queen Victoria commissioned a second monkey picture in 1842, a portrait of the Duke of Saxe-Coburg-Gotha's badger dog Ziva looking up at a monkey eating an apple on a stool. An earlier picture of three marmosets by George Garrard was exhibited at the Royal Academy in 1793 (Yale Center for British Art, New Haven).

108.
A PAIR OF BRAZILIAN MONKEYS, THE PROPERTY OF HER MAJESTY (also called BRAZILIAN MARMOSETS)
By 1842
Oil on canvas, 14 ⅛ x 17 ¾" (35.9 x 45.1 cm)
Inscribed on reverse: *BRAZILIAN MONKEYS / E. LANDSEER*

Provenance: commissioned by Queen Victoria
Exhibitions: London, R.A., 1842, no. 145; Paris, Exposition Universelle, 1855, no. 856; London, International Exhibition, 1862, no. 669; London, 1874, no. 175; London, 1961, no. 19; London, Buckingham Palace, Queen's Gallery, *Animal Painting*, 1966–67, no. 80; Sheffield, 1972, no. 75
Reviews: The Times, May 6, 1842, p. 9b; *Athenaeum,* no. 758, May 7, 1842, p. 410; *Exhibition Catalogue of the Royal Academy, with Critical and Descriptive Remarks* (London, 1842), p. 15
Literature: Art Journal (1859), p. 4; Dafforne, 1873, pp. 48–49; Stephens, 1874, p. 111; Mann, 1874–77, vol. 1, p. 63, vol. 4, p. 146; Graves, 1876, p. 24, no. 313; Manson, 1902, pp. 119–20
Unpublished sources: Queen Victoria's "Acquisitions" (Royal Archives); Landseer to Sir Charles Phipps, May 7, 1856; Miss Skerrett to Landseer, May 25, 1858 (Royal Archives, PP Vic 10089[1856], Add C/4/320)
Prints after: engravings by Thomas Landseer for *Art Journal* (1859), pl. 1; Charles Mottram, 1876, for "Her Majesty's Pets" (PSA, 1892, vol. 1, p. 232); J. C. Webb for *Library Edition,* 1881–93, vol. 1, pl. 67 (PSA, 1892, vol. 1, p. 208)

HER MAJESTY QUEEN ELIZABETH II

Queen Victoria and Prince Albert

This painting records the occasion of a famous fancy-dress ball at Buckingham Palace on May 12, 1842. On April 19, 1842, Queen Victoria wrote to her uncle Leopold of the Belgians: "I am quite bewildered with all the arrangements for our *Bal Costumé,* wh I wish you cd see; we are to be Edward III & Queen Philippa, & a gt number of our Court to be dressed like the people in those times, & very correctly, so as to make a grand Aufzug,—but there is such asking, and so many silks & Drawings & Crowns, & God knows what, to look at, that I, who hate being troubled about dress, am quite *confuse*" (Royal Archives, Y 198/149, Y 90/48). The ball was the occasion for lavish entertainments and a sumptuous display of historical costume, ostensibly in aid of the ailing Spitalfields silk industry. A feature of the ball was the staged meeting between the courts of Anne of Brittany and Edward III and Queen Philippa in the Throne Room. The throne itself was removed and replaced by the Gothic chairs visible in Landseer's picture, together with the canopy and the royal arms emblazoned in silver. Apart from the reception of the two courts, there were processions, quadrilles, and ceremonial events.

Queen Victoria's costume was designed by Vouillon and Laure, under the supervision of a leading expert on historical dress, James Planché, and was inspired by medieval examples recorded in sculpture and manuscript illumination. Over a skirt of velvet, Queen Victoria wore a surcoat of blue and gold brocade lined with miniver and adorned with valuable jewels. The mantle of gold and silver brocade, with flowers of woven silver and brilliants over a gold ground, was woven at Spitalfields. Queen Victoria's hair was folded inward in a style then described as *à la Clovis* and surmounted by a light gold crown. The design of Prince Albert's brocade surcoat was based on the funeral effigy of Edward III in Westminster Abbey. Over it he wore a velvet cloak, also studded with precious stones, together with a crown and a sword, similar to the jeweled state sword, which is part of the coronation regalia.

Describing the ball, *The Illustrated London News* noted: "Masques have been in all ages the recreation of Courts. The name brings with it reminiscences of romance, history, and poetry" (May 14, 1842, p. 7). The historical period chosen as the motif of the ball is significant in that it identifies Victoria and Albert with the great age of English chivalry. Significantly, Edward III was a popular subject with history painters, especially the scene with the burghers of Calais. Like the earlier Eglinton Tournament (*see* no. 80), the ball was one of the more ostentatious expressions of the medieval revival—that obsession with the events, ideals, and pageantry of the Middle Ages so characteristic of the period. The royal couple loved dressing up and playacting, but they were also inspired by the patriotism and paternalism of medieval monarchy.

Landseer must have attended the ball; however, his picture does not seem to record a specific incident, unless it was the procession before the throne. Queen Victoria briefly mentioned the picture in her Journal: in May 1842 she watched the artist "beginning to paint the sketches of us," and in June she sat "for the picture of us in our costumes, which is becoming quite beautiful." In July 1842, B. R. Haydon recorded in his diary a conversation with the portrait painter John Lucas: "He says Landseer is painting the Queen & Prince in bal Costume. The Queen called him [Lucas] in to see Landseer's picture. Landseer did not like it, & said awkwardly it was in its Infancy." The picture was not completed until August 1846, when Caroline Fox noted seeing it in Landseer's studio just finished.

109.
QUEEN VICTORIA AND PRINCE ALBERT
1842–46
Oil on canvas, 58¼ x 44⅛" (148 x 112.1 cm)
Provenance: commissioned by Queen Victoria
Exhibitions: London, 1874, no. 211; London, 1961, no. 94; Paris, 1972, no. 156
Literature: Graves, 1876, p. 25; *Osborne Catalogue* (privately printed, 1876), p. 9; Caroline Fox, *Memories of Old Friends* (London, 1882), vol. 2, p. 62; *Haydon Diary,* 1960–63, vol. 5, p. 185; Winslow Ames, *Prince Albert and Victorian Taste* (London, 1967), pp. 145, 204, pl. 16; Richard L. Ormond, *The Face of Monarchy* (London, 1977), p. 196, pl. 127
Unpublished sources: Queen Victoria's Journal, May 21, 1842, June 2, 1842
HER MAJESTY QUEEN ELIZABETH II

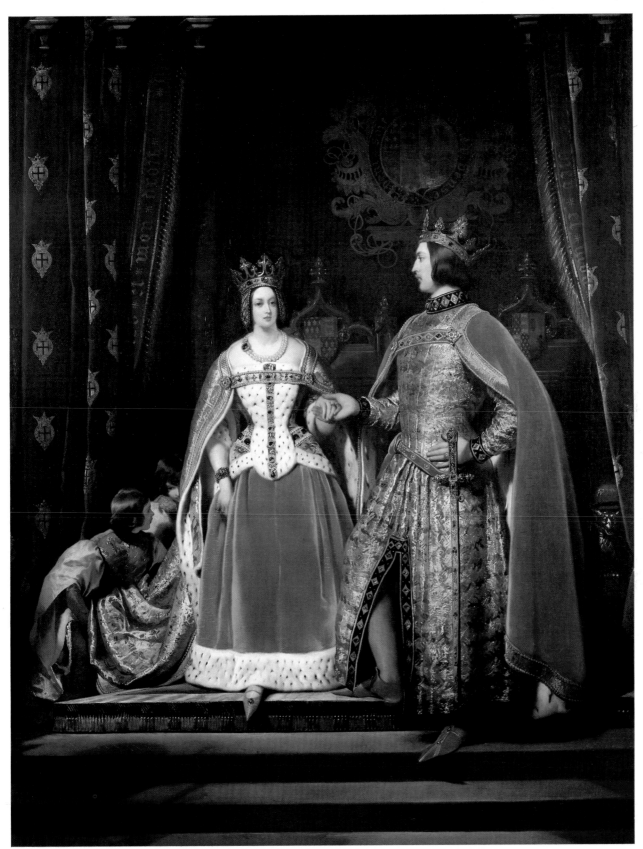

109.

Princess Alice

Princess Alice was the third child of Queen Victoria and Prince Albert. She married the Grand Duke of Hesse-Darmstadt in 1862 and died in 1878 from the effects of diphtheria. Landseer's sketch of her in the Saxon cradle was painted nine days after her birth on April 25, 1843, and is one of his most enchanting studies of babies. He had already painted a number of pictures of the two older royal children, including the Princess Royal with the greyhound Eos, the Princess Royal with a pony and a Saint Bernard dog, and various paintings and drawings of her and the Prince of Wales with their parents. In 1844 he painted a second sketch of Princess Alice with Eos.

This sketch was painted as a present for Queen Victoria's birthday on May 24, 1843. On that day Lady Lyttelton wrote: "Her birthday presents [from Prince Albert] were arranged under a bower of magnificent flowers erected in her breakfast room. . . . The chief present is a *beautiful* sketch by Landseer of the Princess Tiny, in a cradle lately given, which belonged to the old Saxon house. . . . The child lies most nestly and 'comfy' in it asleep, watched over by Dandie, the black terrier, with an expression of fondness and watchfulness such as only Landseer can give. It was prepared in secret by Prince Albert, who looks very *rayonnant* to-day, and made his appearance at eight o'clock in the morning in the nursery, in a handsome many coloured dressing gown, to fetch the children to 'Mama.' "

The way in which Landseer highlighted the baby from the surrounding gloom gives the sketch a romantic mood, suggesting the innocence and fragility of infancy. Dandie, a Skye terrier who died in 1858 at the age of nineteen, appears again in *Windsor Castle in Modern Times* (no. 105). In this picture his head is pressed soulfully against the coverlet, in the role of guardian. Landseer

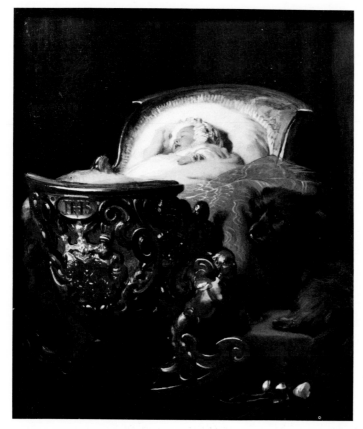

110.

110.
PRINCESS ALICE
1843
Oil on canvas, 11⅜ x 9⅝" (28.9 x 24.4 cm)
Provenance: commissioned by Prince Albert and given to Queen Victoria on her birthday, 1843
Exhibitions: London, 1874, no. 261; London, Buckingham Palace, Queen's Gallery, *Royal Children,* 1963, no. 55
Literature: Mann, 1874–77, vol. 2, p. 45; Graves, 1876, p. 25, no. 323; *Correspondence of Sarah Spencer Lady Lyttelton 1787–1870,* ed. Mrs. H. Wyndham (London, 1912), pp. 337–38
Unpublished sources: Prince Albert's "Acquisitions" (Royal Archives); Landseer to Jacob Bell, 1845 (Royal Institution, London)
Prints after: engravings by Thomas Landseer, 1845 (10¾ x 9¼"); J. W. Josey for *Library Edition,* 1881–93, vol. 2, pl. 2 (*PSA,* 1912, unpaginated)
HER MAJESTY QUEEN ELIZABETH II

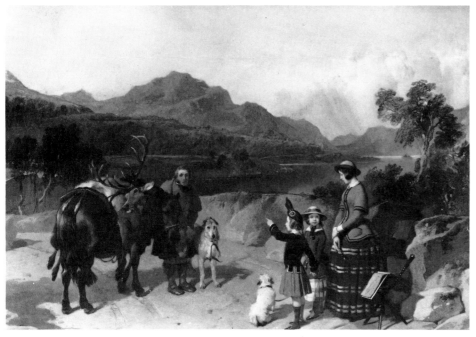

111.

111.

QUEEN VICTORIA SKETCHING AT LOCH LAGGAN
1847
Oil on panel, 13⅜ x 19½" (34.1 x 49.5 cm)
Inscribed on reverse: *Queen Victoria with
Princess Royal and the Prince of Wales at
Loch Laggan Sept'* 1847 *(Edwin Landseer
Xmas 1847.)*
Provenance: commissioned by Queen Victoria
and given to Prince Albert, Christmas 1847
Exhibitions: London, 1874, no. 258; London,
1961, no. 13; Aberdeen Art Gallery, *Artists
and Patrons in the North-East,* 1975, no. 71;
London, R.A., *"This Brilliant Year": Queen
Victoria's Jubilee 1887,* 1977, no. 14
Literature: Mann, 1874–77, vol. 2, p. 106a;
Graves, 1876, p. 28, no. 356; *Graphic Jubilee
Celebration Number* (London, June 20,
1887), repro. p. 17; Marquis of Lorne, *V.R.I.:
Her Life and Empire* (London, 1901), repro.
p. 261; Winslow Ames, *Prince Albert and
Victorian Taste* (London, 1967), p. 216, pl.
59; Ormond, 1973, vol. 1, p. 486; Lennie,
1976, p. 183
Unpublished sources: Queen Victoria's
Journal, December 24, 1847; Miss Skerrett to
Landseer, November 10, 1847, December 20,
1847 (Royal Archives, Add C/4/19, 20);
Queen Victoria's "Private Accounts Pictures,"
recording the price, £200 (Royal Archives,
Add T. 231/146); Landseer to Count d'Orsay,
December 29, 1847 (Houghton Library,
Harvard University, MS Eng 1272, no. 32)
Prints after: engravings by J. T. Willimore,
1858 (13½ x 19½") (PSA, 1892, vol. 1, p.
304); W. Roffe for *Library Edition,* 1881–93,
vol. 2, pl. 70 (PSA, 1892, vol. 1, p. 210)
HER MAJESTY QUEEN ELIZABETH II

might have chosen a larger dog, a bloodhound, for example, as seen in the earlier portrait of the Abercorn children (c. 1834, Barons Court, Northern Ireland), but here he played on the diminutive stature of the dog. No one can doubt Dandie's tenacity if called upon to protect his charge. The picture brings to mind the popular legend of Beddgelert: Prince Llewellyn's faithful dog had saved his master's baby from the wolf and was slain in error. The Saxon cradle, thought to be seventeenth-century German, was acquired by Queen Victoria shortly before the princess's birth and was used for many royal babies.

A picture of a Borromeo baby in a cradle, guarded by a faithful dog, and perhaps inspired by the Landseer, is in the Palazzo Borromeo, Isola Bella, Lake Maggiore.

Queen Victoria Sketching at Loch Laggan

This was the first of Landseer's pictures of the royal family in the Highlands and its success paved the way for *Royal Sports* (see no. 112). During the autumn of 1847, Queen Victoria and her family spent a few days at Ardvereike Lodge on Loch Laggan as guests of the Marquess and Marchioness of Abercorn. She invited Landseer to visit her in Scotland, possibly with this commission in mind. Through the agency of Queen Victoria, in 1843 Landseer had painted a scene on Loch Laggan for the Queen of the Belgians as a present for her husband, Leopold.

Landseer came to Ardvereike on September 16, 1847, while traveling from Black Mount to the holiday retreat at the Doune. The entry in Queen Victoria's Journal for that day simply records that he was there, but does not state whether or not he prepared any sketches. Landseer painted the figures themselves in London. On November 10, 1847, the Queen's private secretary Miss Skerrett informed the artist that Queen Victoria was pleased with his idea for the painting and offered to send him an indoor dress belonging to the Princess Royal, but warned him to come to Windsor Castle only when Prince Albert was absent (this was another of the "surprise" pictures): "Let me hear from you when you find it necessary to see H.M. & The Royal Children." Landseer had only a month in which to finish the work, and Miss Skerrett was careful to

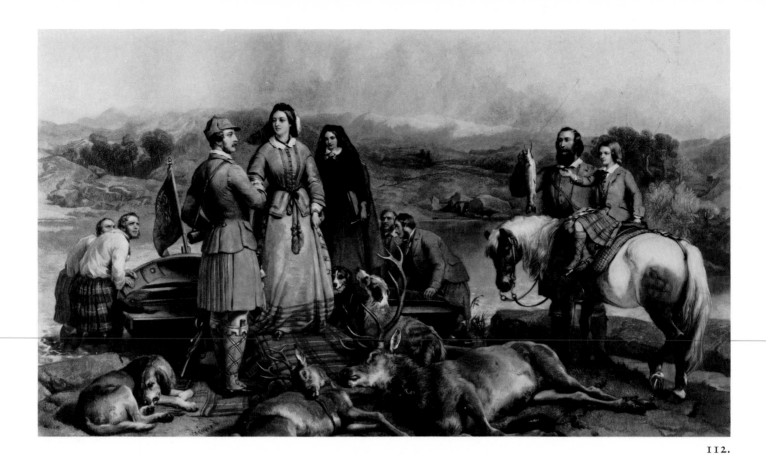

112.
ENGRAVING AFTER "ROYAL SPORTS ON HILL
AND LOCH"
W. H. Simmons after Edwin Landseer
Picture 1850–72, print 1874

Engraving, 20¾ x 36¼" (52.8 x 92 cm)

Literature: Mann, 1874–77, vol. 3, p. 173;
Graves, 1876, p. 31, no. 394; *PSA*, 1892,
vol. 1, p. 325

HER MAJESTY QUEEN ELIZABETH II

send him a reminder before Christmas: "HM has not the least *doubt* of the picture coming." Landseer mentioned the work in a letter to his intimate friend Count d'Orsay, written just after Christmas: "Since I returned from the North I have worked like a loyal subject for Her My. a miniature picture 19 inches by 13 containing the Q. Pss R. and P. of Wales. Forester with deer hounds, Pony, deer on his back &cc. The Q. and P. Albert are quite (to use your word) *mad* about it—I hope to have the Picture again and will send it for Lady B. [Blessington] to see—through her Glass."

This deceptively informal conversation piece is a careful study of royal attitudes. Queen Victoria has been out sketching accompanied by her two eldest children, the Princess Royal and the Prince of Wales, aged six and five, respectively, who sweetly hold hands. She is the devoted mother engaged in appropriately artistic pursuits. Balancing this domestic group is the Highland ghillie with a pony bearing a dead stag shot by the absent Prince Albert, to which the Prince of Wales is pointing. Pride in papa's prowess as a sportsman is evident. Masculine virtues are here contrasted with feminine, active with passive, savage and pastoral, and so on. Even the dogs, a deerhound and a terrier, complement one another. The figures are set against a ravishing landscape, at the east end of Loch Laggan looking towards the East Binnein.

Royal Sports on Hill and Loch

This was the largest and most important of Landseer's royal commissions, a picture intended to identify the royal family with the spirit of the Highlands and the ennobling pursuit of hunting. Queen Victoria discussed the idea for the picture at length with Landseer when he came to Balmoral to begin work. She wrote in her Journal for September 19, 1850: "It is to be thus: I, stepping out of the boat at Loch Muich, Albert, in his Highland dress, assisting me out,

113.

113.
SKETCH FOR "ROYAL SPORTS ON HILL
AND LOCH"
1850–51
Oil on canvas, 17 x 30⅜" (43.2 x 77.2 cm)
Provenance: acquired by Queen Victoria
Exhibitions: London, 1874, no. 388; London,
1961, no. 16
Literature: Millar, 1977, p. 173
Unpublished sources: Queen Victoria's
Journal, April 16, 1851; Miss Skerrett to
Landseer, c. 1861 (Royal Archives, C4/363);
Landseer to Sir Thomas Biddulph, June or July
1866 (Royal Archives, PP Vic 77 [1867])
HER MAJESTY QUEEN ELIZABETH II

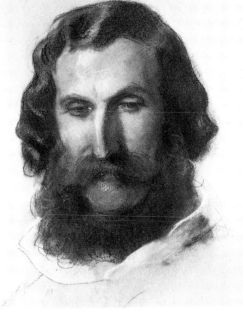

114.

114.
STUDY OF JOHN MACDONALD FOR "ROYAL
SPORTS ON HILL AND LOCH"
1850
Chalk on paper, 17½ x 13½" (44.5 x 34.3 cm)
Inscribed on reverse: *John Macdonald, Jäger,
Died 1860 Sir E.L. 1850*
Provenance: acquired by Queen Victoria
Exhibitions: London, 1874, no. 117; London,
R.A., *The King's Pictures,* 1946, no. 504a;
London, 1961, no. 135
Unpublished source: Queen Victoria's
Journal, September 21, 1850
Shown only in London
HER MAJESTY QUEEN ELIZABETH II

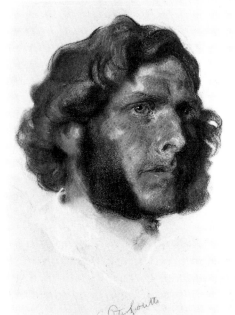

115.

115.
STUDY OF PETER COUTTS FOR "ROYAL SPORTS
ON HILL AND LOCH"
1850
Chalk on paper, 17½ x 13½" (44.5 x 34.3 cm)
Inscribed recto: *Peter Coutts;* verso: *Coutts
Gillie 1850/Now Piper at Invercauld/Sir E.
Landseer 1850*
Provenance: acquired by Queen Victoria
Exhibitions: London, 1874, no. 111; London,
R.A., *The King's Pictures,* 1946, no. 503b;
London, 1961, no. 119
Unpublished source: Queen Victoria's
Journal, September 20, 1850
Shown only in London
HER MAJESTY QUEEN ELIZABETH II

& I am looking at a stag which he is supposed to have just killed. Bertie is on the deer pony with McDonald (whom Landseer much admires) standing behind, with rifles & plaids on his shoulder. In the water, holding the boat, are several of the men in their kilts,—salmon are also lying on the ground. The picture is intended to represent me as meeting Albert, who has been stalking, whilst I have been fishing, & the whole is quite consonant with the truth. The solitude, the sport, the Highlanders in the water, &c will be, as Landseer says, a beautiful historical exemplification of peaceful times, & of the independent life we lead in the dear Highlands. It is quite a new conception, & I think the manner in which he has composed it, will be singularly dignified, poetical & totally novel, for no other Queen has ever enjoyed, what I am fortunate enough to enjoy in our peaceful happy life here. It will tell a great deal, & it is beautiful."

Queen Victoria is the dominant figure in Landseer's composition, which recalls, perhaps intentionally, pictures of Mary, Queen of Scots stepping ashore after her escape from Loch Leven. Here Queen Victoria is followed by her friend and lady-in-waiting Lady Jocelyn, whom Landseer had painted in an earlier portrait of 1842 (Royal Collection). Prince Albert hands his wife down, the game he has just shot laid as a trophy at her feet. On the right is the Prince of Wales on a pony with the superb-looking ghillie John Macdonald, who was a particular favorite of the Queen. Oliver Millar has remarked: "The ghillies were made to look like the Apostles (Landseer himself likened Macdonald to a Giorgione); the agony in the faces of the dead stags is reminiscent of the heads of Saints being torn apart in the more violent altarpieces of the Counter-Reformation" (1977, p. 173).

The romantic and dramatic character of the oil sketch (no. 113) was toned down in the finished picture. The picturesque costumes of Queen Victoria and the Prince of Wales were substituted for more fussy and conventional examples. More space was added around the figures, weakening the impact of the monumental figure composition, more animals and accessories were included, and the wild, mountainous background was made tamer.

The picture began in auspicious circumstances. Queen Victoria and Prince Albert were delighted with the first slight scribble for the picture, as Landseer called it (apparently not the sketch shown here), and Queen Victoria watched him drawing the ghillies with interest (*see* nos. 114, 115). In April 1851 he brought the oil sketch to show them: "the effect is beautiful, & gives one quite an idea of what the large one will be," wrote Queen Victoria in her Journal. In June 1851 sittings began at Buckingham Palace, but Queen Victoria noticed that Landseer kept "washing out what he paints in, so that he gets his faces too faint & weak." There were more sittings in July, but even with the help and advice of the portrait painter Franz-Xaver Winterhalter, Landseer could not get the likenesses right. As usual when things did not go well, he lost heart and the picture languished. Miss Skerrett wrote several times in 1852 anxiously inquiring about its progress; in one letter she advised him to accept the fact that a painter at court is not as free as one at home. Landseer returned to the project in 1854, no doubt under pressure from his patrons. Queen Victoria sat on April 5, when she described the picture as "very fine & all but finished, but our likenesses are not good." She recorded her last sitting five days later. The picture appeared at the Royal Academy exhibition in May 1854 (no. 63), still unfinished, and it received mixed reviews.

Landseer took the picture back at the end of the exhibition, and it continued to weigh heavily on his conscience. The artist George Dunlop Leslie, who

helped on subordinate parts in the late 1860s, thought its failure had hastened Landseer's death. In 1859 the artist told Jacob Bell that he was trying to complete old commissions, and that the Queen approved of his arrangement for the picture. Sometime after 1861 Queen Victoria requested the color sketch from him through Miss Skerrett: "She says it is very valuable to her as a remembrance of happy times & that she will never have the other picture finished." On April 18, 1866, Landseer asked to borrow the sketch, telling Sir Thomas Biddulph that he intended to renew work on the large painting: "I find after years of meditation and trials that all the figures in Balmoral mixture will never *however good* for Deer stalking produce a picture—with the combination necessary for an attractive work. *To live* with Cold Gray is a most ungenerous Colour" (Royal Archives, PP Vic 77 [1867]).

Landseer continued to work on the painting until 1870, painting out passages he had finished, often in fits of irritation, until Leslie thought the surface was ruined. Some of the figures were altered and the fish and birds in the foreground removed: "He used to scrape out with bits of glass, which were broken to a curved scimitar shape, and the floor in front of this picture was frequently covered with paint scrapings" (George Dunlop Leslie, *Riverside Letters*, London, 1896, p. 199). Landseer resented the Queen's criticisms, writing to William Russell on April 13, 1870: "The Balmoral picture criticized on the most trifling points of accuracy such as McDonald always wore a white shirt and grey stockings. I have made up my mind never to accept another commission and not to go to Osborne" (Houghton Library, Harvard University, MS Eng 176, no. 46). When the picture was exhibited for a second time at the Royal Academy in 1870 (no. 152), "less complete than I had hoped," as the artist told Sir Thomas Biddulph, he shuddered when he saw it on the walls. The critics tactfully passed over the work in silence. Landseer still refused to give it up to Queen Victoria or to quote a price. He had been paid five hundred pounds as a first installment, but the final bill of two thousand pounds was settled only after his death.

The big picture (69⅝ x 131½") finally entered the Royal Collection about 1873. Its condition deteriorated while in storage at Windsor Castle, and it was destroyed by order of George V. The engraving records its final appearance.

Prince Albert at Balmoral in 1860 and Her Majesty at Osborne in 1866

Queen Victoria recorded in her Journal on May 6, 1865: "Went to see Sir E. Landseer making a sketch of the pony. Seized with a great wish that he should do 2 more chalk sketches, the one representing dearest Albert with a stag he had shot, at his feet, & I coming up in the distance, with one of the Children to look at it. Then, the reverse of that bright happy time, I, as I am now, sad & lonely, seated on my pony, led by Brown, with a representation of Osborne & a dedication telling the present sad truth. Sir E. Landseer is delighted at the idea & most ready to do it. He has made such a lovely sketch of Baby [Princess Beatrice] on her pony." They lost no time in beginning the work. Queen Victoria was photographed in the stables at Osborne for the picture on May 8, 1865, where she was "Done 3 times very successfully." On May 18 Landseer brought his schemes for the chalk sketches to Windsor Castle to show her. On June 3 he asked for help with the perspective drawing of Osborne House from the artist William Scott Moreton. Queen Victoria saw the sketches on June 19 and thought they were beautiful, although Albert's likeness did not satisfy her. On July 3 she sat to Landseer.

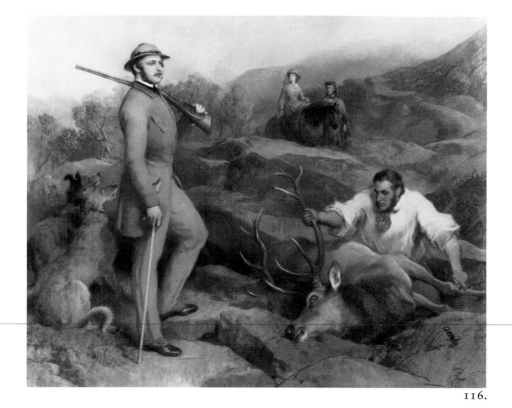

116.

116.
PRINCE ALBERT AT BALMORAL IN 1860 (also
called SUNSHINE and DEERSTALKING)
117.
HER MAJESTY AT OSBORNE IN 1866
(also called SORROW)
1865–67

Both colored chalk on paper, 33½ x 43½"
(85 x 110.5 cm)
Exhibition: London, 1874, no. 48 (Victoria),
no. 138 (Albert)
Literature: Mann, 1874–77, vol. 1, p. 51a
(Albert), vol. 2, p. 93 (Victoria); Graves, 1876,
p. 33, no. 410 (Albert), p. 34, no. 423
(Victoria)
Unpublished sources: Queen Victoria's
Journal, various entries, May, June, and July
1865, June 1867; Queen Victoria to Princess
Alice, May 16, 1865 (Royal Archives, Add
U.143, reel 3); extensive correspondence
between Landseer and Sir Charles Phipps
(Royal Archives, PP Vic 19773 [1865], 20861
[1866]); Landseer to the Prince of Wales,
September 11, 1866 (Royal Archives,
T.4/107); extensive correspondence between
Landseer and Sir Thomas Biddulph, January,
February, May, and August 1867 (Royal
Archives, PP Vic 7437 [1870], 279 [1867],
2/121/12722, Add A 17/1785/25);
photographic accounts from Jabez Hughes
and Bambridge, 1865–67 (Royal Archives,
PP Vic 2/96/9097, 2/98/9500, 2/107/10844,
2/119/12583); account for frames from
W. Eatwell, 1867 (Royal Archives, PP Vic
2/111/11415); account for lithographs from
J. A. Vinter, 1867 (Royal Archives, PP Vic
2/125/13472); Caroline Gordon to Landseer,
undated (V & A, Eng MS, 86 RR, vol. 3,
no. 132); Landseer to W. Scott Moreton,
June 6, 1865 (collection of Miss Moreton,
Edinburgh)
Prints after: lithographs by J. A. Vinter,
privately printed for Queen Victoria, 1867
(22¼ x 29¼", Albert; 20¾ x 34", Victoria);
engravings by W. H. Simmons, 1877
(20⅞ x 33¾", Albert)
Related work: oil version of Queen Victoria
at Osborne (58 x 82", Royal Collection;
exhibited London, R.A., 1867, no. 72)
Shown only in London
HER MAJESTY QUEEN ELIZABETH II

As finished, the two cartoons are very close to Queen Victoria's original idea. Prince Albert is depicted as a noble and manly sportsman—as she always liked to imagine him—in tune with the spirit of the Highlands. The pose and appearance of Prince Albert are similar to a watercolor by Edward Henry Corbould, showing him about to cross a bridge in the Highlands (Royal Collection). Both the Corbould and the Landseer seem to derive from a photograph of Prince Albert with Queen Victoria of March 1861 by John Mayall. Dressed immaculately in shooting clothes, with a deerstalking cap, boots, and spats, Prince Albert gazes out with superb self-assurance, master of the wild terrain he surveys. Two deerhounds crouch behind him and the ghillie John Grant, who also appears in *Royal Sports* (*see* no. 112), holds out the antlers of a royal stag he has just shot. In the distance, Queen Victoria can be seen riding up, attended by John Brown, to admire Albert's trophy.

From the happiness and enthusiasm emanating from the figure of Queen Victoria coming up to share her husband's success, we plunge into the grief of her widowhood in the sequel. Landseer said of his oil version that if there was any merit "in my treatment of the composition it is in the *truthful* and *unaffected* representation of Her Majesty's unceasing grief" (letter to Sir Thomas Biddulph, April 23, 1867, Royal Archives). Shrouded in black and seated on her pony Flora, Queen Victoria listlessly reads a letter. Other letters scattered on the ground and the nearby dispatch box suggest the pressures of state business, with no one to advise her. Her little terrier Prince tries unsuccessfully to attract her attention, while her faithful and taciturn attendant John Brown holds her bridle. On the left are two of the Queen's daughters, Princess Helena, later Princess Christian of Schleswig-Holstein, and Princess Louisa, later Duchess of Argyll. Their inclusion was perhaps intended to underline the Queen's responsibilities as a mother and the fatherless state of the family. In the background is a view of Osborne, the royal palace on the Isle of Wight largely designed by Prince Albert.

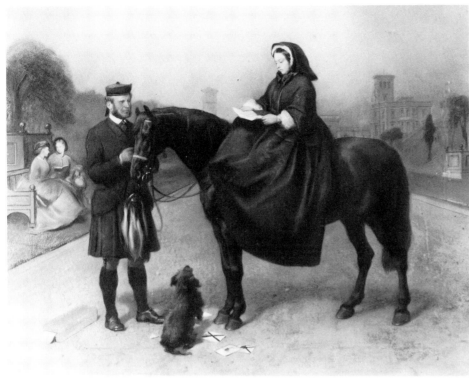

117.

The two cartoons caused no fewer problems than other late royal commissions. In August 1865, the Keeper of the Queen's Privy Purse Sir Charles Phipps told the artist that Queen Victoria wanted the drawings to be double the size of his first sketches. Landseer was soon in trouble for his delay, which he explained by the difficulty of getting cream paper of the right size and quality. In November Phipps wrote of the Queen's disappointment: "She would be satisfied with almost any cartoons, at any rate with very little colour in them. The Queen's great object is to get the subjects fixed for her so that she could have them lithographed." Landseer replied that the drawings were already larger than any lithographed prints, and yet the Queen seemed to want them bigger; should he do reduced copies for the lithographer? Phipps told him that the Queen had no objection to the larger cartoons being done in gray and brown, but she thought a little color in the faces essential for good likenesses: "Her Majesty dwells chiefly upon the reality of their representations." This was in contrast to *Royal Sports* (*see* no. 112), which she regarded as "ideal" in treatment. On his own initiative, Landseer had planned to paint an oil version of Queen Victoria's portrait, apparently as a pendant to *Royal Sports,* but he subsequently reduced its size.

After the initial burst of energy, Landseer's interest in the commission flagged. In September 1866 he asked the Prince of Wales to tell his mother that he was at work on the drawings, but he told the Keeper of the Queen's Privy Purse in January 1867 that he had not touched them, as he had received no orders to renew the work. By this stage he was preoccupied by the oil version of Queen Victoria, which he wanted to show at the Royal Academy. Requests for further photographs of the dogs and of John Brown were made in February and April 1867. In May the drawings were dispatched to Osborne, but a month later Landseer was at Balmoral working on them and attempting to improve Prince Albert's likeness. In August he collaborated with J. A. Vinter on the lithographs and he was paid for the drawings that month.

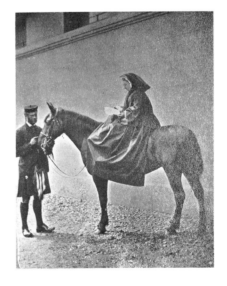

Queen Victoria with John Brown
Photograph by Jabez Hughes(?), May 8, 1865, taken for Landseer (Royal Collection, by gracious permission of Her Majesty Queen Elizabeth II)

The Heroic Stag, 1835-1866

IN HIS DEER PICTURES of the 1840s, Landseer emerged as an imaginative and visionary painter very different from the sporting artist of the 1820s. He did not paint many deer subjects in the early 1830s, perhaps because he was pressured by other commissions. At the end of the decade he painted a number of studies of tranquil deer and one very dramatic picture of a stag and hounds lying at the bottom of a cliff over which they have pitched (no. 119). It was *The Sanctuary* (no. 121), however, that heralded a change of direction: a deer reaches safety in the sublime setting of an evening landscape, full of poetic echoes and suggestions. Here, the deer becomes the symbol of the powerful and tragic forces of nature, noble but inevitably doomed. Landseer depicted his subjects at fateful moments—preparing to fight, being pursued by hounds, lying dead or wounded on the snow. His elongated compositions allowed him to emphasize the great stretches of wild country that are the deer's habitat.

The transcendental qualities of Landseer's pictures can be attributed, in part, to the mood of the time—the spiritual doubts, the fatalism, and the romanticism of the early Victorians. In a serious age, Landseer's pictures were elevating and inspiring, cruel and compassionate, haunting and extreme. Landseer's response to the contemporary preoccupation with questions of the ultimate nature and meaning of existence was deepened by mental tribulations following his breakdown in 1840. From the gilded youth of the Regency period, he had become a more troubled and reflective person, determined at the same time to avoid the pressures of continuous commissions. The deer pictures were painted for himself and they allowed his imagination free scope.

The monumental scale of Landseer's work and its symbolic structure reflect contemporary artistic trends. Nothing illustrates the high-mindedness and idealism of the period better than the schemes of decoration for the new Houses of Parliament, which were intended to spearhead a revival of the arts. Large allegorical murals in the spirit of Renaissance Italy were planned, but relatively few were finished and the project expired in disillusionment and acrimony. *The Monarch of the Glen* (no. 124), Landseer's single most famous work, was originally painted for the refreshment room of the House of Lords, and it represents his effort to raise animal painting to the level of high art.

Landseer was not the only artist of the time to invest the stag with heroic and supernatural qualities. His chief rival in England, Richard Ansdell, painted some spectacular deer subjects, which compare with Landseer's in their virtuosity and naturalism, dramatic power, and suggestion of elemental forces. The range of Ansdell's deer subjects, however, is more limited, and he was content, as Landseer was not, to repeat his more successful formulas. In France, deer subjects became associated with the realist school, such as in the work of Gustave Courbet, who may well have been influenced by Landseer, and in the more popular pictures by Rosa Bonheur, who was his devoted admirer. Stags and staghunts also were sculpted as countless statuettes by *animaliers*.

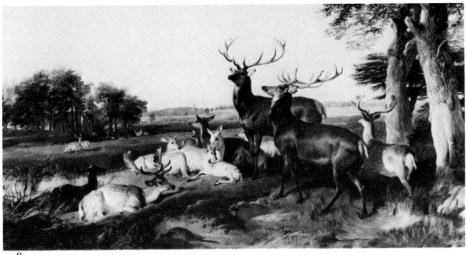
118.

Deer in Coldbath Fields, Woburn Park

Like his predecessors, the 6th Duke of Bedford was a keen agriculturalist and breeder, and he was especially proud of the famous Woburn deer herd. Landseer included fallow deer and red deer, which might be Russian or Corsican examples of the breed, in his depiction of the herd. Landseer's picture is unusually pastoral in mood and reflects the particular circumstances of the commission. The peaceful landscape has none of the charged emotional overtones of his Highland scenes, nor is the golden sunlight of late afternoon overlaid with mystical significance as in *The Sanctuary* (no. 121). The deer here are show animals in the domestic setting of a great English park with its carefully positioned clumps of trees and its gently rolling contours. Coldbath Fields lie to the west of Woburn Abbey in Bedfordshire. Landseer's viewpoint appears to be from slightly south of Coldbath Pond, looking northwest. The building in the trees on the left is probably identical with the ruined eighteenth-century screen, or folly, which still stands near the pond. Three arches of the screen are extant, but what looks like a high wall or superstructure in Landseer's picture has disappeared. A farm chimney rises above a clump of trees in the center of the composition.

The Duke of Bedford, Landseer's most important early patron, commissioned numerous pictures and portraits, including a pair of decorative lunettes, one of deer and one of cattle and sheep in Woburn Park (each 14½ x 36"), which were included in the Bedford sale at Christie's in 1951 (January 19, lots 187, 188) and are now in the collection of Henry P. McIlhenny.

The Life's in the Old Dog Yet

Unlike Landseer's earlier picture of a mountain disaster entitled *Alpine Mastiffs Reanimating a Distressed Traveler* (no. 13), in this picture the victims are animals, and man here befriends the dog. In the impetuosity of the hunt, a royal stag and two deerhounds have pitched over a precipice. Wedged somewhat improbably in a narrow crevice, the stag lies dead, together with one of the dogs, whose shattered body, twisted neck, and bared teeth forcefully evoke the violence of death. A ghillie has descended into the abyss, his rope swooping dramatically across, and he cradles the head of the injured dog in his hand, while calling to the rescuers above. The study of this second dog shows Landseer's sensitivity as a painter of animals; it is clear from its translucent skin and protruding ribs that the dog is not only old but also that it is in shock.

118.
DEER IN COLDBATH FIELDS, WOBURN PARK
1835–39(?)
Oil on canvas, 29½ x 53½" (75 x 136 cm)
Provenance: commissioned by the 6th Duke of Bedford, by descent
Exhibition: London, R.A., 1839(?), no. 222, as "Corsican, Russian, and fallow deer"
Literature: Waagen, 1854–57, vol. 4, p. 332; Colnaghi and McKay, *Catalogue of Pictures . . . at Woburn Abbey* (London, 1868), no. 407; Dafforne, 1873, p. 19; Graves, 1876, p. 22; George Scharf, *Catalogue of the Collection of Pictures at Woburn Abbey* (London, 1877), p. 235, no. 394
Unpublished sources: the Duke of Bedford to Landseer, c. April and August 11, 1835, discussing the picture's title and Landseer's offer to finish the "Corsican" deer (V & A, Eng MS, 86 RR, vol. 1, nos. 33–34)
Prints after: engravings by C. G. Lewis, 1877 (20 x 36½") (*PSA*, 1892, vol. 1, p. 84); A. C. Alais for *Library Edition*, 1881–93, vol. 2, pl. 99 (*PSA*, 1892, vol. 1, p. 210)
THE MARQUESS OF TAVISTOCK

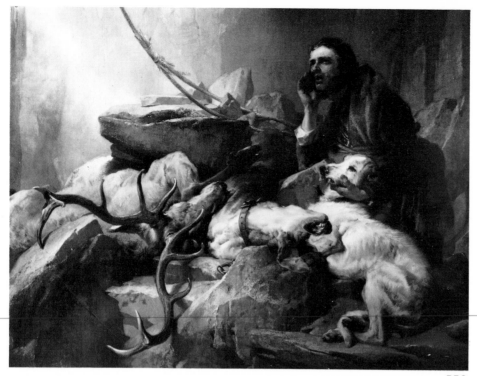

119.

THE LIFE'S IN THE OLD DOG YET (also called THERE'S LIFE IN THE OLD DOG YET)
By 1838
Oil on canvas, 79½ x 104" (202 x 264 cm)
Provenance: painted for Henry McConnel; John Naylor, by 1854; Naylor sale, Harrod's, March 17–19, 1931, lot 455, bt. Miss Cholmondeley; anonymous sale, Sotheby's, May 2, 1962, lot 152, bt. Leger, from whom purchased by present owner
Exhibitions: London, R.A., 1838, no. 21; Liverpool, Town Hall, *Pictures Exhibited at a Soiree Given by John Buck Lloyd, Esquire, Mayor of Liverpool,* 1854, no. 24; Manchester, 1857, no. 331; London, 1874, no. 251; London, R.A., *Old Masters,* 1893, no. 37
Reviews: Morning Post, May 8, 1838, p. 3e; *Athenaeum,* no. 551, May 19, 1838, p. 363
Literature: Early Works, 1869, pp. 58–59, pl. 14; Dafforne, 1873, p. 18; Stephens, 1874, pp. 100–101; Mann, 1874–77, vol. 1, p. 74; Graves, 1876, p. 21, no. 251; Monkhouse, 1879, p. 86; Frith, 1887–88, vol. 3, p. 80; *Vernon Heath's Recollections* (London, 1892), pp. 255–59; Manson, 1902, pp. 94–95; E. Morris, "John Naylor and Other Collections of Modern Paintings in Nineteenth Century Britain," *Annual Report and Bulletin of the Walker Art Gallery, Liverpool,* vol. 5 (1974–75), p. 88, no. 75; Lennie, 1976, pp. 92–93
Unpublished sources: William Wells to Landseer, January 26, 1838, praising the arrangement of the picture, which cannot "fail in your hands to be astonishing" (V & A, Eng MS, 86 RR, vol. 5, no. 323); C.G. Lewis to Jacob Bell, December 8, 1849, mentioning engraving the picture (Royal Institution, London)
Prints after: engravings by H. T. Ryall, 1850 (22⅝ x 28⅝"); C.C. Hollyer, 1872 (both *PSA,* 1892, vol. 1, p. 376); C. A. Tomkins for *Library Edition,* 1881–93, vol. 2, pl. 89 (*PSA,* 1912, unpaginated)
C. H. PITTAWAY

119.

The picture is one of Landseer's finest mountain subjects—dramatic in theme, crisp and exciting in execution (*see* frontispiece). One can almost hear the cry of the ghillie echoing around the cliffs, so real does the scene appear to be. The man and the animals are narrowly confined on the ledge, as if on a stage. The soft textures of the fur and the clothing contrast with the slabby and uncompromising surface of the rocks, which were painted with the palette knife. There is nothing accidental about the way in which the rocks are piled, nor in the arrangement of the animals, which balance one another within a shallow pyramid design. The effect is monumental but not static. The foreground group is sharply focused and brilliantly lighted. Beyond, the picture fades away into misty precipices and waterfalls, lofty heights and dark chasms. The figure of the ghillie is the weakest part of the design, lacking, in the words of the *Athenaeum* in 1838, both "force and precision."

The picture was probably inspired by an incident that Landseer had either witnessed or heard about. The name of the ghillie, Peter Robertson, is recorded by Vernon Heath, who visited him at Dalmally on the west coast of Scotland many years later, in 1876: "'Are you Peter Robertson?' 'Yes,' said he, in a hearty voice. 'Then,' said I, 'Sir Edwin Landseer asked me to call upon you.' The effect was magical; for a moment the man was beside himself. 'Go, go to the door,' he shouted, 'I will be there as soon as you.' And we met; and I, to this day, can recall the grip he gave me. He appeared a hale, healthy man, and was over eighty, and looked as if there was 'life in the old dog yet.' He died, though, only a short time after my visit" (*Recollections,* London, 1892, p. 257). Frederick William Keyl recorded Landseer's reminiscences of a ghillie he called Peter Robinson, probably the same man, in a conversation of August 31, 1866 (Keyl's Papers, Royal Archives, London). Dalmally is not far from Black Mount, where Landseer often stayed with the Marquess of Breadalbane, and it must have been on an early visit there that Landseer conceived the subject.

None But the Brave Deserve the Fair

The picture takes its title from a famous line in John Dryden's poem "Alexander's Feast" (1697):

> The lovely Thais, by his side,
> Sate like a blooming Eastern bride
> In flow'r of youth and beauty's pride.
> Happy, happy, happy pair!
> None but the brave,
> None but the brave,
> None but the brave deserves the fair.

Like other such anthropomorphic titles, this is intended to be read ironically. During the rutting season, two stags are fighting in a natural amphitheater by a stream. Their audience consists of groups of anxious-looking hinds, fixated by this battle for possession of the herds. A third stag in the farther group looks up the hillside, where in the distance a fourth stag issues his challenge. The picture is clearly designed; the brightly lit central area forms a trapezoid defined by the fallen tree trunk and the rocks in the foreground and by the rising ground behind. Beyond the sharply focused arena, the landscape shades into soft, atmospheric effects—the shadowed stream with its flecks of white on the left, a billowing storm cloud above, and snowy mountains on the right. The picture is light in tone, painted in soft lavender grays, buffs, and blues, against which the deep red fur of the deer stands out strongly. It marks a departure in Landseer's work in emphasizing the life of the deer, not as a hunted quarry or trophy, and it anticipates his series of deer studies entitled *The Forest*. The identification of fighting stags with the forces of nature in a wild and heroic setting is also new. The small scale of the deer in relation to the picture space is unusual; they are dwarfed by their surroundings. Other deer subjects of this period, like *Roe Deer* and *Deer Family,* both exhibited in 1838 (private collections), are close-up studies of two or three animals.

120.
NONE BUT THE BRAVE DESERVE THE FAIR
By 1838
Oil on canvas, 28 x 36¼" (71 x 92 cm)
Provenance: William Wells of Redleaf; Wells sale, Christie's, May 10, 1890, lot 48, bt. Vokins; Edward Steinkopf, his sale, Christie's, May 24, 1935, lot 64, bt. Leggatt; Frederick John Nettlefold; Scott & Fowles, New York, by 1951; Mrs. Geraldine Rockefeller Dodge, her sale, Sotheby Parke-Bernet, New York, December 5, 1975, lot 51; W. H. Patterson Gallery, from whom acquired by present owner
Exhibitions: London, R.A., 1838, no. 369; London, 1874, no. 353; London, 1890, no. 69; London, W. H. Patterson Gallery, *European Artists of the Nineteenth Century,* 1976, no. 26
Review: Athenaeum, no. 551, May 19, 1838, p. 363
Literature: Dafforne, 1873, p. 18; Mann, 1874–77, vol. 2, p. 36; Graves, 1876, p. 21, no. 252; Monkhouse, 1879, pp. 86–87; Frith, 1887–88, vol. 3, p. 80; Manson, 1902, pp. 95–96; C. Reginald Grundy and F. Gordon Roe, *A Catalogue of the Pictures and Drawings in the Collection of Frederick John Nettlefold* (London, 1933–38), vol. 3, pp. 35, 38, repro. p. 39; Lennie, 1976, pp. 93, 243
Prints after: engravings by Thomas Landseer, 1853 (23¾ x 36½"); George Zobel, 1870 (both *PSA,* 1892, vol. 1, p. 261); J. C. Webb for *Library Edition,* 1881–93, vol. 2, pl. 72 (*PSA,* 1892, vol. 1, p. 211); part of the picture engraved by Thomas Landseer as a frontispiece for William Scrope, *The Art of Deerstalking* (London, 1839)
Related work: crayon drawing (13 x 19"), Artist's sale, 1874, lot 636
PRIVATE COLLECTION

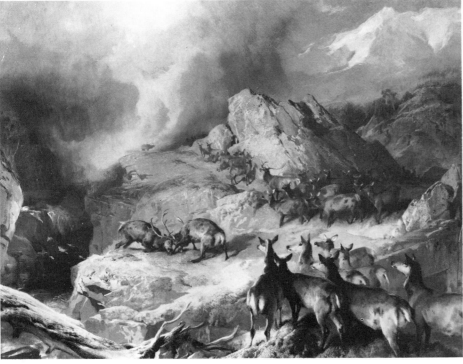

120.

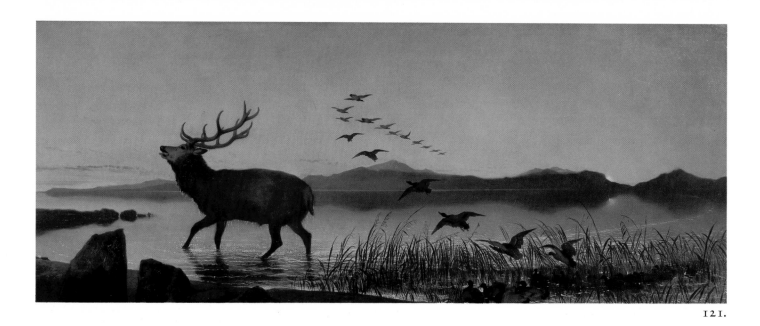

The Sanctuary

This was painted at Loch Maree, a famous lake over twelve miles long on the west coast of Scotland, in the county of Ross and Cromarty. The lake is surrounded by wild and beautiful mountain scenery. Some of its islands are associated with early Christianity; on the Isle of Maree are the ruins of a chapel said to have been the seventh-century hermitage of Saint Maelrubba. The painting was exhibited at the Royal Academy in 1842. Landseer was in Scotland during the autumn of 1841, but he may have begun this picture considerably earlier. His trip to the Highlands in 1839 was brief, and in 1840 he was abroad recuperating from his breakdown.

The Sanctuary is the first of Landseer's symbolic pictures of deer. There is something mysterious but thrilling in the extreme calm and silence of the scene and in the luminous quality of light, a combination of evening sunlight and pale moonlight. The water reflects the pink and orange sky, which changes at the top to ethereal blue. Landseer had painted peaceful Highland scenes before, but never with such visionary intensity, and one is reminded of landscapes by Francis Danby, an artist Landseer is known to have admired. The lake is a refuge from the violent world, although in reaching it the stag disturbs a group of ducks, as though, according to the *Athenaeum* critic in 1842, "there was no purchasing safety for ourselves on this earth, without bringing trouble and peril to others."

The stag has swum across to the shore of the island from the far side of the lake; drops of moisture cling to his coat and the curved track of his passage through the water still glistens. The departing line of ducks makes a balancing curve in flight towards the sunset—and, perhaps symbolically, towards death and oblivion. The picture is redolent of poetic imagery, and one could find many literary parallels for its sublime and mystical conception of nature or its recollection of violence in tranquility. The poem that Landseer used in the Royal Academy exhibition catalogue for 1842, according to Campbell Lennie (1976, p. 144) written by his friend William Russell, was entitled "The Stricken Deer":

> See where the startled wild fowl screaming rise
> And seek in marshalled flight those golden skies.
> Yon wearied swimmer scarce can win the land,

121.

THE SANCTUARY
By 1842
Oil on canvas, 24 x 60" (61 x 152.5 cm)
Provenance: purchased by Queen Victoria from William Wells as a birthday present for Prince Albert, 1842
Exhibitions: London, R.A., 1842, no. 431; Edinburgh, Royal Scottish Academy, 1851, no. 321; Paris, Exposition Universelle, 1855, no. 857; London, International Exhibition, 1862, no. 427; London, 1874, no. 278
Reviews: The Times, May 6, 1842, p. 9b; *Athenaeum*, no. 761, May 28, 1842, pp. 481–82; *Art-Union* (1842), p. 126; *Exhibition Catalogue of the Royal Academy, with Critical and Descriptive Remarks* (London, 1842), pp. 27–28; *Art Journal* (1856), p. 77
Literature: Dafforne, 1873, p. 22; Stephens, 1874, pp. 112–13; Mann, 1874–77, vol. 1, p. 67; Graves, 1876, p. 24, no. 302; *Letters of W. S. Landor*, ed. S. Wheeler (London, 1899), pp. 100–101; Manson, 1902, p. 119; Ruskin, 1903–12, vol. 3, p. 266; Lennie, 1976, pp. 144, 161; Millar, 1977, p. 173, pl. 199
Unpublished sources: Queen Victoria's "Private Accounts Pictures," giving the price as £215 (Royal Archives, Add T. 231/17); Queen Victoria's Journal, August 26, 1842; George Anson, Prince Albert's private secretary, to Jacob Bell, September 5, 1844, September 7, 1844 (Royal Institution, London); Miss Skerrett to Bell, undated (Royal Institution, London); Bell to Landseer, October 22 and 24, 1850, about copyright (V & A, Eng MS, 86 RR, vol. 1, no. 52–53); Landseer to Sir Thomas Biddulph, July 12, 1867, asking permission for his brother to engrave the work (Royal Archives, PP Vic 77 [1867]); Henry Graves to Landseer, September 12, 1867 (V & A, Eng MS, 86 RR, vol. 3, no. 160); Thomas Landseer to Biddulph, offering Queen Victoria a print (Royal Archives, PP Vic 5716 [1867])
Prints after: engravings by C. G. Lewis, 1850 (6 x 11") and 1859 (11½ x 27½"); George Zobel, 1867; Thomas Landseer, 1869 (14½ x 35½"); W. H. Simmons, 1871 (all PSA, 1892, vol. 1, pp. 333–34); J. C. Webb for *Library Edition*, 1881–93, vol. 1, pl. 84 (PSA, 1892, vol. 1, p. 207)
HER MAJESTY QUEEN ELIZABETH II

His limbs yet falter on the water strand.
Poor hunted hart! The painful struggle o'er,
How blest the shelter of that island shore!
There, whilst he sobs, his panting heart to rest,
Nor hound nor hunter shall his lair molest—*Loch Maree*

The picture was widely admired for its sentiment and the sublime beauty of its treatment, by the poet Walter Savage Landor among others. The *Art-Union* reviewer talked of the "power of a great mind over the simplest materials in composition . . . but the poetry of the whole is such as never can be excelled in Art." Its color was criticized by Ruskin and by one writer who complained that the "blue nay almost purple earth and sea" went badly against "the dazzling orange sky above them." When the picture was exhibited in Paris in 1855, it aroused much less interest among the French critics than Landseer's other contributions to the Exposition Universelle.

The Sanctuary was the first of many Highland pictures purchased by the royal family. Queen Victoria recorded in her Journal for August 26, 1842: "My chief present to Albert was a beautiful picture of a stag swimming through water & disturbing wild duck. Mr. Wells gave it up to me."

The Challenge

The title of the picture comes from Thomas Campbell's poem *Lochiel's Warning* (1802), in which a wizard warns Lochiel of his impending fate at Culloden: "Tis the sunset of life gives me mystical lore / And coming events cast their shadows before." This, the second of Landseer's major deer subjects of the 1840s, follows the same format as *The Sanctuary* (no. 121), although on a larger scale. A stag stands on the edge of a lake in moonlight, bellowing in defiance to his rival, who is swimming across the water, leaving a sweeping track in his wake.

Stags continually fight one another during the rutting season, but the idea of a challenge being answered from one side of the lake to the other belongs to the

122.

COMING EVENTS CAST THEIR SHADOW
BEFORE THEM (also called THE CHALLENGE)
By 1844
Oil on canvas, 38 x 83" (96.5 x 211 cm)
Provenance: painted for the 4th Duke of Northumberland, by descent
Exhibitions: London, R.A., 1844, no. 272; London, 1874, no. 199; London, 1890, no. 128; London, 1961, no. 74; Detroit, 1968, no. 175; Paris, 1972, no. 157
Reviews: Art-Union (1844), p. 159; Athenaeum, no. 863, May 11, 1844, p. 433; Illustrated London News, vol. 4, May 11, 1844, p. 306; vol. 5, July 13, 1844, p. 25, repro. as a woodcut p. 24; The Times, May 7, 1844, p. 6f; W. M. Thackeray, Essays, Reviews (London, 1906), pp. 234–35
Literature: Carl Gustav Carus, *England und Schottland im Jahr* 1844 (Berlin, 1845), vol. 1, p. 266; Dafforne, 1873, pp. 26–27, 36; Stephens, 1874, pp. 114–15; Mann, 1874–77, vol. 1, p. 67; Graves, 1876, p. 26, no. 328; *Landseer Gallery,* 1878, pl. 36; Manson, 1902, pp. 128–29; Northumberland Collection (typescript catalogue, c.1930), p. 91, no. 430; *The Genius of British Painting,* ed. D. Piper (London, 1975), p. 251, repro. p. 250; Lennie, 1976, pp. 95, 144, 147
Prints after: engravings by John Burnet, 1846 (16⅜ x 35¾"); C. G. Lewis, 1850 (6 x 11"); Charles Mottram, 1862; Thomas Landseer, 1872 (14½ x 35½") (last three *PSA,* 1892, vol. 1, pp. 49–50, as companions to *The Sanctuary,* no. 121); J. C. Webb for *Library Edition,* 1881–93, vol. 1, pl. 41 (*PSA,* 1892, vol. 1, p. 207)
Related works: fresco, c. 1842, Ardvereike Lodge, Loch Laggan (now destroyed); chalk drawing, *October,* Artist's sale, 1874, lot 554; drawing, Leeds Art Gallery

THE DUKE OF NORTHUMBERLAND

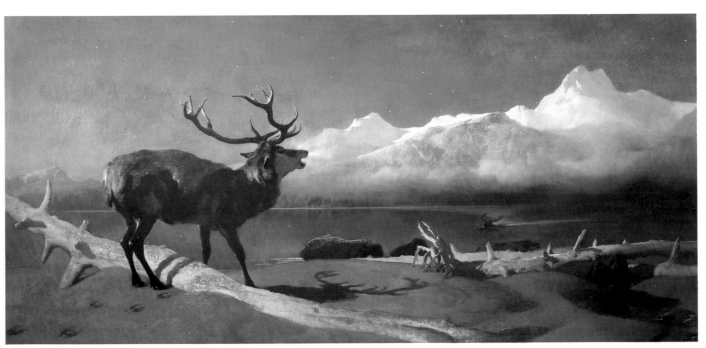

122.

realm of myth. We might be present at a battle between two superheroes to determine the destiny of the world, so epic is the nature of the coming struggle. The landscape is a scene of glacial cold and desolation seen in raking moonlight, of vast spaces and icy heights, that transcends the real world. All this is conveyed in a range of chilly blues and greens, bilious sand colors, ghostly grays and whites. The bellowing stag, one of Landseer's great conceptions, had haunted his imagination since the 1830s; he had used the idea for one of the frescoes at Ardvereike and for many of his drawings of deer. The bellow is of pride, defiance, and sexual aggression. The stag's footprints are firmly imprinted in the sand, and the shadow of its great antlers seems, like Holman Hunt's *Shadow of Death,* to foretell its doom in a typological sense. The roots and branches of the dead trees suggest a deer's Golgotha of antlers and bones, and the assumption that both animals will die, like those in *Night* and *Morning* (nos. 128, 129), does not seem farfetched.

The picture is strongly designed, the tree trunks providing a diagonal grid in the foreground. The line of the horizon divides the picture nearly in the middle. The figure of the stag, aligned close to the front of the picture plane, emphasizes the sense of immense spatial recession. The same kind of dramatic juxtaposition of foreground detail and recessional space occurs in *Hawking in the Olden Time* (no. 72) and is a favorite Landseer device. The setting of the picture has not been identified but may be intended to be Loch Laggan.

At the Royal Academy in 1844 the picture was warmly received and was admired for both its grand construction and its poetic idea. "Never has the deep and terrible stillness of Winter and of Night (if we may hazard the expression) been better painted," wrote the critic of the *Athenaeum:* "It is the death of Nature that we see, the entire torpor whereof enhances and poetizes by contrast the violent expectation of the animal. We were reminded, while looking at this work . . . of that thrilling passage in Scott's romance, where Marmion waits in the moonlight the spectre challenger! There is awe as well as beauty and poetry in this picture." The critic of the *Illustrated London News* also drew a literary parallel: "The picture is full of the poetry of art—that great power which invests the most trifling events in the great drama of Nature with interest, or even sublimity. The sensation of intense cold conveyed by this picture is very extraordinary. The white mountainous horizon is admirably relieved by the deep sky, spangled with stars, and the entire scene reminds us of Byron's 'clear, but oh! how cold.'"

A Random Shot

Many of Landseer's deer subjects of the 1840s, such as *The Sanctuary* (no. 121) and *Stag at Bay* (c.1846, private collection), show deer as the victims of man's aggression. *A Random Shot* takes this theme further. It is one of the unwritten rules of the Highlands that no self-respecting sportsman would shoot a hind with young, but with many inexperienced and trigger-happy sportsmen on the hills it was not an uncommon occurrence. The title of Landseer's picture comes from Sir Walter Scott's epic poem *The Lord of the Isles* and is the poet's comment on Roland's speech of encouragement to his page while they are climbing a rocky pass with Robert the Bruce's army: "Full many a shot at random sent, / Finds mark the archer little meant; / And many a word at random spoken, / May hurt or heal a heart half broken" (canto 5, no. 18). The title illustrates the needless destruction of the deer, which is neither a trophy of the hunt nor a useful source of venison, but a gratuitous victim of violence.

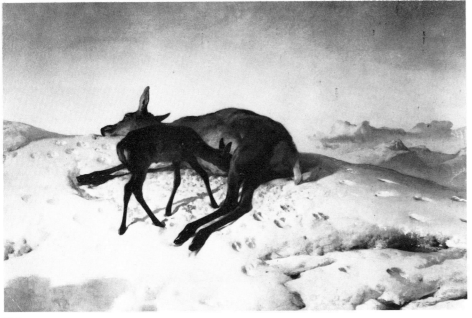

123.

123.

A RANDOM SHOT
By 1848
Oil on canvas, 48 x 72" (122 x 183 cm)
Provenance: commissioned by Prince Albert
(according to Graves, 1876, p. 28); Thomas
Wrigley, given to the Gallery by his children,
1897
Exhibitions: London, 1848, no. 403;
Manchester, 1857, no. 217; London, 1874,
no. 217; Sheffield, 1972, no. 84
Reviews: Art-Union (1848), p. 173;
Athenaeum, no. 1072, May 13, 1848, p. 489;
Illustrated London News, vol. 12, June 3,
1848, p. 360; *Morning Post,* May 2, 1848,
p. 5e; *The Times,* May 2, 1848, p. 6c
Literature: Dafforne, 1873, pp. 33–34;
Stephens, 1874, pp. 117–18; *London
Quarterly Review,* vol. 83 (1874), p. 59;
Mann, 1874–77, vol. 1, p. 96, vol. 2, pp.
110–11, 117; Graves, 1876, p. 28, no. 359;
*Illustrated Catalogue . . . of the Wrigley
Collection* (Bury, 1901), p. 50; Manson, 1902,
p. 138; Ruskin, 1903–12, vol. 4, pp. 334–35;
Magazine of Art (1904), p. 370; Lennie, 1976,
pp. 144–45
Unpublished sources: extensive
correspondence between Jacob Bell, Ernest
Gambart, and C. G. Lewis, 1848–51,
concerning the engraving (Royal Institution,
London)
Prints after: engravings by C. G. Lewis, c.1851
(21 x 31½") (PSA, 1892, vol. 1, p. 308); C. A.
Tomkins for *Library Edition,* 1881–93, vol. 1,
pl. 80 (PSA, 1892, vol. 1, p. 207)
Related work: crayon drawing, *Highland
Sport!,* Artist's sale, 1874, lot 496, exhibited
London, 1874, no. 28
BURY ART GALLERY AND MUSEUM

The setting is a snowy mountaintop in winter, the sun flecking the snow
with pink and mauve tones in an awe-inspiring spectacle of solitude and
desolation. The chill and emptiness of death are reflected in the landscape, the
end of the day, the end of life, lit by an unearthly light. The unsteady tracks in
the snow, the trampled snow under the deer's body, and the poignant drops of
blood illustrate vividly the hind's death agony. The pathos of the fawn,
forlornly searching for nourishment, is all the more harrowing because we
know that it, too, is doomed. The fading light symbolizes the end of any hope
of survival. Soon darkness and death will be all-encompassing.

A Random Shot is a picture of deep feeling, of almost religious awe, and it
touches on universal themes—the dependence of mother and child, the suffer-
ings of the orphan, and the implacable advent of death. Like *The Old
Shepherd's Chief Mourner* (no. 66), it succeeds because it makes its point with
such fine control. The austerity of the composition is well adapted to the
subject. The body of the hind breaks the line of the hill, its legs enclosing the
frail figure of its offspring. The red fur of the animals contrasts vividly with the
snowbank and the golden sky. "To all its details the artist has brought the full
resources of his art," wrote the critic of the *Athenaeum* in 1848, "That chilling
and most unpromising of elements for the painter's purpose has by an ingeni-
ous choice of time and the colouring facilities which it afforded being made
reconcileable to harmonious purpose—while it heightens the ghastly senti-
ment of the whole." The picture moved even Ruskin, not normally an admirer
of Landseer's art, to a rare eulogy: "Certainly the most successful rendering he
has ever seen of the hue of snow under warm but subdued light. The subtlety of
gradation from the portions of the wreath fully illumined, to those which,
feebly tinged by the horizontal rays, swelled into a dome of dim purple, dark
against the green evening sky; the truth of the blue shadows, with which the
dome was barred, and the depth of delicate colour out of which the lights upon
the footprints were raised, deserved the most earnest and serious admiration"
(1903–12, vol. 4, pp. 334–35).

The Monarch of the Glen

Landseer's name is more closely linked with this picture of a stag than with any other. The subject is no longer the relationship of deer to man but the life of the deer in and for itself. Here, in the high mountains, silhouetted against the sky, a royal, or twelve-point, stag surveys the world, its sleek and powerful body poised for action. The sense of untamed freedom, the communion with nature in its most sublime mood, the exhilaration of wild and solitary places—all those things that drew people to the Highlands—are here enshrined by Landseer in a single, monumental image.

Landseer originally designed the picture for one of three panels illustrating scenes from the chase for the refreshment room of the House of Lords. On June 24, 1849, Landseer wrote to the secretary of the Fine Arts Commission, Sir Charles Eastlake, and agreed to carry out the three panels at a cost of one thousand guineas: "I name this sum without any fixed idea as to the class of subject, which would greatly depend on the scheme for the general embellishment of the apartment. If *only* three Pictures are placed—rather above the level of the eye, the subjects represented should, I think, be larger." He also suggested that refreshment rooms were not necessarily the most appropriate setting for his work, a point taken up by various members of Parliament when they struck out the amount from the estimate of the Fine Arts Commission in May 1850. Landseer does not seem to have chosen subjects for the other two panels, and *The Monarch of the Glen,* which he had already begun, was therefore finished as an easel picture and sold privately. Widely admired when first exhibited in 1851, it has remained one of the artist's most popular works.

There are precedents for Landseer's close-up view of the stag. The portraits of bulls by the seventeenth-century Dutch artist Paulus Potter create a similarly overpowering effect. And in English art, the picture *Whistlejacket,* of a rearing horse full of nobility, by the eighteenth-century painter George Stubbs, combines a heroic design with superb realization of the horse's coat and anatomy (on loan to Kenwood House, London). What Landseer does is to endow his equally powerful and naturalistic conception with the spirit of a particular locality. The image is so familiar that it is difficult to look at the picture with a new eye, but it is, in fact, wonderfully painted. The fur of the stag, the foreground grasses, and the evocative landscape behind are brushed in with great brio. The picture captures the freshness of morning in the mountains, with the sun slowly dissolving the mist, in a sparkling key. When the painting was exhibited at the Royal Academy in 1851, the catalogue entry was accompanied by a poem identified as "Legends of Glenorchay":

> When first the day-star's clear cool light,
> Chasing night's shadows grey,
> With silver touched each rocky height
> That girded wild Glen-Strae
> Uprose the Monarch of the Glen
> Majestic from his lair,
> Surveyed the scene with piercing ken,
> And snuffed the fragrant air.

One would assume that the picture represents the forests of Glenorchay belonging to the Marquess of Breadalbane, where Landseer often hunted, but the rocks in the background are said to be identical with a group in Glen Quoich, owned by the Ellice family, which are still called "Landseer's rocks."

124.

THE MONARCH OF THE GLEN
By 1851
Oil on canvas, 64½ x 66½" (163.8 x 169 cm)
Provenance: intended for the refreshment room of the House of Lords; the 1st Lord Londesborough; his widow, later Lady Otho Fitzgerald, her sale, Christie's, May 10, 1884, lot 9; H. W. Eaton, later Lord Cheylesmore, his sale, Christie's, May 7, 1892, lot 42, bt. Agnew; T. J. Barratt, his sale, Christie's, May 11–12, 1916, lot 67, where purchased by Sir Thomas Dewar
Exhibitions: London, R.A., 1851, no. 112; London, 1874, no. 436; London, *Franco-British Exhibition, Fine Art Section,* 1908, no. 19; London, 1961, no. 90; London, Arts Council, *British Sporting Painting,* 1974, no. 188; Edinburgh, National Gallery of Scotland, *The Discovery of Scotland,* 1978, no. 9.4
Reviews: Art Journal (1851), p. 154; *Athenaeum,* no. 1229, May 17, 1851, p. 530; *Illustrated London News,* vol. 18, May 10, 1851, p. 384; *The Times,* May 3, 1851, p. 8
Literature: Dafforne, 1873, pp. 37–38; Stephens, 1874, p. 122; Mann, 1874–77, vol. 1, pp. 121, 141; Graves, 1876, p. 30, no. 372; W. Roberts, *Memorials of Christie's* (London, 1897), vol. 2, pp. 59–60, 185; Alfred George Temple, *The Art of Painting in the Queen's Reign* (London, 1897), pp. 42–44; *Magazine of Art* (1898), pp. 263–64; Manson, 1902, p. 146; Gerald Reitlinger, *The Economics of Taste: The Rise and Fall of Picture Prices, 1760–1960* (London, 1961), p. 359; R.J.B. Walker, *Catalogue of Paintings . . . in the Palace of Westminster* (London), vol. 4 (1962), p. 56; Lennie, 1976, pp. 95, 153–54, 209, 243; Robertson, 1978, p. 343; David Coombs, *Sport and the Countryside* (London, 1978), repro. p. 181
Unpublished sources: Landseer to Sir Charles Eastlake, June 24, 1849 (V & A, Eng MS, 86 M. 3, no. 27); Eastlake to Prince Albert, July 28, 1851, about a proposed place for the picture on a staircase at Westminster (Royal Archives, F. 31/1); Thomas Landseer to Jacob Bell, September 12, 1851, June 9, 1852, about the engraving (Royal Institution, London)
Prints after: engravings by Thomas Landseer, 1852 (23½ x 24⅛"); George Zobel, 1876 (both *PSA,* 1892, vol. 1, p. 242); A. C. Alais for *Library Edition,* 1881–93, vol. 1, pl. 17 (*PSA,* 1892, vol. 1, p. 206)
Related works: drawing of the stag, collection of the Countess of Lymington; unfinished version or copy (43 x 35½"), collection of Richard Williams, sold Sotheby's, March 14, 1962, lot 161, bt. Leggatt
JOHN DEWAR & SONS LIMITED

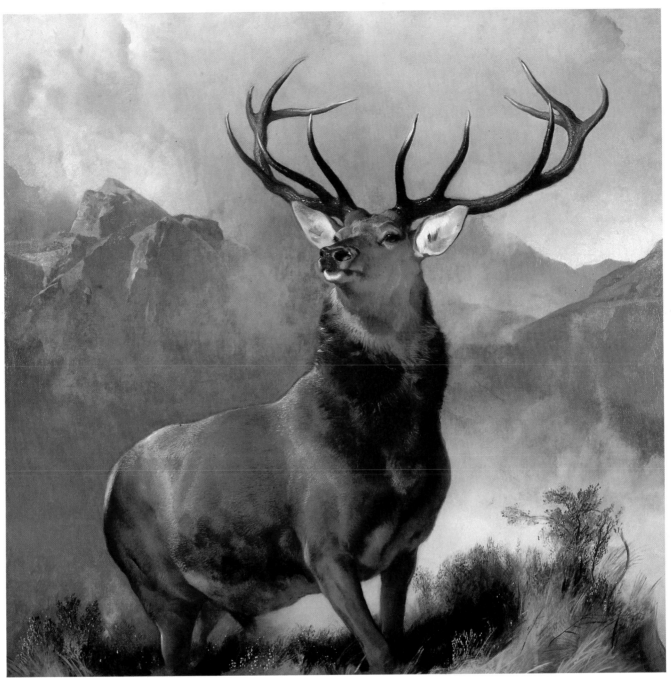

124.

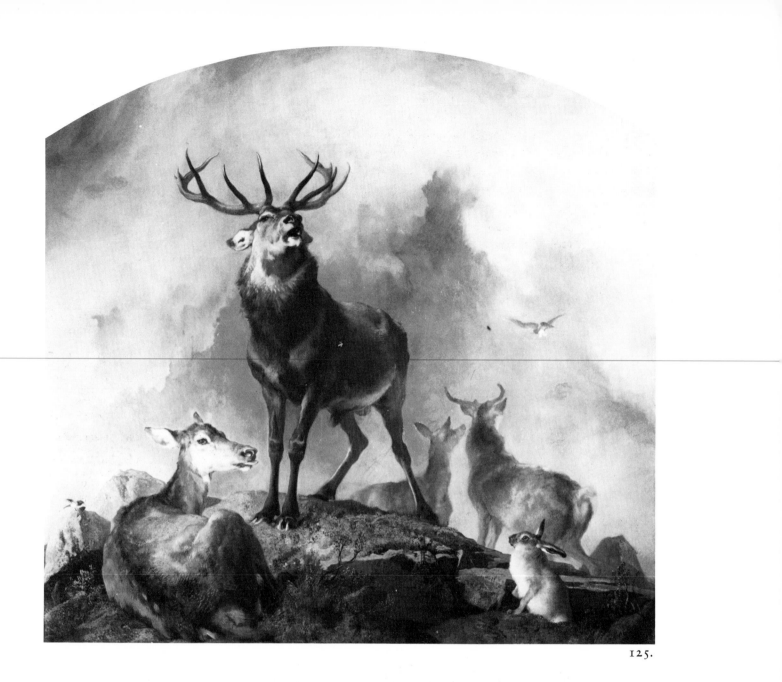

125.

Scene in Braemar

This picture is less consciously naturalistic and more obviously decorative and allegorical than many of Landseer's later deer subjects. It takes its name from the town of Braemar in the eastern Highlands, west of Ballater. Landseer often stayed at Mar Lodge, near Braemar, and hunted in the forests of Deeside.

A huge stag stands on a rocky eminence bellowing at the world in general. Grouped below are three hinds, one sitting meekly at his feet, two others gazing at a soaring eagle with prey in its talons. A white rabbit pops out of its hole on the right, a motif that suggested to one reviewer a fable from Aesop. The stag is depicted as an animal of supernatural power, a denizen of the wilds, heroic and majestic. It is silhouetted against a mountainscape, with wreathing mists suggesting a kind of sublime mystery. The high viewpoint may have been dictated by the position which the picture occupied in the dining room at Preston Hall, for which it was designed, but the viewpoint also has the effect of enhancing the spatial qualities of the design and the scale of the animals. When Landseer went with a party of friends to see the work *in situ* at the home of E. L. Betts, he replied to the chorus of praise: "If you could see the picture with

my eyes, you wouldn't say so many pretty things about it" (Frith, 1887–88, vol. 3, p. 247).

The picture was admired at the time of its exhibition and remained one of Landseer's better known compositions. Critics commented on the slightness of the execution—one called it "slovenliness"—but this was not felt to be a major flaw. "In all surface, however, that knowledge and taste can produce," wrote Stephens in the *Athenaeum*, "without much of that faddling labour that genius too much disdains, Sir Edwin is perfect. In slate rocks, for instance, with their roughness and level cleavages, sometimes grey, sometimes almost pink, growing more beautiful, as some characters do, with the pelting and buffeting of storms, Sir Edwin is a marvel unto many" (May 9, 1857, p. 601).

Later, in a more extended critique of the picture in the *Athenaeum*, Stephens wrote: "This very stag, grand as he is, has a tinge of 'gentility' in him, not wholly desirable in such a subject as this. As one looks at him, a faint suspicion rises in the mind that the creature is not wholly unconscious of himself, of the spreading of his chest, the 'cleanness' of his limbs, the 'set' of his antlers, the condition of his hide. The civilized *human* element is everywhere in Landseer's work; even in such a picture as this, where it is anything but desirable. . . . The pathos of Landseer's animals is so essentially human, that one sees in it the cause of a large proportion of the popularity of his pictures, especially those which the modern world knows best" (November 22, 1873, p. 665).

Drawings and Engravings of Deer

Landseer's fame as a deer painter was enormously enhanced by the publication of prints. It was through this medium that works like *Stag at Bay* (private collection) and *The Monarch of the Glen* (no. 124) achieved their status as familiar household icons. A wide range of Landseer's animal subjects was engraved, but in the late 1840s and 1850s it was the deer pictures above all that earned him his legendary reputation. Included here are some of Landseer's most famous compositions not otherwise represented, such as *The Drive* (no. 126), a huge picture originally commissioned by the Marquess of

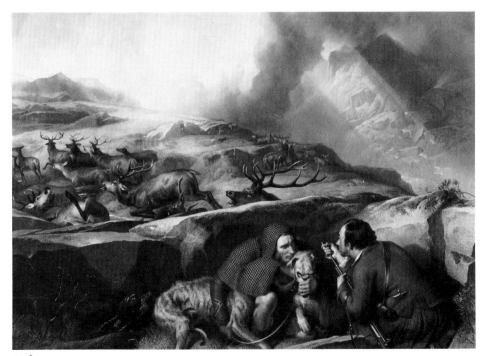

126.

125.

SCENE IN BRAEMAR—HIGHLAND DEER (also called BRAEMAR)
By 1857
Oil on canvas, 107 x 99" (271.8 x 251.5 cm)
Provenance: E. L. Betts, his sale, Christie's, May 30, 1868, lot 68, bt. Agnew; H. F. L. Bolchow, his sale, Christie's, May 5, 1888, lot 48, bt. Agnew; the 1st Earl of Iveagh, by descent
Exhibitions: London, R.A., 1857, no. 77; Manchester, 1887, no. 542
Reviews: Annual Register (1857), "Chronicle," p. 80; *Art Journal* (1857), p. 166; *The Times*, May 2, 1857, p. 9a; *Morning Post*, May 2, 1857, p. 6d; *Athenaeum*, no. 1541, May 9, 1857, p. 601; *Saturday Review*, vol. 3, May 30, 1857, p. 498
Literature: F. G. Stephens, "The Private Collections of England, No. VII," *Athenaeum*, no. 2404, November 22, 1873, pp. 664–65; Stephens, 1874, p. 126; Mann, 1874–77, vol. 2, p. 108; Graves, 1876, p. 32, no. 401; Frith, 1887–88, vol. 3, p. 247; Manson, 1902, p. 151; Ruskin, 1903–12, vol. 14, p. 115; *Journal of Beatrix Potter*, ed. L. Linder (London, 1966), pp. 199–200; Lennie, 1976, pp. 180, 243
Unpublished source: Landseer's Bank Accounts, July 5, 1859, recording £800 from Betts
Prints after: engravings by Thomas Landseer, 1859 (24⅜ x 24⅛"); George Zobel, 1868 (both *PSA*, 1892, vol. 1, p. 36); J. C. Webb for *Library Edition*, 1881–93, vol. 2, pl. 4 (*PSA*, 1892, vol. 1, p. 209)
Related work: oil sketch of stag's head (8¾ x 13"), Christie's, February 2, 1979, lot 83

PRIVATE COLLECTION

126.

THE DRIVE
Thomas Landseer after Edwin Landseer
Picture by 1847, print 1852
Engraving, 28¼ x 40" (71.8 x 101.7 cm)
Literature: Mann, 1874–77, vol. 1, p. 156; Graves, 1876, p. 28, no. 355; *PSA*, 1892, vol. 1, p. 96 (as 1847)
Related work: oil (96 x 139"), Royal Collection, exhibited London, R.A., 1847, no. 71

HER MAJESTY QUEEN ELIZABETH II

127.
STAG AT ARDVEREIKE
c. 1847
Sepia ink on paper, 6¼ x 9½" (16 x 24.1 cm)
Provenance: the 1st Duke and Duchess of
Abercorn, by descent
Exhibition: London, 1961, no. 124
THE DUKE OF ABERCORN

127.

Breadalbane, in whose forests it was painted, but given up to Prince Albert, and *Night* and *Morning* (nos. 128, 129). The last pair records a nocturnal battle between two stags and its fatal outcome the following morning.

The sale and production of prints was a large industry involving many people, which often led to friction and misunderstanding. Landseer's perfectionist approach to the reproduction of his work was often at variance with the commercial outlook of his publishers. Much of his later correspondence and that of Jacob Bell was taken up with copyright negotiation, the slow and laborious process of engraving the plates, and the distribution of the finished prints. Invariably there were rows and compromises. In 1849, for example, there was trouble over the engraving of *The Drive;* Ernest Gambart wanted to exhibit a proof of the unfinished state, against Landseer's objections. Concerned that engravings should be as faithful to his paintings as possible, Landseer took immense pains in touching and retouching proofs to insure the highest quality of reproduction.

Much less well known than his deer paintings are Landseer's chalk drawings, many of them done for an album of twenty prints for which he was responsible entitled *The Forest*. Here, between 1845 and 1868, when the folio was finally published, he depicted the various aspects of deer behavior and deer hunting in a very direct and straightforward way. The titles give a clue to the range of subjects: *Wait Till He Rise, At Bay, Missed, Doomed, Well Packed, The Grealoch, The Fatal Duel,* and *Precious Trophies* (no. 131). Executed in colored chalks on coarse paper, these drawings are large in style and yet lovingly and carefully studied.

Quite different in style are Landseer's wash drawings. Here, in a few broad strokes, he evoked the romantic solitude of the Highlands, with a stag silhouetted against water or sky. *Stag at Ardvereike* (no. 127) was done while Landseer was at the Highland lodge on Loch Laggan belonging to the Abercorns. Landseer, who was a frequent visitor to Ardvereike, decorated the walls of the lodge with a series of rough frescoes, which relate to *The Challenge* (no. 122). Queen Victoria herself made pencil copies of these charcoal murals.

128.

129.

130.

128.

NIGHT

129.

MORNING

Thomas Landseer after Edwin Landseer
Pictures by 1853, prints 1855
Companion engravings, both 22½ x 35½"
(57.2 x 90.2 cm)
Literature: Mann, 1874–77, vol. 2, pp.
43–44; Graves, 1876, p. 31, nos. 389–90;
PSA, 1892, vol. 1, pp. 245, 259 (as 1854)
Related works: oil (57 x 93"),
collection of Henry P. McIlhenny, exhibited
London, R.A., 1853, nos. 46, 69, and London,
1874, nos. 287, 295
THE TRUSTEES OF THE BRITISH MUSEUM,
LONDON

130.

CHILDREN OF THE MIST

1866

Colored chalk on paper, 19¾ x 26"
(50.2 x 66 cm)
Inscribed on verso: *Children of the Mist.
Dunrobin/1866/EL*
Provenance: acquired by Queen Victoria
Exhibition: London, 1874, no. 42
Literature: Graves, 1876, p. 31, under no. 392
Related works: oil (19½ x 23½"),
collection of Lord Brocket, exhibited London,
R.A., 1853, no. 170, and London, 1874, no.
300; crayon drawing (19½ x 27½", oval),
Royal Collection
Shown only in London
HER MAJESTY QUEEN ELIZABETH II

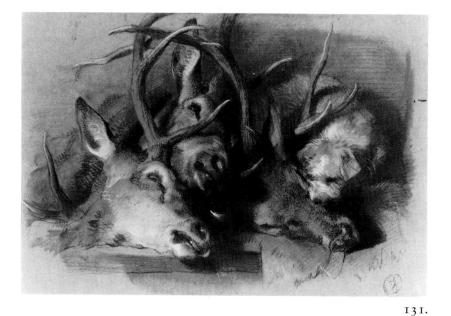

131.

PRECIOUS TROPHIES
By 1857
Colored chalk on card, 13¾ x 19½"
(35 x 49.5 cm)
Signed lower right: *EL*
Provenance: Artist's sale, 1874, lot 478, bt.
Agnew; Albert Grant, his sale, Christie's, April
28, 1877, lot 196; Lady Scott; Sir Samuel
Scott, his sale, Christie's, July 16, 1943, lot 3;
Mrs. Geraldine Rockefeller Dodge, her sale,
Sotheby Parke-Bernet, New York, May 14,
1976, lot 59
Exhibitions: London, 1874(?), no. 85, as
"Group of Stags' Heads"; London, 1890,
no. 125
Literature: Mann, 1874–77, vol. 3, p. 103;
Graves, 1876, p. 32, no. 399
Prints after: engraving by John Outrim, 1858,
for *The Forest* series

PRIVATE COLLECTION

131.

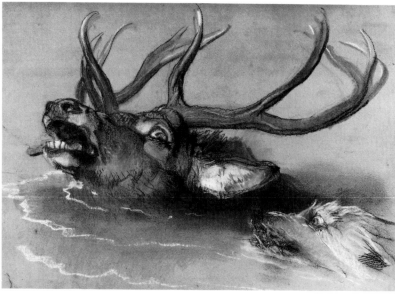

132.

WOUNDED STAG SWIMMING
Colored chalk on paper, 13½ x 19½"
(34.3 x 49.5)
Provenance: Artist's sale, 1874, lot 525;
Albert Grant, his sale, Christie's, April 28,
1877, lot 197, bt. Agnew; Lady Scott; Sir
Samuel Scott, his sale, Christie's, July 16,
1943, lot 6, purchased for the Royal
Collection
Shown only in London

HER MAJESTY QUEEN ELIZABETH II

132.

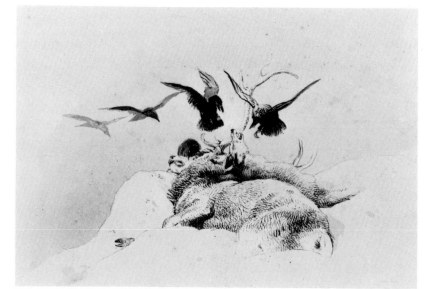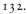

133.

RAVENS ATTACKING A FOX AND A DEAD STAG
Pen, ink, and wash on paper, 5 x 7¾"
(12.7 x 19.7 cm)
Provenance: Artist's sale, 1874(?), probably
acquired by grandfather of present owner
Exhibition: Sheffield, 1972, no. 57

PRIVATE COLLECTION

133.

Subject Pictures, 1844-1851

LANDSEER'S SUBJECT PICTURES of the 1840s, especially the figurative works, are more self-consciously weighty, more symbolic in content, more carefully designed, more finished and smoother in technique than his earlier sporting and historical pictures. His style became more measured and harmonious, less exuberant and spontaneous. The patient study of animal forms remained the basis of his art, and his resources as a painter showed no signs of weakening, as in the following decade.

The Otter Hunt (no. 135) belongs to a long sequence of sporting scenes, but even in comparison with a work as steeped in the old masters as *The Hunting of Chevy Chase* (no. 23), it appears stylized and emblematic, suggesting meanings beyond the immediate incident of the hunt. The picture was painted over a six-year period, slowly evolving from a host of studies in which Landseer familiarized himself with otters and otterhounds. *Shoeing* (no. 134), a portrait of a favorite horse, is another deceptively straightforward work, which owes its air of latent power and mellow repose to the careful balance of the formal elements and the studied realization of textures and luminous effects of light.

Like the deer subjects of the 1840s, Landseer's more novel figure subjects are generalized and visionary. *Time of Peace* and *Time of War*, both destroyed paintings, represented here by prints (nos. 137, 138), contrast the peaceful present with warnings about the consequences of renewed Anglo-French hostility drawn from the immediate past. *The Shepherd's Prayer*, a lost rather than destroyed picture, is an allegory of expiation and redemption set on the fields of Waterloo (*see* no. 136). A second Waterloo subject, *A Dialogue at Waterloo*, by 1851 (Tate Gallery, London), shows the elderly Duke of Wellington escorting his daughter-in-law to the scenes of his former glory, ignored by a group of local peasants. *Royal Sports on Hill and Loch* (*see* no. 112) also belongs to this period and exudes the same sense of idealism. Landseer emerged in these works as a more profound commentator on the issues and ideas of his own day than his earlier work would lead one to anticipate. His naturalism is tempered by a more statesmanlike sense of his role as an artist.

In the following decade, Landseer reverted to the familiar world of deer and dogs, his enthusiasm for new types of figure subjects seemingly exhausted. His last significant subject picture before 1860 is *A Midsummer Night's Dream* (no. 139), his only illustration to Shakespeare and his only experiment as a fairy painter, which resulted from a specific commission. Landseer's retreat from figure painting can be seen both as a reflection of his times and as an indication of the artist's loss of momentum and equilibrium. The 1840s had been a stirring decade for the arts, with exciting projects like the decoration of the new Houses of Parliament offering the promise of a renaissance. The 1850s, dominated by the rise of Pre-Raphaelitism and the voice of John Ruskin, saw the emergence of new aesthetic doctrines with which Landseer and his contemporaries were out of sympathy. Landseer simply went back to animal and sporting subjects, but his reemergence in the 1860s as a heroic figure painter with several Highland subjects is thus all the more remarkable.

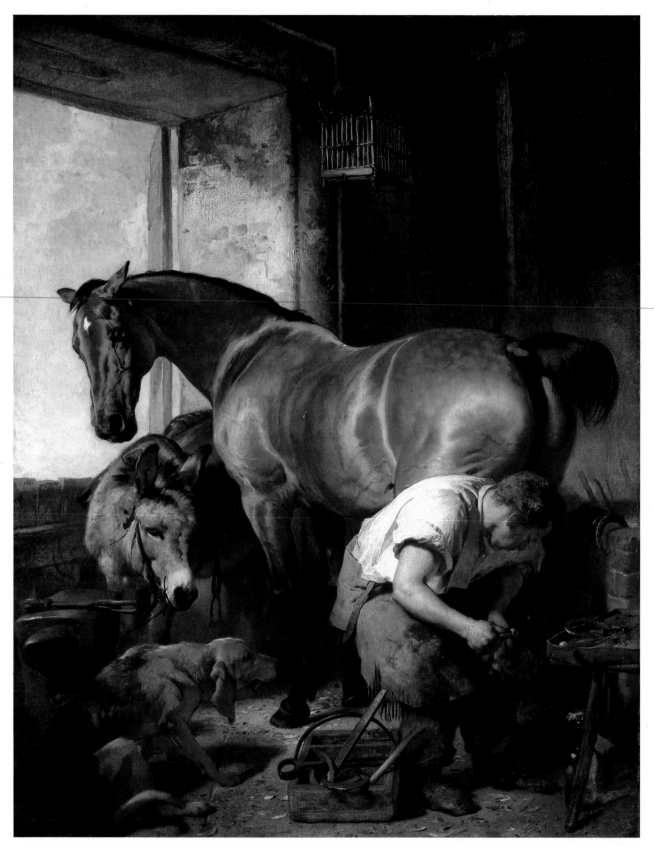

134.

Shoeing

Landseer was probably first asked by Jacob Bell to portray the mare Old Betty, according to Algernon Graves, as early as the mid-1830s, about the same time that he produced *The Sleeping Bloodhound* (no. 64) for Bell. The original intention was to depict the mare and her foal together, but Landseer repeatedly put off the work until about 1843, by which time Old Betty had produced two foals, and both of them had already outgrown their mother. Landseer finally resolved that he would paint the horse and, having decided on a shoeing scene presumably in consultation with Bell, produced the present picture.

One of seven pictures by Landseer bequeathed by Bell to the National Gallery, *Shoeing* has always been one of the most popular of the artist's pictures and numerous copies by other artists exist. Like *The Sleeping Bloodhound,* it is an affectionate and noble portrayal of an animal to which Bell was clearly attached and, since Landseer is known to have borrowed her occasionally, he, too, obviously was fond of the horse.

The bay mare Old Betty dominates the composition, apparently unconcerned while her near hind hoof is shod. Her glossy coat is bathed in the mellow light that floods through the door. The repose of the scene is emphasized not only by the restful stance of the horse and the apparent quiet contentment of her companions, including the gentle slobbering of the old bloodhound Laura in the foreground, but also by the manner in which Landseer arranged the heads of the three animals. In following the heads through a succession of slight turns, the spectator's attention is gradually drawn around from Old Betty's head to the farrier at work. It was an effect that obviously was worked out with some care, for the bridle of the donkey in an earlier, unsatisfactory pose is just visible against the door on the left. Smoke rises up as the hot shoe makes contact with the hoof; the forge glows, and above a blackbird sings in its cage. The picture seems to capture that feeling of patient observation that is the essence of Landseer's animal studies.

The work owes nothing to the romantic mood of shoeing scenes, such as those by Joseph Wright or Géricault, which Landseer undoubtedly would have known through prints; nor is there any sense of that wizardry traditionally associated with the blacksmith, which Sir Walter Scott conjured up in *Kenilworth* (1821) when describing Wayland Smith and his forge. Rather, by drawing on the picturesque elements of the sleek horse, the rough-coated donkey, and the industrious mechanic, Landseer produced an image that has more in common with the work of George Morland as well as with the kind of smithy scenes that frequently appeared at the Royal Academy during the nineteenth century. Its artifice, the suggestion of an elaborate *tableau vivant,* is hinted at in Jacob Bell's account of the picture:

> It has been reported that the mare would not stand to be shod unless in company with a donkey. The truth is that the intimacy of the mare and the donkey commenced in the studio, and was cemented on the canvas. Another rumour states that the scene, as painted, occurred in the forge of a country blacksmith, where the mare was having a shoe fastened, and that the painter was so pleased with the composition that he made an elaborate sketch for the picture on the spot. Some critics have noticed the "oversight" of the mare having no bridle or halter. This was not an oversight, as she would stand to be shod or cleaned without being fastened, but had a great objection to be tied up in a forge or against a post or door. When this has been attempted, she often started back with a sudden jerk and broke the bridle. Other critics have remarked that from the mode of painting the toe of the off fore

134.
SHOEING
By 1844
Oil on canvas, 56 1/16 x 44" (142.3 x 111.8 cm)
Provenance: commissioned by Jacob Bell; his bequest to National Gallery, 1859; transferred to Tate Gallery, 1912
Exhibitions: London, R.A., 1844, no. 332; Liverpool Academy, Autumn Exhibition, 1854, no. 28; Paris, Exposition Universelle, 1855, no. 858; Manchester, 1857, no. 407; London, Marylebone Literary and Scientific Institution, 1859, no. 2; Manchester, City of Manchester Art Gallery, *Art Treasures Centenary: European Old Masters,* 1957, no. 228; London, 1961, no. 85
Reviews: Art-Union (1844), p. 161; *Athenaeum,* no. 863, May 11, 1844, p. 433; *Illustrated London News,* vol. 4, May 11, 1844, p. 306; *New Monthly Magazine,* vol. 74 (1844), p. 251; *The Times,* May 7, 1844, p. 6f, July 11, 1844, p. 7a; *Literary Gazette,* no. 1425, May 11, 1844, p. 307; *Fraser's Magazine,* vol. 29 (June 1844), p. 712; *Art Journal* (1855), p. 281; Théophile Gautier, *Les Beaux-Arts en Europe* (Paris, 1855), pp. 73–75
Literature: John Ruskin, *Modern Painters,* vol. 2 (1846); Dafforne, 1873, p. 27; Stephens, 1874, p. 115, pl. 19; Mann, 1874–77, vol. 1, p. 139; Graves, 1876, p. 26, no. 330; Monkhouse, 1879, pp. 162, 164; Manson, 1902, pp. 125–28; Ruskin, 1903–12, vol. 4, p. 302; Lennie, 1976, pp. 132–34, 161, 163
Unpublished sources: Landseer to Bell, two undated letters, requesting loan of Old Betty; Landseer to Bell, December 17, 1844, about loan of picture for exhibition in Edinburgh; Landseer to Bell, December 6, 1845, that "old slow Betty may remain where she is" (all Royal Institution, London)
Prints after: engravings by C. G. Lewis, 1848 (31 1/8 x 24"); J. C. Webb for *Library Edition,* 1881–93, vol. 1, pl. 29
Related works: oil sketch of donkey's head (paper laid on panel, 9 1/2 x 6 3/4"), Sotheby's at Hopetoun House, November 13–14, 1978, lot 323; monochrome sketch or copy (30 x 25"), private collection, London
THE TRUSTEES OF THE TATE GALLERY, LONDON

foot, the mare appears as if her weight rested on only two legs. This was noticed before the picture was finished, and she was placed in position several times for the purpose of ensuring accuracy. In every instance she placed the foot exactly in the position represented.

The popularity of the shoeing theme and the inevitable comparisons with Dutch low-life subjects, which would have occurred to many critics, coupled with the fact that Landseer's other major exhibits of 1844, *The Otter Hunt* (no. 135) and *The Challenge* (no. 122), were clearly much more original and dramatic compositions, insured that the reaction to *Shoeing* was not altogether favorable. The reviewer in the *Athenaeum* numbered the work among those of "a lower order of Art"; the writer in the *Art-Union* thought that even though the picture had perhaps never been surpassed "as a literal copy of facts . . . as an acquisition to the man of taste [Bell?]—as an example of the high purpose of painting—it is, to our minds, of comparatively small value." Ruskin, in marked contrast to the praise he had lavished on *The Old Shepherd's Chief Mourner* (no. 66) in his first volume of *Modern Painters* (1843), in the second volume, which appeared in 1846, expressed his regret at Landseer "wasting his energies on such inanities as 'Shoeing,' and sacrificing colour, expression, and action to an imitation of a glossy hide." However, the critic of the *Literary Gazette* in 1844 was much nearer to the spirit in which Landseer had conceived the picture: "there is the horse, and no mistake."

R.H.

The Otter Hunt

The spearing of otters was not to die out until the latter part of the nineteenth century, by which time it was recognized as an unnecessarily cruel method of slaughter. Although the subject of otter hunting had been dealt with by a number of artists before Landseer (J. N. Sartorius, the Alkens, Philip Reinagle, and Thomas Bewick, for example), it is Landseer's work that stands out as the most vivid and original conception; it is also his most explicit rendering of impalement.

The action takes place on the banks of a rocky stream, probably in the vicinity of Haddo House, Lord Aberdeen's seat in Aberdeenshire. Landseer depicted the moment just before the otter's carcass is thrown to the hounds—the culmination of a chase during which the otter would have been pursued, perhaps for several hours, as it swam up and down the shallows until forced out of its final refuge to be speared, still in the water, by the huntsman. As he thrusts, the hunter twists the spear to insure that the creature is firmly impaled and prevented from writhing off. As if to emphasize its notorious cunning and viciousness, which, together with its depredation of fish stocks, account for the hunters' hatred of the creature, the pierced otter is shown vengefully thrusting against the top of the spear and arching backward to bite the shaft. The cycle of violence is completed by the presence of two dead salmon lying on the bank near the huntsman's left elbow. The composition is simple and effective, relying for impact and visual tension on that careful placing of the slender spear, which Landseer would have known from hunting scenes by Rubens. The red-jacketed huntsman stands at the center, his face in profile, tense with rage or revenge in a manner that suggests Landseer's study of Sir Charles Bell's *Anatomy of Expression;* at the same time his body echoes the contortions of the otter. He holds aloft the spear, which dramatically bisects the pyramid of raised muzzles and leads the eye directly to the otter silhouetted against the sky.

135.

THE OTTER SPEARED, PORTRAIT OF THE EARL OF ABERDEEN'S OTTERHOUNDS (also called THE OTTER HUNT)
By 1844
Oil on canvas, 78¾ x 60½" (200 x 153.7 cm)
Provenance: commissioned by George, 4th Earl of Aberdeen; Albert (Baron) Grant, his sale, Christie's, April 28, 1877, lot 190, bt. Agnew; Angus Holden, by 1887; Lawrence, 3rd Baron Haldon, his sale, Christie's, July 18, 1913, lot 60, bt. Sampson; James, 1st Baron Joicey; his gift to the Gallery, 1924
Exhibitions: London, R.A., 1844, no. 13; Edinburgh, Royal Scottish Academy, 1857, no. 205; London, 1874, no. 191; Manchester, 1887, no. 632
Reviews: Art-Union (1844), p. 154; *The Times,* May 7, 1844, p. 6f; *Athenaeum,* no. 863, May 11, 1844, p. 433; *Illustrated London News,* vol. 4, May 11, 1844, pp. 305–6; *Literary Gazette,* no. 1425, May 11, 1844, p. 307; *Art-Union* (1847), p. 304
Literature: John Ruskin, *Modern Painters,* vol. 2(1846), p. 86; Dafforne, 1873, p. 26; Stephens, 1874, pp. 108, 113–14; Mann, 1874–77, vol. 1, p. 68; Graves, 1876, p. 26, no. 329; *Landseer Gallery,* 1878, pl. 35; Monkhouse, 1879, pp. 98, 106; Manson, 1902, pp. 124–25; Ruskin, 1903–12, vol. 4, p. 149, vol. 23, p. 475; Lennie, 1976, pp. 131–32, 243
Unpublished sources: Landseer to Horatio Ross, November 6, 1838, discussing visit to Haddo House (Historical Society of Pennsylvania, Philadelphia); the Earl of Aberdeen to Landseer, November 27, 1838, May 9, 1840, October 14, 1841, and 1844, about commission (V & A, Eng MS, 86 RR, vol. 1, nos. 7–10); Aberdeen to Landseer, eight letters, 1838–40 (Mackenzie collection, nos. 835–42); William Wells to Landseer, September 20, 1839 (V & A, Eng MS, 86 RR, vol. 5, no. 324); Landseer to Sir Robert Peel, October 7, 1839 (Fitzwilliam Museum, Cambridge, MS-1949, no. 95); Wells to Landseer, September 2, 1841 (V & A, Eng MS, 86 RR, vol. 5, no. 325); Landseer to Count d'Orsay, undated, saying he has obtained otterhounds from Scotland (Houghton Library, Harvard University, Cambridge, Mass., MS Eng 1272, no. 51); Landseer to Mrs. William Russell, March 6, 1844, thanking her for loan of her otterhound Leorach—"you will find her near to the fore to your Salmon" (Houghton Library, MS Eng 176, no. 9); Landseer to C. G. Lewis, July 15, 1846, and 1847, discussing the print (British Library, London, Add MS, 38608, f. 29); Landseer to Jacob Bell, September 15, 1844 (Royal Institution, London); Frederick W. Keyl, March 1, 1867 (F.W. Keyl's Papers, Royal Archives, London)
Prints after: engravings by C. G. Lewis, 1847 (34¾ x 27⅛"); S. A. Edwards for *Library Edition,* 1881–93, vol. 1, pl. 19 (PSA, 1892, vol. 1, p. 208)
Related works: oil sketch of composition, Artist's sale, 1874, lot 275 (Monkhouse, 1879, p. 99, pl. 22?); watercolor sketch of composition, 1844, Courtauld Institute Galleries, London; crayon sketches, Artist's sale, 1874, lots 502, 609, 619, 620, 626, 958
TYNE AND WEAR COUNTY MUSEUMS SERVICE (LAING ART GALLERY, NEWCASTLE UPON TYNE)

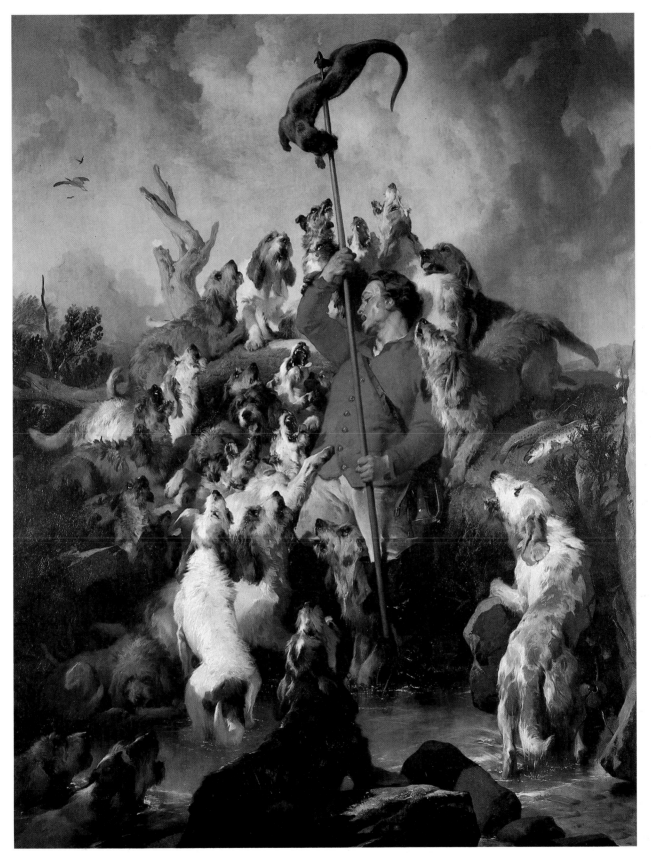

The Earl of Aberdeen had definite ideas about the kind of picture he had commissioned, causing Landseer to revise radically his first ideas. This, together with the artist's customary dilatoriness and the interruption caused by his breakdown of 1840 and his subsequent European tour, accounts for a gestation period of more than five years. It was a period that also saw a number of other, smaller, otter subjects, for example, *Otters and Salmon* (exhibited London, Royal Academy, 1842, no. 96; collection of Sir J. Fitzherbert), which although not directly connected with *The Otter Hunt* might well have been stimulated by work on the larger picture.

The first mention of a picture for Aberdeen occurs in a letter of November 27, 1838, from the earl to Landseer, probably written after the artist had returned from a visit to Haddo House. In the letter Aberdeen enlarged on his ideas for the painting: the introduction of a pony would "help to tell the story," and the scene would be set not in "a great landscape" but on "a bit of broken bank of the river." Only genuine otterhounds were to be represented, that is, Landseer was to exclude the foxhounds that usually hunted with the earl's pack. While Aberdeen accepted that the subject required a canvas with "a certain degree of magnitude," he did not want it to be too large because of lack of space and because it was to be a subject he would "wish *to live with*."

Landseer worked on the subject during 1839. By October 1841, with the picture apparently well advanced and with William Wells urging him to finish it, the artist was at Haddo, probably with the intention of making studies from Aberdeen's otterhounds. However, Aberdeen wrote to Landseer from London on October 14 suggesting that the picture be of "small dimensions"—such as those used for his painting *Horses at a Fountain,* which had been exhibited at the Royal Academy in 1840 (27¼ x 35¾"; location unknown). As a palliative to the shock he knew he was giving Landseer, Aberdeen noted that two pictures of the smaller size might be painted. The picture Landseer was working on at this time was perhaps the painting referred to by Aberdeen as "the one with the hounds in the water," probably the large *Digging Out the Otter* (60 x 98"; Barons Court, Northern Ireland), which remained unfinished in Landseer's studio at the time of his death. Algernon Graves (1876, p. 28) dated that large painting to 1847, but it seems reasonable to regard *Digging Out the Otter* as the original work arising out of the 1838 commission and to redate it to 1838–41. Possibly the earl's suggestion of two otter hunt pictures might have prompted Landseer to explore a spearing scene as a sequel to one showing dogs in the water. In the end, the commission produced only one completed picture, very different from Landseer's first idea and considerably larger than what Aberdeen had thought desirable in 1841.

The enthusiastic praise that the picture received when it was exhibited in 1844 may, in view of the violent subject, seem surprising to present-day audiences. In fact, the superb pictorial qualities of drama and handling drew forth the by now predictable encomiums, and precisely these qualities led one writer to qualify his praise with the hope that Landseer would turn from such obviously brilliant subjects to more substantial themes. In August 1847, when the engraving was reviewed in the *Art-Union,* the critic echoed this sentiment by expressing pleasure at the fact that Landseer was "about to abandon this style for one of a far loftier order"—perhaps a reference to *A Random Shot* (no. 123), exhibited in 1848.

It was John Ruskin who directed the most severe comment against the artist and his picture, although not until April 1846 in a note to the chapter on "Vital Beauty" in the second volume of *Modern Painters*. In a display of sensitivity

which anticipated the pain Turner's *Slave Ship* was to give him years later, Ruskin dwelled on man's "Continuance of cruelty, for his amusement," and commented on *The Otter Hunt:*

> I would have Mr. Landseer, before he gives us any more writhing otters, or yelping packs, reflect whether that which is best worthy of contemplation in a hound be its ferocity, or in an otter its agony, or in a human being its victory, hardly achieved even with the aid of its more sagacious brutal allies, over a poor little fish-catching creature, a foot long.

<div align="right">R.H.</div>

The Shepherd's Prayer

This strange, religious allegory shows a Belgian shepherd kneeling before a crucifix on the fields of Waterloo, his huge flock stretching into the distance. The theme of Christ the Good Shepherd is allied with the idea of sacrifice and redemption in a place associated with the bloodshed and heroism of war. "The exquisite Sabbath calmness of this work is beyond the power of words to convey," wrote the *Athenaeum* reviewer when the painting was exhibited at the Royal Academy, "every accessory aids the sentiment of the picture; the briar with its roses trailing over the broken stone-work . . . the butterfly skimming the surface of the water, unaffrighted by the near presence of a human being,—the very aspect of the sainted image, are one and all harmonious" (no. 915, 1845, p. 466).

136.
THE SHEPHERD'S PRAYER
T. L. Atkinson after Edwin Landseer
Picture by 1845, print 1858
Engraving, 21¾ x 39½" (55.3 x 100.4 cm)
Provenance: acquired by Queen Victoria
Literature: Mann, 1874–77, vol. 3, p. 12; Graves, 1876, p. 27, no. 339; *PSA*, 1892, vol. 1, p. 344
Related work: oil on canvas (27½ x 50½"), exhibited London, R.A., 1845, no. 141, last recorded New York art market, 1958
HER MAJESTY QUEEN ELIZABETH II

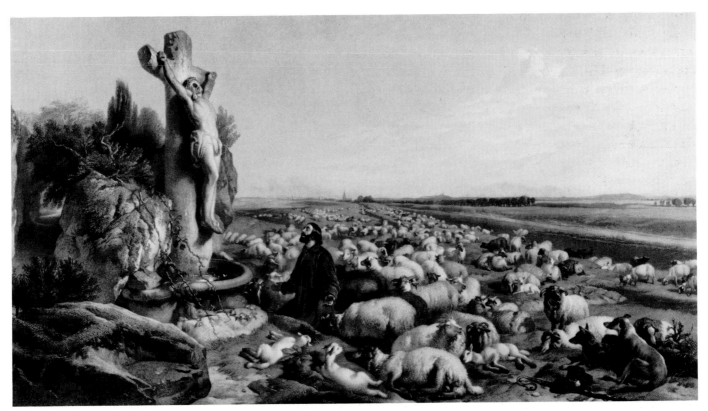

136.

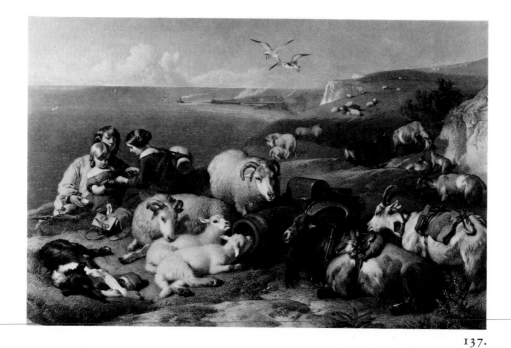

137.

137.
TIME OF PEACE
T. L. Atkinson assisted by Frederick
Stacpoole, after Edwin Landseer
Picture by 1846, print 1850
Engraving, 21⅞ x 33¾" (55.7 x 85.8 cm)
Provenance: acquired by Queen Victoria
Literature: Mann, 1874–77, vol. 1, p. 143;
Graves, 1876, p. 27, no. 347; *PSA,* 1892,
vol. 1, p. 282
Related work: oil on canvas (34 x 52"),
exhibited London, R.A., 1846, no. 53,
Tate Gallery, destroyed 1928

HER MAJESTY QUEEN ELIZABETH II

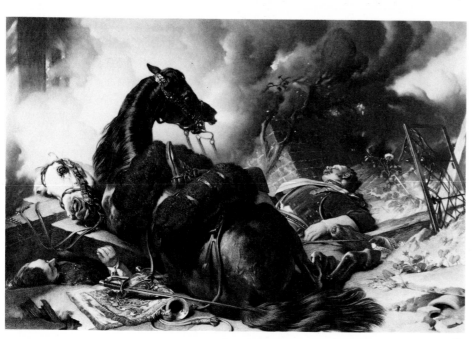

138.

138.
TIME OF WAR
T. L. Atkinson after Edwin Landseer
Picture by 1846, print 1850
Engraving, 22 x 33⅜" (56 x 84.8 cm)
Provenance: acquired by Queen Victoria
Literature: Mann, 1874–77, vol. 1, p. 140;
Graves, 1876, p. 28, no. 348; *PSA,* 1892,
vol. 1, p. 405
Related work: oil on canvas (34 x 52"),
exhibited London, R.A., 1846, no. 83,
Tate Gallery, destroyed 1928

HER MAJESTY QUEEN ELIZABETH II

Time of Peace and Time of War

These two immensely popular works, represented here by engravings, were inspired by fears of Anglo-French conflict in the early 1840s. In the spirit of Rubens, Landseer contrasted the blessings of peace with the horrors of war. The first work shows an idyllic pastoral scene on the Cliffs of Dover: sheep and goats quietly browse beside a rusty cannon, while a boy watches as a little girl helps her sister to wind a skein of wool. The second picture shows a scene suggestive of the Napoleonic Wars. Two cavalrymen, their contrasting white and black horses beside them, lie dead amidst the ruins of a farm.

A Midsummer Night's Dream

This, Landseer's only illustration to Shakespeare, was commissioned by the famous Victorian engineer Isambard Kingdom Brunel for a set of Shakespearean subjects to decorate his dining room. Landseer is said to have received four hundred guineas for the picture. Among the other artists involved in the project were Sir Augustus Wall Callcott, Charles West Cope, Thomas Creswick, Augustus Leopold Egg, Charles Robert Leslie, Daniel Maclise, and Clarkson Stanfield.

On December 14, 1847, Landseer accepted an invitation from Brunel for a preliminary discussion of the project over dinner with the other participants. On December 27, Brunel sent Landseer a cogent outline of the scheme together with a plan of the wall where the pictures were to hang; at this stage there were seven works planned, and that by Landseer, with the dimensions already given (32 x 52"), was to be located at bottom right. Brunel left the choice of subjects to the artists, stipulating only that they should be either scenes on stage or images suggested by the language from the acted and popular plays by Shakespeare. A second meeting was proposed for January 15, 1848, when the artists were to name their subjects in order to avoid duplication. A third meeting was planned for rough sketches to be shown to secure "harmony." Finally, Brunel wanted the pictures to display the qualities of each painter's art, "and that peculiar style in which his prominence has been most universally acknowledged," to "produce as it were a characteristic picture of himself."

J. D. Francis states, improbably, that the picture was in hand for sixteen years, and that Titania was first painted from one of the Russell ladies and repainted from Liz Macdowell, a blonde servant-girl who worked for the painter James Sant and who later died of drink (J. D. Francis Album, Tate Gallery, London).

Landseer's picture illustrates act 3, scene 1, of the play. The drugged Titania awakes, sees Bottom, who has been transformed into an ass, and at once falls in love with him:

> And I do love thee. Therefore, go with me.
> I'll give thee fairies to attend on thee,
> And they shall fetch thee jewels from the deep,
> And sing, while thou on pressed flowers dost sleep:
> And I will purge thy mortal grossness so,
> That thou shalt like an airy spirit go.
> Peasblossom! Cobweb! Moth! And Mustardseed!

In the center of the painting is Bottom, leaning against a huge tree trunk, with Titania clinging to his arm. The fairies enter from the right, two of them mounted on white hares. In the foreground are scattered flowers and grasses and one of Bottom's shoes.

It is obvious why Landseer was attracted to *A Midsummer Night's Dream*. Like *The Defeat of Comus* of 1843 (fig. 35), it offered him a ready-made anthropomorphic subject, with humans and animals in fabulous circumstances. It also gave him a chance to try his hand as a fairy painter. The 1850s were the high point of fairy painting in England, a cult in which a passion for the mysterious and occult went hand in hand with an obsessive concern for naturalistic detail. *A Midsummer Night's Dream* was a fruitful quarrying ground for fairy painters, inspiring such notable works as *The Quarrel of Oberon and Titania*, 1850, and *The Reconciliation of Oberon and Titania*, 1847, both by Sir Joseph Noel Paton (National Gallery of Scotland, Edin-

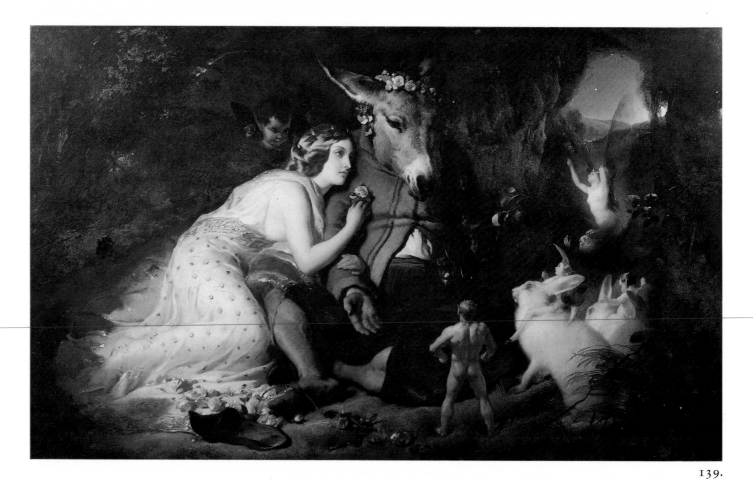

burgh), *Titania Asleep,* c. 1847, by R. Huskisson (private collection), and *Contradiction: Oberon and Titania,* 1854–58, by Richard Dadd (Tate Gallery, London). In contrast to these pictures, Landseer's simple, pyramidal composition is relatively uncluttered and, apart from the fairy elements, is much closer to the way in which the play might have been staged. In Paton's pictures, on the other hand, the disparity in scale between fairies and humans is preserved throughout. Although by no means original in conception, Landseer's picture is full of lovely passages and preserves a genuine sense of the comic and the fanciful. The weakest part of the design is the figure of Titania, a rather limp and vapid female.

Critics were divided. The *Times* reviewer thought it highly "imaginative, fantastical, and elvish, yet full of natural grace and reality" while the *Art Journal* thought its only value lay in "the beautiful colour and charming execution." This was echoed by the critic of the *Athenaeum:* "The supernatural character of the spiritual agency is suppressed in the literally rendered material forms, through which it is here sought to be presented." Queen Victoria, on the other hand, thought it "a gem, beautifully fairy-like and graceful."

139.

SCENE FROM "A MIDSUMMER NIGHT'S DREAM": TITANIA AND BOTTOM
1848–51

Oil on canvas, 31½ x 51⅜" (80 x 130.5 cm)

Provenance: commissioned by I. K. Brunel, his sale, Christie's, April 20, 1860, lot 225; 2nd Earl Brownlow; Thomas Agnew & Son; Sir W. C. Quilter, his sale, Christie's, July 9, 1909, lot 60; Felton Bequest to the Gallery, 1932

Exhibitions: London, R.A., 1851, no. 157; London, 1874, no. 236; Manchester, 1887, no. 635; London, R.A., *Old Masters,* 1901, no. 67; London, *Franco-British Exhibition, Fine Art Section,* 1908, no. 88

Reviews: The Times, May 3, 1851, p. 8; *Athenaeum,* no. 1229, May 17, 1851, p. 530; *Art Journal* (1851), p. 155

Literature: Art Journal (1860), p. 181; Dafforne, 1873, p. 39; Stephens, 1874, pp. 122–23; Mann, 1874–77, vol. 2, p. 27; *Macready's Reminiscences,* ed. Sir F. Pollock (London, 1875), vol. 2, p. 394; Graves, 1876, p. 30, no. 371; *Magazine of Art* (1897), p. 178; Manson, 1902, pp. 146–47; *Catalogue of the National Gallery of Victoria* (Melbourne, 1948), p. 83; Lennie, 1976, pp. 153, 243

Unpublished sources: Landseer to Brunel, December 14, 1847 (Bodleian Library, Oxford, MS C. 6, f. 61); Brunel to Landseer, December 27, 1847 (Mackenzie collection, no. 978); Queen Victoria's Journal, April 8, 1851

Prints after: engravings by Samuel Cousins, 1857 (21 x 34"); A. C. Alais, 1880 (both *PSA,* 1892, vol. 1, p. 237); C. A. Tomkins for *Library Edition,* 1881–93, vol. 1, pl. 68 (*PSA,* 1892, vol. 1, p. 206)

NATIONAL GALLERY OF VICTORIA, MELBOURNE

The Noble Dog—Later Subjects, 1840-1864

THE MORE GENERALIZED and symbolic nature of Landseer's subject matter from the 1840s onward is reflected in his dog paintings. *The Old Shepherd's Chief Mourner* (no. 66), painted by 1837, depicts an individual animal expressing almost human anguish at the death of a beloved master. However, the characteristic works of the next decade are Hogarthian moralities that satirize human affairs. This tendency is foreshadowed in such earlier pictures as *Low Life* and *High Life* (nos. 58, 59) and *A Jack in Office* (no. 62), but with less explicit anthropomorphism. Landseer created an elaborate skit on the legal system, exaggerating the absurdities of human behavior through their canine equivalents, in *Laying Down the Law*, painted by 1840 (no. 140). *Alexander and Diogenes* (no. 144) is another humanized dog picture, apeing a classical subject popular with history painters. A later picture in the same vein is *Uncle Tom and His Wife for Sale* (by 1857, Tate Gallery, damaged in the 1928 flood), a picture of two black pugs inspired by the slavery issue in the United States.

Like his independent subject pictures, Landseer's commissioned portraits of dogs become more consciously idealized and ingratiating. The pictures of royal dogs, especially, parody the conventions of the conversation piece and serve as witty reminders of the owners whose pets they are. The incongruous friendship of big dogs and little dogs is the theme of several storytelling pictures, for example, *Lion and Dash* (by 1840, Badminton, Gloucestershire) and *Doubtful Crumbs* (by 1859, Wallace Collection, London). Landseer also continued to paint more straightforward sporting commissions—retrievers with pheasant in their mouths, spaniels with duck. Toward the end of his life, the artist allowed a more personal element into his pictures—posing dogs with paintbrushes as in *Well-Bred Sitters* (no. 146) or showing dogs looking critically over his own shoulder while he sketches, in the well-known self-portrait entitled *The Connoisseurs* (by 1865, Royal Collection). The artist, as it were, looks at himself and his art satirically through the eyes of the animals that had been his chief inspiration.

Laying Down the Law

A pamphlet accompanying the publication of the print described the origin of the subject: "A French poodle, the property of Count D'Orsay, was resting on a table in the attitude represented by the Artist, when it was remarked by a certain noble and learned Lord who was present, and who, from having held the Seals, was certainly a competent Judge, that 'the animal would make a capital Lord Chancellor.' On this hint, which seemed palatable to the artist, he set to work; and the result was the celebrated Picture, now in the collection of the Duke of Devonshire" (quoted in *Notes & Queries,* June 20, 1857, p. 482). The learned judge in question was later identified by James Manson as Lord Brougham. Landseer's original pen-and-ink drawing shows d'Orsay's poodle sitting up on a chair, both forelegs on the table, a quill pen tucked under its ear, confronting a small dog over a bundle of documents.

It has been suggested that the picture was intended to satirize known individuals on the bench or in the Privy Council. If so, the key remained a private joke among Landseer and his friends. Since Hogarth's famous print *The Bench,* the cruelty and obscurantism of the legal system had been the object of pictorial satire and ridicule. In Landseer's time, pressure for long-

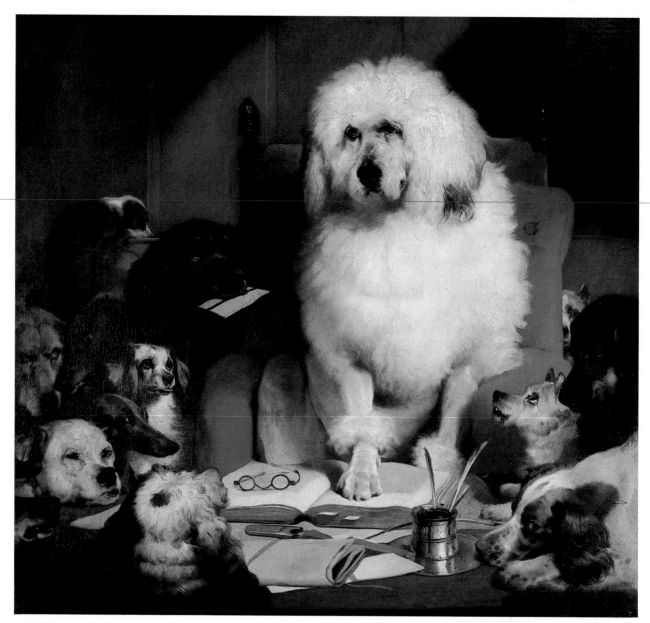

140.

needed legal reforms reached a crescendo. The puffed-up poodle in his picture is the perfect emblem of a pompous judge, its paw self-importantly resting on one page of the book, its spectacles incongruously placed on the other. The dog's floppy ears and fluffy front parody the judge's full-bottomed wig, ruffles, and ermine, while the red chair and cushion suggest the scarlet robes of the bench. On the table are inkwells, quill pens, sealing wax, and documents. The clerk of the court is a long-eared spaniel seen from behind. Squashed in on each side of the poodle is a variety of dogs, which ape lawyers, court officials, and jurors: a stolid bulldog resting its chin on the green baize on the left; an effete greyhound; a deerhound and bloodhound behind; a black retriever with a letter in its mouth; a spaniel distracted by something behind the bench; a bull terrier, Irish terrier, mastiff, and spaniel on the right. The Blenheim spaniel behind the greyhound was the Duke of Devonshire's dog Bony, who was inserted after the other dogs. The preliminary outline etching for the mezzotint published in 1843 shows the state of the picture before the introduction of the Duke of Devonshire's spaniel (see no. 141). The unlikely combination of breeds and the exaggerated expressions of the individual dogs draw out the uneasy humor and satire of the courtroom scene.

The use of animal fable for satirical subjects of this kind was certainly not new. The political cartoonist John Doyle, who often borrowed subjects from artists, had drawn the Legislative Assembly of Newfoundland as Newfoundland dogs, with a bewigged speaker in the center of his composition, similar to *Laying Down the Law* ("HB's Sketches," no. 187, March 1832). Landseer's picture belongs to a long-established tradition of political caricature and is new neither in subject matter nor in composition. But here we see Landseer's inimitable ability to create living animals, who, whatever their human antecedents, have the touch of real dogs. One may object to the sentiment and the

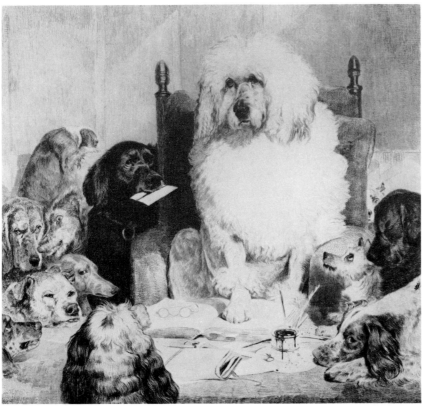

141.

140.

LAYING DOWN THE LAW (also called TRIAL BY JURY)
By 1840
Oil on canvas, 47½ x 51½"
(120.7 x 130.8 cm)
Provenance: the 6th Duke of Devonshire, by descent
Exhibitions: London, R.A., 1840, no. 311; Leeds, *National Exhibition of Works of Art,* 1868, no. 1396; London, 1874, no. 205; Nottingham University, *Victorian Exhibition,* 1959, no. 35; London, 1961, no. 81
Reviews: Art-Union (1840), p. 74; *Examiner,* no. 1683, May 3, 1840, p. 278; *The Times,* May 6, 1840, p. 6d; *Athenaeum,* no. 657, May 30, 1840, p. 435, no. 798, February 11, 1843, p. 141; *Blackwood's Magazine,* vol. 48 (1840), p. 382
Literature: the 6th Duke of Devonshire, *Handbook of Chatsworth and Hardwick* (privately printed, 1845), p. 12; Waagen, 1854–57, vol. 1, p. 381; *Notes & Queries* (London, June 20, 1857), p. 482; Dafforne, 1873, p. 20; Stephens, 1874, p. 107; Mann, 1874–77, vol. 1, p. 72, vol. 4, pp. 18–19a, quoting Tom Hood's poem on the picture; Graves, 1876, p. 22, no. 275; *Reminiscences of Solomon Hart,* ed. A. Brodie (London, 1882), pp. 111–12; *Magazine of Art* (1891), p. 396; Manson, 1902, pp. 101–2; Ruskin, 1903–12, vol. 22, p. 487; Lennie, 1976, pp. 68, 72, 88
Unpublished sources: Landseer to Count d'Orsay, undated, saying he is ready for the poodle and that in his present state he is perhaps more comic (Houghton Library, Harvard University, MS Eng 1272, no. 51); the Duke of Devonshire to Landseer, December 26, 1842, urging him to paint Bony (V & A, Eng MS, 86 RR, vol. 2, no. 86); Thomas McLean, publisher, to Landseer, November 23, 1840, and April 25, 1841 (V & A, Eng MS, 86 RR, vol. 4, nos. 221, 223)
Prints after: engravings by Thomas Landseer, 1843 (*see* no. 141); George Zobel, 1851 (*PSA,* 1892, vol. 1, p. 203); J. B. Pratt for *Library Edition,* 1881–93, vol. 2, pl. 68 (*PSA,* 1892, vol. 1, p. 210)
Related works: oil of Bony and Var (20½ x 27½"), Chatsworth, Derbyshire; oil sketch of a bull mastiff (14 x 12¼"), exhibited London, 1961, no. 80; pen-and-ink drawing of the poodle, called "The Chancellor," from d'Orsay's collection, etched by C. G. Lewis, 1850 (Graves, 1876, p. 22, no. 269)

THE TRUSTEES OF THE CHATSWORTH SETTLEMENT

141.
LAYING DOWN THE LAW
Thomas Landseer after Edwin Landseer
c. 1841–42
Etching, 23¼ x 25⅛" (59 x 63.9 cm)
Provenance: acquired by the Museum, 1854
Literature: Graves, 1876, p. 22, no. 275

THE TRUSTEES OF THE BRITISH MUSEUM, LONDON

humor, but the dogs, especially the superb poodle, are carefully and lovingly studied.

The picture was well received by the critics. In May 1840 the *Athenaeum* characterized it as "a capitally sketched and beautifully painted piece of whimsicality, touching at once the characteristic peculiarities of canine nature and the absurdities of judicial administration. . . . In the drapery of all his figures—we beg pardon—in the wool, and the hair, and the bristle of his several *dramatis personae*, Mr. E. Landseer is as masterly as ever." The *Examiner* described the dogs themselves: "Look on the daring confidence of that Irish mastiff, and see the nasal snarl and twitch of that Scotch stag-hound; observe the wicked shrewdness of that aristocratic blood-hound, and the silly exclusiveness of that old English gentleman greyhound. So may the O'Connells and Broughams, the Lyndhursts and Burdetts, still hope to live for ever. . . . Then, as a matter of painting, what dashing facility, combined with the most exquisite finish; what truth of imitation, without that apparent carefulness which disgusts!"

Decoyman's Dog and Duck

Decoy dogs are trained to lure duck into specially constructed nets, known as pipes, along rivers or lakes. The dog attracts the curiosity of the duck by darting hither and thither along the bank. The duck follow into the pipe, which becomes gradually narrower, until they enter the trap at the end. Pipes are still used for banding birds, but not for hunting. Part of the frame and netting of a pipe can be seen in the background on the left of Landseer's picture.

The painting is, however, less an illustration of decoy hunting than a magnificent still-life rendering of dead game. Landseer had used the idea of contrasting hunters and prey, life and death, in several earlier pictures of dogs with dead deer. Here the small crossbred terrier sits proudly amidst the trophies of the hunt, in a take-off of the conventional image of the sportsman with his bag. The reviewer for *The Times* noticed the contrast between "the soft yielding plumage of the dead birds," which invites the touch, and the terrier "rejoicing boldly in his wiry hair." The delicacy of touch in the rendering of fur and plumage was regarded as a weakness by the *Art-Union* reviewer in 1845, who found it difficult to believe the birds were really dead: "Some of the touches here are microscopic, while the bright green of the head is broadly and freely touched upon over a luminous emerald ground."

The terrier, which belonged to the artist, was a famous ratter. According to Frederick Goodall, Landseer brought the dog to Redleaf, the home of William Wells, for a contest with a rat of similar size. The dog kept the rat at bay for twenty minutes, but was unable to finish it off; a drawing by Landseer entitled *The Rat at Bay* is in the Redleaf albums (private collection). Goodall recorded how Landseer began this picture one Sunday while everyone was at church: "And when we came home he showed us into his painting-room where stood the portrait of this dog. It was cold weather, and the creature was shivering all the time he was painting it; its very nose was wet. He had just sketched in charcoal the decoy net, and a number of dogs [presumably duck] lying about, also in charcoal. He said, 'I intend to call it "The Decoy Man's Dog,"'" and it certainly turned out a very pretty picture" (*Reminiscences*, London, 1902, pp. 119–20).

Another picture of the same period shows a retriever carrying a dead duck in its mouth (collection of Anne, Duchess of Westminster).

142.
DECOYMAN'S DOG AND DUCK
By 1845
Oil on canvas, 17¾ x 31¾" (45.1 x 80.7 cm)
Provenance: William Wells of Redleaf; Wells sale, Christie's, May 10, 1890, lot 53; the 5th Earl of Carysfort, by descent
Exhibitions: London, B.I., 1845, no. 1; London, 1874, no. 340
Reviews: The Times, February 11, 1845, p. 5e; *Athenaeum,* no. 903, February 15, 1845, p. 177; *Art-Union* (1845), p. 73
Literature: Dafforne, 1873, p. 27; Graves, 1876, p. 27, as "Dairy Maid dog and ducks"; *Reminiscences of Frederick Goodall* (London, 1902), pp. 119–20; T. Borenius and J. V. Hodgson, *A Catalogue of the Pictures at Elton Hall* (London, 1924), p. 28
PRIVATE COLLECTION

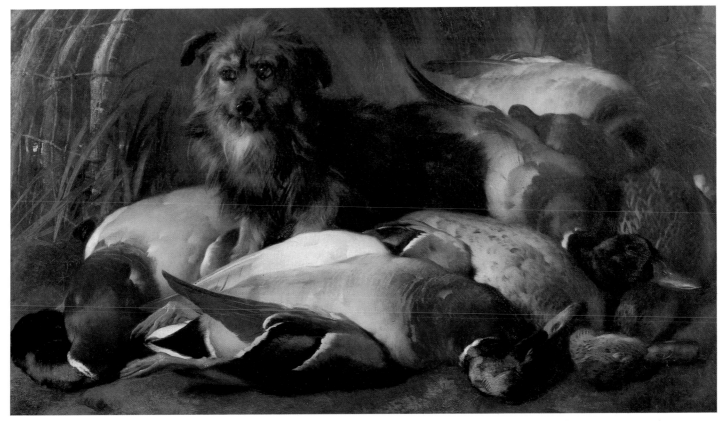

142.

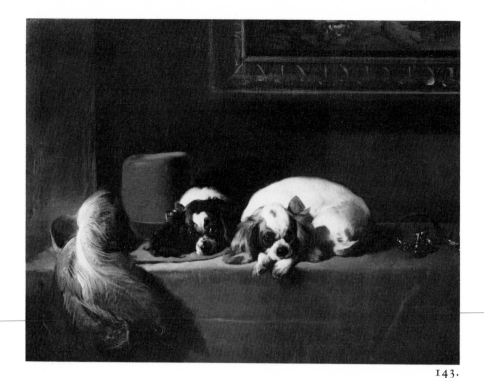

143.

143.

KING CHARLES SPANIELS (also called
THE CAVALIER'S PETS)
By 1845
Oil on canvas, 27½ x 35½" (70 x 90.2 cm)
Provenance: commissioned by Robert
Vernon; his bequest to the National Gallery,
1847; transferred to the Tate Gallery, 1919
Exhibitions: London, B.I., 1845, no. 134;
London, Whitechapel, *British Art
1830–1850,* 1920, no. 104
Reviews: Art-Union (1845), p. 75;
Athenaeum, no. 903, February 15, 1845,
p. 177; *Literary Gazette,* no. 1465, February
15, 1845, p. 109; *The Times,* February 26,
1845, p. 6d
Literature: Art-Union (1845), p. 371; *Art
Journal* (1852), p. 8; Waagen, 1854–57, vol.
1, p. 382; Anne Thackeray [Ritchie], "Sir
Edwin Landseer," *Cornhill Magazine,* vol. 29
(1874), p. 89; Stephens, 1874, pp. 82–83;
Mann, 1874–77, vol. 1, pp. 73, 157; Graves,
1876, p. 27, no. 341; Monkhouse, 1879, p.
102; Frith, 1887–88, vol. 1, p. 319; National
Gallery Catalogue, 1888, p. 85; *Vernon
Heath's Recollections* (London, 1892), pp.
8–14; Manson, 1902, pp. 129–31; Tate
Gallery Catalogue, 1913, p. 373; A. M. Eyre,
Saint John's Wood (London, 1913), pp.
47–50; Lennie, 1976, pp. 134–37
Unpublished sources: Capt. L. Smith to
Landseer, December 15, 1844; Landseer to
Jacob Bell, December 1844(?), and January 9,
1845, discussing *Lady and Spaniels;* Robert
Vernon to Landseer, February 16, 1845,
accepting Landseer's offer of *King Charles
Spaniels* (all Royal Institution, London)
Prints after: engravings by John Outrim, 1852
(7⅜ x 9½") for *Art Journal* (1852), opposite
p. 8; Alfred Lucas, 1875 (PSA, 1892, vol. 1, p.
48); J. C. Webb for *Library Edition,* 1881–93,
vol. 1, pl. 40 (PSA, 1892, vol. 1, p. 208)
Related works: two oil sketches of single dog's
heads, perhaps by Landseer: one (7 x 9½")
exhibited London, Knoedler, *Artist and
Animal,* 1968, no. 77, and the other (10 x 8")
with Rafael Valls, London, 1980

THE TRUSTEES OF THE TATE GALLERY,
LONDON

The Cavalier's Pets

The Cavalier's Pets is one of the most celebrated and best-known examples of Landseer's brilliant powers in handling paint. The history of the commission, with its delays, Landseer's struggle to complete the picture to his satisfaction, and his ultimate triumph with a dazzling tour de force—reportedly accomplished in one or two days—underscore the artist's romantic image and legendary talents.

The fact that *Cavalier's Pets* was painted in a very short time remains undisputed, but there are several different accounts of how Landseer came to produce this picture for his patron Robert Vernon. The earliest version appeared in 1852 in the *Art Journal* (reiterated by Algernon Graves and F. G. Stephens); the longest and seemingly most authoritative account appeared in *Recollections,* by Vernon Heath, Robert Vernon's nephew. Neither version, however, is entirely accurate.

In 1838 Landseer was commissioned by Robert Vernon to paint a picture that included portraits of his spaniels. The composition was agreed upon to include a portrait of Ellen Power, Lady Blessington's niece. Landseer procrastinated and Vernon became incensed when an engraving of it was published, without his consent, in June 1842. The painting itself, known as *Lady and Spaniels,* was on the artist's easel in August 1844, according to Landseer, when its progress was interrupted by his serious fall from a horse. In mid-December, Landseer assured his patron, who by that time was feeling "ill-treated and neglected," that the painting would be at Vernon's disposal by mid-January 1845. By January 9, 1845, Landseer considered the painting, at last, to be "worthy" of Vernon's collection and had Jacob Bell obtain Vernon's permission to show the painting at the forthcoming exhibition at the British Institution. Landseer explained that Vernon could have his canvas between the submission date for the exhibition and the opening, on February 10, by submitting only the frame for the painting to hold a space for it while the exhibition was hung; however, Vernon never did retrieve his canvas. During the three weeks that the exhibition was being organized, without

Vernon having seen his painting, Landseer made what must have been a hasty decision to paint a reinterpretation of the subject of *Lady and Spaniels* for his patron. This had to be the same size as the first work because a frame was already at the gallery. Landseer is said to have spent no more than one or two days dashing off the new painting—*Cavalier's Pets*. To produce it he turned either to an original sketch said to have been made in 1838, or, more likely, he took the figures directly from *Lady and Spaniels*. The earlier painting was never exhibited, and Vernon must have renounced his interest in it, for it subsequently passed into the possession of King Leopold of Belgium.

Cavalier's Pets is an exercise in animal portraiture, with a dash of historical allusion of the kind used in *Scene at Abbotsford* (no. 55), for example, to add substance and to evoke a historical period. A white Blenheim and a King Charles spaniel lie on a pale red velvet table covering; above them hangs what seems to be a hunting scene in the manner of Snyders. A high-crowned, broad-brimmed gray felt hat, cocked on one side, with its ostrich-feather plume trailing forward toward the spectator, and a gilt spur are placed beside the animals. The speed at which it was executed is evident both in the thin application of the paint and in the assured, impulsive brushstrokes used for the feather.

R.H.

Alexander and Diogenes

In its subtle and skillful use of recognizable images, and as an example of how Landseer contrived to make a picture operate at a number of different levels, *Alexander and Diogenes* marks a high point in the genre of scenes from canine life. It juxtaposes familiar opponents conceived in the same terms as, for example, *Low Life* and *High Life* (nos. 58, 59) or *Dignity and Impudence* (no. 68). In its nearness to satire of the *Punch* variety, the work can be seen as a companion to *Laying Down the Law* of 1840 (no. 140), but it is also related to

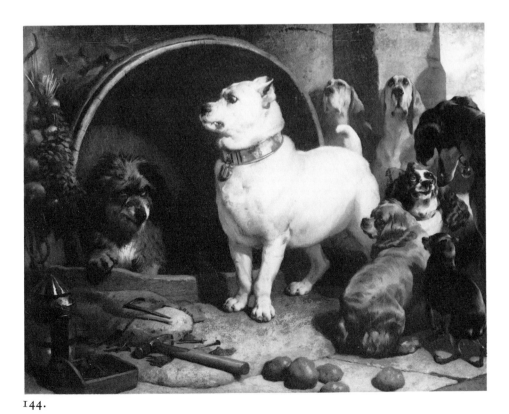

144.

144.
ALEXANDER AND DIOGENES
1848
Oil on canvas, 44⅛ x 56⅛"
(112.5 x 142.6 cm)
Provenance: painted for Jacob Bell(?); his bequest to the National Gallery, 1859; transferred to the Tate Gallery, 1897
Exhibitions: London, R.A., 1848, no. 208; Birmingham, Society of Artists, 1854, no. 94; Manchester, 1857, no. 336; London, Marylebone Literary and Scientific Institution, 1859, no. 6
Reviews: Morning Post, May 2, 1848, p. 5e, May 13, 1848, p. 3e; *The Times,* May 2, 1848, p. 6c; *Literary Gazette,* no. 1633, May 6, 1848, p. 316, no. 40, n.s., April 2, 1859, p. 440; *Athenaeum,* no. 1072, May 13, 1848, p. 489; *Art-Union,* vol. 10, June 1, 1848, p. 169; *Illustrated London News,* no. 321, vol. 12, June 17, 1848, p. 391; *New Monthly Magazine,* vol. 83, no. 330 (1848), p. 230
Literature: Stephens, 1874, pp. 118–19; Mann, 1874–77, vol. 1, pp. 140a, 152; Graves, 1876, p. 28, no. 360; W. Cosmo Monkhouse, "Hogarth and Landseer, III: Landseer as a Humorist," *Art Journal* (1879), pp. 248–49; Monkhouse, 1879, pp. 138, 143–44; Manson, 1902, pp. 102, 139
Unpublished sources: Thomas Landseer to Bell, undated [after July 8, 1851], reporting visit from Gambart's agent; receipt of partial payment for engraving; Thomas Landseer to Bell, September 12, 1851, mentioning impression from plate sent to Landseer in Scotland; receipt for the picture, signed by C. L. Eastlake, director of the National Gallery, on behalf of the trustees, June 29, 1859 (all Royal Institution, London)
Prints after: engravings by Thomas Landseer, 1852 (21½ x 27½"); C. Hollyer, 1873 (both PSA, 1892, vol. 1, p. 6); J. C. Webb for *Library Edition,* 1881–93, vol. 1, pl. 34; woodcut by Alfred Harral (6⅞ x 9") for *Illustrated London News,* no. 321, vol. 12, June 17, 1848, p. 291 (Graves states that Landseer made the drawing on the wood, 1876, p. 28)

THE TRUSTEES OF THE TATE GALLERY, LONDON

the more modest *Be It Ever So Humble, There's No Place Like Home* of 1842, which shows a terrier outside a kennel made from a barrel (Victoria and Albert Museum, London).

Landseer's witty substitution of dogs for men in a well-known incident taken from Plutarch's life of Alexander the Great is more considered than any of these earlier subjects. When the painting was exhibited at the Royal Academy in 1848 it was accompanied by the following illustrative text:

> One day Alexander visited Diogenes, and condescendingly asked what he could do for him. "Stand a little on one side then," replied Diogenes; "you prevent me from feeling the sun." The courtiers with Alexander expressed their indignation that he so much honoured that old dog Diogenes. Alexander perceiving their humour, turned to them and said, "If I were not Alexander, I would be Diogenes."

The Cynic Diogenes was an obvious candidate for Landseer's anthropomorphizing brush, for the word "cynic" derives from the Greek for dog. The "snarling and currish" philosopher who lived in a tub on the streets of Athens and whose shamelessness earned him his name of "dog" is transformed by Landseer into an old and scruffy terrier—very like, in fact, the "rough and gruff" Diogenes in Dickens's *Dombey and Son* (which the artist undoubtedly would have read). Alexander is shown as a white bull terrier, the padlock on his brass collar hanging like a campaign medal. Accompanied by his pampered and unconcerned courtiers, he stands haughtily at the center of the picture—his profile in sharp contrast to the dark semicircle of the tub interior—as he is rebuked.

Other incidental details—the tub in which Diogenes lived (which should more properly be a large earthenware jar and not a wooden barrel), the lighted lantern that he once carried through the streets in the daytime while searching for an honest man, the coarse blanket and cheap victuals (potatoes and onions), the hammer, nails, and hook that denote self-sufficiency—all combine to suggest the asceticism that the philosopher's biographers record in numerous anecdotes. The appropriateness of these objects to the habitat of a dog, which F. G. Stephens nicely deduced to be a blacksmith's mongrel, is self-evident.

In the suggestion of "high art" implicit in the title and in the subsequent *reductio ad absurdum* of a meeting between soldier and philosopher which greets the viewer, the picture is a total confounding of the ideals in history painting for which the Academy still stood. Landseer must have been aware of this, but, curiously, it went unnoticed among his contemporaries, as indeed did the irony of a former pupil of the history painter B. R. Haydon exhibiting such a work in the Royal Academy. Its ready acceptance is as much a commentary on Landseer's complete success in attributing to his animals the motives and manners of men as it is a reflection of the status of academic art in mid-nineteenth-century Britain.

When the painting appeared at the Royal Academy in 1848, the critics were unanimous in their praise. The reviewer in the *Art-Union* for June described it as a "truly happy conception, carried out in a manner which no painter who has lived hitherto could have accomplished!" The month before, the *Athenaeum* had noted that "if anything can reconcile us to seeing Art employed in epigrammatizing a high moral, it must be such a success as Mr. Landseer's." Within a few weeks of its first showing, the *Illustrated London News* described *Alexander and Diogenes* as a "famous picture."

When the painting was shown again in London at the Marylebone Literary

and Scientific Institution in 1859, Jacob Bell, who had a personal interest in Parliamentary politics, proposed that the subject could be read in two ways, depending upon the inclination of the viewer: as a straightforward depiction of a group of dogs or as an allegory showing a bullying leader and his flattering followers.

R.H.

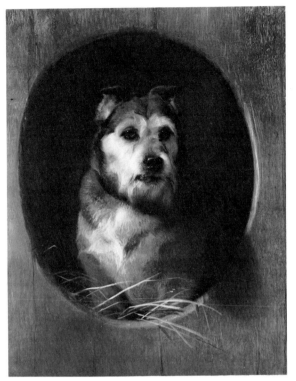

145.

145.
PINCHER, THE PROPERTY OF MONTAGUE GORE, ESQ.
By 1848
Oil on canvas, 22 x 17½" (55.9 x 44.5 cm)
Signed lower right: *E. Landseer*
Provenance: Montague Gore, his sale, Christie's, June 27, 1863, lot 81, bt. Earl; Mrs. Alice Brunton; anonymous sale, Christie's, May 8, 1914, lot 142; Leger Galleries, London, by 1963, from whom acquired by present owner
Exhibitions: London, R.A., 1848, no. 48; San Francisco, California Palace of the Legion of Honor, *The Collection of Mrs. John Wintersteen*, 1966, no. 14
Reviews: Art-Union (1848), p. 166; *Athenaeum*, no. 1072, May 12, 1848, p. 489
Literature: Graves, 1876, p. 29

MRS. JOHN WINTERSTEEN

Pincher

Landseer had used a kennel as a framing device with notable aplomb in *Dignity and Impudence* (no. 68). Here it suggests a picture within a picture, a dramatic trompe l'oeil effect. The illusion is heightened by the cast shadow of the terrier and the wisps of straw escaping from the kennel opening. The simplicity of the geometrical oval and square concentrates attention on the portrayal of the dog, treated in a direct frontal pose. Brightly lit and wonderfully alive, its nose twitching, Pincher looks out as faithful watchdog and guardian. The reviewer of the *Art-Union* in 1848 considered that the terrier's "cropped ears and earnest gaze denote inquiry, and the expression of his features bespeaks honesty and *bonhommie*."

Well-Bred Sitters That Never Say They Are Bored

The theme of dogs and dead game was nothing new in Landseer's work, but the inclusion of paintbrushes suggests a more playful and satirical vein, as if the artist were humorously commenting on the nature of his art, while the title underlines his preference for canine, opposed to human, sitters. His failure as a portraitist was a source of considerable bitterness to Landseer. In the year following *Well-Bred Sitters*, he painted two dogs looking over his shoulder while he sketched, for the well-known self-portrait entitled *The Connoisseurs* (Royal Collection).

The dogs in this picture have not been identified, but may well have belonged to Edward J. Coleman, who owned the painting. On the left is a

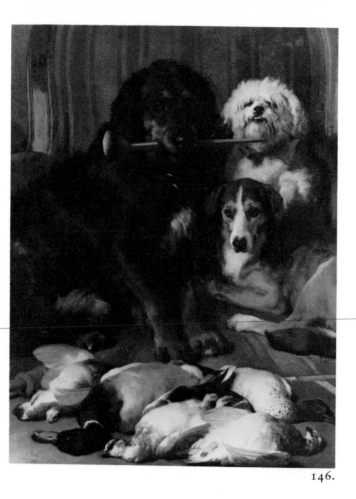

146.

146.

WELL-BRED SITTERS THAT NEVER SAY THEY
ARE BORED
By 1864
Oil on canvas, 43 ½ x 34″ (110.5 x 86.5 cm)
Provenance: Edward J. Coleman, his sale,
Christie's, May 28, 1881, lot 48, bt. Agnew;
Daniel Thwaites, by 1887, by descent
Exhibitions: London, B.I., 1864, no. 68;
London, 1874, no. 255; Manchester, 1887,
no. 640
Reviews: Art Journal (1864), pp. 87, 89;
The Times, February 11, 1864, p. 12d;
Athenaeum, no. 1894, February 13, 1864, p.
234; *Saturday Review,* vol. 17 (1864), p. 287
Literature: Dafforne, 1873, p. 56; Stephens,
1874, pp. 139–40; Graves, 1876, p. 34;
Manson, 1902, p. 162; Lennie, 1976,
pp. 209, 243
Unpublished sources: Landseer to Coleman,
October 29, 1866, April 29, 1867, May 14,
1867 (collection of B.D.J. Walsh); Coleman
to Landseer, undated, thanking him for his
trouble over the picture (V & A, Eng MS, 86
RR, vol. 2, no. 73)
Prints after: engravings by W. H. Simmons,
1879 (28½ x 22¼″) (*PSA,* 1892, vol. 1,
p. 410); A.C. Alais for *Library Edition,*
1881–93, vol. 2, pl. 28 (*PSA,* 1912,
unpaginated)

PRIVATE COLLECTION

spaniel, to the right a hound, and behind them is a toy dog, almost certainly a poodle. The dead game consists of duck, teal, and ptarmigan. The animals are posed on a striped armchair or daybed, evoking a cozy and luxurious interior, in contrast to the wildness of nature, represented by the game. Landseer had used a similarly striped armchair for his much earlier study of the Duke of Devonshire's dogs Bony and Var (c. 1840, Chatsworth, Derbyshire).

Landseer liked having dogs around him as he painted, and they formed part of the familiar world of his studio, unlike people, whose intrusion he resented. Frederick W. Keyl, his pupil, recorded how Landseer had once praised his dog Lassie as a sitter, then "put her down, stuck a Brush in her mouth one in each leg &c. Miss Jessie who had come in very cleverly said it looked too much like skewers" (Keyl's Papers, April 9, 1867, Royal Archives, London).

The picture was popular with the critics when it was exhibited in 1864, and the *Athenaeum* called it "a dashing and vigorous work," while the *Saturday Review* reported that Landseer had "never painted with more complete and faithful subservience to the dog nature, with more absence of that human caricaturism which an artist who has so much power in dramatic and humorous representation rarely refrains from importing into his animals." Landseer took the picture back after its exhibition at the British Institution, London, in 1864 and continued work on it. In October 1866 he was complaining of being held up by the absence of ptarmigan, and six months later he was still promising Coleman that he would finish the work shortly.

The Last Works, 1860-1872

IT IS A COMMON PATTERN for British artists to do their best work as young men, lacking the resources and the imagination to sustain their vision into old age. By all odds this should have happened to Landseer, a brilliant prodigy spoiled by success and a prey to psychological disorders. There are stories of his scraping out and reworking paintings, and the surfaces of most of his late pictures are unsatisfactory, summary and fluffy in some parts, overworked and messy in others. His technical fluency deserted him, but if his hand lost its old cunning, his creative energy was not inhibited. There is something heroic about the aging Landseer battling away on some of his most grandiose compositions, in the face of loneliness, alcoholism, and severe depression. He might have given up or relied on old familiar ideas, as he did in the 1850s. But the 1860s, paradoxically, show him expanding rather than contracting the range of his subject matter and starting out on fresh themes. What his last pictures lack in finesse is overridden by originality of conception and power of feeling. They are visionary works dealing with profound issues. The imagery is dark and fatalistic; death and destruction in nature are inevitable; there are always predators and victims. Although inevitable, the individual circumstances are no less harrowing, and Landseer treats the violence with hypnotic compulsion.

It is worth recording that throughout his life Landseer had an obsessive interest in murderers and criminals. The artist Solomon Hart, for example, recorded that Landseer made a series of designs of the particulars of the murder of Weare by the Thurtell brothers at Elstree in 1824 (*Reminiscences*, ed. A. Brodie, London, 1882, p. 111), and the Duke of Richmond wrote to Landseer to advise him not to visit the convict Michie in jail (January 3, 1847, Mackenzie collection). In his late works, Landseer felt able to give expression to his highly pitched and violent sensibility with complete self-confidence in his powers.

In his last paintings, Landseer seems to have been less conscious of what was happening in the world of art, pursuing his own vision without thought of what was expected of him or the need to earn the plaudits of the crowd. His ear was still finely attuned to the contemporary world, and both *Man Proposes, God Disposes* (no. 151) and *The Swannery* (no. 156) were inspired by headline events: one by the search for the lost Arctic explorer Sir John Franklin, the other by the struggle between France and Germany. These works do not belong, however, to the mainstream of later Victorian art. More powerfully than ever they reveal Landseer as a great romantic painter, whose roots go back to the early nineteenth century.

Flood in the Highlands

Since his early picture *Alpine Mastiffs Reanimating a Distressed Traveler* (no. 13), Landseer was fascinated by mountain disasters. The spectacle of man's insignificance in the face of the uncontrolled forces of nature was a romantic theme linking his work with earlier pictures of floods such as John Martin's *Deluge* (c. 1826, location unknown) and Francis Danby's *Deluge* (c. 1840, Tate Gallery, London). A later flood scene, of 1870, with a baby adrift in its crib, by J. E. Millais, is in the Manchester City Art Gallery. Although not a Biblical scene, Landseer's croft is, nevertheless, suggestively like a Highland version of Noah's ark, with humans and animals crowded together for safety.

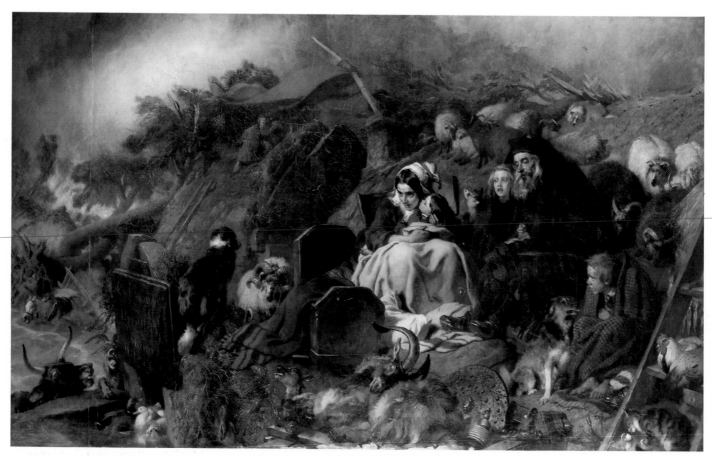

147.

Landseer had painted many scenes of Highland life with picturesque acces-
sories, but none of such intensity. The disparate elements of the design are here
united in a single dramatic theme. It is a psychological study of the effects of
fear and despair induced by a sudden catastrophe. The picture is not entirely
easy to read. The figures in the foreground appear to be sitting on the turf roof
of an outhouse, not the roof of the croft itself, which is shown further back
with sheep and a collie dog on top of it. The relationship of the one to the other
is not clear. There is a ladder on the right, rafters appear under the goat in the
center, and on the left is a board inscribed "Alick Gordon/Upputting/Stance/
Mile East." The cottage is an inn providing accommodations ("upputting")
for drovers, who could leave their cattle in the pen ("stance") a mile to the east.
It was essential to rest animals during the droves, and such inns and stances
played a crucial role in their success (*see* A.R.B. Haldane, *The Drove Roads of
Scotland,* London, 1952, pp. 36–37).

Seated on a chair in the center of the composition is a terrified and
desperate-looking mother clutching her beautiful son. A cradle with an up-
turned horseshoe on the end for luck is beside her. This motif recalls, in a
nightmare version, Landseer's earlier picture of *The Shepherd's Home* (c.
1842, private collection), a domestic scene with a similarly dressed mother
bending over a cradle, her husband's hand resting on her shoulder.

The presence of a Highland targe, or shield, two dirks, and the handle of a
broadsword wrapped in a scarf seems to be a reminiscence of the 1745

202

rebellion, when Highlanders hid their arms after the defeat of Bonnie Prince Charlie, which would set the picture further back in the historical past. The animals, in their terror, gather near the people; a rabbit overcomes its natural fear of humans, while a mallard drake and two white ducks seem to relish the situation. Below them a bleating goat desperately tries to clamber up onto the wall on the left. In the lower left-hand corner a black ox is about to be sucked down by the waters, while a group of men struggle to save a horse and an upturned cart from the flood waters. Storm clouds streak across the sky; trees are bent over the buildings by the force of the wind. Forming a monumental pyramid, the foreground figures appear to be frozen and static, as if on a stage, for all the turbulence taking place around them. The impact of the scene is all the greater because the flood itself is barely shown.

It is said that the picture was inspired by the Moray floods of August 1829. As a result of abnormally heavy rains, the rivers fed by the Cairngorms and Monadhliath Mountains flooded and caused severe damage and some loss of life. In *An Account of the Great Floods of August 1829 in the Province of Moray and Adjoining Districts* (Edinburgh, 1830), Sir Thomas Dick Lauder recorded that a number of families were forced to seek refuge on the roofs of their houses. Although several buildings were swept away, most of the crofters were saved. Landseer's picture is supposed to represent Dandaleith, the first farm below Craigellachie, where the combined waters of the Fiddick and the Spey scoured twenty-five acres and covered another fifty with a three-foot layer of sand and debris. Landseer rarely went to Scotland before September or October, so it is unlikely that he witnessed this particular summer flood, although he saw others.

Landseer began work on the picture in the mid-1840s. Solomon Hart recorded a conversation he had with Landseer's close friend and fellow-artist Frederick Lee, who recalled seeing the picture nearly finished in 1846. When he saw it again in 1860, "it had been so altered that he no longer liked it. One of the models, who had resumed her sittings for a figure in that picture after such an interval, expressed to me her astonishment at seeing the picture almost obliterated by scrapings, save only the part for which she had sat. Landseer

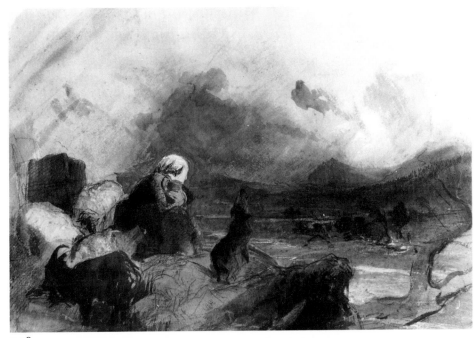

148.

147.

FLOOD IN THE HIGHLANDS (also called HIGHLAND FLOOD)
By 1860
Oil on canvas, 78⅛ x 122½"
(198.5 x 311.2 cm)
Provenance: H. W. Eaton, later Lord Cheylesmore, his sale, Christie's, May 7, 1892, lot 60, bt. in; acquired from the 4th Lord Cheylesmore by Spink & Son, London, 1947; purchased by Sir James Caird and given to the Gallery in the same year
Exhibitions: London, R.A., 1860, no. 106; Brussels, *Exposition Générale des Beaux-Arts,* 1860; Birmingham, Society of Artists(?), 1861; London, 1874, no. 243
Reviews: Art Journal (1860), p. 164; *Critic,* vol. 20, February 18, May 19, and June 2, 1860, pp. 213, 626, 691; *Athenaeum,* no. 1697, May 5, 1860, p. 620; *The Times,* May 5, 1860, p. 5b; *Saturday Review,* vol. 9, May 26, 1860, p. 678; *Gazette des Beaux-Arts* (Paris), vol. 8 (1860), pp. 93–94
Literature: Dafforne, 1873, p. 51; Stephens, 1874, pp. 131–34; Anne Thackeray [Ritchie], "Sir Edwin Landseer," *Cornhill Magazine,* vol. 29 (1874), p. 89; Mann, 1874–77, vol. 1, pp. 121–22, vol. 3, pp. 8–11; Graves, 1876, p. 33, no. 408; *Reminiscences of Solomon Hart,* ed. A. Brodie (London, 1882), pp. 108–9; Manson, 1902, pp. 156–57; Aberdeen Art Gallery, *Permanent Collection Catalogue* (Aberdeen, 1968), p. 61; Lennie, 1976, pp. 197–98, 209, 210; Robertson, 1978, pp. 403–4, fig. 190.
Unpublished sources: Queen Victoria's Journal, April 3, 1849, recording that she saw the picture in Landseer's studio; Peter Hollins to Jessica Landseer, August 19, 1861, thanking her for help in securing loan of the picture, presumably for the Society of Artists, Birmingham (V & A, Eng MS, 86 RR, vol. 3, no. 175)
Prints after: engravings by T. L. Atkinson, 1870 (20½ x 36¼") (PSA, 1892, vol. 1, p. 130); J. Scott for *Library Edition,* 1881–93, vol. 2, pl. 50 (PSA, 1912, unpaginated)
Related works: chalk drawing of woman's head, Artist's sale, 1874, lot 597; two drawings, Artist's sale, 1874, lots 460, 934
ABERDEEN ART GALLERY AND MUSEUMS

148.

RELATED STUDY FOR "FLOOD IN THE HIGHLANDS"
Watercolor on paper, with touches of Chinese white, 13 x 19" (33 x 48.3 cm)
Provenance: S. C. Turner Bequest to the Trust, 1948
NATIONAL LOAN COLLECTION TRUST

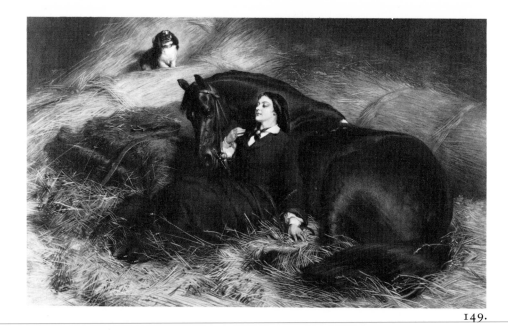

TAMING THE SHREW (also called THE PRETTY
HORSEBREAKER)
By James Stephenson after Edwin Landseer
Picture by 1861, print 1864
Engraving, 20¾ x 34½″ (52.7 x 87.6 cm)
Provenance: acquired by Queen Victoria
Literature: Mann, 1874–77, vol. 1, p. 94,
vol. 2, pp. 13–14; Graves, 1876, p. 33,
no. 412; *PSA*, 1892, vol. 1, p. 374
Related work: oil (32¾ x 50¾″), location
unknown, exhibited London, R.A., 1861,
no. 135

HER MAJESTY QUEEN ELIZABETH II

149.

had entirely changed the scheme of the picture, which seemed to be an incubus upon him." When Landseer saw the picture hanging at the Royal Academy in 1860, he was upset that the color of the dado was exactly like some of the color of the foreground of his picture, and he had it altered.

The picture was well received by the critics, most of whom gave extended descriptions of the subject. The critic of *The Times* wrote: "Above all, the swirl of the rain laden clouds, the rush of the waterspout, and the dust of the driving rains are mingled with a pall of dun horror that veils the distance."

Trafalgar Square Lions

The only works by Landseer that have always remained on public view from the time of their first appearance to the present day are the four bronze lions at the base of Admiral Nelson's Column in Trafalgar Square (fig. 20). Landseer's monumental conception of the lion as the king of beasts and symbol of British pride is an apt reminder of his command over the animal kingdom, which at the time of his death was legendary. For the Victorians, certainly, the lions were an appropriate, almost necessary, memorial to a unique genius: on the day of Landseer's funeral they were hung with wreaths and one of the first portraits of the artist to enter the National Portrait Gallery, in 1890, was that by John Ballantyne of Landseer modeling one of the Trafalgar Square sculptures (fig. 21).

Landseer's involvement with the monument to Admiral Nelson was characterized by the same confusion and procrastination that had marked its history since the architect William Railton won the competition for a design in 1839. Although the statue of Nelson had been hoisted into place at the top of the column by 1843, and the reliefs for the column pedestal were in hand by 1846, the question of the lions remained unresolved for the next twelve years. When the commission was finally given to Landseer in 1858, the decision proved to be highly controversial.

Landseer, too, regarded the matter with some reluctance and was hesitant to undertake the task "from motives of delicacy towards the sculptor's profession [but] groups of friends urged me to yield which I finally did" (Landseer to William Cooper, First Commissioner of the Board of Works, August 1, 1862, Public Records Office, London, works 20, item 3-2, no. 74). And, in spite of

accusations of ministerial favoritism, it was unquestionably Landseer's fame as an animal painter that made him the obvious choice.

Landseer's part in the completion of this national monument was a fitting sequel to his brief studentship with B. R. Haydon, from whom he had borrowed drawings of a dissected lion as early as 1815. It also seems, in retrospect, an appropriate climax to the series of lion subjects that had punctuated his career up to the late 1840s—the very early sketches made in the menageries, the celebrated pictures of Van Amburgh with his animals (exhibited London, Royal Academy, 1839, no. 351, and 1847, no. 186) and *The Desert* (Manchester City Art Gallery).

The press concentrated its attacks on the appointment of a painter to do a sculptor's job. In mid-November 1858, when it was reported that the lions were to be bronze rather than stone, the change was attributed to Landseer's inability to handle a chisel, whereas, in fact, he could model in clay—the most that would be needed in preparing for a bronze cast. By December 1858 Landseer was making studies from an old lion sent to him from the London Zoo. The lion died on December 21, while Landseer was out of town, and his studio assistant, Frederick Keyl, propped up the corpse in several positions to "help towards the national work," as he wrote to Jacob Bell (December 23, 1858, National Maritime Museum, London). On December 27, Landseer was confident enough to predict that with his "experience of the Animal—Photographs, Casts in plaster—and studies," he would, "neither disappoint . . . the country or the brave Nelson in my treatment of these symbols of our national defences" (Landseer to Jessy Landseer, National Maritime Museum, London).

By January 1859 Landseer was sharing a studio in Onslow Square belonging to the sculptor Baron Carlo Marochetti, and it was probably Marochetti

150.

STUDY OF A LION
c. 1862

Oil on canvas, 36 x 54¼" (91.5 x 137.8 cm)

Provenance: given by Landseer, with a companion sketch, to Thomas Hyde Hills, 1869; his bequest to the National Gallery, 1892; transferred to the Tate Gallery, 1919

Exhibitions: London, R.A., 1869, no. 32; London, International Exhibition, 1872, no. 346; London, 1874, no. 212; Philadelphia, International Exhibition, 1876, no. 89 or 90(?)

Reviews: Art Journal (1869), p. 163; *The Times,* May 1, 1869, p. 126; *Athenaeum,* no. 2167, May 8, 1869, p. 642, no. 2412, January 17, 1874, p. 99; *Illustrated London News,* vol. 54, no. 1537, May 8, 1869, p. 471

Literature: Punch, vol. 52, February 9, 1867, pp. 56–59; Graves, 1876, p. 35; Anne Thackeray [Ritchie], "Sir Edwin Landseer," *Cornhill Magazine,* vol. 29 (1874), p. 98; *Magazine of Art,* 1892, pp. 249, 251 (repro.)

Prints after: engraving by J. C. Webb for *Library Edition,* 1881–93, vol. 2, pl. 85

Related work: replica or copy (36 x 54"), private collection, London

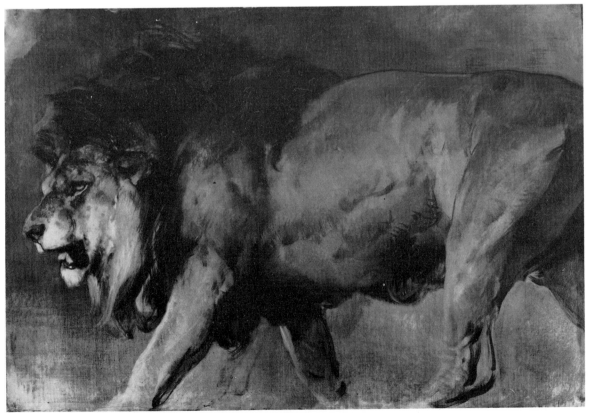

150.

who told him of the existence of a set of casts, in Italy, taken from a lion that had belonged to one of the kings of Sardinia. Perhaps disappointed with the results of his own studies, Landseer asked for replicas of these casts, particularly of the head and limbs before dissection. It is difficult to know precisely what part these casts played in the formation of Landseer's design, but waiting for them obviously delayed him; the casts did not arrive in England until June 1861. By 1862 the First Commissioner of Works was explaining to the House of Commons that the delay was because the artist "had not yet been able to satisfy himself as to the work of art which he was to place upon [the] monument. . . ." Rather curiously, in view of the time spent on the project so far, he added that Landseer "was now very accurately studying the habits of lions, and was to be seen in Zoological Gardens making himself thoroughly acquainted with their attitudes" (*Hansard's Parliamentary Debates*, 3rd ser., vol. 166, col. 554). The evidence points to this *Study of a Lion* being the product of the visits Landseer made to the zoo at this time: the paint is very sketchily handled in broad brushstrokes, the pose is that of a lion as it paces its cage, and there are clear indications, at the corners of the canvas, of the picture surface having been protected while the paint was still wet, probably when it was transported back to the studio.

All of Landseer's efforts up to this time had been devoted to producing a design for standing lions, hence the *Study of a Lion,* but as Railton's original plan had called for couchant lions and as the government wanted to economize, Landseer was compelled to alter his design. In what must have been one of the most dispiriting episodes of his entire career, he had to produce, as rapidly as possible because of the growing indignation in the press and in Parliament, a model of a crouching lion. By March 1863 such a model—in clay and about six feet long—was approaching completion.

The studio in Onslow Square was opened to a few friends and critics in August 1863 and the final appearance of the model was greeted with universal praise and a sense of unqualified relief. The studio also contained "two sketches in oil and four in crayon, life size, of lions" (*Building News,* vol. 10, August 28, 1863, p. 664). The crayon sketches do not appear to have survived, but the oil sketches were undoubtedly this *Study* and a companion, also dating from c. 1862, formerly in the Tate Gallery, London (destroyed in 1928).

At this time work commenced on the larger clay model, scaled up to a finished length of about twenty feet, from which the first bronze cast was to be made. Baron Marochetti and his staff cast all four of the lions by the end of November 1866 and on January 31, without any ceremony but with Landseer present, all four bronze lions were unveiled. The impact made by the lions was all the greater because they had been conspicuously absent for so long. The critical reception was mixed, but perhaps the words that best summed up the welcome that greeted the lions were those beneath the *Punch* cartoon of Nelson taking Landseer gratefully by the hand: "Thank you Sir Edwin. England at last has 'done her duty.'"

R.H.

151.

MAN PROPOSES, GOD DISPOSES
1863–64

Oil on canvas, 36 x 96" (91.4 x 243.8 cm)
Provenance: E. J. Coleman, his sale, Christie's, May 28, 1881, lot 49, bt. Sir Thomas Holloway, and given with his collection to the College
Exhibitions: London, R.A., 1864, no. 163; London, 1874, no. 222; Paris, Exposition Universelle, 1878, "British Fine Art Section," no. 128; London, Guildhall, *Loan Collection of Pictures,* 1897, no. 92; London, Wembley, *British Empire Exhibition,* 1925, "Arctic Section"
Reviews: Annual Register (London, 1864), part 1, pp. 332–33; *Art Journal* (1864), p. 168; *Examiner,* April 30, 1864, p. 280; *The Times,* April 30, 1864, p. 14c; F. G. Stephens, *Athenaeum,* no. 1906, May 7, 1864, p. 650; *Illustrated London News,* vol. 44, May 7, 1864, p. 455; *Spectator,* May 14, 1864, p. 564; *Blackwood's Magazine* (July 1864), p. 95; *Fine Arts Quarterly Review* (1864), pp. 27–28; *Fraser's Magazine* (July 1864), p. 67; Francis Palgrave, *Saturday Review,* vol. 17 (1864), p. 689
Literature: Portfolio (1871), pp. 165–71; Dafforne, 1873, p. 57; Stephens, 1874, pp. 138–39; Mann, 1874–77, vol. 2, pp. 73–74; Graves, 1876, p. 34, no. 417; Monkhouse, 1879, pp. 106, 112; Frith, 1887–88, vol. 3, pp. 246–47; *Magazine of Art* (1891), p. 270; C. W. Carey, *Royal Holloway College, Egham, Catalogue of Pictures* (1896), pp. 36–37; Manson, 1902, p. 161; Gaunt, 1972, pl. 122; Lennie, 1976, pp. 207, 209, 243; Robertson, 1978, pp. 416–17; Jeannie Chapel, *Catalogue of the Royal Holloway College Collection* (forthcoming)
Unpublished sources: Landseer to Hugh Falconer, February 2, and March 16, 1864, and Falconer to Grace, April 28, 1863 (Falconer Papers, Falconer Museum, Forres, Morayshire, DAV ZF 117, nos. 245, 267); Landseer to Coleman, undated (V & A, Eng MS, 86 RR, vol. 2, no. 73); Landseer to Coleman, October 29 and 31, 1866, April 15, May 14, and July 10, 1867, and copy of the receipt for the picture (collection of B.D.J. Walsh, London)
Prints after: engravings by Thomas Landseer, 1867 (15¾ x 42") (PSA, 1892, vol. 1, p. 228, as 1871); C. A. Tomkins for *Library Edition,* 1881–93, vol. 1, pl. 66 (PSA, 1892, vol. 1, p. 208)
Related works: sketchbook with studies of polar bears, Artist's sale, 1874, lot 998; earlier drawing of a polar bear, sold Sotheby's, May 17, 1979, lot 176

ROYAL HOLLOWAY COLLEGE (UNIVERSITY OF LONDON), EGHAM

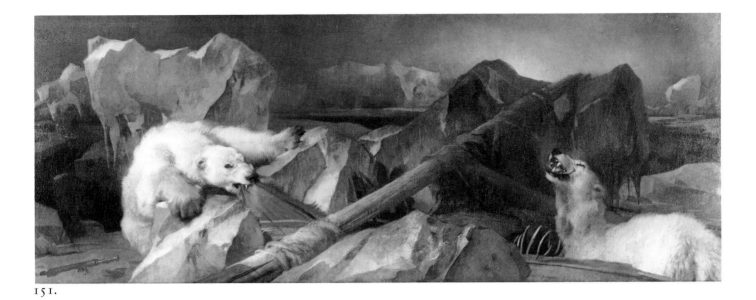

151.

Man Proposes, God Disposes

One of Landseer's greatest works, this picture still has the power to haunt and disturb the imagination. In a desolate Arctic setting two polar bears despoil the remains of a shipwreck. The bear on the left tears at the remains of a sail wrapped around the mast or spar of a sailing ship, one of two diagonal lines that bisect the design and lead the eye into the picture space. The other bear crushes a bone from the rib cage of a skeleton visible above the planks or gunwale of a boat. A navy coat and a telescope on the left are harrowing reminders of disaster and death in this polar waste. "Over all is the greenish light of an arctic moon," Stephens wrote in the *Athenaeum,* "a purple veil of mist is drawn aside—as if a secret were displayed, and in order that we might see what became of our long-lost countrymen. The veil gone, rose-tints of sunlight fall on the nearest and the highest points of rock-like ice, while light itself penetrates the sea green blocks, and lucid shadows appear among the masses that strew the shore." The idea of death in faraway lands in the service of the nation was to become part of the mythology of latter-day British imperialism.

The title of the picture comes from a proverb in the Bible (Prov. 16:9) and owes its present form in Latin, "Homo proposit, sed Deus disponit," to Thomas à Kempis, *De Imitatione Christi* (1427). In the face of God's omnipotence, man's affairs are of small consequence. The broken mast in Landseer's picture might be taken to represent the wreck of civilization or, to extend the parallel, the destruction of both humanity and religion. The way in which the mast and sail are arranged at the very center of the composition, supported by great blocks of ice, suggests some huge, shattered trophy. It was a brilliant stroke of invention to show the bears, symbols of the violent and destructive forces of nature, closing in from the sides, with only their heads and shoulders visible yet still dwarfed by the central image of failed human endeavor and heroism. The visionary treatment of the landscape, with its gaunt shapes, like molar teeth, and infinite horizons, underlines the deeper spiritual meaning of the subject.

Arctic subjects were certainly not new to romantic painting. Caspar David Friedrich's *Frozen Shipwreck* (1824, Kunsthalle, Hamburg) and Frederick Church's *Icebergs* (1861, Sotheby Parke-Bernet, New York, 1979) are obvi-

ous predecessors, but there are no bodies or marauding animals in those works. Landseer's picture had been inspired by the tragic loss of Sir John Franklin's Arctic expeditionary fleet in 1847. Franklin had set out in May 1845 with two ships in search of the Northwest Passage, that mirage which inspired so much polar exploration in the nineteenth century. By 1848 disquiet about his whereabouts led to a series of relief expeditions. The search for Franklin became headline news and created one of the great Arctic legends. In 1854 Arctic explorer John Rae first heard news of Franklin's party from some Eskimos, who said that they had died of starvation. In 1857 the expedition financed by Lady Franklin and led by Francis McClintock discovered the remains of Franklin's expedition, including human skeletons. A written record and relics including a telescope were found. Particularly shocking to the Victorian public was evidence of cannibalism, which adds a macabre twist to Landseer's interpretation.

Although inspired by the search for Franklin, Landseer's picture does not seem to have been intended as a record of a specific location. Prints and book illustrations accompanied the records of the various relief expeditions, so there was no lack of primary visual evidence. Jeannie Chapel describes a picture by E. W. Cooke, exhibited in 1860, showing one of Franklin's ships from an earlier expedition wedged in the ice, and another lost painting by Captain W. W. May of a ship abandoned in the ice, with two polar bears, entitled *Deserted*. A quite different treatment of the Northwest Passage theme is J. E. Millais's picture of that title showing an old explorer being read to by his daughter (1874, Tate Gallery, London).

Landseer had a natural liking for disaster pictures and his antennae were tuned to contemporary events, but what drew him to this particular subject is unclear. His patron E. J. Coleman kept letters and cuttings about the loss of Franklin (now in the Surrey Record Office, Kingston-on-Thames), and it may have been he who suggested the subject. Landseer may also have been attracted by the idea of painting polar bears, which he had not previously done. A pair of adult bears, who had a cub in 1865, could have been seen at the London Zoo.

Unlike most of his late works, which went through long periods of gestation, *Man Proposes, God Disposes* seems to have been executed within the course of two years. Although painted quite summarily, and in places very thinly, it seems to have presented few technical problems, and Landseer maintained his enthusiasm for the subject to the end. On April 28, 1863, the distinguished paleontologist Hugh Falconer sent a Landseer autograph to a friend, adding as a postscript: "He failed to get a bear's skull—and the picture was too late for the exhibition." On February 2, 1864, Landseer himself wrote to Falconer: "The P. Bear skull is exactly what I wanted—When my Picture is in a seeable State you must do me the favour to come and tell me if I have done justice to the grand Head you have kindly trusted me with."

The picture made a profound impression at the Royal Academy of 1864. Francis Palgrave, in the *Saturday Review*, thought that what gave the picture "supremacy in rank is the force and height of the idea. True, this is indeed one aspect of the terror of death—one which almost touches on the horrible. From a too powerful sense of this the artist has saved his work, in part by the poetical feeling thrown into the desolate landscape, in part by the total freedom from sentimentalism."

Landseer took the picture back in 1866, apparently for the engraving about which he wrote to Coleman on several occasions. In his last letter, of July 10,

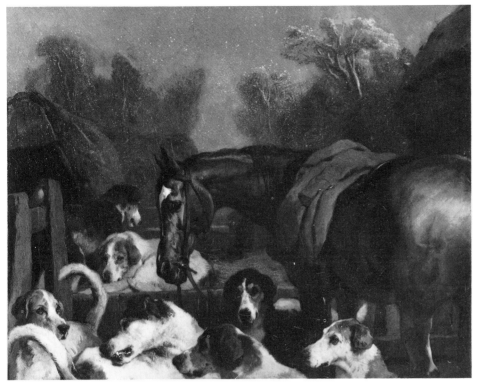

152.

152.

NO HUNTING TILL THE WEATHER BREAKS
(also called HUNTER AND HOUNDS)
By 1864
Oil on canvas, 27½ x 36½" (69.9 x 92.7 cm)
Provenance: H. W. Eaton, later Lord
Cheylesmore, his sale, Christie's, May 7,
1892, lot 46; Leger Galleries, London, by
1953; H. A. Sutch; anonymous sale,
Christie's, February 13, 1976, lot 60; E.J.H.
Cross, from whom acquired by present owner
Exhibitions: London, B.I., 1865, no. 189;
London, 1874, no. 397; London, 1890, no. 6
Reviews: Art Journal (1865), p. 74; *The
Times,* February 6, 1865, p. 5e; *Athenaeum,*
no. 1946, February 11, 1865, p. 203
Literature: Mann, 1874–77, vol. 3, p. 18,
vol. 4, p. 126; Graves, 1876, p. 33, no. 415
Prints after: engravings by Thomas Landseer,
1864 (19 x 24¾") (PSA, 1892, vol. 1, p. 177);
J.C. Webb for *Library Edition,* 1881–93,
vol. 1, pl. 60 (PSA, 1892, vol. 1, p. 206)
IAN POSGATE, ESQ.

1867, he wrote to say that his brother had been disappointed not to receive "more evident approbation for the Bear Plate—which many of his friends think his best work."

No Hunting Till the Weather Breaks

The theme of hunters and hounds is common in Landseer's work and in Victorian art in general. What is unusual here is the winter setting. The picture is boldly designed—the rump of the horse cut off at the right and the bodies of the hounds along the bottom—and it is broadly and beautifully painted throughout. The prevailing greenish gray tonality is set off by the huntsman's red coat and the robin redbreast singing on the fence. The hounds are gathered in a pen, or stockade, with an old thatched barn in the background on the left and a haystack on the right. The subject is cozy and secure, a reassuring vision of the countryside and of country pursuits on a cold day, and not a melancholy or frustrating scene as the title might imply.

Landseer painted a number of horse subjects in the 1860s, including *Pensioners* (c. 1864, location unknown), *Prosperity* and *Adversity* (c. 1865, locations unknown), companion works of a bay horse in its prime and then as a broken-down cab horse, and *Indian Tent, Mare and Foal* (c. 1866, Wallace Collection, London). It is not known if *No Hunting* was a commissioned work. Algernon Graves dated the painting to 1862 and the engraving to 1863, though the latter was not declared until 1864. The engraving shows a number of variations from the finished picture.

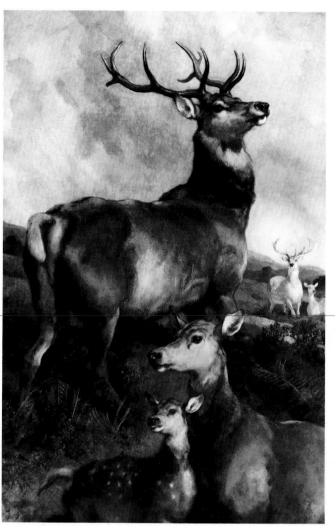

153.

153.
DEER OF CHILLINGHAM PARK,
NORTHUMBERLAND
154.
WILD CATTLE OF CHILLINGHAM
By 1867
Both oil on canvas, 90 x 61½"
(228.5 x 156.3 cm)
Provenance: commissioned by the 6th Earl of
Tankerville; anonymous sale, Christie's, July
14, 1933, lot 171(?), bt. in; acquired by the
British government in lieu of death duties from
the estate of the 8th Earl of Tankerville, 1973,
and placed on loan at the Gallery
Exhibition: London, R.A., 1867, nos. 124
(*Deer*), 144 (*Cattle*)
Reviews: Art Journal (1867), p. 145; F. G.
Stephens, *Athenaeum,* no. 2062, May 4, 1867,
pp. 594–95; *The Times,* May 4, 1867, p. 12d
Literature: Dafforne, 1873, pp. 61–62;
Stephens, 1874, p. 142; Mann, 1874–77, vol.
2, pp. 129 (*Deer*), 132 (*Cattle*); Graves, 1876,
p. 35, nos. 426 (*Deer*), 427 (*Cattle*); Manson,
1902, pp. 167–68; J. G. Millais, *Mammals of
Great Britain and Ireland* (London, 1904–6),
vol. 3, repro. facing p. 198 (*Cattle*); Lennie,
1976, pp. 221–22
Unpublished sources: Landseer to Sir Thomas
Biddulph, April 9, 1867, saying he is
"struggling on" with the wild cattle and deer
(Royal Archives, PP Vic 7437 [1870]); the 6th
Earl of Tankerville to Landseer, April 25,
1867, giving the passage from Scott about the
wild bull of "Woody Caledon" (V & A, Eng
MS, 86 RR, vol. 5, no. 312); the Earl of
Tankerville to Landseer, December 3 and 19,
1867 (Mackenzie collection, nos. 876, 878);
the countess to Landseer, undated, saying that
of course he must come to Chillingham to
finish the pictures: "Be advised, start at once"
(V & A, Eng MS, 86 RR, vol. 5, no. 314); Lady
Leslie, "Memories," in which she records
meeting Landseer at Chillingham while at
work on the pictures (Castle Leslie Archives,
Eire.); discussion of the pictures, Frederick W.
Keyl's Papers, April 9, 1867 (Royal Archives,
London); copyright agreement between
Landseer and Henry Graves for the prints
(250£ each), August 20, 1867 (British
Library, London, Add MS, 46140, F. 289)
Prints after: engravings by Thomas Landseer,
1869 (*Deer,* 27 x 18¼"; *Cattle,* 27 x 18⅝");
George Zobel, 1873 (all *PSA,* 1892, vol. 1, pp.
310, 416); C.A. Tomkins for *Library Edition,*
1881–93, vol. 2, pls. 29 (*Cattle*), 30 (*Deer*)
(*PSA,* 1892, vol. 1, p. 209)
TYNE AND WEAR COUNTY MUSEUMS SERVICE
(LAING ART GALLERY, NEWCASTLE UPON TYNE)

Deer and Wild Cattle of Chillingham

These companion pictures were commissioned by the 6th Earl of Tanker-ville, one of Landseer's oldest friends, to hang high up on each side of the doorway of the dining hall at Chillingham Castle, facing *Death of the Wild Bull* (no. 78), painted thirty years earlier. That they were designed for a particular space in an overall scheme of decoration explains their high view-point. Landseer may have had more to do with the decoration of the room, as suggested by a letter from the Countess of Tankerville thanking him effusively for the plan of the ceiling. The effect of the three paintings in the large and lofty hall at Chillingham must have been singularly impressive.

The pictures were designed to face one another. Although their landscape backgrounds do not exactly correspond, they are similar, with rocks and ferns and rolling hills; in the cattle picture there is a lake in the middle ground with a heron standing near the edge. Both pictures are heroic and emblematic in conception, with colossal male figures rearing up against the sky, females and calves nestling for protection under them and in their shadows. The stag is a superb ten-pointer, seen in profile and proudly snuffing the air like the *Monarch of the Glen* (no. 124). The presence of a fallow buck and doe in the background underlines the fact that these are park deer, rather than wild deer on the hill. No one would mistake the bull, on the other hand, for a domestic animal. He belongs to the famous herd of Chillingham wild cattle, one of three

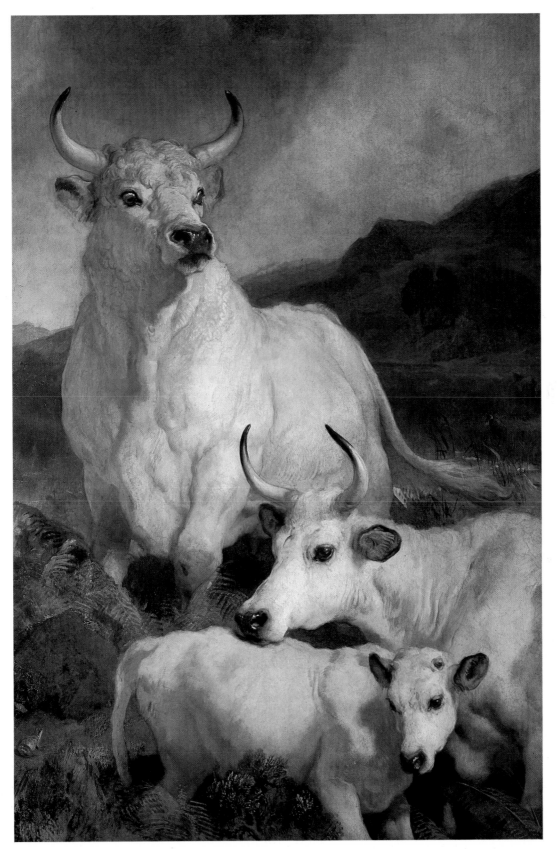

154.

211

surviving native breeds from pre-Roman times, remarkable for their ferocity and their pure pinky white color. The Tankerville family has always been proud of its cattle and has saved them from extinction on more than one occasion.

Landseer's pupil Frederick Keyl visited the artist's studio on April 9, 1867, and recorded his "admiration of the immense breadth, feeling, knowledge more hidden than displayed in them." He noted that the paintings were intended for a dark place in the dining room at Chillingham. He thought the head of the stag too small for its body, but seeing how tired and dejected Landseer looked, forebore from pointing it out:

> I presently asked him whether it was the old stag he stalked (whose skin he had prepared) he said he used him as a foundation.—Somebody was there, with a small bag at his side and he asked him lots of somewhat feeble questions about the Animals and caused him to scrape in a dangerous way at shoulder of Deer by asking whether a lightish not very obvious streak was a particular mark of the Animal or whether they all had it. It was an accident. . . . He then began putting the pictures with some trouble so that in glass I should see continuation of landscape of one into other forming one view. . . . He suffered from that feeling of half hating the things.

Landseer had drawn and painted the bulls from the early 1830s on, and there is no doubt he felt a special affinity for them. There is no animal in all his work so powerful and massive in conception as this bull, which seems to be on the point of charging, a little frog at its feet. When *Wild Cattle* was exhibited at the Royal Academy in 1867, it was accompanied in the catalogue by a quotation from Sir Walter Scott:

> Mightiest of all the beasts of chase
> That roam in woody Caledon
> Crashing the forest in his race,
> The mountain bull comes thundering on
> Fierce, on the hunter's quiver'd band,
> He rolls his eyes of swarthy glow,
> Spurns, with black hoof and horn, the sand,
> And tosses high his mane of snow.

F. G. Stephens in the *Athenaeum* waxed lyrical about the bull: "A beautiful creature is this, magnificently painted in all respects of handling, and in the largest, finest manner of the artist. The student will delight in the treatment of the white hide of this bull; its warm hue, that is mixed with faintly-tinted stains and marks of diverse coloured hair; the sense of strength that is apparent in all its limbs, its flanks, weighty neck and chest,—the last, with its pendulous flesh and lines of rigid hair, is a triumph of painting." The way in which the figures of the calf and the cow are cut off at the side and bottom of the picture helps to emphasize the sheer physical bulk and energy of the bull. At the very end of his life, Landseer seems to have risen to new heights of grandeur in his animal pictures, and one is reminded here more than ever of the great Dutch and Flemish masters, of Paulus Potter especially.

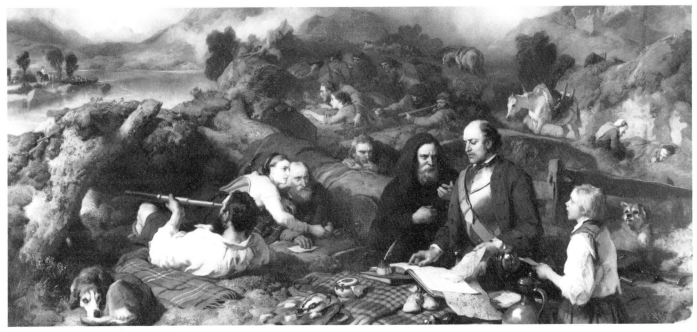

155.

Rent Day in the Wilderness

This picture was commissioned by Sir Roderick Impey Murchison to com-
memorate the bravery of his ancestor Donald Murchison, for whom he also
built a monument in the churchyard at Cononside in the parish of Urray.
Roderick Murchison (1792–1871), probably the most distinguished British
geologist of his day, was the author of several pioneering studies, including
The Silurian System (1838), president of the Royal Geographical Society, and
director-general of the Geological Survey. He posed for the portrait of his
ancestor in Landseer's picture.

In his book *Domestic Annals of Scotland,* Robert Chambers devoted several
pages to the exploits of Donald Murchison. The 1868 Royal Academy
catalogue gave the following quotation from Chambers: "After the defeat of
the Stuart army of 1715, at Sheriff Muir, Colonel Donald Murchison, to
whom the Earl of Seaforth confided his confiscated estates in Rosshire, de-
fended them for ten years, and regularly transmitted the rents to his attainted
and exiled chief; 'a more disinterested hero never lived.' " Not only did Donald
Murchison collect rents for his exiled master in defiance of the law, but he
resisted all attempts on the part of the government commissioners to reassert
control over the Seaforth estates. In October 1721 he ambushed a company of
more than a hundred soldiers close to the end of Loch Affric with a large force
of Mackenzies and drove them back. A year later he successfully repelled a
second invasion. In 1725 the English general Wade complained to the king
that Murchison was still collecting rents and that he had come to Edinburgh
unmolested to remit eight hundred pounds to the Earl of Seaforth. Murchison
is said to have been treated ungratefully by the earl, when he once more took
possession of his estates, and to have died of a broken heart.

Landseer's picture does not seem to record the Loch Affric ambush specifi-
cally, but to be a more general record of Murchison's exploits. The hero of the
picture is dressed in a brown coat, with a breastplate and a leather sword belt
with a Highland broadsword, and he rests his account book, dated 1721 and
inscribed, "The Earl of Seaforth, Kintail," on a man-made bank. Many
reviewers complained about the device of showing the three foreground
figures in a sunken pit, as they appeared to have no legs. In his panoramic

155.
RENT DAY IN THE WILDERNESS
By 1868
Oil on canvas, 48 x 104½″ (122 x 265.5 cm)
Provenance: commissioned by Sir Roderick
Murchison, and bequeathed by him to the
Gallery, 1871
Exhibitions: London, R.A., 1868, no. 123;
Edinburgh, Royal Scottish Academy, 1872,
no. 29; London, 1874, no. 252; Sheffield,
1972, no. 103
Reviews: Annual Register (London, 1868),
part 1, p. 316; *Art Journal* (1868), p. 109; *The
Times,* May 2, 1868, p. 11d; *Illustrated
London News,* vol. 52, May 9, 1868, pp.
462–63; *Saturday Review,* vol. 25, May 23,
1868, p. 685; *Spectator,* May 30, 1868, pp.
647–48; *Athenaeum,* no. 2118, May 30,
1868, p. 768
Literature: Dafforne, 1873, p. 63; Mann,
1874–77, vol. 1, p. 94, vol. 2, p. 189; A.
Geikie, *Life of Sir Roderick I. Murchison*
(London, 1875), vol. 1, p. 5; Graves, 1876, p.
35; *Art Journal* (1905), p. 59, repro. p. 60;
*Catalogue of the National Gallery of Scotland,
Edinburgh* (Edinburgh, 1946), pp. 206–7;
Lennie, 1976, pp. 222–23
Unpublished sources: Murchison to Landseer,
December 15, 1855, and July 17, 1867
(V & A, Eng MS, 86 RR, vol. 5, nos. 346–47);
Murchison and his wife to Landseer, August 1
and 5, 1868, May 27, 1869, and July 19, 1871
(Mackenzie collection, nos. 924–25,
1153–54); Landseer to Murchison, January
15, 1860 (British Library, London, Add MS,
46127, f. 48)
Related work: oil sketch of Murchison,
Artist's sale, 1874, lot 267

NATIONAL GALLERIES OF SCOTLAND,
EDINBURGH

compositions, Landseer often cut off the figures in this way to enhance the immediacy of the subject. Murchison holds a piece of paper inscribed, "Private/Colonel Donald Murchison/Kintail," apparently brought by the hooded figure in a cloak, and points out an entry in his book. A stoneware inkwell and quill pen lie in front of him on the plaid blanket, together with a badger's-head sporran, a large ivory snuffbox given to Murchison by the Old Pretender and owned by his descendant, a Highland dirk, a stoneware jug, and two bags of money. The butts of two muskets are visible behind him. The boy on the right approaches Murchison with a document in his hand. Behind these figures, various groups of Highlanders can be seen crouching behind a roughly constructed defense work made out of tree stumps and turf. The attention of the Highlanders is focused on the company of approaching redcoats, who are disembarking from a ferryboat and coming along a track on the left, led by an officer on horseback. Amidst the bustle and excitement of an expected attack, Murchison alone seems unmoved, continuing with the task in hand, like Drake with his bowls, the image of the calm and resourceful leader.

The composition is carefully layered along a sequence of bisecting diagonal lines that lead the eye up and into the picture space. The hill that encloses the groups of Highlanders forms a shallow pyramid, echoed by a series of triangular shapes. The color scheme of soft greens, lavender grays, and blues, with accents of red, is typical of Landseer's late style. Two additional strips of canvas have been added along the bottom and the right-hand side, and the paint surface shows signs of extensive shriveling.

The picture was commissioned in 1855, Murchison writing to Landseer at the time, "The wish of my heart . . . is to be possessed of a painting by yourself, of a Highland scene which was marked by the devotion of my ancestor, Donald Murchison. Of this I spoke to you more than once & I inferred that the subject was one which pleased you." Murchison himself had drawn the scenes of his ancestor's exploits, with the assistance of two artists. In 1860 Landseer wrote to his patron to apologize for the delay, which he attributed to illness and to work on other outstanding commissions. In 1867 a sorely tested Murchison wrote, enclosing his ancestor's box: "May your real Highland genius inspire you to complete the work everlastingly here or elsewhere receive the grateful blessings of yours sincerely."

The picture was critically received at the Royal Academy exhibition in 1868; reviewers complained of the scattered nature of the composition and the mannered qualities of style. The *Saturday Review* commented: "We may observe, further, that all Sir Edwin's best compositions have been simple compositions, that any scattering of groups has always been fatal to the arrangement of his pictures, and that whatever tends to display, in too obvious a degree, the dexterities of his style detracts from his serious consideration."

The Swannery Invaded by Eagles

This grandiose late composition is heroic in conception and violent as a subject. A group of predatory sea eagles have attacked the peaceful sanctuary of a swannery, situated by the mouth of a river or a creek; F. G. Stephens suggested that the attack has been provoked because the swans have built their nests too close to the eyries of the eagles. The mute white swans, their undulating necks contorted in the agony of their death struggle, stand out with eloquent appeal. The destruction of creatures of such majesty and beauty seems sacrilegious, an outrage against nature, and the graphic way in which it is depicted adds to the horror of the scene.

156.
THE SWANNERY INVADED BY EAGLES (also called SWANNERY INVADED BY SEA EAGLES)
By 1869
Oil on canvas, 69 x 109" (175.3 x 277 cm)
Provenance: the 3rd Marquess of Northampton; 1st Baron Masham; by descent to the Countess of Swinton; Swinton House sale, Yorkshire, Christie's, October 20–21, 1975, lot 479, where acquired by present owner
Exhibitions: London, R.A., 1869, no. 120; London, 1874, no. 156; Paris, Exposition Universelle, 1878, "British Fine Art Section," no. 131; London, 1890, no. 68; London, Guildhall, *Loan Collection of Pictures*, 1895, no. 77
Reviews: Annual Register (London, 1869), part 1, p. 355; *Art Journal* (1869), pp. 165–66; *Athenaeum*, no. 2167, May 8, 1869, pp. 641–42; *Gazette des Beaux-Arts* (Paris), n.s., vol. 2 (1869), p. 58; *Saturday Review*, vol. 27, May 8, 1869, p. 617; *The Times*, May 10, 1869, p. 12b; *Spectator*, May 29, 1869, p. 651
Literature: Punch, vol. 56, May 8, 1869, p. 188; G. D. Leslie, *Riverside Letters* (London, 1869), p. 192; Dafforne, 1873, pp. 63–64; Stephens, 1874, pp. 142–43; Graves, 1876, p. 35; J. G. Millais, "Shooting," *Magazine of Art* (1896), pp. 286–87, repro. p. 285; Manson, 1902, pp. 170–71; G. S. Layard, *A Great "Punch" Editor, Being the Life, Letters, and Diaries of Shirley Brooks* (London, 1907), p. 350; Lennie, 1976, pp. 225–26
Unpublished source: Richard Sheridan to Landseer, December 3, 1868, about sending a swan (Mackenzie collection, no. 1242)
Prints after: engravings by J. B. Pratt, 1889 (22½ x 34½") (PSA, 1892, vol. 1, p. 371); H. Sedcole for *Library Edition*, 1881–93, vol. 2, pl. 87 (PSA, 1912, unpaginated)
PRIVATE COLLECTION

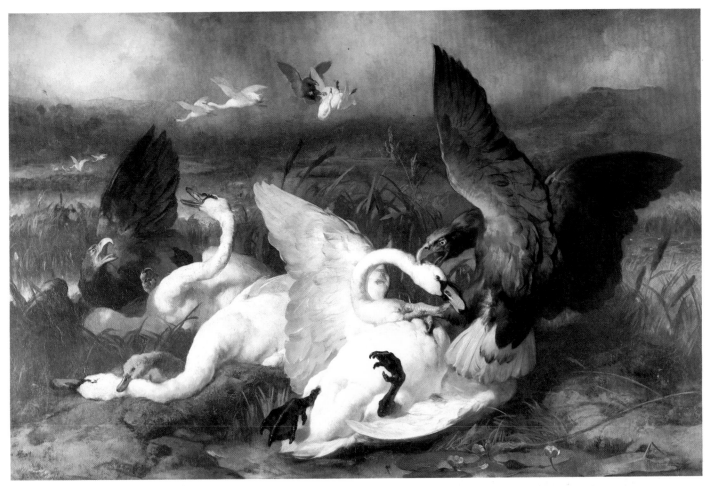

156.

The three swans in the foreground, their necks forming a symmetrical pattern of curves not wholly unlike those of the Laocoön, are framed at each end by the threatening eagles, a triumph of black over white, cruelty over innocence. The outstretched wing of the swan on the right, the top edge smeared with blood and almost horizontal, comes in the middle between the upraised wings of its enemies. Although dead or about to be destroyed, the swans have not given in without a fight. Indeed, the swan on the left is temporarily on top of its aggressor, but is, one feels, doomed. The swan in the middle with its cygnet forms a pathetic group of dead mother and grieving young. The swan on the right is lying on its back, its soft flesh gouged by the talons of the eagle, its neck twisted and torn, but it continues to grip the eagle's leg with its own beak. In the background a third sea eagle brings down a swan in flight, while two more swans fly off to join the survivors of the raid. The violence in front is mirrored in the stormy landscape behind, which throws into relief the brilliant white plumage of the swans.

The likelihood of such a scene taking place is remote. Sea eagles, which became extinct in Scotland later in the century, inhabited the wildest parts of the coast, where one would not expect to find swanneries. And the idea of a mass attack of this kind belongs to the realms of fantasy. J. G. Millais wrote that a sea eagle "never touches anything in life which might offer the slightest resistance, and would just as soon think of assailing a mute swan in flight (a bird half as big again as itself) as a hansom cab."

Because the animals in *The Swannery* have such expressive force and feeling, human parallels at once suggest themselves. *The Times* reviewer evoked Norse raids as a historical precedent, while other critics interpreted the

subject as a comment on the impending struggle between France and Germany. The unsettled state of Europe at the time may well have influenced Landseer's choice of subject. His earlier pictures *Time of Peace* and *Time of War* (*see* nos. 137, 138) had been inspired by the growing tension between England and France in the 1840s. Such use of animal painting as an emblem of political events was not new. Melchior d'Hondecoeter's two pictures *Emblematic Representations of King William's Wars* at Holkam House, Norfolk, are said to symbolize the battles between the armies of William III and Louis XIV. Landseer's picture belongs to the great tradition of Dutch and Flemish animal painting, and critics were quick to point out parallels with the work of Frans Snyders; the picture *Dead Game* by Snyders in the Philadelphia Museum of Art shows an eagle pecking at an apparently dead swan (fig. 37).

The picture was begun some years before its exhibition, but exactly when is not known. The artist G. D. Leslie recorded that he painted some of the yellow water lilies in the foreground, Landseer always going over his work with a big brush to prevent it looking too neat and finished. The painting itself is very uneven, some passages barely finished and weakly rendered, but the overall effect is profoundly impressive. In several areas the paint surface has shriveled, perhaps as a result of the constant reworking. According to the reviewer of *The Times*, Landseer based his picture on the famous swannery at Abbotsbury in Dorset. Richard Sheridan sent him a live swan of the same breed from Dorset in 1868. It is also significant that among the items in the sale of the contents of his house were a stuffed swan and a stuffed sea eagle (London, Daniel Smith, Son & Oakley, July 28–30, 1874, lots 208–9).

The following poem was quoted in the 1869 Royal Academy catalogue:

> As rapt I gazed upon the sedgy pool,
> Where in majestic calm serenely sailed
> Its arch-necked princes in their snow-white plumes—
> Cleaving the air with sharp and strident sound,
> Down swooped the tyrants of the sea-girt caves
> Screaming for blood, and in their ancient holds
> "Fluttered the Volsces" of that tranquil reign.

Like *Man Proposes, God Disposes* (no. 151), *The Swannery* dominated the Royal Academy exhibition. "Standing before this magnificent picture," wrote *The Times* critic, "as noble as any work of purely animal strength and suffering, beauty and ferocity, can be—one feels that Sir Edwin has renewed his youth, as fable tells us did the eagles he has painted." Philippe Burty in the *Gazette des Beaux-Arts* saw the swans as symbols of the dying poet, while the *Art Journal* reviewer found the action and movement of the piece magnificent, and the situation "to the last degree thrilling." Most criticism was directed at the chalky and opaque color. But no one questioned that the work was a major tour de force. The *Saturday Review* said that "no circumstance is wanting which can either awaken sympathy or intensify horror. The swans are as lovely as swans can be, and the quiet retreat among hills and sedgy grass might seem an abode sacred to peace and happiness. We can only say that the nursemaids and children who feed swans in the park will be horrified when they hear what cruel fate Sir Edwin Landseer has permitted to befall their favourite bird. But then the art of the painter has become proverbial for cruelty."

157.
THE PTARMIGAN HILL
By 1869
Oil on canvas, 51 x 88″ (129.5 x 223.5 cm)
Provenance: Sir John Fowler, his sale, Christie's, May 6, 1899, lot 58, bt. Agnew; W. Lockett Agnew; C. T. Milburn, his sale, Christie's, December 12, 1945, lot 146, bt. Stevens; Scott & Fowles, New York, by 1951; Mrs. Geraldine Rockefeller Dodge, her sale, Sotheby Parke-Bernet, New York, May 14, 1976, lot 57, where acquired by present owner
Exhibitions: London, R.A., 1869, no. 224; London, 1874, no. 306; Paris, Exposition Universelle, 1878, "British Fine Art Section," no. 127; London, 1890, no. 193; Rome, International Fine Arts Exhibition, 1911, no. 46
Reviews: Art Journal (1869), p. 170; *Athenaeum*, no. 2167, May 8, 1869, p. 642; *The Times*, May 10, 1869, p. 12b
Literature: Dafforne, 1873, p. 64; Mann, 1874–77, vol. 2, p. 61; Graves, 1876, p. 35, no. 430; Manson, 1902, p. 171; *Connoisseur*, vol. 30 (1911), p. 83
Unpublished source: William Agnew to T. H. Hills, January 25, 1869, offering the same price for this picture as he had paid for another work by Landseer in 1868 (V & A, Eng MS, 86 RR, vol. 1, no. 12)
Prints after: engravings by Thomas Landseer, 1873 (20½ x 34½″) (*PSA,* 1892, vol. 1, p. 300); A. C. Alais for *Library Edition*, 1881–93, vol. 1, pl. 79 (*PSA,* 1892, vol. 1, p. 209)
THE WARNER COLLECTION OF GULF STATES PAPER CORPORATION, TUSCALOOSA

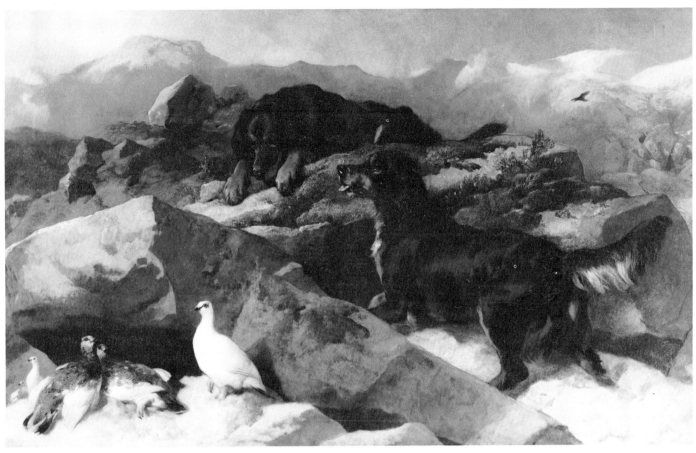

157.

The Ptarmigan Hill

This picture captures the spirit of the high hills in late autumn or early winter, as Landseer's earlier ptarmigan subjects had done (*see* no. 37), and like them it almost certainly depicts the Cairngorms. It was probably begun some years before its exhibition. Two Gordon setters are putting up the ptarmigan, one lying on a rock, the other gliding stealthily forward. There is pathos in the subject, for not only are the birds beautiful, but they are about to die. A male ptarmigan in its white winter plumage is on the right; two more birds, whose plumage has not yet turned fully white, are to the left, with two more birds lower down. An eagle sweeps across the sky in the background on the right.

As in many of his earlier Highland subjects, Landseer employed the slabs of rock to build up a stage for the animals and to provide a rugged textural contrast to soft fur and feathers. Behind the rocks is a magnificent view of ice blue mountains, some of them snowcapped, as fine as anything Landseer painted. There are few parallels in Landseer's work for this type of subject. His outdoor studies of dogs tend to be of single animals, more self-consciously posed.

Sir John Fowler (1817–1898), the first owner of the painting, was a distinguished engineer, responsible for, among other things, the Forth Bridge. His important sale of pictures included twelve works by Landseer, most of them landscape sketches.

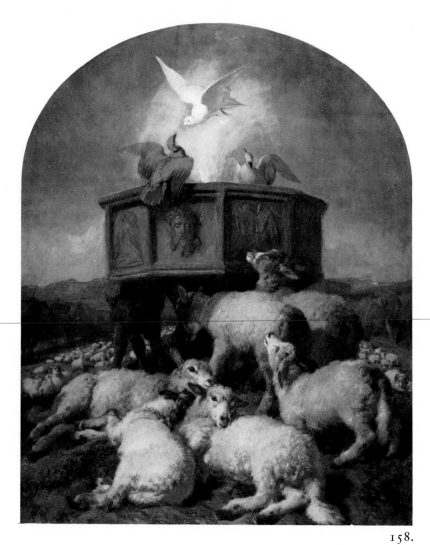

158.

158.

THE BAPTISMAL FONT (also called THE FONT)
By 1872
Oil on canvas, 73¾ x 66" (187.5 x 167.6 cm)
Provenance: acquired by Queen Victoria,
1872
Exhibitions: London, R.A., 1872, no. 190;
London, 1874, no. 348
Reviews: Athenaeum, no. 2323, May 4, 1872,
p. 566; *Art Journal* (1872), p. 153; *The Times,*
May 4, 1872, p. 5a; *Illustrated London News,*
vol. 60, May 11, 1872, p. 466
Literature: Dafforne, 1873, p. 67; Anne
Thackeray [Ritchie], "Sir Edwin Landseer,"
Cornhill Magazine, vol. 29 (1874), p. 99;
Mann, 1874–77, vol. 1, p. 118, vol. 3, p. 66;
Graves, 1876, p. 36, no. 433; *Osborne
Catalogue* (privately printed, 1876), p. 274;
Manson, 1902, p. 172; Lord Frederic
Hamilton, *The Days Before Yesterday*
(London, 1920), p. 24; Winslow Ames, *Prince
Albert and Victorian Taste* (London, 1967), p.
145; Lennie, 1976, pp. 233, 234–35, 245;
Millar, 1977, pp. 173–74
Unpublished sources: Sir Thomas Biddulph to
Landseer (copy), April 4, 1870 (Royal
Archives, PP Vic 6687 [1870]); extensive
correspondence between Arnold White, Sir
Francis Grant, and Biddulph, July and August
1872, about the best method of getting
Landseer to relinquish the work (Royal
Archives, PP Vic 13635 [1873]); later
correspondence about payment, photographs
of the picture and the engraving, August
1872—March 1873 (Royal Archives, PP Vic
13635, 14974 [1873], 14899 [1873])
Prints after: engravings by Thomas Landseer,
1875 (27⅜ x 21⅝") (PSA, 1892, vol. 1, p.
131); A. C. Alais for *Library Edition,*
1881–93, vol. 2, pl. 12 (PSA, 1892, vol. 1, p.
211)

HER MAJESTY QUEEN ELIZABETH II

The Baptismal Font

The spiritual undercurrent evident in many of Landseer's late paintings breaks out into the open in two remarkable religious works exhibited in 1872, *The Baptismal Font* and *Lion and the Lamb* (Johannesburg Art Gallery). According to Mann, the former work had originally been commissioned by the famous philanthropist Baroness Burdett-Coutts as a sort of altarpiece for one of her benevolent institutions. Discovering that the baroness had lost interest in the commission, Queen Victoria took it over in 1870, asking the artist to carry it out "just as you have begun it."

According to Lord Frederic Hamilton, Landseer had painted on the picture while staying with his parents, the Duke and Duchess of Abercorn, at the Priory: "It is a perfectly meaningless composition, representing a number of sheep huddled round a font, for whatever allegorical significance he originally meant to give it eluded the poor clouded brain. As he always painted from the live model, he sent down to the Home Farm for two sheep, which he wanted driven upstairs into his bedroom, to the furious indignation of the house-keeper, who declared, with a certain amount of reason, that it was impossible to keep a house well if live sheep were to be allowed in the best bedrooms. So Landseer, his easel and colours, and his sheep were all transferred to the garden."

Landseer's picture shows a group of lambs surrounding a Renaissance-style font; the two left panels are decorated with the figure of a kneeling angel and

the head of Christ with the crown of thorns, symbols of atonement, and the panels on the right are indecipherable. On top of the font are three doves surrounding a kind of celestial fountain, presumably the power of the Holy Spirit, "hope being symbolised in the iris lit by the light of heaven" (*Illustrated London News*, May 11, 1872, p. 466). In early Christian art, doves denote purity, although they may also be intended to serve here as a symbol of the Trinity. The lambs stand for Christians, who are redeemed through baptism. Christ the good shepherd of his flock was a popular image in Victorian religious iconography, and Landseer had used it before in his visionary picture *The Shepherd's Prayer (see* no. 136). According to Anne Thackeray, the picture is "an allegory of all creeds and all created things coming together into the light of truth." For the reviewer of *The Times,* the subject was "life in all gradations, from spotless innocence to the darkest sinfulness." The meaning of the allegory, which is certainly far from clear, stands apart from the mainstream of contemporary religious art. In the spandrels of the frame are crowns of thorns and olive branches, symbolizing the making of God's peace with man.

Although unfinished and in parts weak and unresolved, the picture remains a remarkable testament to the enduring sweep of Landseer's imagination and his facility of hand in the face of physical and mental collapse. The composition is boldly conceived as a steep pyramid, the foreground groups of lambs sinuously arranged to give the impression of uplift. They are carefully studied, and there are some finely treated effects of texture and impasto. The ground falls steeply away from the font itself, revealing more sheep on the lower slopes and a distant panorama of hills. Over all is a fitful and unearthly light, suggesting the very moment of spiritual illumination.

When the picture appeared at the Royal Academy in 1872, reviews were mixed. Everyone admired the painting of the lambs—"truly beautiful," one critic called them—but there was more doubt about the allegorical elements. The critic of the *Athenaeum,* for example, thought that the introduction of the iris and the doves was a serious aesthetic error. At the close of the exhibition, there remained the problem of extracting the picture from Landseer's hands. Queen Victoria was warned that an indirect approach through the president of the Royal Academy might prove counterproductive, "while he would feel honored & flattered by a direct communication." Such proved to be the case and Landseer relinquished the picture at the end of August 1872, although it was not until December that he was finally paid for the work (1500 guineas).

Bibliographical Abbreviations

ARTIST'S SALE, 1874
London, Christie, Manson & Woods. *Catalogue of the Remaining Works of That Distinguished Artist, Sir E. Landseer, R.A., Deceased.* May 8–15, 1874.

BELFAST, 1961
Belfast, Belfast Art Gallery. *Pictures from Ulster Houses.* 1961.

B.I.
British Institution, London.

BOASE, 1959
T.S.R. Boase. *English Art 1800–1870.* Oxford, 1959.

DAFFORNE, 1873
James Dafforne. *Pictures by Sir Edwin Landseer, Royal Academician. With Descriptions, and a Biographical Sketch of the Painter.* London, 1873.

CONSTABLE CORRESPONDENCE
John Constable's Correspondence. Edited by R. B. Beckett. 6 vols. London, 1962–68.

DETROIT, 1968
Detroit, The Detroit Institute of Arts. *Romantic Art in Britain: Paintings and Drawings, 1760–1860.* January 9–February 18, 1968. *Also shown at* Philadelphia Museum of Art, March 14–April 21, 1968. Catalogue by Frederick Cummings and Allen Staley. Essays by Robert Rosenblum, Frederick Cummings, and Allen Staley.

EARLY WORKS, 1869
The Early Works of Sir Edwin Landseer, R.A.: A Brief Sketch of the Artist Illustrated by Photographs of Sixteen of His Most Popular Works. With a Complete List of His Exhibited Works. London, 1869. Text by Frederick G. Stephens. Expanded into *Landseer Gallery,* 1871, and Stephens, 1874.

FRITH, 1887–88
William Powell Frith. *My Autobiography and Reminiscences.* 3 vols. London, 1887–88.

GAUNT, 1972
William Gaunt. *The Restless Century: Painting in Britain, 1800–1900.* London, 1972.

GRAVES, 1876
Algernon Graves, comp. *Catalogue of the Works of the Late Sir Edwin Landseer, R.A.* London, 1876.

HAYDON DIARY, 1960–63
The Diary of Benjamin Robert Haydon. Edited by W. B. Pope. 5 vols. Cambridge, Mass., 1960–63.

LANDSEER GALLERY, 1871
The Landseer Gallery: A Series of Twenty-Two Autotype Reproductions of Engravings after the Celebrated Early Paintings of Sir Edwin Landseer, R.A., with Memoir and Descriptions. London, 1871. Text by Frederick G. Stephens. Expanded version of *Early Works,* 1869.

LANDSEER GALLERY, 1878
The Landseer Gallery Containing Thirty-Six Reproductions from the Most Celebrated Early Works of Sir Edwin Landseer, with a Memoir of the Artist's Life and Descriptions of the Plates. London, 1878.

LANDSEER GALLERY, 1887
The Landseer Gallery Being a Collection of Forty-Five Steel Engravings after Pictures by the Late Sir Edwin Landseer. London, 1887.

LANDSEER'S BANK ACCOUNTS
Ledgers detailing Landseer's banking transactions, 1832–73. Barclay's Bank, Fleet Street Branch (formerly Gosling's Bank), London.

LENNIE, 1976
Campbell Lennie. *Landseer: The Victorian Paragon.* London, 1976.

LIBRARY EDITION, 1881–93
Library Edition of the Works of Sir Edwin Landseer, R.A. 2 vols. London, 1881–93.

LONDON, 1874
London, Royal Academy of Arts. *The Works of the Late Sir Edwin Landseer, R.A.* Winter 1874.

LONDON, 1890
London, Grosvenor Gallery. *Works of Art Illustrative of, and Connected with Sport.* Winter 1890.

LONDON, 1951
London, Royal Academy of Arts. *The First Hundred Years of the Royal Academy, 1769–1868.* 1951–52.

LONDON, 1961
London, Royal Academy of Arts. *Paintings and Drawings by Sir Edwin Landseer R.A. 1802–1873.* Winter 1961.

LONDON, 1973
London, The Tate Gallery. *Landscape in Britain, c. 1750–1850.* November 20, 1973–February 3, 1974.

MANCHESTER, 1857
Manchester. *Catalogue of the Art Treasures of the United Kingdom.* 1857.

MANCHESTER, 1887
Manchester. *Royal Jubilee Exhibition.* 1887.

MANN, 1874–77
Cabel Scholefield Mann. Interleaved copy of London, 1874, with extensive annotations and photographic reproductions of most known Landseer prints. 4 vols. 1874–77. V & A, Eng MS, 86BB. 19. Two similar sets compiled by Mann, one given to Queen Victoria, are now lost.

MANSON, 1902
James A. Manson. *Sir Edwin Landseer, R.A.* London, 1902.

MILLAR, 1977
Oliver Millar. *The Queen's Pictures.* London, 1977.

MONKHOUSE, 1879
William Cosmo Monkhouse. *The Works of Sir Edwin Landseer, R.A. Illustrated by Forty-Four Steel Engravings and About Two Hundred Woodcuts from Sketches in the Collection of Her Majesty and Other Sources with a History of His Art-Life.* London, 1879. The final version of Monkhouse's *Studies of Sir Edwin Landseer* and *Pictures by Sir Edwin Landseer, R.A.,* both London, 1877.

NATIONAL GALLERY CATALOGUE, 1888
London, National Gallery. *Descriptive and Historical Catalogue of the Pictures in the National Gallery; with Biographical Notices of the Painters. British School.* London, 1888.

NATIONAL GALLERY CATALOGUE, 1913
London, National Gallery. *Descriptive and Historical Catalogue of the British and Foreign Pictures, with Biographical Notices of the Painters.* London, 1913.

ORMOND, 1973
Richard L. Ormond. *National Portrait Gallery: Early Victorian Portraits.* 2 vols. London, 1973.

PARIS, 1972
Paris, Musée du Petit Palais. *La Peinture romantique anglaise et les préraphaélites.* January–April 1972.

PSA, 1892
London, Printsellers' Association. *An Alphabetical List of Engravings Declared at the Office of the Printsellers' Association, London, ... Since Its Establishment in 1847 to the End of 1891.* 2 vols. London, 1892–94.

PSA, 1912
London, Printsellers' Association. *An Alphabetical List of Engravings Declared at the Office of the Printsellers' Association, London, ... from 1892 to 1911.* London, 1912.

QUEEN VICTORIA'S JOURNAL
Royal Archives, Windsor Castle.

R.A.
Royal Academy of Arts, London.

ROBERTSON, 1978
David Robertson. *Sir Charles Eastlake and the Victorian Art World.* Princeton, 1978.

RUSKIN, 1903–12
The Works of John Ruskin. Edited by E. T. Cook and Alexander Wedderburn. Library edition. 39 vols. London, 1903–12.

SCOTT LETTERS, 1932–37
Letters of Sir Walter Scott. Edited by H.J.C. Grierson. Centenary edition. London, 1932–37.

SHEFFIELD, 1972
Sheffield, Mappin Art Gallery. *Landseer and His World.* February 5–March 12, 1972.

STEPHENS, 1874
Frederick G. Stephens. *Memoirs of Sir Edwin Landseer. A Sketch of the Life of the Artist, Illustrated with Reproductions of Twenty-Four of His Most Popular Works. Being a New Edition of "The Early Works of Sir Edwin Landseer."* London, 1874. A revised edition, *Sir Edwin Landseer,* was published in London in 1880 as part of "The Great Artists" series.

SUDLEY, 1971
The Emma Holt Bequest. Sudley: Illustrated Catalogue and History of the House. Liverpool, 1971.

TATE GALLERY CATALOGUE, 1898
London, The Tate Gallery [National Gallery of British Art]. *Descriptive and Historical Catalogue of the Pictures and Sculpture in the National Gallery of British Art, with Biographical Notices of the Deceased Artists* London, 1898.

TATE GALLERY CATALOGUE, 1913
London, The Tate Gallery [National Gallery of British Art]. *The National Gallery of British Art Catalogue.* London, 1913.

V & A
Victoria and Albert Museum, London.

V & A CATALOGUE, 1857
London, Victoria and Albert Museum [South Kensington Museum]. *Inventory of the Pictures, Drawings, Etchings, &c. in the British Fine Art Collections Deposited in the New Gallery at Cromwell Gardens, South Kensington. Being for the Most Part the Gift of J. Sheepshanks.* London, 1857.

V & A CATALOGUE, 1877
London, Victoria and Albert Museum [South Kensington Museum]. *Pictures at South Kensington: The Raphael Cartoons, the Sheepshanks Collection, etc.* London, 1877. Catalogue by Henry Blackburn.

V & A CATALOGUE, 1893
London, Victoria and Albert Museum [South Kensington Museum]. *A Catalogue of the National Gallery of British Art at South Kensington Part I. Oil Paintings.* London, 1893.

V & A CATALOGUE, 1907
London, Victoria and Albert Museum. *The National Gallery of British Art, Victoria and Albert Museum. I. Catalogue of Oil Paintings by British Artists and Foreigners Working in Great Britain.* London, 1907.

V & A PRESS CUTTINGS
Press cuttings, 1686–1835. 6 vols. V & A, PP17.G.

WAAGEN, 1854–57
Gustav Waagen. *Treasures of Art in Great Britain* 3 vols. London, 1854. Supplementary vol. 4. *Galleries and Cabinets of Art in Great Britain* London, 1857.

WHITLEY, 1930
William T. Whitley. *Art in England 1821–1837.* Cambridge, 1930.

221

Index of Works Illustrated

**Photographs from the Royal Collection are
reproduced by gracious permission of
Her Majesty Queen Elizabeth II.**

Photographs were supplied by the owners, except
the following: Barnes & Bradforth, London, cover,
frontispiece, nos. 4, 5, 6, 70, 71, 77, 78, 93, 94, 122,
133, 142, 151, 156; Beedle & Cooper, Northampton,
fig. 19; L. Borel, Marseilles, fig. 43; Will Brown,
Philadelphia, nos. 37, 49, 69; Bushey Colour Labs,
London, no. 124; A.C. Cooper Ltd., London, nos. 60,
105, 106, 130, 132, 152; Cooper-Bridgeman Library,
London, no. 20; courtesy of Courtauld Institute of Art,
London, nos. 11, 12, 16, 25, 39, 42, 45, 54, 80, 123,
148, 155, fig. 3; Cowper & Co., Perth, no. 30; Mike
Ford Photography, Sheffield, nos. 73, 140; John R.
Freeman & Co., London, no. 8, fig. 12; Hazlitt, Gooden
& Fox, London, nos. 47, 48, 75; John Mills, Liverpool,
no. 24; courtesy of National Portrait Gallery, London,
fig. 11; Philipson Studios, Newcastle upon Tyne, no.
153; Photo Studios Ltd., London, nos. 76, 82; Prudence
Cuming Associates Ltd., no. 131; Gordon H. Roberton,
A.C. Cooper Ltd., nos. 103, 108, 109, 121; courtesy
of Royal Academy of Arts, London, no. 90, fig. 8;
Tom Scott, Edinburgh, no. 79; courtesy of Sotheby
Parke-Bernet, fig. 10; John Watt, Perth, no. 32;
courtesy of Woburn Abbey, Bedfordshire, no. 96.

Library of Congress Cataloging in Publication Data

Ormond, Richard.
 Sir Edwin Landseer.

 Catalog of an exhibition, Philadelphia Museum of Art,
Oct. 25, 1981–Jan. 3, 1982, and the Tate Gallery, London,
Feb. 10–Apr. 12, 1982.
 Bibliography: p.
 Includes index.
 1. Landseer, Edwin Henry, Sir, 1802–1873—
Exhibitions. I. Landseer, Edwin Henry, Sir, 1802–1873.
II. Rishel, Joseph J. III. Hamlyn, Robin.
IV. Philadelphia Museum of Art. V. Tate Gallery.
VI. Title.
ND497.L2A4 1981 759.2 81–10737
ISBN 0–87633–044–8 (pbk.) AACR2